SHORT FILM DISTRIBUTION

SHORT FILM DISTRIBUTION
Film Festivals, the Internet, and Self-Promotion

Jason Moore

MERCURY LEARNING AND INFORMATION
Dulles, Virginia
Boston, Massachusetts

Publisher: David Pallai

MERCURY LEARNING AND INFORMATION
22841 Quicksilver Drive
Dulles, VA 20166
info@merclearning.com
www.merclearning.com
1-800-758-3756

This book is printed on acid-free paper.

J. Moore. *SHORT FILM DISTRIBUTION. Film Festivals, the Internet, and Self-Promotion.*
ISBN: 978-1-9364201-4-8

The publisher recognizes and respects all marks used by companies, manufacturers, and developers as a means to distinguish their products. All brand names and product names mentioned in this book are trademarks or service marks of their respective companies. Any omission or misuse (of any kind) of service marks or trademarks, etc. is not an attempt to infringe on the property of others.

Library of Congress Control Number: 2011922262

111213321

Our titles are available for adoption, license, or bulk purchase by institutions, corporations, etc. For additional information, please contact the Customer Service Dept. at 1-800-758-3756 (toll free).

The sole obligation of MERCURY LEARNING AND INFORMATION to the purchaser is to replace the disc, based on defective materials or faulty workmanship, but not based on the operation or functionality of the product.

CONTENTS

Preface xix

Chapter 1 **What is Distribution?** 1

Overview and Learning Objectives 1
What, Exactly, is Distribution? 2
Benefits of Distribution 2
 Distribution is a step-by-step process 6
A Brief History of Film Distribution 7
 Early film distribution 8
 Television and independent film 10
 Cable television and home entertainment 13
 Film festivals and short films 14
 The game changer: The Internet 15
Opportunities for You 16
Summary 17
Review Questions: Chapter 1 18
Discussion / Essay Questions 18
Applying What You Have Learned 19
 Research/Lab/Fieldwork Projects 19

Chapter 2 **What Types of Projects Can Be Distributed?** 21

Overview and Learning Objectives 21
What Types of Short Films or Videos Can Be Distributed? 22
 Short films 22
 Alternative content 22

User-generated videos 24

Amateur videos (Can be distributed, but should not be) 25

Short Films: Your Best Chance for Success 25

Short films can advance your career 26

There is an established distribution
model for short films 26

Short films are popular around the world 26

Who Can Participate in Short-Film Distribution? 27

The aspiring feature director 29

Aspiring cinematographer, editor, set designer,
sound designer, and other creative crew members 29

Intermediate level filmmaker looking for experience 30

The first-time filmmaker looking to learn the ropes 30

One More Thing to Consider . . . Your Film Itself 31

Qualities of Successful Short Films 32

Your short film should be short 32

Longer Running Times 33

Production value: Your film must look like a "real" film 34

Subject matter: Audiences respond to
personal and original work 35

What Exactly Do "Original" and "Personal" Mean? 36

Summary 37

Review Questions: Chapter 2 38

Discussion / Essay Questions 38

Applying What You Have Learned 39

Research/Lab/Fieldwork Projects 39

Chapter 3 **Distribution Goals, Plans, and Models** 41

Overview and Learning Objectives 41

Setting Goals and Making a Plan 42

Distribution Models 42

Two Popular Distribution Models: Classic and DIY 43

Classic distribution model 43

DIY (Do It Yourself) distribution model 44

Classic and DIY models compared 45

Which Model Is Better? 47

Benefits of the Classic Model 48

Challenges of the Classic Model 48

Benefits of the DIY Model		48
Challenges of the DIY Model		48
Why Not Just Do Both Models and Get the Best of Each of Them?		49
Exclusivity		49
What's the Solution?		50
The Hybrid Model		50
Distribution Plans		51
Choosing your distribution goal		52
Setting Expectations and Measuring Your Success		52
Creating your distribution plan		52
Summary		53
Review Questions: Chapter 3		53
Discussion / Essay Questions		53
Applying What You Have Learned		54
Research/Lab/Fieldwork Projects		54
Chapter 4	**Deliverables**	**55**
Overview and Learning Objectives		55
Distribution First Steps: Preparing Your Deliverables		56
Don't I just need my film?		56
Deliverables Defined		57
Rights and releases		57
Promotional materials		57
The film itself		58
Typical List of Deliverables		58
Rights & releases		58
Promotional materials		58
The film itself		59
Managing Your Deliverables		59
Rights and Releases in Detail		60
1. Producer / Director release		62
2. Talent releases		62
3. Screenplay release		64
4. Music releases		64
5. Locations release		65
6. Art materials release		68
7. Music cue sheet		68

Promotional Materials in Detail 70

 8. One sheet (Poster) and DVD artwork 71

 9. Production stills 72

 10. Director biography 74

 11. Director's statement 74

 12. Crew list 76

 13. Film synopsis 76

 14. The script 76

The Film Itself in Detail 76

 15. Master in various formats 77

 Film Festivals 77

 Distributors, Broadcasters, and Buyers 78

 16. Music and effects track (M&E) on channel 3 & 4 79

 17. Dialog list 79

Filmmaker Types: Who Needs What? 79

 Aspiring feature director 80

 Aspiring creative crew member 80

 Intermediate-level filmmaker 80

 First-time filmmaker 82

Strategies for Collecting Rights and Releases 82

 Producer / Director release 82

 Talent releases 82

 Screenplay release 83

 Music release 83

 Location release 85

 Art materials release 86

Summary 87

Review Questions: Chapter 4 87

Discussion / Essay Questions 88

Applying What You Have Learned 89

 Research / Lab / Fieldwork Projects 89

Chapter 5 **Promoting Your Film and Yourself** **91**

Overview and Learning Objectives 91

Self-Promotion: Step One of Your Distribution Plan 92

 The benefits of promoting your film 92

 What if the film is not perfect? 93

Understanding your audience 93
Standing out from the crowd 95
Believe in yourself, believe in your film, and
 enjoy the process 95
Traditional Versus DIY Promotion Models 96
Putting Together Your Press Pack 98
One sheet (poster)/DVD artwork/Postcards 98
Production stills 99
Director's biography 102
Director's statement 102
Film synopsis 102
Trailer 102
Behind-the-scene clips and bonus material 104
Business card 104
Creating your story 105
Putting it all together 106
Summary 107
Review Questions: Chapter 5 107
Discussion / Essay Questions 108
Applying What You Have Learned 109
Research/Lab/Fieldwork Projects 109

Chapter 6 Promoting in the "Real World" and on the Internet 111

Overview and Learning Objectives 111
Promoting Yourself in the "Real World" 112
But what, exactly, do I say? 112
Add Value 112
Give More than You Receive 113
The test screening 114
The elevator pitch 115
More "real-world" promoting 116
Promoting Yourself on the Internet 116
Promoting with Email 117
Email Newsletter 117
Email Announcing Your Web site / Blog / Podcast 118
Your "Home" on the Web: your Web site 118
Blogging 119

	Podcasting	121
	Social networking sites: MySpace, Facebook, & Twitter	123
	Personal Page or Project Page	123
	Timing Your Promotions	125
	Start early	126
	Phases of your film	126
	Golden Rule of Promoting Your Film: Don't Release It!	127
	Summary	128
	Review Questions: Chapter 6	128
	Discussion / Essay Questions	128
	Applying What You Have Learned	129
	Research / Lab / Fieldwork Projects	129
Chapter 7	**Preparing for the Festival**	**131**
	Overview and Learning Objectives	131
	Film Festivals: Step Two of Your Distribution Plan	132
	What, exactly, is a film festival?	132
	Who Organizes Film Festivals, and Why?	132
	Who Attends Film Festivals?	133
	Who Screens Films at Film Festivals?	133
	What Happens at a Film Festival?	133
	Film Festival Strategy: Finding and Entering the Right Festivals for You	134
	Aspiring feature-director strategy	135
	Intermediate-level filmmaker strategy	136
	Aspiring creative crew-member strategy	136
	First-time filmmaker strategy	137
	Using the Internet to Research and Apply to Film Festivals	137
	Using withoutabox.com	138
	Register	139
	Create a Project	139
	Finishing the Project Form	144
	Building Your Online Press Kit	144
	Researching Festivals	147
	Submitting to Festivals	148
	Submission Status	151
	Summary	155
	Review Questions: Chapter 7	155

Discussion / Essay Questions 156
Applying What You Have Learned 156
 Research/Lab/Fieldwork Projects 156

Chapter 8 **At the Festival** **157**

Overview and Learning Objectives 157
Congratulations, Your Film Has Been Accepted! 158
Preparing for the "Big Night" 158
 Communicating with the festival 158
 Format 158
 Volunteer Yourself 159
Promoting Your Screening 160
 Remember: Add value and give more than you receive 160
 Flyers/Postcards/Swag 161
 Refining your "story" 162
 Interviews and press opportunities 164
Setting a Goal for the Festival 165
 Goals for aspiring feature directors 166
 Goals for intermediate-level filmmakers 168
 Goals for aspiring creative crew members 169
 Goals for first-time filmmakers 170
Summary 176
Review Questions: Chapter 8 177
Discussion / Essay Questions 177
Applying What You Have Learned 178
 Research/Lab/Fieldwork Projects 178

Chapter 9 **Preparing for the Sale: the Language of a Contract** **179**

Overview and Learning Objectives 179
Let's Make a Deal 180
 Broadcast distribution: Step 3 of your distribution plan 180
 Selling vs. Licensing 181
 Promoting on the Web: Trailers only! 181
 Deliverables: Standing by 182
 Festival success: Is it crucial? 182
Understanding Distribution Language 183
 Distribution company (distributor) 183
 Sales agent 183
 Film buyer 184

Distribution platforms 184
 Broadcast 184
 Home Entertainment 184
 Educational 185
 Internet 185
 Mobile 186
 Theatrical 186
 Other Distribution Platforms 187
Territories 187
Exclusivity 187
Exclusivity across platforms 188
Exclusivity among distributors and sales agents 189
Nonexclusive 189
Term 190
Fee 190
Release window 191
Summary 196
 Intermediate-level filmmakers, creative crew
 members, and first-time filmmakers 196
Review Questions: Chapter 9 197
Discussion / Essay Questions 198
Applying What You Have Learned 198
 Research/Lab/Fieldwork Projects 198

Chapter 10 Broadcast Distribution **201**

Overview and Learning Objectives 201
Broadcast Distribution Overview 202
 1. Submit your film to a distribution
 company or sales agent 202
 2. Negotiate a deal 202
 3. Continue the process for all worldwide
 territories and platforms 203
 4. Explore contacting buyers directly 203
Finding and Approaching Distribution
 Companies and Sales Agents 203
 How to find distribution companies and sales agents 204
 Internet Research 204
 Film Festivals and Markets 205

Networking to Find Distributors 206

International Distribution Companies 207

How to approach distributors and sales agents 207

Cover Letter 208

Press Pack 208

The DVD 209

Follow Up 210

Negotiating a Deal 211

First contact 211

The contract 212

Negotiating 212

Negotiating Fees 217

Negotiating Exclusivity, Platforms, and Territories 218

Negotiating Internet Deals with
Distributors and Sales Agents 218

Negotiating the Term 219

Approaching Broadcast Buyers Directly 220

Finding broadcast buyers 220

The contract 221

Getting paid 221

Summary 223

Review Questions: Chapter 10 224

Discussion / Essay Questions 224

Applying What You Have Learned 225

Research/Lab/Fieldwork Projects 225

Short Film Distributors - Domestic and Foreign 226

Short Film Buyers – Domestic and Foreign (*Selected*) 227

Chapter 11 Non-Broadcast Distribution **231**

Overview and Learning Objectives 231

Non-Broadcast Distribution Platforms 232

Securing Internet distribution (Either with a distributor
or DIY style): Step 4 of your distribution plan 232

Paid Internet deals through a distributor 233

Home entertainment 235

Educational 237

Mobile 238

Other non-broadcast platforms 240

When to Move to DIY Distribution 240
 The Internet release window 240
Summary 242
Review Questions: Chapter 11 243
Discussion / Essay Questions 243
Applying What You Have Learned 244
 Research/Lab/Fieldwork Projects 244
Educational Distribution Companies: a Partial Listing 244

Chapter 12 DIY Distribution on the Internet **247**

Overview and Learning Objectives 247
Securing Internet Distribution (Either with a Distributor
 or DIY Style): Step 4 of Your Distribution Plan 248
DIY Explained 248
 Types of DIY techniques we will explore 249
Web Sites with a "For-Pay" Model 249
 YouTube.com 249
 YouTube Channels 250
 YouTube Partner Program 250
 IndieFlix.com 252
 DVD Fulfillment 252
 Amazon's CreateSpace.com 253
 Babelgum.com 254
 Revver.com, Openfilm.com, HungryFlix.com,
 MDistribute.com 256
Web Sites Geared Toward Filmmakers 256
 Triggerstreet.com 257
 TheSmalls.com, ShootingPeople.org, Raindance.tv 257
 Atom.com 257
VODO (Voluntary Donation) 258
Web sites with a "no-pay" model 259
 Vimeo.com 260
 Facebook.com, MySpace.com, Your personal Web page 260
 Other Web sites 261
 Netflix.com 262
 Hulu.com 262
 Sling.com, Current.tv, Blip.com 262
 Bittorrent 262

Exclusivity and Territories on the Internet 262
Summary 263
Review Questions: Chapter 12 264
Discussion / Essay Questions 265
Applying What You Have Learned 265
 Research/Lab/Fieldwork Projects 265

Chapter 13 Distributing Alternative Content **267**

Overview and Learning Objectives 267
Alternative Content 268
 Career paths 268
 Episodic Television/Webisodes 268
 Spec Commercials and Music Videos 269
 Action-Sports Videos 270
 Other Career Paths & Projects 270
The Alternative-Content DIY Plan 271
 Promote your project and yourself 271
 Know your audience 272
 Distribute your work on the Web, DIY style 272
 Webisodes 273
 Spec Commercials and Music Videos 277
 Action-Sports Videos 280
 Other Types of Projects 282
Summary 283
Review Questions: Chapter 13 284
Discussion / Essay Questions 284
Applying What You Have Learned 285
 Research/Lab/Fieldwork Projects 285

Chapter 14 Distributing Your Demo Reel **287**

Overview and Learning Objectives 287
Why Have a Demo Reel? 288
 What, exactly, is a demo reel? 288
 The DVD Demo Reel 288
 What goes on a demo reel? 291
 Specialized Reels: Director Reel,
 Cinematographer Reel, Editor Reel 292
 Demo Reels Show Small Pieces of Work 293

Demo Reels Are Short and Fast Paced 293
Demo Reels Showcase Only the Best Work 294
The Evolution of a Demo Reel 294
Recent graduate/Early stages of career 294
Narrative or documentary film reel 295
Specialized industry reel 295
Further specialized reels 295
Distributing Your Demo Reel 296
On request 296
Submitting your reel 297
Cinematographers and Editors Seeking Representation 297
Directors Seeking Representation 297
Movie Studios, Networks, and Cable Companies 298
Networking and day-to-day encounters 298
Distributing your reel on the Internet 299
Social Networking and Free Video Sites 299
Professional Networking Sites 299
Paid Demo-Reel Hosting Web Sites 299
Your Personal Web Site 300
Summary 309
Review Questions: Chapter 14 309
Discussion / Essay Questions 310
Applying What You Have Learned 310
Research/Lab/Fieldwork Projects 310

Chapter 15 The End of One Cycle, the Start of Another 311

Overview and Learning Objectives 311
Winding Down 312
Wrapping things up 313
Dealing with Rejection 314
Leveraging Success and Gaining Momentum:
Step 5 of Your Distribution Plan 315
Self-Evaluation 315
Self-Evaluation: The Film 316
Self Evaluation: The Distribution Process 317
Make your next film distributable 317
Utilize your network of fans, friends, and peers 318
Leverage your success 318
Gain momentum 319

Summary 320
Review Questions: Chapter 15 321
Discussion / Essay Questions 321
Applying What You Have Learned 322
 Research/Lab/Fieldwork Projects 322

Appendix **323**
Index **339**

PREFACE

Many film students benefit from having wonderful teachers who instruct them in all the aspects of pre-production, production, and postproduction. Once their film is finished, however, there isn't a great deal of discussion on how to use it to further one's career. Just as I was graduating with a thesis-level short film under my belt, video on the Internet was taking off, and there seemed to be a greater number of opportunities for the screening and distribution of short films than ever before. Unfortunately, there was very little information available regarding how to navigate that field.

Full of enthusiasm and passion, I forged ahead. I found success on the festival circuit, sold my film to both domestic and international broadcast distributors, and struck several Internet deals. I discovered how to leverage my short film to help start my career as a director. It was a struggle, however, and during the process it seemed to me that there was a need for the same type of training for the distribution phase as for the other aspects of film-making.

As I started working in the film industry and teaching film classes, it became clearly evident that although there have been one or two books covering the topic, what was needed was an in-depth manual to take students step-by-step through the long and somewhat complex undertaking of distributing their films. This book, written after several years of lecturing on the topic in my classes, is the collection of experiences, lessons learned, and tips that I wish I had in film school.

The goal of this book is to give film students and hobbyists a clear, easy-to-understand overview of the short-film distribution process. Almost every

film can find an audience and help a filmmaker move closer to his dreams. Now, more than ever, the opportunities for filmmakers with short films are almost limitless. The sheer volume of outlets and large numbers of people competing for attention, however, conspire to make navigating this field as intricate as ever. What is needed is a comprehensive examination of all the options available and some strategic advice from someone who has been through the process successfully.

The intended audience for *Short Film Distribution: Film Festivals, the Internet, and Self-Promotion* is film students and filmmakers who are new to the distribution process. It has been written for four distinct types of filmmakers: directors with a finished, thesis-level, or advanced film who are ready to enter the world of distribution with enthusiasm and determination; intermediate-level filmmakers who want to investigate film distribution on a limited level; first-time filmmakers who might not have a film to distribute but want to be proactive and learn what is involved; and students who are seeking a career in other areas of film production, such as editors, cinematographers, production designers, and sound designers. This last group of creative artists can greatly benefit from an understanding of film distribution, and their needs in this regard have typically been ignored.

This book was designed by a film instructor with both students and teachers in mind. Film instructors will find *Short Film Distribution: Film Festivals, the Internet, and Self-Promotion* useful as a text in a course specifically about distribution or as a complement to any number of courses on film production and post-production. The chapters end with quiz and essay questions, field assignments, and projects.

This book is best read in a linear fashion, because each chapter builds upon and grows out of lessons, terms, and concepts from those preceding. Filmmakers with a completed film will find that devoting one week per chapter—hopefully under the guidance of an instructor or a friend who is an experienced filmmaker—will be the best way to use this material.

I wish to offer my thanks to everyone who helped make this book possible, including my editors and publishers at Mercury Learning for their tireless efforts, my peers and colleagues for their feedback and contributions, my friends and family for their support, my wife for her endless love and patience, and most of all, my teachers and my students for their inspiration.

J.M.

WHAT IS DISTRIBUTION?

OVERVIEW AND LEARNING OBJECTIVES

In this chapter, you will:

- Understand the basic definition of distribution
- Learn about the benefits of distribution
- Learn how this book is organized
- Learn about the history of early film distribution
- Learn about modern digital distribution
- Understand the opportunities created for you by digital distribution

What, Exactly, is Distribution?

If you are reading this, you probably have a dream to work in the film industry on some level: as a cinematographer, an editor, maybe even a writer, director, or producer—and there is a good chance that you have also made a short film or video, or at least that you've worked on one. If so, then congratulations! You're on your way! This book will definitely help you get there. In fact, if you read this book and follow the guidelines and lessons, you might find yourself arriving at the door to your dream faster than you had imagined. Here's why: there are more opportunities for filmmakers today than ever before in the history of film. Thousands and thousands of filmmakers are finding success and living their dreams every year. You might not have heard of many of them, but you can be sure they are out there, making films, getting them seen, and yes, even making money. One of the ways they are getting their films seen is by understanding how film and video distribution works. Even if you're not aware of it, you already have a general understanding of what film distribution is; after all, you have been participating in the chain of distribution ever since you saw your first movie. Distribution is simply the term that describes filmmakers putting their movies into circulation to be seen by people. For the big studios and major production companies, distribution is the process of releasing their films to theaters and selling tickets. For television networks, distribution is about broadcasting TV shows and charging advertisers for commercials to be shown during breaks. When you watch or upload a clip to You Tube, you are a part of that video's distribution. When you click on a link on iTunes® and buy a music video, or when you rent a movie, someone—in fact many people—make money from your purchase. For professionals working in the film and television industry, distribution is how they make money on the projects they create and show to audiences. See Figure 1-1 for a basic explanation of how distribution works.

Benefits of Distribution

For you, a novice filmmaker, distribution can be as simple or as complex as you want it to be. It can be as basic as screening your project for family and friends. Or, if you've got the right project and are ambitious, it might mean traveling the world on the *international film festival circuit*, speaking on *panel discussions*, participating in *film markets*, *licensing the film rights* to buyers, and negotiating deals for real money. It might also mean uploading your film to your personal Web site, or licensing the rights to a Web site that specializes in showing short films. The possibilities are endless, and the rewards are great.

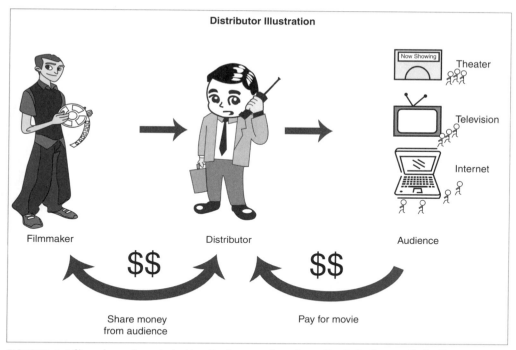

FIGURE 1-1. A filmmaker makes a deal with a distributor to share the profits. A distributor sells the film to theaters, TV stations, Internet sites, and other outlets. Courtesy of Jason Moore. Used with permission.

KEY TERM:

International Film Festival Circuit Film festivals are events that celebrate films of every kind: features, short films, documentaries, art films, and more. The Film Festival Circuit, both national and international, gives you the chance to submit your film to many of the hundreds of festivals occurring around the world every year. "Doing the festival circuit" with your film is kind of like a rock band going on tour. It's fun, it's exciting, and you are showing your work to adoring fans. It's an amazing experience and one of the ultimate goals for most filmmakers.

Along with "doing the festival circuit," there are opportunities for the people who have worked on a film to participate in *panel discussions*; they are an excellent venue for you to "talk up" your film.

KEY TERM:

Panel Discussion A panel discussion occurs after a screening of a film, usually at film festivals or special screenings. The panel will consist of the key filmmaking team: the director, writer, actors, producer, or a combination of these. A moderator will facilitate a Q&A session and the panelists will share inside information about the making of the film, the meaning of the film, and so forth. A panel discussion is seen by filmmakers as a terrific way to promote their film and themselves.

A *film market* provides an opportunity for you to sell your film to a distributor and will help you achieve your dream of getting your work seen by a wider audience.

KEY TERM:

Film Market A film market is an event where films are screened for potential buyers. They are usually run as part of a major film festival, and the audience for film market screenings will be made up of people who are potentially interested in buying the film.

Licensing film rights is a complex subject and could warrant several chapters in this book. Don't worry; once we start looking at the details, it will all be clear.

KEY TERM:

Licensing Film Rights When someone "buys" a film, they don't actually purchase the actual film; rather, they buy the "rights," or permission, to rent the film to yet another person—usually a theater, TV station, or Web site. When you license your film, you are giving someone the permission to screen the film, and for that you get paid.

Distribution involves more than just making money. It's also about getting your work seen, getting attention from the media, and building a reputation. Think about all those funny viral videos you have seen, or the top-rated videos on You Tube, or those amazing short films you might have seen at a festival or online. Although these types of short films might not always earn money, they do create a *buzz* around their creators and give their filmmakers a chance to make a name for themselves and further their ability to work in the film industry.

KEY TERM:

Buzz In the film industry, buzz is everything. It means attention, interest, or excitement about you and your work. You want as much buzz as possible.

It is important to understand the distribution aspect of filmmaking and to be aware that there is a *distribution model* for almost every type of film.

KEY TERM:

Distribution Model A distribution model is the industry term for the plan or process undertaken for distributing your film. Different types of films have different models. A big-budget Hollywood film might have a distribution model that spends millions of advertising dollars, opens in theaters around the world on the same day, and plans for eventual releases to cable, DVD, and the Web. However, a model for a low-budget, independent film might rely on taking the film on the film festival circuit, screening it at a film market, and hoping that a buyer will purchase a license for the rights. A short film has its own model, which is what we will be exploring in the upcoming chapters!

If you dream about directing films professionally and are willing to work hard and do everything it takes to get there, this book can help you. If you are just starting out with filmmaking as a hobby and want to explore putting a project on the Web or showing it privately to friends and family, this book can show you how. For anyone with a goal that falls somewhere between that of the amateur and the aspiring professional, making almost any type of project as a director, writer, cinematographer, actor, or producer, this book can show you how to get your work seen and how to benefit from successful distribution.

Distribution is a step-by-step process

Distributing a film is a complex and time-consuming effort, and it can seem a bit intimidating. This book will guide you step-by-step through the distribution process and will show you exactly what to do and what to expect along the way. Anyone can participate, with just about any type of project. You will have to do some work, but your efforts will be compensated by the benefits: fame, fortune, and fun, to name just a few. Here are the topics we will explore in the following chapters of this book:

- The history of distribution. This will offer you some context and understanding of how this vital aspect of the film business came about.

- An overview of modern, digital distribution. With the invention of the Internet, distribution has changed for the better, and you'll explore the many opportunities the modern digital age can provide for you.

- How to plan for distribution right from the very start. You will learn to make smart decisions about what kinds of films work best and what to do to maximize the chances of getting your film seen. This book is designed to help you at any stage of the process, whether you've already got a completed short film or you are just thinking ahead.

- How to prepare a distribution plan. A well-planned distribution campaign will get your film seen.

- Becoming a promoter. Remember when you convinced your friends or family to chip in and help you with your film? This is much easier: now you're going to ask them to sit back, relax, and watch.

- Preparing for the film festival circuit. Before you get ready to "do the circuit," there are a few things you need to know. What, exactly, is the festival circuit, and how do you get your film shown and those events?

- Finding success at the festival. We'll explore all the things you need to know so you can get the most out of your experience at the festival itself.

- Understanding various types of distribution, from theatrical and broadcast television to the Internet, mobile devices, and much, much more.

- Finding a distributor. These are the people who can help take your film to the next level and put money in your pocket. We'll talk about who they are, what they do, and where to find them.

- How to sell your film. Dealing with rights, contracts, and deliverables so you can successfully (and legally) sell your film and perhaps even make some money.

- Distributing alternative content. This book is written mainly for filmmakers with short films to distribute, but there are options for anyone, regardless of the type of film content. If your film will be entertaining to an audience, you will be able to distribute it.

- Distributing your demo reel. Though not exactly the ultimate distribution, your demo reel can, and should, be treated similarly—it's your calling card and you need to get it seen.

- Tracking your progress and completing the cycle.

Each chapter will explore a topic in detail, using real-life case studies and examples of films and filmmakers who have been successful. Each chapter will end with suggested activities and exercises to help you meet the goals outlined for each step of the way. You are encouraged to read this book in a linear way—hopping around from chapter to chapter is not advised, because many details in later chapters build on concepts explored in the beginning sections. If, however, you've got a film ready to launch and are itching to learn right away about the festival process or your online options, feel free to glance over those chapters; just be aware that your best chance of success will come with a patient and organized approach to the process. While there are many, many possibilities open to you for distributing your work, the process does demand a certain focus. You need to take it as seriously as making the film itself. Now, let's get started.

A Brief History of Film Distribution

It's important to have a general understanding of the history of film distribution, so you have the whole picture in mind as you begin your own process of distribution. Though you almost certainly will be dealing with a short-form project, such as a short film or video, the history of distribution is mainly about feature films; but you'll learn how the evolution of feature-film distribution has shaped and influenced short-film distribution. As we progress along the timeline, you'll see not only where your film fits in, but you'll also gain a sense of how the industry came to be where it is today.

Early film distribution

In the early twentieth century, when filmmaking and movie going were just beginning, audiences visited nickelodeons, which were simple, neighborhood movie theaters that would screen short, silent films for the admission price of five cents. As films grew longer and more sophisticated, the number of theaters began to grow, and the theaters themselves became larger, decorated with grand designs (Figure 1-2), and seated hundreds of people.

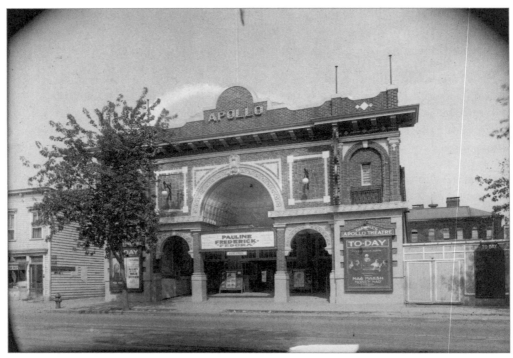

FIGURE 1-2. Crandell's Apollo Theater, Washington, DC, 1920s. Courtesy of the Library of Congress.

In 1927, sound synchronized for film was invented, and Warner Brothers Studios released *The Jazz Singer*. It was the first "box office smash," with audiences across the country flocking to theaters. The success of *The Jazz Singer* was so great that it created a surge of interest and investment in filmmaking. Soon there were large movie studios churning out hundreds of films a year. This marked the rise of the *Studio System Era*, a period of time from the 1920s to the 1950s. Studios became huge enterprises, employing thousands of workers. Film grew from the status of a pastime novelty to become an American industry as prosperous as the automotive

or steel industries. To make sure as many people as possible bought tickets to their movies, Warner Brothers and seven other large film studios bought their own chains of movie theaters. When a studio finished making a film, they sent it out to the various movie theaters they owned in cities around the country and charged money for tickets; money was made if the film was popular and numerous tickets were sold. This was the first time films were distributed on a large scale; however, owners of independent movie theaters that were not part of the studios' chains (think: small businesses versus giant corporations) and people making films outside the studio system were at a disadvantage. The top studios held a monopoly on film distribution, and exploited this to make as much money as possible. Theater owners were forced to buy an entire year's worth of films from a studio without ever seeing them; if they wanted any movies, they had to buy them all. Smaller production companies had difficulty getting studio-owned theaters to screen their films. After all, there was no incentive for a studio to allow one of their chains of theaters to screen work produced by the competition. See the accompanying sidebar: "The Studio System."

THE STUDIO SYSTEM

From the 1920s to the 1950s, film production was dominated by eight major Hollywood studios: Fox Film Corporation, Loew's Incorporated, Paramount Pictures, RKO, Warner Brothers, Universal Pictures, Columbia Pictures, and United Artists. These early studios controlled every aspect of film production and distribution. They had writers, directors, and actors "under contract" who worked exclusively for the studio on whatever pictures the studio heads decided to make. The studios owned all of the equipment: cameras, lights, and so forth, and owned vast areas of land on their back lots where sets of all sizes were constructed for filming. Editors, musicians, costumers, carpenters, and thousands of crew members, worked on the "lot," and studios cranked out fifty or sixty films a year. When a film was completed, it was distributed to the studio-owned chain of theaters. This monopoly held by the "Big Eight" made competition from smaller film production companies or independently owned movie theaters impossible. In contrast, today's studios, while still powerful, do not hold a monopoly on the production process or the distribution process. Studios work with writers, directors, and actors on a film-by-film basis. They no longer own the camera or lighting equipment, they make many movies on location as opposed to on their back lots, and they turn out far fewer (closer to twenty) films a year. Most important, they do not own their own theaters.

In the late 1940s, the government finally stepped in and declared the top studios to be in violation of the *Sherman Anti-Trust Act* and forced studios to separate themselves from theaters. This greatly benefitted theater owners and smaller production companies. Now theater owners could buy films they believed in, and a minor-league production company had a shot at getting its film into a theater. A lower-budget film from a small company could compete against a large studio film as long as the film itself was good and gathered audiences. This was a major disruption of the status quo, however, and the big studios lost millions of dollars in revenue. They were forced to lay off thousands of workers, and before long the Studio System Era was over. The upside to all of this, for filmmakers everywhere, is that the few, powerful studios that controlled everything had to relinquish their grip on distribution, and by doing so, opportunities were created for more people to become involved in film production. It was the first of many changes to come.

KEY TERM:

The Sherman Anti-Trust Act is a law used by the US government to break up unfair business monopolies and to help stimulate competition. When companies grow so large and powerful that they completely dominate an industry, they can fix prices and prevent smaller companies from offering more inexpensive services. The Sherman Anti-Trust Act is used to prevent this.

Television and independent film

At the same time the Anti-Trust Act was being enforced, television was invented, further changing the filmmaking industry and the way films were distributed (Figure 1-3).

Early television programming was based on radio shows that had been popular for decades: news programs, variety shows, comedies, dramas, and the like. Now that audiences could watch filmed entertainment in the comfort of their own homes, for free, studios and production companies had to scramble to stay relevant and to stay profitable. Major studios started making fewer films and began to rely on big-budget, high-spectacle films that were more extravagant, exciting, and larger-than-life than anything produced for television. This was the beginning of the "blockbuster" film—the one large film a studio had to make every year to keep itself in business. As television grew more popular, *television networks* like ABC, CBS, and NBC grew as powerful as the movie studios. Often, studios and networks worked together to create programming.

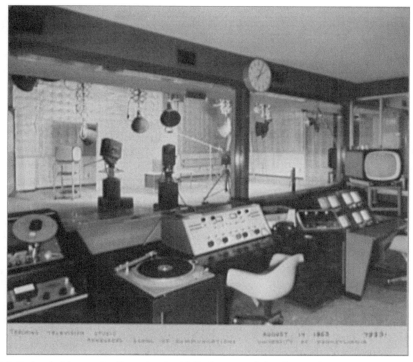

FIGURE 1-3. Early television studio, Pennsylvania, 1963. Courtesy of the Library of Congress.

KEY TERM:

Television Network A television network will usually consist of a parent company (ABC, NBC, CBS) and many local "affiliates," smaller companies located in cities across the countries. The parent company provides most of the content that is broadcast on each of the affiliate channels: national news, daytime talk shows, sports broadcasts, and "prime time" sitcoms and dramas, but the affiliate will also produce some shows on their own, mainly local news and local weather.

Although some were afraid that television would hurt the film industry, ultimately more opportunities were created for everyone from actors to *executive producers*.

Executive Producer Have you ever noticed how many producer titles there are on a feature film? Executive Producer, Co-Producer, Line Producer; what are all these positions and why are there so many? A producer is someone who helps get the movie made, and because it takes a lot of work to make one, there are a lot of people helping in many different ways. A line producer oversees the budget, while a co-producer might be someone who helped find the screenplay or convinced the director to get involved. The executive producer is someone who oversees all the other producers, and is usually associated with the person who finances or finds financing (monetary support) for the film.

As studios grew more concerned with big-budget pictures, and as television opened up new channels for distributing entertainment to audiences, another significant change occurred. Films made outside the studio system by *independent film companies* with smaller budgets and *niched subject material* began to find success at the box office. These "indie" films were possible because of the new distribution rules—distributors looked at films from anyone, and if a film was good enough they would buy the rights, and theaters would screen it. In the 1970s, as the independent film movement began to take off, films such as Dennis Hopper's *Easy Rider* did as well or better at the box office than the big studio movies. For the first time, it was possible for a filmmaker who was not "connected" to a big studio to make a film and have it seen by millions. Since these independent companies did not have the kind of money the studios had, budgets were smaller, and films did not have to make as much money in order to turn a profit. An "indie" film could be produced for a million dollars—or less—and if it made one or two million at the box office, it was considered quite successful. Compared with films with budgets ten, twenty, or even fifty times that much, these were small films.

Independent Film Company As opposed to a studio, an independent film company is much smaller. It has no back lot, does not typically make big-budget films, and often will make films without Hollywood stars. These companies often make very successful films, however. There are forty to fifty well known independent film companies in business today; some well-known names are: the Weinstein Company, Morgan Creek, Lionsgate, Silver Pictures, Summit Entertainment, and TriStar. Some of these companies have deals and business partnerships with major studios to help with financing and distribution. Some highly successful independent films are: *Pulp Fiction*, *Memento*, *Se7en*, *American Beauty*, *Eternal Sunshine of the Spotless Mind*, *Fargo*, *Amores Perros*, and *Hotel Rwanda*.

The smallness of the "indies" became an advantage to many filmmakers—they could afford to take chances and make films outside the mainstream. Films catering to smaller audiences could afford to be edgier, darker, subversive, and even politically incorrect, because they did not rely on huge numbers of people seeing them in order to be profitable. With the rise of the independent film movement, interest in more diverse types of films increased, which again created more opportunities for anyone involved in the film business.

KEY TERM:

Niched Subject Material Niche means specialized, and, in terms of independent films, it means making a film about a subject that appeals to a smaller audience.

Cable television and home entertainment

The next major change in the way films and other forms of entertainment were distributed came with two major events that affected the television industry in the 1980s. The first was the invention of the VCR in the late 1970s. The second was the introduction of "cable TV." Cable TV expanded the number of television networks from the "big three"—ABC, NBC, and CBS—to include networks that were offered to homes as paid subscriptions and were delivered via a wire cable instead of over the free airwaves. The VCR allowed audiences to rent and watch films on videotape, and cable TV offered many more viewing options in addition to the traditional networks. The

growth of the film and television industry was increasing more rapidly each year. Thanks to the VCR, studios and indie films could now make additional money in movie rentals and sales. Cable television began with HBO in the 1970s and then grew quickly in the 1980s with new stations like CNN, MTV, and USA. Cable offered dozens, and soon hundreds, of additional channels of entertainment for a monthly fee. Television and movies became America's (and the world's) most popular and profitable forms of entertainment, and could be found anywhere, anytime. New movies were released in the theaters every week, new releases to video rental stores appeared just as fast. New television shows popped up on new cable stations seemingly every day. As with the independent film movement, the cable TV movement offered niche-subject shows to small, specific types of audiences. All-news channels, all-sports channels, channels featuring only cartoons or only science fiction— if you could name a niche, a cable TV station could fill it.

Film festivals and short films

As home entertainment (TV, cable, and rentals) continued to expand the way films and videos were distributed to audiences, more opportunities were created. Short films, although popular as "warm-ups" to feature films during the Studio System Era, were not widely seen after the 1950s and the death of the studio system; but with the growing number of channels on cable, "shorts" found a home on various networks catering to film buffs and independent film enthusiasts. Simultaneously, the independent film movement was growing stronger; with increased demand for content, more and more filmmakers were given the opportunity to work and distribute their projects. Film festivals grew more and more popular, not just as places where film buffs would gather to watch art films, but also as marketplaces for up and coming directors (Figure 1-4).

The Sundance Film Festival, one of the world's most prestigious festivals, was founded in 1978 and quickly became a place where indie filmmakers could screen work made outside the studios—indeed, sometimes on shoestring budgets and credit cards—and hope that a distribution company would buy the rights to their film. Independent filmmakers like Jim Jarmusch (*Dead Man, Ghost Dog, Broken Flowers*), Steven Soderberg (*Oceans Eleven, Out of Sight, Erin Brockovich*), Robert Rodriguez (*Sin City, Spy Kids, El Mariachi*) and Kevin Smith (*Clerks, Mallrats, Chasing Amy, Cop Out*) began their careers by winning a prize at Sundance. Although features are the focus, shorts are embraced by nearly every festival. Award-winning short films (and their filmmakers) can expect to tour the nation, and sometimes the world, with a short film, sometimes with expenses paid by the festivals. In many

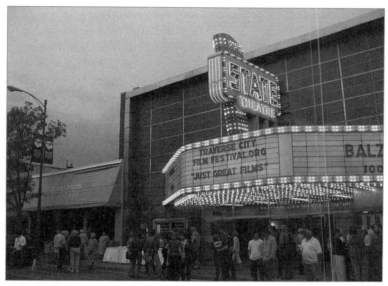

FIGURE 1-4. Traverse City Film Festival, Michigan. Founded by Academy Award winning documentary film director Michael Moore, this festival runs annually from late July to early August and screens nearly 100 films. Courtesy of Andrew McFarlane. Used with permission.

cases, shorts are purchased by distributors and are screened in a variety of different ways: on cable TV shows, at schools and universities, packaged together and sold to rental companies like Blockbuster®, even on airplanes. Remember, as mentioned above, understanding the history of distribution will help you know where your film fits in. Festivals are where short films started to get respect and attention. This is where the amazing opportunities that await you actually began. It's good to know your roots!

The game changer: The Internet

In the 1990s through the early years of 2000, film distribution continued to change and continued to grow. Studio film budgets kept growing, and income from these big films continued to come from ticket sales at theaters around the world, video rentals (now in the form of DVDs, not VHS), and television/cable broadcasts. Indie films continued to be popular, and more and more film festival events were organized. Then came the biggest step in the evolution of film distribution since the projector . . . the Internet. At first, the Internet was too slow to be a part of the distribution process. Video clips simply took too long to load, and the imaging and audio quality was unacceptable. Over time, as software developers learned new ways to compress video, video slowly but surely crept onto the "Net." In the earliest days of video on the

Web, since file size and download speeds were still obstacles, it was the short film and video that benefitted the most. Shorter films were much easier to stream and download than two-hour features. For the first time in almost a hundred years, the short film actually got more attention than features! Early Web sites devoted to streaming and downloading films and videos were Atom Films, founded in 1998, and iFilm, founded one year earlier. Short filmmakers could submit their films and, if accepted, get them seen by thousands if not millions of viewers. Many of the filmmakers were paid licensing fees and some have made thousands of dollars from a single short film. These were exciting times for short-film filmmakers and as technology improved and the Internet grew, opportunities for filmmakers grew as well. More and more Web sites began offering "content" (industry term for entertainment, mostly in the form of short films and video clips), and short-film filmmakers became "content producers," being paid to create and upload short films, video clips, funny animations, and more. In 2005, You Tube was launched, and immediately the world was given the opportunity to broadcast itself. You Tube was the world's first public access network that allowed anyone, anywhere, anytime to upload videos that anyone, anywhere, anytime could watch. "User-generated videos" took the idea of independent filmmaking to a whole new level. Video clips were being made and uploaded by complete amateurs; if original or compelling enough, they were seen by millions in just a few days. Other, professional filmmakers took advantage of the wide scope of You Tube and found ways to launch their own careers, like filmmakers Bruce Branit and Jeremy Hunt with their short film 405. Bruce and Jeremy used their skills as professional visual-effects artists and created a low-budget short film with high-end visual effects that drew millions of downloads from You Tube's Web site. 405 is considered the very first Internet film "blockbuster," and its success catapulted Bruce and Jeremy into the spotlight and helped launch their careers. Another major innovation in the mid-2000s was Apple's iTunes store, which allowed viewers to rent and buy movies—both shorts and features—via the Internet. Innovations and opportunities continue today, and are found not only in the form of Web sites devoted to playing films and videos. The Internet, with its ability to connect people and share information easily, has allowed independent and short filmmakers to network, build fan clubs, promote themselves, meet potential buyers of their work, and much more.

Opportunities for You

There's never been a better time to be a filmmaker, and if that's your goal, consider yourself lucky. Never before has the playing field been so level.

For the past one hundred years, most people could only dream of actually making films and having them seen by wide audiences. For the hard-working, connected, or extremely lucky few who did make a film, it cost them thousands if not millions of dollars, and was rarely shown beyond a cast-and-crew screening. Today, in addition to low-cost digital cameras, affordable editing stations, special-effects software, sound-editing software, and a world populated by film-hungry audiences, there is another opportunity, one that is perhaps the most important: the Internet. By harnessing the power of the "Net," filmmakers have been able to distribute and promote their work in ways never before imagined; and by doing so, thousands of filmmakers every year are finding success on a variety of levels. Digital filmmakers are seeing their work winning awards, getting licensed, creating fan bases, logging millions of hits and downloads, building their reputations, and opening doors for other projects. Each and every one of you reading this book has the potential to take advantage of these opportunities and begin to realize your dream of working in the film and television industry. Of course, with all this opportunity comes a challenge: competition. There are more films than ever before for audiences to choose from, and more filmmakers than ever before who are trying to do exactly what you are trying to do. So you've got to bring your "A" game, get focused, and work hard. If you're able to do that, you stand a better chance to make it now than ever before. Good luck!

SUMMARY

The overall purpose of this chapter was to introduce the concept of film distribution and to give you a little history about how it evolved. At this point you should have a million questions about your own project and how you'll actually participate in this aspect of the film industry. Your questions will be answered in the following pages of this book—and the next chapter is all about you and your film. For now, it's just important that you have a general understanding about what, exactly, film distribution is and how it has evolved over the years.

REVIEW QUESTIONS: CHAPTER 1

1. How would you define Film Distribution in your own words?

2. As a novice filmmaker, what are some of the ways you will benefit from distributing your short film?

3. What was the law enacted by the US Government to break up the monopoly of the "Big Eight" studios during the Studio System Era of filmmaking, and what is the law used for?

4. Name some of the major steps that the evolution of film distribution has gone through, and how they affected filmmakers.

DISCUSSION / ESSAY QUESTIONS

1. Why is now the best time in history to be a filmmaker?

2. What challenges did independent film companies and theater owners face during the Studio System Era?

3. Why do you think the Internet has revolutionized film distribution?

Research/Lab/Fieldwork Projects

The following research exercises are designed to help you begin to understand some of the concepts you'll encounter in the pages of this book.

Film Research Exercise

Learning how to use the Internet to research is a critical step for you as you begin the process of distributing your own film. You will need to learn how to find film festivals, look up distributors, learn about sites that show films on the Web, and much more. Get comfortable with using the Web to find information by completing the following exercise:

1. Make a list of your top five favorite feature films. Using the Internet, research the films and determine the following about them:

 a. What year the film was made

 b. The names of the writer, director, and main actors

 c. The name of the studio or independent production company

 d. The budget and how much money the film made

2. Make a list of your top five favorite short films. Collect as much information as you can about them (it's often harder to research shorts, so just do your best).

3. Make a list of your top five favorite TV shows and what networks they are on.

4. Make a list of your top five favorite Web sites.

When researching on the Internet, use Google, IMDB (The Internet Movie Data Base), and Wikipedia (an online encyclopedia) to help find the information you are looking for. If your first search results are not yielding the information you are looking for, try refining and changing your search terms.

When your research is completed, review your results and your research technique. Keep a list of which search terms, Web sites, and research techniques were most helpful.

WHAT TYPES OF PROJECTS CAN BE DISTRIBUTED?

OVERVIEW AND LEARNING OBJECTIVES

In this chapter, you will:

- Learn what types of projects can be distributed
- Discover who can participate in short-film distribution
- Understand what types of short films get the most distribution

What Types of Short Films or Videos Can Be Distributed?

At the end of Chapter 1, you were asked to make a list of your top films, TV shows, and Web sites. Consider all the various types of programs you enjoy watching. When we talk about all the varieties of things you can watch, we use the term Filmed Entertainment. This covers everything we watch: feature films, short films, TV shows, music videos, action sports videos, YouTube videos, Webisodes, and so forth. (See the accompanying sidebar "Filmed Entertainment.") Now consider all the types of projects you have created, or want to create. As a filmmaker, you will find that you can distribute much of what you create. Let's look at some of the various types of filmed entertainment that you might create, and explore what can be distributed to audiences:

Short films

Short comedies, dramas, and films of all genres: horror, thriller, action, romance, and others, can be distributed in many ways: through festivals, on television, on the Internet, even on mobile phones. Other types of short films that can be distributed are documentaries, animated films, and *experimental* films.

KEY TERM:

Experimental Films Although most of you will be familiar with other types of films like drama, comedy, and documentary, the term *experimental* might be new to you. Experimental films are generally considered to be films without a traditional plot or storyline. They may be abstract, poetic, impressionistic, or surreal. As their name implies, experimental films experiment with the ways films are made.

Alternative content

There are many types of entertainment other than short films. Some of these types of projects can also be distributed, and can help filmmakers get their careers started. Music videos, *Webisodes*, *action sports videos*, and *spec commercials* all have potential to find an audience and to get their creator noticed.

Webisode A Webisode is like a television episode (a part of an ongoing series) made for the Web. A Webisode can be a spin-off from a mainstream TV series, like *Rookie* from the TV series *24* or *Interns* from the show *Scrubs*. A Webisode can also be original material airing only on the Web. Although Web-only Webisodes are fairly new, and none have crossed over into mainstream TV, momentum in this field is growing. The titles are often obscure and the shows are not yet as mainstream as more familiar television series, but more and more people are watching, especially younger viewers. Nearly 12 million people watched *Smosh*, one of the most popular online Webisodes, in August of 2009.

Action Sports Videos appeal to audiences all over the world; unlike mainstream, organized, team sports that air on major television networks, these short films focus on "extreme" sports.

Action Sports Videos refer to programs that highlight the spectacular skills of skateboarders, surfers, snowboarders, BMX, and Motocross riders.

A spec commercial can be used to help you find work in the entertainment industry.

Spec Commercials Television commercials are a popular division of the industry for directors, cinematographers, editors, and other creative film artists. Often, commercials are used as a training ground where artists can hone their craft before moving into features. A spec commercial is not a "real" commercial; it is one made by (and paid for by) an aspiring director, in order to get work directing commercials. It serves a purpose similar to that of a short film: it highlights the abilities of the creator (usually a director). In the commercial industry, a spec commercial is usually preferable to a short film, because the clients who hire artists want the comfort of knowing that whomever they hire understands the specific language of thirty-second commercials.

User-generated videos

With the rising popularity of Web sites like You Tube, more types of filmed entertainment are being created and distributed. A large number of these types of films or videos are not viable for helping a filmmaker start their career paths, but they may be entertaining to some audiences and could potentially get the filmmaker some attention. These types of projects include *vlogs (video blogs), machinima,* and *mashups & remixes.*

KEY TERM:

Vlogs Internet blogs are Web sites where authors write daily posts on a variety of topics: politics, culture, arts, society, or whatever is of interest to them. A vlog is similar, but the author posts his or her ideas using video clips rather than the written word.

Machinima can encompass popular genres such as dance videos, comedy, and drama. This type of film can be advantageous to both the filmmaker and the video game maker in terms of getting them noticed and known.

KEY TERM:

Machinima An emerging form of filmed entertainment, machinima is a type of animated video that uses premade characters and environments from video games. Video game makers allow users to record gameplay, and some users repurpose these videos and turn them into dramatic and comedic stories by recording new dialog and staging fictional scenes and stories within the game environment.

Mashups & remixes may gain the aspiring film professional some attention and can inspire a connection between filmmaker and viewers that could prove to be valuable and productive.

> **KEY TERM:**
>
> **Mashups & Remixes** An unexpected result of the popularity of You Tube videos is that an interactive relationship has formed between video maker and video watcher. After watching a video, many You Tube audiences will download the video, remix or repurpose the original into something new, and then upload it as a "video response." Music videos and songs get re-edited and films and videos get mixed, mashed, combined, and altered in countless ways. Some become extremely popular, and their creators gain notoriety.

Although these types of videos do take some level of skill, they may not lead the filmmaker to professional success. However, it's true that some are emerging forms of entertainment, and, as such, people are still learning how to use them to further their careers.

Amateur videos (Can be distributed, but should not be)

Some types of projects do not help a filmmaker with their careers and should not be distributed at all. In fact, some types of videos might actually hurt your career. It might not seem important, but in a world where anything online takes on a life of its own and is accessible by many people, you need to be careful what you show that has your name on it. Some types of projects that you would not want to distribute are early class projects, videos with low production value (bad lighting, poor camera work, bad audio, etc.), or videos with crass, questionable, or explicit content. Basically, anything that might make you look bad, show more weaknesses than strengths, embarrass you or someone else, or simply not demonstrate your positive skills as an aspiring professional should not be distributed to a wide audience. The last thing you want is for people to see your work and develop a negative opinion about you. You don't want to become the butt of an Internet viral joke, or to have your personal life get re-edited and broadcast across the Internet. Distribution is for good quality, reel-worthy work that will help you with your career.

Short Films: Your Best Chance for Success

With so many types of projects that can be distributed, the opportunities for a filmmaker can seem endless, and it's true: there are more types of projects and ways to distribute them than ever before. And while this book will teach you how to distribute many types of these projects, it will concentrate on the distribution of just one: short films.

Short films can advance your career

Many novice filmmakers study film and create short films with the dream of working in the film industry some day, perhaps as directors, or writers, or in some other creative position. More than any other type of project you might create, a short film can help you along that career path. To most professionals in the industry, a short film is the standard *portfolio piece* they want to see in order to judge the quality of your work. Many filmmakers, from Steven Spielberg and Martin Scorsese to Robert Rodriguez and Wes Anderson, have used successful short films to advance their careers.

KEY TERM:

Portfolio Piece As you begin to look for professional work in the film industry, you will need a portfolio. A portfolio is a set of work that you have created that demonstrates your abilities. For a filmmaker, a portfolio is usually a DVD demo reel with a collection of your best work: short films, music videos, commercials, TV shows, whatever you have made that you feel represents your best work.

There is an established distribution model for short films

Filmmakers have been distributing shorts for decades, and there is a clear and straightforward model for you to follow. This is not true for many other types of work you may create—a sketch comedy TV show, for instance, will not have the benefit of an established distribution model to follow, since it's simply not done very often.

Short films are popular around the world

Audiences love to watch short films, and there are tremendous opportunities for distributing them. Your chances of finding opportunities for distribution with a short film are much better than with other forms of filmed entertainment. Shorts are not only popular in America, but all around the world. You're just as likely to find success in Europe or even Asia.

FILMED ENTERTAINMENT: IT'S ALL AROUND US

The term "Filmed Entertainment" is traditionally used by major media corporations to describe all of the companies it owns that make movies, television shows, and other types of entertainment that they film. For example, the corporation Fox Filmed Entertainment owns at least ten different companies. Some are: Twentieth Century-Fox (big movies), Fox Television (TV shows), and Fox Searchlight (small, independent films). The term, "filmed entertainment," is often used as a catch-all term to describe the entire range of media that audiences watch (or listen to) for fun. Besides movies and TV shows, you may consider filmed entertainment to be YouTube videos, music videos, action sports videos, Web series, and just about anything else you watch. Technically, things like commercials and movie trailers would not be considered "entertainment" because they are actively trying to sell you products, but increasingly, the lines are being blurred. Consider that during the Super Bowl, many people tune in just to watch the commercials!

Who Can Participate in Short-Film Distribution?

You might be asking yourself where you fit in all this. Those of you with a film or two under your belt and lofty aspirations might be thinking, "This is great, just what I'm excited about," while some of you might be wondering if you are ready to participate in distribution. That's understandable; all filmmakers are different, and with that in mind, this book has been written to accommodate as many different types of novice and experienced filmmakers as possible. In the next section, we'll identify some different types of filmmakers in order to help you find a path that is right for you. We'll even share some case studies and stories of professional filmmakers. As you read about the various ways to participate in short-film distribution, try to identify a way that feels right for yourself, in your particular situation. Here is a list of general types of people who can benefit from the lessons in this book:

- Aspiring feature-film director, producer, or writer. This is an ambitious, hard-working filmmaker who has a lot of drive, energy, and passion for filmmaking. They dream of the day when they will make a feature film.

- Aspiring cinematographers, editors, sound designers, set designers, and other creative crew members. These folks prefer to specialize in specific areas of the project. They have performed their particular

role on a few film-school or amateur projects. They love their craft and dream of working in that area as a professional.

- Intermediate-level filmmaker who is still deciding on what part of the film industry he or she wants to work in. This person has made a film and has worked as a crew member on some projects, and is still gaining experience and exploring his options. He enjoys the process of filmmaking and looks forward to finding a job as a professional in some aspect of the business.

- First-time filmmaker just getting started. This hobbyist may not have completed a film yet and is just getting started working on crews as a student, amateur, or intern. She is passionate about film, may have an idea of what she wants to do, and is looking forward to gaining experience.

Hopefully, one of these types of filmmakers reminds you of yourself. If so, you'll be able to read more about how you can participate in short-film distribution in the following sections. If you still feel like you don't quite fit in, continue reading anyway—you may find that the more you learn, the more you'll understand where you might find your niche and how you might benefit from all the possibilities.

SIDE NOTE

FILM TERMINOLOGY: WHAT ABOUT VIDEO?

In this book, you'll find terms like filmmaker, film student, short film, and film school. But what about if you shoot video? What's the difference? In a word: nothing. Technology has come a long way since the early video cameras of the 1980s, and now most film schools have either a mix of film and video cameras or even no film cameras at all. When the term "film" is used, it refers to the art form, not the recording medium. A short movie shot on digital video is still a "short film." A person studying directing, editing, and cinematography, using video or film, is a filmmaker. The term video production, short video, and video student implies something more akin to wedding videography. In this book, we're talking about the art and craft of cinema, and regardless of what medium you shoot on, you're a filmmaker making short films.

The aspiring feature director

If this is your dream, then short-film distribution is going to be a big part of your path toward success. The more often you can expose your work to people, the better your chances of finding someone who will be truly inspired by what you can do, someone who will help you find the money and resources to make that film. You are trying to demonstrate to everyone that you have potential and talent. Ideally, you have a film that you feel does just that. You'll want to follow every step in the book and give it your all. You'll make a plan and follow it. You'll promote yourself and your film tirelessly. You'll want to get your film screened wherever you can: festivals, online, anywhere! You'll network and build relationships. You'll try to sell the film, but you'll give it away if you need to. You'll track your progress and adjust your plan as you go. By the end of the process, you'll have exposed your film and yourself to as many people as possible, building a network of friends and industry peers as well as a list of people you can contact in the future as you complete more films. You'll start down the path toward your dream of making feature films. These types of filmmakers have made several short films and a variety of projects, and have worked in crew positions on many other projects. They are usually near the end of their formal education, but not necessarily.

Aspiring cinematographer, editor, set designer, sound designer, and other creative crew members

If you dream of working as a creative crew member, you'll need people to see your work, recognize your talents, and begin to ask you to work on more and more projects. You'll want to work alongside the directors of short films and participate in the process of distribution with them. In addition to supporting them as they try to get their films seen, you'll work on your own and set your own plan. Your primary goal will be to get a film seen by as many people as possible. Everyone who sees it is a potential director or producer who could hire you for their next films. You'll help get the film into festivals, you will promote yourself and your role on the film, and you'll build a network of friends and peers in the world of filmmaking. While you won't and shouldn't distribute the film on your own, without your director, you certainly can and will distribute pieces of it on your demo reel. You'll take advantage of every opportunity you can find to share the film and show your work so that you'll maximize your chances of having just the right person see what you can do.

Intermediate level filmmaker looking for experience

You have completed a project, or even several projects, perhaps in film school. You've worked on several crews. You're building a reel and are learning more about your art and craft every day. You might not be ready to go all out on distributing one of your films though: either your film has some flaws that you acknowledge, or you are simply not ready to start pushing your work or yourself on the entire world just yet. You want to get some feedback on your work, you want to try some of this out, but you know that it might be your *next* project that is ready for the time and effort it's going to take to do the distribution thing right. You can try out some of the steps now, get some practice, read about what to do for your next film, and by the time you have a project that is solid, you'll be ready to go. In fact, reading this book and working on the exercises at the ends of the chapters will help you create a film that has a better chance of success. You will learn about what kinds of films work, how to do things correctly from the very first step, and you'll have the "big picture" in mind before you even start shooting. So roll up your sleeves, choose a project, and get ready to start. Make a plan, do some practice promoting and networking, and instead of submitting your films to the festival circuit, start with a neighborhood or school festival. Rather than seek a for-profit Internet distribution deal, just get the film on the Web and create some buzz. Learn about selling your film so you'll be savvy when it's your turn. You'll do the lessons you are able to do and study the ones you can't actually complete. You'll learn valuable lessons every step of the way, lessons that will set you up for success when it's your turn to make a big push on your next project.

The first-time filmmaker looking to learn the ropes

You have just started on your journey and it is little more than a hobby at this point. Perhaps you are taking entry-level classes in film school. Maybe you've shot some classroom exercises and instructor supervised projects, or made a film with the help and advice of supportive family and friends, but you have not actually written, directed, and edited your own short film yet. Or perhaps you have, but it's truly a "first film" and is not ready for the critical eye of an audience yet. You've been reading this book thinking that you are not ready for any of this yet, and maybe it's a bit intimidating. You wonder if you'll ever have a film worth distributing. Don't worry: we all felt like that when we first started out. It can be scary, but it's also exciting. You won't be distributing a film or even screening work for an audience yet, but you will be learning every step of the way. The number one thing you'll do is watch. Watch films. Be the audience. Learn about what you like and

don't like, and learn what works and what doesn't. While the experienced filmmakers will be submitting films to festivals, you'll be attending them and soaking it all up. Instead of negotiating distribution deals, you'll read up and learn about what they are. You'll watch films online, and make note of the techniques you see and those we'll be using. By the time you make your next project, you'll have many ideas and resources, and you'll have the confidence it takes to start showing it. And that's important. So follow along and pay close attention: soon, it will be your turn to take advantage of all of these opportunities on a film of your own!

One More Thing to Consider . . . Your Film Itself

After reading the last section, we hope you've determined what level of distribution you are ready for. There is one other factor that you need to consider when deciding exactly what path to take: your short film itself. You may be ready, but is your film ready? If not, then you might want to consider scaling back your expectations and slowing things down. How do you know if your film is "ready" for distribution? You have to get feedback: from your friends and family, from experienced filmmakers, from people who will give you an honest evaluation of the work, even from complete strangers. Not everyone needs to love your film before you think about distribution, but you don't want to push hard on a project that a majority of people think doesn't work. This is tricky for novices, and even for experienced filmmakers: who to trust, how to know, does anyone really know? Well, most of the time, you can count on the idea of majority rule. You don't need the majority to like it, but you don't want the majority of people to NOT like it. If you are having trouble finding people who think your film is working and is ready to be screened in public, then it is probably best to take their advice and plan to distribute your next film. Because the one thing you don't want to do is promote yourself and your work before you are ready. The best advice you'll get is usually from people with filmmaking experience. Chances are they have seen many, many more films than you have. People with film-making experience have almost certainly attended many more film festivals than you have, and they know what works for an audience and what doesn't. People with experience—film instructors, advanced film students, online film bloggers / critics —are almost always going to give you the honest truth, whether you like it or not, and that will be more valuable to you. Your friends and family will often not have the heart to tell you what they are really think-ing, or their tastes may not be completely developed. Your film, once it's out there, will be playing for a much wider demographic than your close-knit circle of ten or twenty friends. Ideas, shots, and subject matter that seem funny, cool, or believable to you and your buddies might not work for a wider audience. And the truth about film distribution is that your film needs

to work on as wide a level as possible. So get some feedback and carefully weigh what everyone tells you. Don't let someone talk you out of doing what you want to do, but also, don't shut them out completely.

Qualities of Successful Short Films

Every year there are thousands of short films made around the world, but not all of them get distributed beyond the filmmaker's cast and crew screening. The truth is, *most* don't. Short films are a learning ground for filmmakers, and often they are imperfect, uneven, overambitious, or not quite entertaining enough to catch the attention of a wide audience. And that's not necessarily a bad thing—in nearly every case these short films fulfilled a very important mission: they taught the filmmakers many things about their art and craft. But in order to be selected by a film festival, or to get picked up by a distributer, or to get buzz on the 'net, a film has to be good. Though there is no formula for what makes a film successful, there are some basic elements that a filmmaker can expect will have an effect on whether or not the film becomes popular with audiences. Here are a few components of a film that most agree are critical to success on the film festival circuit and/or distribution:

- Film length
- Production value
- Subject matter / what your film is about

Your short film should be short

A short film is defined as a film that is under forty minutes in length. It can be as short as you like, even to the point of just a matter of seconds. However, the most successful short films are between five and twenty minutes. There have been short films with running times of longer than twenty minutes that have been successful, but often these are made by experienced filmmakers with substantial budgets and resources. They must sustain an audience's interest for a longer time, and cannot afford any mistakes. If you have a generous budget and connections, you have a chance at being successful with a longer short film. However, the majority of films that do well on the festival circuit and that find distribution fall between five and twenty minutes, for the following reasons:

- A short running time allows the filmmaker to maximize his or her efforts and resources. In other words, time and money can be concentrated on

fewer scenes, and therefore the scenes are generally better in terms of writing, lighting, editing, and all the disciplines that go into it.

- A short running time is easier to program in a festival, on a TV show, a DVD, and most other outlets. Short films are very often bundled together to create a longer program with diversity and variety. An evening of short films at a festival might consist of two hours of shorts. Most festival programmers prefer to have a lineup of many films with short running times rather than two or three films that play for thirty minutes or more.

- Audiences generally prefer their short films to be short. With some exceptions, most people prefer to keep their short-film viewing experiences short. Perhaps it's because they don't want to invest a lot of time in a film they generally know nothing about (as opposed to a feature film where they have had the opportunity to see a trailer and decide if they want to watch it). Whatever the reason, if you ask someone to watch your thirty-minute short film, you are less likely to get an enthusiastic response than if you ask them to watch your five-minute short.

Longer Running Times

It's true that shorts with longer running times can be successful. They have time to develop characters and pull audiences into the story. The stories can be more complex in terms of plot and structure. There are more opportunities to demonstrate what the filmmaker is capable of, since there are more scenes. However, for many filmmakers, the longer running time becomes a trap. They ache to tell a longer story, but lack the experience and the resources to do it well, and the end result is that the film is long, but not good. This can be disastrous. The only thing worse than a bad short film, is a bad short film that goes on for thirty or forty minutes. If your film is long, and you feel it can work at a shorter length, you should trim it down and get some feedback. Most of the time, if you can tell your story in a shorter, rather than longer, running time, the film is improved. And your audience will thank you. After all, when was the last time you walked out of a movie and thought "Hmm, that just wasn't long enough"?

A common mistake is to set the film over a period of time that is too long. If your film script needs flashbacks, montages, or flipping calendar shots to take the audience forward or backward over time, you might be in trouble when it comes to film length. Most of the great short scripts tell their story in a matter of minutes, hours, or a day or two.

Production value: Your film must look like a "real" film

Although most short films are made on limited budgets or no budgets at all, some look better or sound better than others. That's production value. Things like lighting, shot composition, the look of the location or set, the soundtrack and the mix, even the little details like props, hair, and makeup. Audiences will be forgiving of films that don't look as slick or expensive as Hollywood films, but they don't want to sit through "amateur hour." Any visual or sound mistake will hurt your chances of success: harsh lighting that blows out the highlights? Not good. Bad dialog recording on set that was not corrected in post? Doesn't help. Empty, messy dorm room for a set? Usually a minus, unless it's an important part of the character development or plot. Shaky, hand-held camera work in a scene that doesn't require that type of shot? Audiences will instantly recognize it and start to disconnect from the film. For a short film, production value does not necessarily mean the film has to have perfect costumes, amazing locations, or fancy wardrobe, it just means the film should have few or no mistakes, and should be pleasing to the eye and ear. A filmmaker with some experience, good taste, and vision can make even a zero-budget film pass the production-value test, simply by making smart choices along the way. Never write a script that calls for a location you don't know for sure you can secure. Don't write a night exterior scene unless you have a firm understanding about how you are going to light it. As you write your script, think carefully about your budget, your schedule, and all of the other production challenges and limitations you might face. Make sure your key crew members (DP, set designer, wardrobe, etc.) are at least as experienced as you, if not more so. And yes, the truth is that even among short films, those with bigger budgets and higher production values often take the prizes at festivals and get the best distribution deals. Audiences love beautiful films, and sometimes a short film can make up for weakness in other areas by maintaining high standards of production. Regardless of budget, though, the basic idea is that if your film looks like you threw it together quickly, it's probably not going to do well with a wide audience.

Make a list of things you own or have access to that would look good on screen. Then write your story and design your shot list around them. Know someone who works in a slick looking office building? See if they can get you access. Uncle owns a bar? Call in a favor and shoot there. Know someone with a cool poster or an interesting object that would work great as a prop? Borrow it. Great production value can come directly from your own personal resources.

Subject matter: Audiences respond to personal and original work

Obviously film is an extremely subjective form of art and entertainment. There are many different types of films and many different types of audiences. Trying to figure out what genre of films do best or what kinds of stories audiences respond to is nearly impossible. However, there are plenty of data out there (lists of short films winning major festival awards, or lists of short films with the highest distribution numbers) that suggest that certain qualities are inherent in many successful films. Ask a festival programmer (someone who decides which films are accepted and which films are rejected for a festival) for a genre of film that notoriously does well at festivals, and most will tell you that comedies are extremely popular with festival audiences in the short film division. This might have to do with the fact that a dramatic film can be much more difficult to develop in five or ten minutes, whereas a comedy film can introduce characters and string together a series of funny scenes in a fairly short amount of time. An interesting note, however, is that it's the longer (twenty minutes or so) dramatic short films that seem to consistently win the top awards. Dramas have historically been award winners and comedies have historically been crowd pleasers (with healthy distribution numbers, too). In the short category, these two genres dominate, with the third most popular being the short documentary. Some genres are very hard to pull off in a short film, and often fall flat due to poor production value: science fiction, thriller, and horror shorts need to be carefully executed and need to look great if they hope to be widely successful. Other genres that are often budget-dependent are musicals, historical/period films, westerns, and action films.

Even more important than genre however, is the need for a successful short film to be original and/or personal. This is the biggest stumbling block for beginning filmmakers. It's not that beginners cannot make original or personal films—they absolutely can—but it's common for a "newbie" to resist the idea and instead favor making a *homage* to their current favorite popular film. It's an understandable urge: you love movies, you want to make movies just like the ones you love, so you decide to make one just like the one you've been obsessing over lately. For some it's a gory horror film, for others it's an urban action film, a vampire flick, a zombie movie, or, sometimes, a combination of all of these. The problem is that it's extremely difficult to make these types of films on the typical low budget. While the feature versions of these types of films may sometimes be original, personal, or have a decent story, the primary reason most people buy tickets to this type of film is the visual spectacle and production value. It's rare that a novice filmmaker can satisfy the expectations audiences have for these types of films, which is

why it's rare to see this type of short film at a festival or have it picked up for distribution. Often, the cast and crew screening is where this type of film is most successful.

KEY TERM:

Homage To pay homage to your favorite film means to show the film respect or honor publicly. Filmmakers love to re-do shots from their favorite films when they make their own work, and often they will refer to this process as "paying homage." However, inexperienced filmmakers sometimes mistake homage for "rip off" or "lamely copy." Don't ever just copy someone else's film.

What Exactly Do "Original" and "Personal" Mean?

There's a saying among filmmakers: "write what you know." When you write about things you know—really know—the work seems personal and authentic. Audiences love to peer into other people's lives, and believe it or not, all of our lives can be fascinating to an audience. Writing about people, places, and events in your own life is a great way to connect with an audience. And when you do, you are being personal and original all at once. Original does not mean you have to come up with the most amazing, brand-new story ever written, it simply means you should try to explore a topic that hasn't been overdone. Personal does not mean your film should read like a page out of your journal, it just implies that you should include details from your own life experiences somewhere in there. Here's an example: there have been dozens of "A hit man is about to retire" films. DOZENS. They are always terrible. A twenty-year-old student actor usually plays the hit man. The dialog is one cliché movie line after another. The plot is weak (he's double crossed or set up, and dies in the end, which is only ten minutes later), and there are several "action" sequences that are really nothing more than the actor running through the streets with a toy gun. This type of film will never help the filmmaker's career—it won't get into festivals, won't get distributed, and professionals who might see it will write off the filmmaker for being unoriginal and unable to demonstrate their filmmaking abilities, since this film will be compared to Hollywood action/thrillers that get it right. However, it is possible to be creative with the gangster/thriller/action genre. One aspiring filmmaker wanted to try, and he made his film personal. He created three young characters, early twenties, living in a poor part of town. They were naive, innocent, and annoying, trying to be "gangsters" by acting tough around each other, even though it was obvious they were really just school

kids. When a truly degenerate character from the 'hood offered to hook them up with a small time score—helping to rob a pot dealer—they nervously accepted. It all went wrong, one of the kids got shot, another busted by the cops, and the neighborhood degenerate got the money and got away. Perhaps not completely original, but it was much more believable and honest than a generic "hit man" script. The personal touches were the characters, and the dialog. The characters seemed as though they were modeled on real people (they were) and the dialog had a rough, spontaneous, realistic quality (many lines were improvised). Additionally, this filmmaker followed the previous two rules: the film was fourteen minutes long and was shot mostly at night in his neighborhood. Although the locations were gritty, they worked perfectly with the concept of the film, and the night look gave it a tense, eerie vibe. Audiences responded, and the film won some awards. So: write about what you know, what you've experienced, about people in your life or stories you have heard. Your film should have a voice: your own.

SUMMARY

The goal of this chapter was to introduce the various types of projects that can be distributed and to get you to start thinking about where you fit in. Before you move on to the next chapter, you should:

- Pick one of the four "filmmaker types" to use as your model going forward. As we introduce the various Research / Lab / Fieldwork projects at the end of every chapter, we'll make suggestions based on these four types. This way, you'll do the correct variety and amount of work that is appropriate for you.

- Choose a project to distribute. This should be done in consultation with someone who has some filmmaking experience. If you don't have a project to distribute, that's fine too—you'll have plenty to do in terms of research, preparation, and learning so that when you do have a project, you'll be ready to go.

In the next chapter, you'll be taking the first steps toward distributing your work, so it's important to be prepared.

REVIEW QUESTIONS: CHAPTER 2

1. List as many opportunities that exist for you to distribute your short film as you can.

2. What is "Filmed Entertainment"? List as many examples as you can.

3. Why are short films the best type of filmed entertainment to distribute?

4. What are three important qualities that help a short film get distributed?

DISCUSSION / ESSAY QUESTIONS

1. Where do you fit into short-film distribution (pick one of the four "filmmaker types" from the chapter) and why? Discuss your reasons for wanting to be involved in the film business, your current career goals, and your experience level.

2. In your own words, describe why short-film distribution can help you achieve your career goals.

3. Describe what you feel "original and personal" filmmaking means.

4. Think of the best short film you've ever seen. Discuss the film in terms of the three important qualities that help a film get distribution. Did your favorite film have the benefit of any of these?

Research/Lab/Fieldwork Projects

The following lab projects will help you prepare for the work you will be doing in the next chapter.

Projects for the Aspiring Feature Director, Aspiring Creative Crew Member, and Intermediate-Level Filmmaker

1. Screen your film for your friends and/or experienced filmmakers and ask for their honest feedback. Share with them which of the four "filmmaker types" you plan to use as a model and listen to their opinion. Use this feedback to help determine which project to select and which filmmaker type to follow.

Projects for the First-Time Filmmaker

1. Using the Internet, the library, or any other resource you can think of, watch several short films and critique them for research purposes. Write down as much as you can about the level of distribution the film had (did you pay for it, watch it for free, see it at a festival, etc.). Also write down a short synopsis of the film and critique the three qualities discussed in this chapter. As you continue through this book, keep adding films and information about each film to your list. You will be able to use this resource to help you identify common qualities and elements of successful films.

DISTRIBUTION GOALS, PLANS, AND MODELS

OVERVIEW AND LEARNING OBJECTIVES

In this chapter, you will:

- Learn how to create a distribution goal and a distribution plan
- Learn about the two basic distribution models: Classic and DIY (Do It Yourself)
- Learn the benefits and challenges to the Classic and DIY models
- Understand the benefit of a Hybrid Distribution Model
- Choose your distribution goal

Setting Goals and Making a Plan

Distributing a short film is a big project. It's going to take a lot of time, work, and energy. The rewards are obviously worth it, but for the best chance of success, you need to think carefully before you begin and have some idea about what, exactly, you are going to do and how you are going to do it. Begin by considering your distribution goal. Your distribution goal is what you want: is it a prize at a major film festival? Cold, hard cash from a distribution deal? A meeting with a Hollywood producer? A fun experience at a local screening? All of the above? It might seem difficult to imagine what your goal should be this early in the game; after all, we have only started to introduce some of the possibilities that are available to you. But by the end of this chapter, hopefully you will begin to have an idea about what kind of a goal you would like to have for your film. We'll review goals again once all the various options have been presented, so for now, just consider that soon you'll be choosing a goal. Start dreaming a little, and let that concept percolate. In addition to a goal, you'll need a distribution plan. A distribution plan is the step-by-step process you will take in order to achieve your goal. Each plan is different, depending on the goal and the person. Having a plan is critical—there are so many steps and so much to consider that you'll need to break things down into small, manageable pieces and take them one at a time. Think about your goal, and plan as you would for a road trip: your goal is where you want to go, and your plan is the map you'll use to get there. There will be more detail on both of these subjects at the end of the chapter.

Distribution Models

As explained in Chapter One, a distribution model is a process for distributing a film. It's almost identical to a distribution plan, only a plan is something that is *hopefully* going to be done, and a model is something that has *already* been done over and over. Building on the road-trip analogy, consider a trip from New York to California. A plan would be the various roads you consider taking and some of the strategies you might use along the way (take that highway, pack tons of food, don't forget the mix tape, bring gas money, etc.). A model would be the roads and strategies other people have taken already (Route 66, stop for cheese steaks in Philly, etc). A distribution model is a set of steps that other filmmakers have already taken in order to distribute their films. Understanding the various models makes your life much easier—your plan can simply be to follow an existing model. Or, if you are

feeling adventurous, you can use parts of an existing model but add a few different steps of your own. Most filmmakers follow existing models and add or change minor steps along the way depending on the requirements of their film, their experience, their abilities, and their goals.

Two Popular Distribution Models: Classic and DIY

Just as there are many popular routes from New York to California, there are many varieties of distribution models. Each one has a slightly different goal, a slightly different plan, and certainly a different film. In this book you'll find two popular models identified for you: the Classic distribution model and the DIY (Do It Yourself) distribution model. Understanding these two models will allow you to create your own goals and plans. Let's begin with the Classic model.

Classic distribution model

The Classic model is the tried and true, long-standing, well-respected model of short-film distribution. Filmmakers following the Classic model usually have fairly ambitious goals: they want to be in festivals, to try to get a distribution deal, and hope to someday work as a director, producer, or writer. Here is a basic outline for the Classic model:

1. *Premier* film in a *top-rated film festival* (if you are lucky, win a prize)

2. Submit to (and be accepted to) as many other festivals as possible on the festival circuit (if possible, win more prizes)

3. Accumulate positive press reviews and buzz along the way

4. Meet distributors, negotiate deals, and sign agreements to distribute the film to as many venues as possible:

 a. Broadcast Television (both national and international, network and cable)

 b. Home Entertainment

 c. Internet

 d. Other outlets

5. Use success of film to reach ultimate goal of feature directing or working in feature film industry:

 a. Gain access to producers and companies working in feature films (pitch projects, hope for a feature-film deal)

 b. Build a reputation as a successful filmmaker

 c. Earn money from distribution deals

If you've ever seen a short film that has won a several awards, or is part of a DVD compilation, it likely followed this Classic model.

KEY TERM:

Premier A premier is the first time a film is screened. Film festivals love to be able to advertise that they have the premier screening of a film; it gives their festival an edge on the others. It's a bigger deal for feature films, but even for shorts, you'll always prefer to premier your film at the biggest, highest-profile festival you can.

Film festivals don't have formal rankings, but there are a group of festivals that are considered to be *top-rated film festivals* and are recognized as the most prestigious.

KEY TERM:

Top-Rated Festivals have earned their reputation though a combination of things: how long they have been around, the number of films they show, the number and quality of films that premier at their festival, and the number of distribution deals that are made during their festival. In America, festivals such as Sundance, The Los Angeles Film Festival, South by Southwest, and Tribeca are among the top-rated festivals.

DIY (Do It Yourself) distribution model

The DIY Distribution model is relatively new; it's only been around since the late 1990s, around the same time the Internet was really taking off. In fact, this model is directly tied to the 'net—it harnesses the massive power of the

Internet and takes an entirely different approach to film distribution. The DIY model goes something like this:

1. Upload film to the Internet

2. Build an online fan base and generate views

3. Generate revenue using online *e-commerce*

4. Organize screenings outside a typical festival setting

5. Use success of film to achieve a variety of goals

 a. Generate reputation or buzz for filmmakers and use to help with future projects

 b. Make money from online sales

 c. Gain access to producers and production companies working in all areas of film, television, and the Web (pitch projects, hope for a production deal)

If you've seen a short film on YouTube or any of the other hundreds of video Web sites, it's quite possible the filmmaker followed the DIY distribution model.

KEY TERM:

E-Commerce refers to electronically buying and selling over the Internet, such as using a credit card or Pay Pal to buy a book on Amazon or a song on iTunes. In the world of short films, filmmakers can try to sell or rent their films over the Internet using e-commerce.

Classic and DIY models compared

There are quite a few differences between these two models. The Classic, being the older and more established model, is geared toward a more traditional measure of success: a successful run on the festival circuit, positive reviews in the press, and deals with distributors that make the filmmaker some money (probably not a lot, but some). You can think of the Classic model as the "big time" model, in some ways. It carries with it the all-important cachet of industry respectability. Films that win the coveted Academy Award for Best Live-Action Short Film traditionally use the Classic model. Filmmakers who have films that have successfully followed this model will showcase their

awards, deals, or festival lists on their resumes, and can expect some opportunities to come along. Having a film do well on the Classic distribution model is often the *brass ring* that an inexperienced filmmaker reaches for.

The DIY model has developed more recently and is a direct result of some major changes in the film industry. The primary change that resulted in the DIY model becoming popular is the invention of the Internet. The Internet opened more outlets for filmmakers to show their films and also created new ways for filmmakers to communicate with their audiences. In contrast to the Classic model, through which filmmakers must rely on a festival coordinator to accept their films, the DIY model utilizes the Internet, where individuals can upload and screen their films. In the Classic model, a filmmaker must rely on a distributor to broker deals and generate income for their films, but in the DIY model, a filmmaker can harness the power of e-commerce on the Web and generate his or her own income by dealing directly with the audiences. The DIY model is about taking the control of the film out of the hands of others and keeping it in the hands of the filmmaker. It's about doing it yourself: distributing your film on your own terms, and finding ways for the film to be seen and be successful through your own efforts. The measure of success for a filmmaker following the DIY model will be geared more toward exposure than money or awards. A successful film following the DIY model might be viewed on the Web by thousands or even millions of people all over the world. It might amass a following of fans using *social networks*, or generate buzz for the filmmakers through film *blogs, vlogs*, or other film-related Web sites.

KEY TERM:

Social Networks Web sites such as My Space, Facebook, Twitter, Flikr, YouTube, Vimeo, Digg, (and many, many more) are social networks – they allow anyone access to millions of other people and help facilitate communication on an unprecedented level. Some sites focus on media sharing, others are news oriented, some are humor based, and others are geared simply toward connecting people and allowing them to meet, share, and communicate ideas.

Anyone on the planet can write a column or record his or her opinions, interactions, or events and upload it as a *blog* or *vlog* on the Internet. Many *blogs and vlogs* provide opportunity for discussion and feedback.

> **KEY TERM:**
>
> **Blogs** The term blog is derived from "Weblog," and is used to describe a Web site created and maintained by an individual who records regular entries of commentary. Blogs are incredibly popular—there are over 100 million blogs currently on the Web. Bloggers in the film community write about upcoming features, shorts, festivals, and every other aspect of film production. Having your short film reviewed favorably by a blogger can often create buzz and generate views. As we saw in Chapter 2, vlogs are video blogs; the individual talks into a Webcam instead of writing.

Which Model Is Better?

Good question. Filmmakers debate this all the time and there is no quick answer. Both Classic and DIY models are aimed at getting your film seen, and helping you toward your career goals of working in the film and television industry. They just take different roads to get there. The Classic model puts more weight on the festival circuit and finds value in being accepted to high-profile festivals. The Classic model is geared toward getting a distribution deal that may earn the filmmaker money or get the film screened on TV, which will give the filmmaker some professional respect and cachet. The DIY model is more about exposure and having the film seen by as many people as possible. Yes, it's on the computer and not in a theater or on TV, but consider this: a film screening at a festival might be in a theater that can hold five hundred people. A short film screened on TV might be seen by a few thousand people. But a film on the Web can be seen by millions of people, all over the world. The DIY model attempts to tap into that power and generate such a large amount of interest that opportunities begin to appear for the filmmaker. Imagine if your film became one of the hot *Internet memes* of the week, getting passed around and watched by the entire planet. That excitement and the potential opportunity it creates is part of the allure of the DIY model.

> **KEY TERM:**
>
> **Internet Meme** When an idea, picture, or video gets passed along from person to person, gaining popularity. It is sometimes referred to as "viral," as in, "his funny video went viral." It's difficult to predict how or why any idea, picture, or video becomes a meme, but if it happens to your short film you can count on a lot of exposure, which could potentially result in career opportunities.

There are benefits and challenges associated with each model. Let's take a look:

Benefits of the Classic Model

- Because it's been around for a while, there is an established system of outlets and people ready to help make your film successful, meaning the road is well marked and the path is easy to follow.

- The Classic model can generate the types of success that can be very helpful for your career: festival awards, distribution deals (money), positive press, and meetings with producers. It's got a certain built-in level of respect.

Challenges of the Classic Model

- You must rely on other people to judge the worthiness of your film. The film must be accepted to a festival by the festival committee (same for awards), and a distributor must decide your film is worth the effort it will take to distribute it.

- Competition for festival selection and distribution is high; you may have a decent film but because of the sheer numbers of other filmmakers also trying for the "brass ring," your film may not be accepted, may not win awards, and may not get distributed.

Benefits of the DIY Model

- You are in control of your film's destiny. Rather than waiting for acceptance or a distributor's attention, you can screen your film on your own terms.

- The size of your potential audience is almost limitless. This greatly increases your chances of finding people who will respond to your work.

- As the Internet becomes an increasingly more viable place to distribute films and communicate with audiences, it can be a good idea to gain experience using this model now.

Challenges of the DIY Model

- You and you alone are responsible for promoting your film. You have to get people to visit the Web site and watch your film. You have to promote yourself without the help of a festival or a distributor. This can be a lot of work.

- Although it's always a long shot that money can be made on a short film, the revenue earned through online e-commerce is generally much less than revenue earned through classic distribution deals. The DIY approach is usually not a big money earner.

- Because the DIY approach is so new, the model itself is not as established, and not as easy to follow as the classic. There are so many possible ways to "DIY" that it can be confusing to decide what steps to take.

- The amount of competition is even greater than with the Classic model. There are over one hundred million videos on YouTube alone. Sifting through the volume of material on the Web can be a huge chore, and becoming a standout in that crowd can be very difficult.

Why Not Just Do Both Models and Get the Best of Each of Them?
Who wouldn't want it all—an Academy Award, a lucrative distribution deal, several million views on the Web, and a huge following of online fans? So why not just submit your film to festivals, put your film online, send it to distributors, send it to *everyone*, and hope for the money and fame to come rolling in? Well, mainly this: *exclusivity*. In other words: the delicate balancing act of deciding who, exactly, gets to see your film and when they get to see it.

> **KEY TERM:**
>
> **Exclusivity** A term used in distribution to describe who has the rights to show your short film. It is often used in relation to a particular territory (a country or group of countries). If someone asks for exclusive rights to North America, they mean that you would not be able to sell the rights in North America to anyone else after selling it to them.

Exclusivity

Imagine you are in charge of a film festival. You spend all year promoting your festival and trying to get people to attend (you want the festival to be great, popular, and well attended, right?). You advertise, make posters, rent theaters, screen and select films, and do all the thousands of other things it takes to put a festival together. When you select films for your festival, you want to make sure people come see them. However, if the film you want to show is also currently available online and can be watched by anyone just by clicking their mouse, it's harder to convince them to come to your festival. So festival

coordinators want some degree of exclusivity; they don't want you showing the film online while they are out there trying to sell tickets and promote their festival. It's the same for distributors. A distributor is going to try to license the screening rights to your film to, say, a TV station that is putting together a two-hour special of short films. The TV station is willing to pay a small fee for each film. But they are not going to do that if those same films are already available online for anyone to see—there is less motivation for someone to watch their two-hour special. How can they compete with that? They can't, so they won't pay the fee if the film is already online. And festivals will often not accept a film if it's already online. So you need to consider exclusivity and be careful about what steps you take first, where you show your film, and when.

What's the Solution?

This is where your goal and your plan come in. The solution will be different for every filmmaker. If you are an aspiring director with an advanced film, you might want to go the Classic route. If you are an intermediate-level film-maker you might explore a version of the DIY plan by putting your film online and seeing if you can get some buzz going. Since every film and every film-maker is different, you will have to make some choices and decide for yourself which model works best. However, for those of you who want the best of both worlds, I have another suggestion: a Hybrid model. A hybrid is a combination of two things, like a hybrid car that uses both a gas engine and an electric engine. The Hybrid distribution model utilizes certain aspects of the Classic and certain aspects of the DIY and can be a great way to achieve success.

The Hybrid Model

In this book you'll be encouraged to follow the Hybrid model as the best model for most short-film filmmakers. You can and should explore the festival circuit in an attempt to win awards, meet distributors, and experi-ence all the other opportunities that the Classic model offers you. But along the way you can leverage some of the techniques of the DIY model, like creating an online fan base and using the power of the 'net to reach out to your audience. If your film is doing well on the Classic model enjoy the excitement of a live audience watching your film, and reap the rewards of a real distribution deal. Part of your deal will likely include Internet distribu-tion, so you'll also be able to eventually put your film online. If, however, you are not finding success on the Classic model, you can always switch over to the DIY and start promoting yourself. By starting with the Classic and falling back on the DIY, you can keep most of your options open and give yourself the best chance of success on every level. And that's how this

book is organized: techniques related to the Classic model are explored first, with brief comparisons of DIY here and there, and then a closer look at DIY techniques comes a little later. The Hybrid model that this book will follow looks something like this:

1. Promote yourself and your film on the Web in a variety of outlets (without actually uploading the entire film)

2. Submit to festivals and attempt to "do the festival circuit"

3. Contact distributors and attempt to negotiate traditional broadcast distribution deals

4. Depending on the success of the above steps, either negotiate an Internet release of your film through a distributor or release on the Internet using DIY methods.

5. Leverage your success (no matter how much or how meager) into momentum for your next project.

Remember, this Hybrid model is just a suggestion, and there are plenty of other perfectly good models you might decide to follow. Keep reading, make some initial decisions, and be prepared to change your plans if you feel the need to do so.

Distribution Plans

Now that we've looked at distribution models, let's talk about your distribution plan. If the model is the route you can take to get to your goal, the plan is what you need to do, step-by-step, to follow that route. For instance, if you are following the Classic model and want to submit your film to a festival, how exactly do you do that? What are the steps involved? Outlining these steps and doing them one by one is what your plan is about: first, you'll research the lists of festivals and find out which ones you should enter. Then you'll fill out entry forms and send a copy of your film, you'll create a press pack with still pictures and bios of cast and crew, and much more. There are lots of steps you need to take to achieve each part of a distribution model, and your plan helps you figure out what those steps should be. You don't have to figure out your entire plan from start to finish right now. You can just work on the first few steps. This book is designed so that you can learn about and then execute parts of the plan one step at a time. And along the way, you can always reconsider, make changes, and try something different. The main idea is for you to begin to think a few steps ahead.

Choosing your distribution goal

Now you should begin considering what your distribution goal is going to be. Probably, your goal will be related to the filmmaker type you most closely relate to. If you are an aspiring feature director with an advanced film, you'll probably follow the Classic model or the Hybrid. If you are an aspiring creative crew member, your goal may be tied closely to your director's goal. If you are an intermediate-level filmmaker, you may be more comfortable on the DIY model. If you are a first-time filmmaker, you will probably choose to just keep reading and start to create a goal and plan for your upcoming film.

Setting Expectations and Measuring Your Success

An important thing to consider when choosing your goal is to balance your expectations with your ability. This means setting the bar high enough so you are excited about the potential rewards, but not setting the bar so high that it's unlikely you'll reach any of your goals. Try to set reasonable expectations so you won't be too disappointed if you don't get to where you want to be. Sure, it's okay to reach for the stars and fall a little short, but you don't want to get your hopes up if there is just no chance of achieving your goal. Of course you don't want to set your sights too low either! Your experienced filmmaker "mentor" can help you—he or she can evaluate your film, your experience, and all the other variables that will affect your success and help you make some decisions about what a good distribution goal might be for you. Remember that the process is supposed to be fun, exciting, and creatively rewarding. The best chance you'll have for success is to pick an achievable goal.

Creating your distribution plan

As was said earlier, you won't be able to create a complete distribution plan just yet—you are still learning the ropes and you can't plan for steps you have not even learned about yet. But you know that there are some basic distribution models available to choose from and that your plan will lay out the many steps you will be taking along the way. This first time through the process, you'll be making your plan and enacting it as you go, but the next time you'll be able to lay it out in much greater detail at the very beginning.

This chapter was about introducing you to the idea of goals, plans, and models. You should have a pretty good idea about the Classic, DIY and Hybrid models, and you should be able to start choosing a realistic goal for yourself. You don't have a plan yet, but you will begin to make one in the next chapter. Hopefully, you are excited and ready to get to work.

REVIEW QUESTIONS: CHAPTER 3

1. What is a distribution goal?

2. What is the difference between a distribution model and a distribution plan?

3. Why does a festival or TV station want the "exclusive" rights to your film?

4. What are the five steps of the Classic distribution model?

5. What are the five steps of the DIY model?

6. What are the five steps of the Hybrid model?

DISCUSSION / ESSAY QUESTIONS

1. In your own words, describe the different benefits and challenges of the Classic versus the DIY short-film distribution models.

2. Write an essay describing your short-film project and your distribution goals. Try to set realistic, do-able goals. Share this essay with your friends or experienced filmmaker mentor and solicit their feedback.

Research/Lab/Fieldwork Projects

The following lab projects will help you prepare for the first steps of your distribution plan.

Projects for the Aspiring Feature Director, Aspiring Creative Crew Member, and Intermediate-Level Filmmaker

1. Purchase a three-ring binder, a file box, or some sort of organization system to hold papers and forms. You'll need this to stay organized as you begin to distribute your short film.

2. Write down your distribution goal and file it. Remember to set your sights high, but make your goal realistic.

3. Write down the five basic steps of the distribution model you have chosen to follow (Classic, DIY, or Hybrid). These five steps will help you design your plan in the following chapter.

Projects for the First-Time Filmmaker

1. Purchase a three-ring binder, a file box, or some sort of organization system to hold papers and forms. Although you won't be distributing a film just yet, as you read this book you will be able to collect valuable information that will help you when it's your time. Use the file system to keep track of each piece of information so it's at your fingertips when the time comes.

2. Although you don't have a film yet, it's okay to have a distribution goal for your next project. Write down what you'd like to do with your film in terms of distribution, but remember to make your goal realistic.

DELIVERABLES

OVERVIEW AND LEARNING OBJECTIVES

In this chapter, you will:

- Learn what Deliverables, Rights, Releases, and Promotional Materials are and why you need them
- Learn strategies for making short films with deliverables in mind
- Take the first step of your distribution plan by preparing your deliverables

Distribution First Steps: Preparing Your Deliverables

In the last chapter, you compared various distribution models, and you set a distribution goal that was informed by the filmmaker type you most identify with: Aspiring Feature Director, Aspiring Creative Crew Member, Intermediate-Level Filmmaker, or First-Time Filmmaker. As was said in the last chapter, regardless of your goal, you will create a distribution plan to help you follow the five basic steps of the Hybrid distribution model, which are:

1. Promote your film and yourself
2. Submit to film festivals
3. Attempt traditional broadcast distribution (through a distributor)
4. Secure Internet distribution (either with a distributor or DIY style)
5. Leverage your success (no matter how big or small) into momentum for your next film

Even though the first part of the Hybrid model is promoting yourself, self-promotion will not be discussed in this chapter. The first step in your plan is actually more like pre-production: you need to get prepared and ready for the distribution process. In this chapter, you will do that by learning about deliverables. Deliverables are all the various things you will need in order to distribute your film.

Don't I just need my film?

No, you need several more items than just your film. You need forms such as releases from your actors giving you permission to screen the film. You need artwork such as a poster or a DVD cover to promote your film. When it comes to your film, you need to have specific technical things like proper formats for various screening environments. Of course, it all depends on your own personal distribution plan, but basically, you need more than just your film. As with the road trip that was used as an analogy in Chapter 3, it's not enough to have just a car and a map: if you are taking a trip, you need to pack your bags, bring extra supplies, and be prepared for a variety of scenarios. It's the same for short-film distribution: there are several important things you need to have ready before you actually begin to distribute your film. This chapter will teach you exactly what all those materials are, which you will need for each level of your distribution plan, and how to get them.

Deliverables Defined

Each type of filmmaker and each type of distribution plan will need different deliverables. Let's begin by gaining a basic understanding of what they all are, and then we can get into the specifics of what each type of project needs.

Deliverables can be broken down into three areas:

- Rights and Releases
- Promotional Materials
- The Film itself & additional technical materials

Rights and releases

These are the legal materials you need if you are going to sell your film or screen it at a festival or online. Anytime you are showing your work to an audience, you need to have permission to do so, and the rights and releases you obtain are your proof of this. As the filmmaker, you hold some of the rights to the film, but there are other people involved, such as the actors and musicians, who legally own the rights to their images and performances until they sign them over to you. A big part of being able to actually sell your film is collecting all your releases and proving to a distributor that you own *all* the rights. Without them, a distributor will not be able to sell your film.

Promotional materials

Promotional materials are items that you will use to advertise your film to get as many people as possible to see it. A poster (commonly called a *One Sheet*) will give people an idea about the style and tone of your film. A short synopsis of the story will be printed in film festival brochures, on the back of your DVD, and on Web sites showing your movie. These and other promotional materials will be an important part of your distribution plan.

> **KEY TERM:**
>
> **One Sheet** In the film industry, a promotional poster is called a one sheet. It is one of the most valuable promotional tools you will create. The artwork and images on this one, single poster will convey to audiences the character, genre, and style of your film.

The film itself

This is not the "master" of your film (which you keep somewhere safe), but rather a copy of it, used to screen at a festival or on television, or on the Web. It can be a film print, videotape, or a digital file. Depending on your type of distribution plan, you might need more than one format of the film, to accommodate different viewing platforms. You'll also need to give some distributors additional technical materials if the film is going to play in a foreign market.

Typical List of Deliverables

Below is a list of the deliverables that a distributor will typically ask for. As you will see, there are numerous documents and materials. Don't let it overwhelm you, but understand that distributing a short film, at its most advanced level, is a pretty big deal. You will be entering into a business deal complete with contracts and legal language. Because of the collaborative nature of filmmaking, you must assure all parties involved with the deal that you, in fact, own the film and the rights to distribute it. In terms of promotional materials, the more you have, the easier it is to advertise your film. Although you might not need all of these items if you are just showing your film at a festival or online, you'll need at least some of them.

Rights & releases

1. Producer / Director release (also known as the "General" release)
2. Talent releases
3. Screenplay release
4. Music release
5. Locations release
6. Art materials release
7. Music cue sheet

Promotional materials

8. One Sheet (poster) & DVD-cover artwork
9. Production stills
10. Director biography

11. Director's statement
12. Crew list
13. Film synopsis
14. Script

The film itself

15. Master in various formats
16. Music and Effects track (M&E) on channel 3 & 4
17. Dialog list

Managing Your Deliverables

"Yikes! That's a lot, I'll never be able to do all of that!" Yes, that's what we all say the first time we look at the deliverables list. It can be intimidating, daunting, and overwhelming. Often it will trigger the "I give up" response, sending a filmmaker into a bout of depression. If you are starting to feel that way, here's the good news: you're going to be fine. Here's why:

- You probably don't need every single thing on the list: this is a comprehensive list of everything that could *possibly* come up.

- The level of things you need is directly related to the level of success you are having with your film. If you need many or most of these items, it means your film is successful!

- For the first few steps of your distribution plan, the list of things you need is very small. Doable. Putting them together is actually kind of fun.

- As you begin to make a small list of the most essential items on the list, you'll gain confidence as a filmmaker; you're doing it for real. With that confidence, will come the ability to take the next step—gathering more deliverables. Soon, you'll be able to collect all of the items on this list with ease.

Does it seem a little less intimidating, now? A little more "doable"? Let's discuss exactly what all this actually means. After it's all explained, we will look at each filmmaker level and a corresponding distribution plan and identify exactly what you'll need to achieve your personal distribution goal.

Rights and Releases in Detail

As was said earlier, when you distribute your film you are entering into a business deal. You hope to make money by allowing people to screen your film, and the people you are dealing with hope to make money, too. It all needs to be fair and legal. Imagine this scary scenario: You upload your film to the Web, and then someone downloads the film and starts selling it to TV stations to air on a program of short films. The TV station buys your film and the person who stole your film pockets the money. You made the film, you worked hard, gathered your crew, directed the shots, edited the film, you own it! They don't have the right to sell it or buy it without your permission and certainly not without paying you for it! Doing that is illegal; the thief and the TV station could both be sued, and that's why people don't engage in that activity. That's the whole point of rights and releases. Films never get stolen and re-sold; it's simply against the law. The type of person who would consider doing something like that is not the type of person who would be able to get that huge list of things the TV station would need, so don't worry; your film will more than likely never be stolen from the Web. It might get virally passed around, but that's another whole chapter, and it's a good thing. The real point here is this: in order to be fair and legal, someone who is selling a film must prove that they own all the rights to the film. Otherwise a distributor will not buy it. This is also true for screening the film at a festival. Festivals sell tickets to the screenings, so they must engage in legalities, and therefore when you are accepted into a festival, you will almost always be expected to sign a form stating that you own the rights to the film.

So, rights and releases are about doing things legally and fairly. They not only protect you, the primary filmmaker, they also protect the people who work for you—your actors or the musicians who write and play music for your film. Even though most of the time none of these people are paid, they actually legally own the rights to their own performances and contributions. Actors own the rights to their performances and musicians own the rights to the music they wrote and/or performed. Even though they all agreed to do this for you (*with* you, really), you actually don't legally own their work— they do. This comes as a surprise to most novice filmmakers, who tend to believe that everything and anything in their film is theirs and theirs alone.

RIGHTS AND RELEASES ARE CRUCIAL

Consider that super-cool music track you used on one of your projects. You know—the hit song on the radio that everyone recognizes and that really "made your film." Well, you didn't make that music, did you? In fact, whoever did is currently selling it and making money from it. If you try to sell your film with their music in it, you'd be trying to earn money, in part, from their hard work. This is something that you could be sued for! You are not allowed to profit from someone else's efforts without permission from the original source. Often, in the case of actors, they "say okay" just by showing up and acting in the film. In a class project or amateur short film that doesn't get distributed, it's common for the filmmaker to have absolutely no rights or releases; it's understood that everyone is chipping in for the greater cause of doing good work, learning, and gaining experience. Once money is charged for viewing, it becomes business, and procedures must be followed correctly. In fact, it's not even just about money. Legally, you must own the rights of your work even if you simply show it at a festival or on the Internet. Ever clicked on a video Web site link only to see a message saying, "this video has been removed . . ." ? That's because the owner of the video (usually a big media corporation like a television broadcasting station, movie studio, or record company) controls the rights to the work and doesn't want it being shown or played anywhere but on their TV station, or in their movie theater, or via their CD. It's a complex issue and plenty of people ignore these rights, causing continual legal battles and arguments. For a short filmmaker, however, the rules are fairly clear: if you are screening the film in public or trying to earn money from the film, you need to own all the rights and/or have permissions for all third-party material in the film.

A release form is an agreement that someone signs to release (or give over) his or her rights to you. It looks like a short contract, and is usually one page. You give the release to someone, they sign it and return it, and that gives you the right to show their portion of the work and charge for it. Depending on the wording of the release, you might have to pay them a fee or a royalty of some kind. When you start making distribution deals, you give copies of these release forms to whoever asks for them (the distributor or buyer) and that proves that you own all the rights to the film.

Now, let's move on to some detailed information about each of the deliverables on the list.

1. Producer / Director release

As the short-film filmmaker, you are almost always both the producer and the director, so this release form is straightforward. Often, it's known as a General Release form, and, by signing it, you are declaring that you own all the rights to your film. This is the type of form a film festival will ask you to sign. They don't want numerous legal forms; they just want something in writing that declares you to be the owner of the film. This type of release is usually written into the language of a film festival's entry form, near the bottom. Also, it's written into many Web site agreements that you click on before uploading your work. It's assumed that by signing or agreeing, that you have obtained all the other rights to your film. If you are making a film that involves enough work to warrant a separate producer and director, then both parties will need to work out an agreement about who actually owns the film, and one of them will need to sign their rights over to the other, usually for some sort of shared credit and portion of the revenue, if any.

2. Talent releases

Actors own the rights to their images and performances until signing them over to you. You are not legally allowed to show your film in public without the actors' consents. This is usually not an issue, because they are usually happy to be in your film and can't wait to see it screen in a festival, or better yet, on TV or in the iTunes store. If you don't have a signed release form, you technically are violating their rights, and they can take legal action to stop you. A distributor requires these release forms before they can work with you. If your actor is not a member of the Screen Actors Guild (SAG), then they are considered to be nonunion and you can present them with a basic release form. Once they sign it you legally have the rights to their image and can screen it anywhere. If they are a SAG actor, the process is more complex. SAG actors are working actors and the union expects them to be paid. The union has a system of agreements allowing their members to work on low-budget and no-budget student films, for free, but SAG will actually make you sign a contract with them stipulating that if you sell the film, their actors get paid. Have no fear though: SAG understands that short films rarely make much money, often not even enough to cover the expense of making the film, so the amount of money they ask you to pay their actors is fairly minimal (around $100/day). Once you sign the SAG contract, the SAG actor can sign your release form. The SAG Web site has this form available for filmmakers to download, sign, and return: www.sagindie.org. See Figure 4-1 for an example of a talent release contract.

Note: This form can also be found on the companion DVD.

Performer Release Agreement

For valuable consideration, including the agreement to produce the motion picture film currently

entitled [TITLE], I hereby irrevocably grant to [COMPANY] (hereinafter referred to as "company"),

its licensees, agents, successors and assigns, the right (but not the obligation), in perpetuity

throughout the world and in all media either now or heretofore unknown, to use in any manner the

company deems appropriate, and without limitation in and in connection with the motion picture,

by whatever means exhibited, advertised or exploited, my appearance in the motion picture, still

photographs of me, recordings of my voice taken or made of me by it, any music sung or played by

me, and my actual orfictitious name. On my own behalf, and on behalf of my heirs, next of kin,

executors, administrators, successors and assigns, I hereby release the company, its agents, licensees,

successors and assigns, from any and all claims, liabilities and damages arising out of the rights

granted hereunder, or the exercise thereof, as provided by the terms of this Agreement.

_____ _____

Print Name Telephone Number

_____ _____

Sign Name Email Address

Date

Address

FIGURE 4-1. There are dozens of Talent and Actor releases available for free on the Internet. Most will be suitable for your needs, but as with any legal document, it's best to show it to a lawyer first. Courtesy of Jason Moore. Used with permission.

3. Screenplay release

You are probably starting to get the idea about releases; people who make major creative contributions to the film are considered to be the "owners" of those contributions. The writer is no exception. In the world of short films, it's rare that the writer is not the director, so this is usually an easy release form to deal with; if you wrote the script and also directed and produced the film you own all those rights automatically. If you teamed up with writers, however, they need to sign over their rights to you in order for you to screen or sell the film. If you based your film on a book or other material that is owned by someone, you need permission from them for the screenplay rights. It's never a good idea to write a script that is not original without first asking for the rights; the author could very well find it offensive and troubling if you make a film based on material they wrote, only to wait to contact them after it's done. It's unlikely they will be willing to sign the rights over at that point, so make sure to do this at an early stage. If you have found a short story that you want to use, you can write to the author or publisher and request permission.

4. Music releases

Music can be the biggest stumbling block for amateur filmmakers as they start down the road to distribution. It's an all too common mistake: a student makes a wonderful film that includes a song, or several songs, for which they don't hold the rights. Distributors and buyers of short films are very aware of this and the first question they will often ask is "Do you have the music rights?" It's easy to understand why this is. Music plays a very important role in a film, and in many cases, a short-film filmmaker uses one of their favorite songs as part of their film. It's crucial to understand that the person who wrote the music and lyrics to the song owns the rights, as does the person who performed the song (not always the same person). Those people often—almost always—will charge significant fees for film rights, as much as thousands and thousands of dollars. It's how they make their living. Depending on the artist, they might not be interested in being part of someone's movie, regardless of money. Musicians are constantly turning down professional, feature films simply because they don't feel their artistic visions will be properly represented. Remember, what might be simply a music track for your film is, for the musician, their work of art.

*Consider this unhappy scenario: you make a great film, but part
of its greatness hinges on the awesome song that you don't own the
rights to. You screen it at a festival, a distributor is interested and
wants to buy it from you, but can't. You don't have the rights. A
huge opportunity is lost. This happens frequently.*

NOTE

Later, there will be discussion about music strategies and some ways
to include great music in your film and still retain the rights, but for the
moment, let's just explore the actual releases and how they work. A music
release, like a screenplay or talent release, gives the rights to the music to
you, the filmmaker. As mentioned above, there are two parts to every piece
of music, in terms of ownership: the lyrics and music as written on the page,
and the actual performance of that music. The person who writes the song
might not be the one who sings it.

SIDE NOTE

Perhaps you're using a song by a punk band that covers a Frank Sinatra song—a rock
n' roll version of "My Way." You need to get permission for the music and lyrics from
the copyright holders, probably Frank's record label, and from the punk band for
the recording. Unfortunately, you'll quickly learn that Frank Sinatra didn't write the
song; Paul Anka did. If you want the rights to the song, you'd need to write a letter
to the punk band and Paul Anka's manager or record label, asking each of them for
permission to the part of the song they were responsible for. While the punk band
might be convinced to sign over the rights to the performance, they will probably
want payment in exchange. Paul Anka's people? They will probably ask for a large
sum for the music-and-lyrics rights for such a popular song! Of course, you might
find out that they sold the rights to someone else.

See Figure 4-2 for an example of a music release form.

Note: This form can also be found on the companion DVD.

ON DVD

5. Locations release

When you film on someone's private property, they own any images taken
of their location, just as actors own their pictures of themselves. A "location

MUSIC RELEASE FORM

Name of Person Authorized to Release Musical Rights (Licensor)

Name of Film

Name(s) of Producer(s)

The Licensor named above grants the Producer(s) listed above the non-exclusive, irrevocable right, license, privilege and authority to record on film, videotape, and/or other media and use the musical compositions and recordings, in whole or in part, entitled_____, in synchronization or timed relation with the Film ("Film") named above. This grant includes the right to use the musical compositions and recordings, in whole or in part, for promotional and publicity efforts.

The Licensor understands that s/he and the artists represented by said Licensor have no rights to the Film or any benefits derived therefrom. The Licensor named above hereby represents and warrants that s/he has the full legal right, power and authority to grant this license.

Licensor will indemnify and hold harmless the Producer(s) and their successors from any and all claims, losses, expenses, and liabilities of every kind, including attorney's fees arising from any breach of Licensor's warranties, representations or covenants under this license. By signing this agreement, the Licensor also grants permission to the Producers and their successors to reproduce, in whole or in part, the above mentioned musical compositions and recordings for publications and exhibitions and to distribute, in whole or in part, the musical compositions and recordings for promotional or educational purposes.

This agreement represents the entire understanding of the parties and may not be amended unless mutually agreed to by both parties in writing.

Signature of Person Authorized to Release Musical Rights (Licensor), Date

FIGURE 4-2. If you have someone who can write the music for your film and also play it, you'll need only one release form, such as this Basic Music Release form. Courtesy of Jason Moore. Used with permission.

release" is signed by the owner of the property and it gives you the right to use those images. If you shoot on public property, in a park, for instance, you don't need a locations release; you actually are part owner of that park. A locations release is also needed if you are shooting images of the outside of someone's property—perhaps their storefront signage. See Figure 4-3 for an example of a location release form.

 Note: This form can also be found on the companion DVD.

STANDARD LOCATION RELEASE

FILM TITLE:

PRODUCTION DATE:

Permission is hereby granted to [YOUR COMPANY NAME] to use the property located at:

for the purpose of photographing and recording scenes for the above film produced by

[YOUR COMPANY NAME].

Permission includes the right to bring personnel and equipment onto the property and to remove them after completion of the work. The permission herein granted shall include the right, but not the obligation, to photograph the actual name connected with the premises and to use such name in the program(s).

The undersigned hereby gives to [YOUR COMPANY NAME], its assigns, agents, licensees, affiliates, clients, principals, and representatives the absolute right and permission to copyright, use, exhibit, display, print, reproduce, televise, broadcast and distribute, for any lawful purpose, in whole or in part, through any means without limitation, any scenes containing the above described premises, all without inspection or further consent or approval by the undersigned of the finished product or of the use to which it may be applied.

[YOUR COMPANY NAME] hereby agrees to hold the undersigned harmless of and free from any and all liability and loss which [YOUR COMPANY NAME], and/or its agents, may suffer for any reason, except that directly caused by the negligent acts or deliberate misconduct of the owner of the premises or its agents.

The undersigned hereby warrants and represents that the undersigned has full right and authority to solely enter into this agreement concerning the above described premises, and that the undersigned hereby indemnifies and holds [YOUR COMPANY NAME], and/or its agents, harmless from and against any and all loss, liability, costs, damages or claims of any nature arising from, growing out of, or concerning the use of the above described premises except those directly caused by the negligent acts or deliberate misconduct of [YOUR COMPANY NAME], or its agents.

By:

 Signature of Authorized Property Representative

Date:

FIGURE 4-3. A standard location release form. Courtesy of Jason Moore. Used with permission.

6. Art materials release

If your film has a shot of any image that is owned by a third party, and you want to sell the film (i.e., use it for "commercial" purposes), you'll need to obtain permission. This can be a long and daunting list, including: a poster of a movie (the studio probably owns that), a painting (the artist probably owns that), or someone wearing an NFL T-shirt (the NFL owns the logo). Ever see a music video where the performer is wearing a shirt and the logo is blurred out? That's probably a music video that didn't obtain the "arts materials" release from the clothes designer. Other types of materials (images) that need releases are corporate brands of any type: a can of Coke®, a logo on a computer laptop, and things of that nature. To get the release, you must write a letter to the copyright owner requesting permission. If they agree, you may use it, and if they don't, then legally you cannot use that image. See Figure 4-4 for an example of a materials release form.

 Note: This form can also be found on the companion DVD.

7. Music cue sheet

Musicians who are members of the American Society of Composers, Authors, and Publishers (ASCAP) receive royalties (usually monetary compensation) for the music they write when itis broadcast or screened theatrically. The TV networks and film studios pay these royalties. Even if the composer gave you the music *gratis* (free), because he is a member of ASCAP, he might still earn royalties if you sell the film to a TV network; and the way they are assured of that is through the music cue sheet.

> **KEY TERM:**
>
> A *cue sheet* is a form that the producer (you, most likely) completes when the film is distributed. The cue sheet documents the name and running time of each music cue along with the name of the musician who wrote it. ASCAP then reviews the cue sheet and pays royalties appropriately.

<div>

MATERIALS RELEASE FORM

[YOUR COMPANY NAME], respectfully requests permission to use: [NAME OF MATERIALS, LOGOS, IMAGES, ETC. YOU WISH TO USE]

which will become part of the film entitled "YOUR FILM TITLE".

This film may be screened in public, broadcast on television, distributed on DVD and/or the Internet, and/or other platforms in the United States or other regions.

Full credit would be given to [OWNER OF MATERIALS] in the closing credits of the film.

We sincerely hope that you will grant us the permission requested, and will indicate such by signing and returning this form. Your prompt and courteous consideration of this request is very much appreciated.

PERMISSION GRANTED THIS [DAY] OF [MONTH], [YEAR]:

[NAME OF FIRM OR ORGANIZATION]

Authorized By:

Signature: _____

Position:

Address:

City, State, Zip:

Phone Number:

</div>

FIGURE 4-4. The process of obtaining materials releases can take weeks, or even months. If you absolutely must film materials that require a release, you need to start the process with plenty of lead time. Never film materials with the intent of obtaining a release later; if you are rejected, you can't use the shot. Courtesy of Jason Moore. Used with permission.

See Figure 4-5 for an example of a cue sheet.

Note: This form can also be found on the companion DVD.

Blank Cue Sheet Template

Series/Film Title:
Episode Title/Number:
Estimated Airdate:
Program Length:
Program Type:

Company Name:
Address:
Phone:
Contact:
Network Station:

Cue #	Cue Title	Use°	Timing	Composer(s) Affiliation / %	Pulisher(s) Affiliation / %
1					
2					
3					
4					
5					
6					
7					
8					
9					
10					
11					
12					
13					
14					
15					
16					
17					
18					
19					
20					
21					
22					
23					
24					
25					
26					
27					
28					
29					
30					

°Use Codes: **MT** = Main Title **VI** = Visual Instrumental **BV** = Background Vocal
VV = Visual Vocal **ET** = End Title **BI** = Background Instrumental
T = Theme

FIGURE 4-5. An example of a Music Cue Sheet. Courtesy of Jason Moore. Used with permission.

Promotional Materials in Detail

An important part of distribution is promotion. People don't just automatically buy or watch your film just because it's available: they are usually convinced to go see it by some type of promotion: an appealing poster, an interesting sounding synopsis, or a positive review from a friend. As the filmmaker, you are the main promoter and as such, you'll need promotional materials to help you publicize information about it. If you are accepted to a film festival or about to sign a deal with a distributor, they will also need these marketing materials, so they can do some promoting themselves.

8. One sheet (Poster) and DVD artwork

Think about how many times a good movie poster has encouraged you to see a film—it's a very powerful and persuasive type of advertising. If you have a design background, you might create this yourself, but often you'll use your filmmaking managerial skills to recruit someone to design it for you, just as you recruited a great DP and terrific actors. Your DVD artwork will be similar to your poster, and just as important. We'll cover One Sheets and DVD covers in more detail in the upcoming chapter. See Figure 4-6 for an example of a one sheet.

FIGURE 4-6. Promotional poster for *Sincerely, P. V. Reese*, a short film by Philip B. Swift. Courtesy of Philip B. Swift. Used with permission.

Here is an example of DVD cover art (see Figure 4-7). A well-designed DVD cover can attract attention and be a standout on someone's desk.

FIGURE 4-7. DVD cover art for Don't Eat The Chili at the Detour Diner, a short film by Jason Moore. Courtesy of Roy Larsen. Used with permission.

9. Production stills

Production stills are photographs of your crew and actors in action on the set. These pictures fall into two categories: actors "playing the scene" and "behind the scenes." Photographs of actors "playing the scene" will be shots taken of them while they are acting in a scene that you are filming. These shots can also be *frame grabs* from the raw footage of the scene, but often a frame grab does not have sufficient resolution for printing; high-resolution images from a still camera are preferred. "Behind-the-scenes" pictures are shots of you and your crew at work: setting up the camera and lights, directing actors, and any activities such as those. These photos will get used in a variety of ways: on a Web site, in a festival brochure, as part of your DVD, and so forth. See Figures 4-8, 4-9, and 4-10 for examples of production stills.

Behind-the-scenes photographs show you at work, directing and filming your actors.

FIGURE 4-8. Production still from *Paradise, Nebraska*, a film by Jason Moore. The director, Jason Moore, cinematographer, Alex Naufel, and actor, Chris Cote on location in Fiji, in the South Pacific. Courtesy of Jason Moore. Used with permission.

A group photograph of you and your crew is one type of production still. Audiences enjoy this type of photo because it allows them to feel a degree of familiarity with the people who have worked behind the scenes on a film.

FIGURE 4-9. A crew photo from *Don't Eat The Chili at the Detour Diner*, a short film by Jason Moore. Courtesy of Diana Larsen. Used with permission.

Often photographs are taken during a rehearsal, so that the camera flash does not show up on the film or video you are recording.

10. Director biography

A short biography of yourself provides additional material for festivals and distributors as they promote your film. Audiences usually like to know something about the filmmaker; it helps them further understand the film itself. Your "bio" should be less than a page, and it should highlight your accomplishments in film, your interests, and any other personal information you would like people to know. A bio is a good opportunity to promote yourself so take advantage of it! See Figure 4-11 for an example of a director's biography.

11. Director's statement

In a director's statement, he will write about his relationship to the film, including additional insight about his rationale for making the film, and

FIGURE 4-10. This production still from *Paradise, Nebraska* shows the actor "playing the scene." It later became the image used on the poster and DVD cover. Courtesy of Jason Moore. Used with permission.

A lifelong student of cinema, with his mother passing on her passion to him the day he was born, Philip has pursued a career as a filmmaker since he was a child.

"When I was 10, I found myself having to explain to my friends why I loved 'Singin' in the Rain' so much. They all thought I was a nerd, but after breaking it down it really got through to them why I found that movie so spectacular."

While attending the Art Institute of New York City from 2006 – 2008, Philip had the opportunity to work on many different projects covering all genres of film. In his first year he won an award for sound design on his experimental film "You Want Fries With That?", a not so subtle statement about the fast food culture of America that featured a tower of hamburgers topped with a donut and then lit on fire. He also participated in two consecutive 48-hour film competitions where he and his team were tasked to write shoot and edit a short film in just two days. Both times, his team walked away with the best film award in the competition. Philip's culminating achievement came in his final year of school when his film "Dark Beer Drank Imitation Paris" won Best In Show at the school's annual film festival, *Alpha Channel*, held at the Tribeca Cinemas.

With a resume covering everything from music videos to documentaries, his love of cinema can be seen not only in his own work, but also in his commitment and determination to educate others about the art form he holds so dear.

All aforementioned films, along with others, can be viewed at Philip B. Swift's Website: dearmothman.com

FIGURE 4-11. A sample director biography. Courtesy of Philip B. Swift. Used with permission.

what the director was trying to communicate to the audience. It might also contain some anecdotes about the process of making the film.

12. Crew list

A crew list is a complete list of everyone on your crew. Be sure to include your actors and everyone who helped in all stages, not just in production. This information is used when information about your film is printed in a catalog, online, or in a festival brochure.

13. Film synopsis

A synopsis of your film is a brief, written description of the film, designed to arouse some interest in the reader and potential viewer. This is a critical item in your promotional efforts, because it's often the piece of information that will convince the reader to watch your film. Your synopsis should be concise and intriguing. You don't need to explain everything, and most of the time you won't want to reveal the ending. Try to "tease" the readers just enough to make them want to find out more by watching the film.

14. The script

Although film festivals will rarely ask you to submit a script, many distributors require a copy for their records.

The Film Itself in Detail

During post-production, when you finally complete your film, you end up with a master copy on whatever format you decide is best: film, videotape, a high-resolution digital file, and so forth. When you submit your film to festivals or distributors you'll send them "screeners"—usually a DVD, but sometimes it's a link to an online version of your film that they can watch on their computers. When you are accepted to a festival or when you have made a deal with a distributor, they will want a copy of your film on a specific format that suits their needs. Different festivals and distributors will require different formats depending on how they are screening the film—this will be discussed in detail below. You might also be asked for some additional materials if your film is going to be screened in a foreign country.

15. Master in various formats

The type of master that you deliver will depend on the way the film is going to be screened. Festivals have different types of screening setups, as do television broadcasters, Internet Web sites, home-video outlets, mobile outlets, and the like. In other words, you need to be prepared to deliver your film in many different ways. It's critical that you become familiar with as many different formats as possible, so you can more easily convert, dub, copy, or print your film from its original format to whatever is expected. Let's start by looking at the various formats you'll need for the film festival circuit.

Film Festivals

If you shot on 35mm or 16mm film, you will obviously want to screen on film whenever possible. You'll need to make a release print, or several, depending on how popular your film is. Most film festivals will have 35mm and 16mm projectors, although some of the smaller fests might not. If you shot on video, you will want to screen on a video format that is nearest in quality to your master. That is, if you shot in High Definition (HD), you'll want to screen in HD versus screening in Standard Definition (SD). Also, you'll need to be able to move back and forth between actual videotape and digital files. Many digital filmmakers today complete the post-process by exporting a high-resolution digital file, but if that is your master, you'll likely need to convert that file into a tape-based format for festivals and distributors. Just burning it to a DVD won't be enough in many cases. Be aware that some of the top film festivals screen only on film formats, so it's possible in rare circumstances that you might need to convert your video to film, although, as you might imagine, it's very costly. Here are some of the most common video formats being used on the festival circuit:

DVD

This is the lowest quality format on which a festival will screen films, and they are almost always doing so because that is the only affordable option for them. It's important to realize that film festivals are usually not well funded and therefore must do the best they can on whatever their budget might be. The DVD format is an SD format, so although it can look good on a television set, once it is increased to the size of a movie screen, the image quality starts to deteriorate. It's a very affordable option for a filmmaker, though, because nearly everyone can burn a DVD from her personal computer. Other downsides to screening in the DVD format, however, are scratches (don't use a DVD you have played more than once or twice) and unreadable discs (always have several backups on hand).

Digital Betacam & BetaCam

These formats are popular at festivals because of the relatively low cost of the DigiBeta / BetaCam deck. They are both SD formats so the resolution of the image is similar to that of a DVD; however, these are tape-based formats, which are generally more reliable: no issues with scratches, unreadable discs, or issues of that nature. As with any tape-based format (including the ones below), you will need to have a dub (a copy) made at a professional facility (often known as a Dub House). You'll be charged for both the tape and the dubbing fee.

HD CAM

This tape-based HD format is the Sony format, made specifically for cameras such as the F35 Cine Alta. It's a high-end format and your HD footage will look very good if the festival offers this type of format. The tape and the transfer costs are slightly higher than DigiBeta or BetaCam.

Blu-Ray

Blu-Ray has potential to be an amazing format for both festivals and filmmakers alike. Still in its infancy, Blu-Ray has got two big pluses: it's inexpensive and it yields high quality footage. The 1920 x1080 resolution is large enough to screen HD work in the proper size, but the discs and players are extremely inexpensive: a few hundred for a player and no more than five dollars for a DVD. This is a format that everyone is excited about, so if you are unfamiliar with Blu-Ray, get familiar with it quickly!

Distributors, Broadcasters, and Buyers

Regardless of what format you shot, a distributor, broadcaster, or buyer will want some type of video master, perhaps several formats, depending on the company and how they plan to screen the film. Because distributors might be dealing with all varieties of broadcasters and buyers, they will need a format that satisfies each of these outlets. So be prepared to have your distributor request several formats. If you are dealing directly with broadcasters or buyers, they will tell you exactly what they need.

- Television Broadcasters and Home-Entertainment Buyers will likely want a tape format, like DigiBeta or HD CAM.

- Web Broadcasters and Mobile Broadcasters will want a digital file. They will perhaps want an uncompressed digital file, or they could give you compression specs and ask you to deliver them something that is "Web-ready." Common Web compression codecs are Apple's H.264 and Flash's FLV codec.

16. Music and effects track (M&E) on channel 3 & 4

Shorts are popular worldwide, and a thriving distribution market currently exists for American shorts in foreign countries. If a distributor or foreign buyer wants your film, and if you have English dialog, the foreign buyer will perhaps want to dub your film into the language of her country. Of course she wants to preserve your sound design and music, so she will request that you put your music and sound effects, without any dialog, on two separate audio channels on the master you give them. Channels 1 & 2 will have your full mix: English dialog, music, and sound effects. On Channels 3&4, you will remove the dialog and just keep music and sound effects. Subsequently, the buyer will bring in voice artists, and will use your dialog list (see below) to record a foreign language version of your dialog. Then, before they broadcast your film, they will combine your M&E tracks with their new foreign-language dialog track.

17. Dialog list

If a foreign buyer wants to dub your English dialog into their language, they will request a Dialog List from you. The list will include every line of dialog in your film along with the time code of when it starts and when it ends, the character that says it, and the running time (in seconds) of each line. A translator will use the list to write appropriate dialog that will fit the timing of your film.

Filmmaker Types: Who Needs What?

Now that you've got the details about each of the potential deliverables, you might be feeling overwhelmed again. If the list seemed endless, collecting the details for each of the items can be daunting. Just relax and take it all one step at a time. Remember; if you're just starting out, there are many items you won't need. If you do need most of them, you're lucky; that means your film is doing well or has a chance of doing well! Now let's look at which deliverables are most relevant for each of the filmmaker types we've been discussing. Then, you'll learn some important tips about how, exactly, to collect what you need.

Aspiring feature director

If you have a film that you're passionate about , you're in a very exciting position. You're about to take some big steps toward becoming a professional. You're going to try to create a solid distribution plan and maximize your chances of success along the way. With this in mind, you'll need almost all of the items on this list. You might not need them all at once, but you should realize that along the way, many of these items will be requested. Have your releases ready; they are the first things a distributor will want. As far as your promotional materials, they are also essential. Promoting will be a huge task, and you'll be able to use all the images and artwork you can get. For the film itself, you can take it one step at a time. As you get replies from festivals, you can deal with dubs, prints, or format conversions as you need to. For the M&E track and dialog list, as long as you have all of your audio files (Pro-Tools® session, audio files, etc.) you can prepare them as needed, or, if you know about this before you finish your mix, you can do a separate M&E mix on a separate master.

Aspiring creative crew member

If you are a cinematographer, production designer, editor, or other creative crew member, you are not only helping your director promote your film, you are also trying to promote yourself. Toward that end, promotional materials will highlight your activities. If you have artistic skills to help design an appealing one sheet and DVD package for the film, you should. If you can bring a camera to set and shoot pictures of the set, lighting, costumes, behind-the-scenes activities, and so forth, that will help the film and help you; make sure to get pictures of you doing your job (operating the camera, building the sets, working at the computer in post, etc.). You should have your own demo reel with footage from this project (with effective DVD artwork as well) ready to go, before the director begins the distribution process. In the same way your director will write a statement about her vision for the film, you should, too. What creative decisions did you make? What hurdles did you leap over? What was your vision? Help your director collect materials and also collect your own.

Intermediate-level filmmaker

Perhaps you have a film and are ready to try a few steps of the distribution process, but are not ready to go all out yet. That's actually a good way to learn about the process and you'll be one step ahead on your next project. You're going to screen your film at your school's festival and perhaps submit to one

or two small, local festivals. You are going to get your film on the Web, but perhaps not get into major negotiations with distributors; rather, you're just going to try to get the film seen and start to build a reputation for yourself. With these distribution goals in mind, you will not need as many deliverables, although it will be beneficial to try and collect as many as you can. For Rights and Releases, you will really need to have them all. It might seem as though you don't need them; legally, you actually do. You are supposed to have talent releases, music releases, location and art materials releases for any film you screen in public. This means at any festival, even your school or neighborhood festival, and online. Plenty of filmmakers ignore these rules and there might never have been a case of a student being sued over screening a film without obtaining the rights, but the fact is, you are supposed to own the rights to anything you screen. If you use a popular song in your film, you are supposed to contact all the rights holders and request permission (you can ask for "Festival Screening Rights," which are often granted free of charge). If you have actors in your film, you are supposed to get their signed permissions.

SIDE NOTE

Yes, it's probably unlikely that the Coca-Cola Company® is going to sue you for unauthorized use of their logo because your lead actor holds a can of Coke® in his hand during your movie. Let's imagine that your movie happens to be successful and slightly edgy ("R" rated), and perhaps the Coke can plays in a pivotal scene. Perhaps this lead character kills the villain, takes a long slug of Coke, burps, and crushes the can on the villain's forehead in a close-up shot. Let's imagine that you post the film to the Web and it goes viral, gets downloaded by millions, generating press from bloggers and mainstream media. You're on top of the world. Everyone's talking about your viral film, and that great scene with the Coke can. And then the phone rings, and it's the Coca-Cola Company. They've seen the film, and they're not happy. They don't like the way you portrayed their product in your film, and they really don't like the fact that you did it without permission. Are you prepared to deal with their lawyers?

In terms of promotional materials, you might not need a large fancy poster but some sort of DVD artwork is important. You might not have a hundred production stills, but having at least a picture of yourself, or perhaps a group picture of you and your cast and crew is necessary. Bios and statements can come later. And for the various formats of the film itself, take it one step at a time; it's likely you'll just be using a DVD or a basic video file like a QuickTime® movie, so there's no need to worry about those details for now.

First-time filmmaker

If you are reading this and don't yet have a film to distribute, you might just be in the best possible place. Understanding deliverables before you write and direct a film is extremely helpful. You can think ahead and make decisions that will maximize your chances of success and minimize your headaches. Pay close attention to the next section on strategies for collecting deliverables; you'll want to employ these from the very first draft of your script.

Strategies for Collecting Rights and Releases

There are two avenues of advice for collecting your releases: strategies for filmmakers with a completed film and strategies for a filmmaker in pre-production. Both are covered in this section. As you might have guessed, it's a bit easier to deal with releases if you are in the pre-production stage, but even if you've got a completed film, there are plenty of ways to collect what you need.

Producer / Director release

Assuming you give yourself permission to distribute your film, this should be a nonissue. If you worked with a producer, you'll want to work out an agreement to share costs and profits.

Talent releases

Before you offer an actor a part in your film, explain to him that you hope that the project will be successful and that if you are all lucky, you plan to distribute the film. Of course, you'll also be clear about the probability that you'll never earn back what it cost you to make the film, so it's extremely unlikely anyone is going to be paid. Any exposure is good, however, and with that in mind, you'd like them to sign your *Performer Release* form. This

gives you permission to promote the film in festivals, online, and wherever else you can. Your actors should be willing to sign this: they benefit from the film's success. As mentioned above, SAG deals will be more complex than nonunion deals, and if you are hoping to use SAG actors, you'll have to review the SAG paperwork on actors in short films. Essentially, SAG will ask that you offer the actors some small cash stipends if the film produces any revenue.

If you've completed your film and need to go back to your actors and ask them to sign a release form, simply explain to them that you are gearing up for a big promotional push and are putting all the pieces together; they'll understand, and might even offer to help you get the word out. They have as much at stake in the film as you do.

> **KEY TERM:**
>
> **Performance Release Form,** also called the Talent Release Form. Actors own the rights to their images and performances. When they sign the Performance Release (Talent Release) they are releasing their work to the filmmaker. A filmmaker is not legally allowed to show his film in public until the actors have released their performances to him.

Screenplay release

Assuming you're the writer, or that you and the writer have worked out an agreement, you should easily obtain this release before or after filming.

Music release

This section might be the most important part of this entire chapter. If you are making a film and want all of your options open: festivals, distribution, online, everything . . . *then you must control the music rights.* That means either working with a composer or working with a band or making the music yourself or having no music at all. Working with a composer is a good solution, you can hire them as you would an actor; you don't pay them because it's a win/win for all of you in terms of exposure. Don't think of a composer as a traditional, tuxedo-wearing symphony composer. Composers are like any other talented musicians; there are dreadlocked composers who write hard, edgy break beats, hippy composers who write guitar-based scores, and, of course, there are hard-rock composers. Composers are musicians who write

music; many of them compose music for film, and they can write in any style. There are many advantages to collaborating with composers, but the most important is that they write the music especially for your film. Every dramatic or comedic beat can be punched up with music. That pop song you dropped in might work on some level, but a composed score works on every level, at every moment of your film. Plus, it's *original*. Nobody has heard it before. It's yours! A film with an original score trumps a film with a pop soundtrack ten times out of ten. Working with a local band is just as effective. Even writing the music yourself, if you have the talent, is preferable to using a song from your iPod. There are just as many "starving" composers looking for film directors as there are "starving" actors—put your feelers out and hire them early on. You won't regret it. You'll end up with music scored specifically to your film, the way you like it, and you'll own the rights so you can screen and sell it as you wish.

If you have a completed film with music that you don't own the rights to, you have a few choices: negotiate for the rights with the publisher and performers, ignore the rights and take your chances with legal issues, or find new music, using a composer or a band you select. To contact the publisher and performers, send a letter asking for permission to use the song. You can request *festival rights* which allow you to screen at a festival but not to sell the film; these might be easier to obtain. Give yourself several months to negotiate and obtain the agreements. You should expect that the more popular the song, the less likely you are to get the rights; rights for songs can cost thousands and thousands of dollars, and that is assuming the publishers or artists like the film and believes it's a good fit for their music. Not to dwell on this too much, but there is one final, important reason why original music is almost always preferable to music from your iPod®: it's more creative. When you take an amazing, powerful pop song and use it as the sound track it to your film, some people respond negatively, feeling that you are just kind of riding on the success of the song. It's best to screen work that is completely your own, on every level.

KEY TERM:

Festival Rights are rights conveyed to the filmmaker to use a piece of music for a film to be shown at a festival; these do not allow the music to be part of a film that is intended for distribution.

Location release

When you are writing or prepping your film, you always want to choose locations you have permission for, mainly because you don't want someone telling you on the morning of your shoot that they've changed their mind, and you can't come shoot. Once you do get permission, it's a good idea to get a location release; it helps remind the person you are dealing with that you are serious, and it can prevent him from reconsidering at the last second, because he will be obligated once the release is signed. Remember when shooting exterior locations that you should be cautious about what you're filming. If you are in Times Square, you're going to have a hundred brands and logos in every shot. This actually is not a big deal; it's a public space, and as long as you are not featuring one billboard or sign for an extended period of time, you're safe.

If you have a big scene that takes place in front of a McDonald's®, be prepared for the manager to come out and ask if you have permission to shoot their Golden Arches® (notice the capitalization? The Golden Arches are a trademark, and they are protected).

NOTE

If you've already shot, you should go back and get the location release signed, if possible. If you can't, just be aware that there is always a chance someone could see your film and not be happy with the fact that you filmed outside their place of business or location, and if they really want to pursue legal action, they can. This rarely happens, but it can.

Consider this factual scenario: A big exterior crane shot in a busy area of Venice Beach, California. The shot started high on the exterior of a colorful beachside building and boomed down to the actors walking. After the crew had been shooting for an hour, the owner of the building appeared and told the producer that unless he was paid $2500 for the filming of the exterior of his record shop, he would take legal action to prevent the shot from being used. The producer couldn't afford it, couldn't negotiate with the owner, and the director had to cut the shot. This could have been prevented with some planning.

TECHIE'S TIP

Art materials release

When you're planning your shoot, plan on avoiding all major brands, logos, and trademarks, because you must have permission from the companies that own them in order to screen and sell your film. Lead actor wearing a polo shirt? Put him in a plain one rather than one with a crocodile or a polo player. Music and movie posters in the bedroom? Not a good idea; instead, create your own fictitious ones. Your lead actress snuggles a Minnie Mouse® as she falls asleep? No, she snuggles a generic stuffed animal instead. You get the picture; any major, recognizable brands or logos should be avoided at all costs. If they appear in the background, in a brief moment, it's probably not an issue, but if it's easy to spot and it's obvious, better safe than sorry—remove it or fix it. Art department crew members are constantly *greeking out* logos and brands, even on big-budget movies and commercials. A piece of black tape over the logo on a laptop can blend in with the black plastic and never be noticed, if done correctly.

KEY TERM:

Greeking Out refers to the film industry practice of masking logos and obscuring brand names, or removing them if possible, when a release to allow the display of a particular brand or product on film has not been obtained.

If you've already shot, you'll have to decide for yourself what to do about any visible logos or brands. The more popular and successful your film, the more important things of this nature become. If you're just screening at school or for your family, it's not likely to be an issue. Once you start circulating your film, however, the real-world rules start to apply.

SUMMARY

Now that you are familiar with what deliverables are and how to go about collecting them, it's time to take the first step of your distribution plan: gathering as many of them as you can. In the next chapter, you'll start to promote your film, but in order to do that, you need to have your rights, releases, promotional materials, and film formats properly prepared. Blank release forms can be found on the Internet, and some are included within this chapter and on the companion DVD.

ON DVD

REVIEW QUESTIONS: CHAPTER 4

1. What are deliverables and why are they important?

2. There are seven important Rights and Releases filmmakers must have in order to distribute their films. Name as many as you can.

3. Why must filmmakers have more than one format of their films?

4. Why is the music release so important and what is one of the best strategies for ensuring that you own the rights to your music?

1. Each filmmaker type will have a different distribution plan and will need different levels of deliverables. Write a short essay about your personal distribution plan and what deliverables you think you will most need.

2. Write a follow-up essay describing the strategies you will use in order to collect your deliverables. In other words: what exactly are you going to do in order to collect them?

3. For a first-time filmmaker without a film: as you prepare your film, what steps are you going to take in order to ensure that you can collect as many deliverables as possible?

Research / Lab / Fieldwork Projects

The following research exercises are designed to help you understand the concepts discussed in this chapter.

Collect Deliverables

Make a detailed list of the deliverables you need to collect and begin to gather them. Set a deadline so you will not procrastinate. Work with someone who has experience to come up with realistic goals, to troubleshoot problems you might have along the way, and to ensure that you use every possible strategy you can to collect your deliverables. Concentrate on Rights and Releases at first. We will cover Promotional Materials in greater detail in the next chapter. For your film formats, again, work with your "mentor" to determine which of them you need first and how best to create them.

Sample Forms

The following forms that were included in this chapter are all available on the companion DVD.

ON DVD

- Sample Release Contract
- Basic Music Release Form
- Standard Location Release Form
- Materials Release Form
- Music Cue Sheet

PROMOTING YOUR FILM AND YOURSELF

OVERVIEW AND LEARNING OBJECTIVES

In this chapter, you will:

- Discover what promoting yourself means and why it is important
- Understand the difference between traditional promotion methods and the new, DIY-style of promotion
- Review the necessary components of a professional press pack

Self-Promotion: Step One of Your Distribution Plan

Promoting a film is the act of getting audiences to go to see it. It makes sense that anyone producing a film, be it a major studio or a first-time film-maker, wants an audience to watch it. Just because you've made a film does not automatically mean that audiences are going to attend your screening; they need to learn a little about what it is, and they need to be convinced that it's a film they would enjoy watching. Motivating a potential audience is promoting, and it's essential to the success of any film. Consider how you discover a movie; it's usually the result of a substantial advertising campaign financed by the studio. You see a poster for it in the neighborhood, you see a trailer at the movies, or on television, or online. You read reviews from film critics or bloggers. You might find the Web site, or hear a radio advertise-ment, or hear a positive review from someone. All of that exposure is the result of the studio capitalizing a substantial promotional campaign for its film. Because you are not a big studio with a considerable budget for your promotional campaign, you will need to take a different approach in order to let audiences know about your film. Fortunately, the Internet has signifi-cantly changed the way film promotion works, and there are more opportu-nities for independent filmmakers than ever before. Especially filmmakers who are Web savvy. In this chapter, some of the new methods of promo-tion available to you are explained. You will put together your *press pack*, develop a personal story, and begin to promote your film, both in the "real world" and on the Web.

> **KEY TERM:**
>
> **Press Pack** Various materials that are used for the successful promotion of your film, including posters, photographs, director's biography, director's statement, film synopsis, trailer, behind-the-scene clips, business card, and so forth.

The benefits of promoting your film

If you've ever screened your own film for an audience of any size and heard their applause at the end, you'll know that showing your work and listen-ing to feedback is tremendously satisfying. You worked extremely hard on your film, your goal was to affect an audience in some way, and it's during

the process of screening your film that you are rewarded for your efforts. Most filmmakers will tell you that it's a high point of their professional lives to screen a film for an audience. Understandably, people don't just happen to wander in from the street to your screening; you need to tell them about it. Promoting your film helps you find audiences for your work. Your relationship with your audiences is at the heart of a successful promotion, and it's at the heart of filmmaking. You made your film to be seen by an audience, so once you've finished filming, it's important to reach out to the public and let them know you've got something for them. You will learn from your audience: they will give you valuable opinions about what they enjoyed, and perhaps what they believe can be improved. Someone in the audience might be so impressed with what they see that they will help your career by hiring you for a job, or help you obtain an opportunity to direct another film. Someone in your audience, perhaps a distributor, might find the film extraordinary and want to help you earn money from it. The more people that see your film, the more likely you are to learn, grow, and advance your filmmaking career.

What if the film is not perfect?

All filmmakers ask themselves that question; we are our own worst critics. It can be daunting to screen your film and listen to the response. It's a lot easier to promote your film if everyone who sees it thinks it's wonderful. Even if your film isn't exactly perfect, even if you feel you could have done some things differently, that doesn't mean that you shouldn't screen it. There are hundreds of millions of movie watchers in the world, and sometimes it just takes time to find your audience. The more promotion you do, the better your chances are of finding your audience; and understanding your audience is essential to a successful promotion.

Understanding your audience

Every film falls into a specific category or *genre*, and each genre has its own type of audience. For example, if your film is a documentary on extreme snowboarding, the audience for that will probably not be the same as people who want to see a drama set in eighteenth-century France. Different films attract different audiences, and in order for your film to be well received, you'll want to identify and promote directly to your audience. The first step

is to identify your genre, if you haven't already. There are dozens and dozens of genres, and subgenres. Here are just a few of the more popular:

1. Drama
 a. Romantic Drama
 b. Biographical Drama
 c. Costume / Historical Drama
2. Comedy
 a. Action Comedy
 b. Romantic Comedy
 c. Spoof Comedy
3. Adventure
 a. Treasure Hunts
 b. Historical Adventure
 c. Martial Arts
 d. Jungle / Safari Adventure
4. Action
 a. Buddy Cop Action
 b. Espionage / Spy
 c. Heist / Caper
 d. Disaster / Doomsday

There are dozens of genres, sub-genres, and hybrids (combinations) of films. It's important to recognize what category your film falls into. Once you've identified your genre, you have also identified a large built-in audience. Everyone has a few types of movies that they particularly enjoy, and when they hear about that kind of film they are excited and ready to see it. When you reach out directly to fans of your genre they are quite likely to want to see your film, and are also more likely to enjoy it. So lesson number one: identify your genre and realize that people who enjoy that type of movie are a good target for your promotional efforts.

KEY TERM:

Genre Means "category" or "type," particularly in relation to artistic works. One of the key steps to successfully promoting your film is to understand what genre of film you have and who its audience is.

Standing out from the crowd

Another very important thing to understand is that, promoting is about making your film stand out from the thousands of other short films available to audiences. Because the technology required to make a film is now inexpensive and widely available, there are greater numbers of filmmakers and films, and increased competition for audiences. It's important to discover ways to get noticed. Identifying your genre and its audience is one way; developing a *personal story* that connects you and your film to people is another (this will be discussed in detail, later). As all the various options to help you promote yourself and your film are introduced in these pages, continue to ask yourself these questions: what can I do to be a standout? What can I do to attract attention? What can I do to encourage people to notice me? How can I generate interest in my film and convince people to want to experience it? It's not enough to simply announce your film with a poster, flyer, or Web page. You need to reach people, to engage and excite them, and show them why your film deserves their attention.

Believe in yourself, believe in your film, and enjoy the process

Obviously you can have a successful distribution process with a film that is so undeniably first-rate that everyone who sees it is amazed and tells all their friends about it. If you're fortunate enough to have a film this wonderful, others will promote it for you, offer to help, and create opportunities for you. Regardless of how popular your film is, *you* need to believe in yourself and believe in your film. Your film, no matter how smart, clever, heartfelt, or well crafted, deserves to be seen. There is an audience for it somewhere. You put forth a great deal of effort to make it, and by completing it, you did something that most people cannot do: you made a movie. Even if you make numerous mistakes, you'll learn and grow through the process of screening it. You need to motivate yourself before you get started, because the truth is, if you are not excited about your film, nobody else will be.

Believe in Yourself and Enjoy Your Audience. You'll never get an audience if you shrug your shoulders and say, "I guess it's okay..." Nobody has time to watch an "I guess it's okay" movie. You need to sincerely want people to see your film. You need to sincerely believe that it's excellent—or at least that it has some excellent parts! If you can't muster a strong level of enthusiasm for your film, then it's probably not the film to distribute. Guaranteed: the best way to generate some enthusiasm and confidence about your film and yourself is to adopt an attitude that values learning, growth, and a collaborative relationship with your audience. You should value your audience's opinions, input, and advice. Make the process of screening your film something akin to a dialog: you and the audience participating together. Your audience's reaction will not be positive if your manner is aloof and superior. Make their experience—and yours—a cool, fun journey that you are taking together in a truly collaborative way. It's because of them that you made the film; if you make the event about you *and them*, it will be less stressful, more playful, and ultimately, more rewarding.

Traditional Versus DIY Promotion Models

In the pre-Internet age, a filmmaker relied on a fairly simple, standard method for promoting his film. Promoters of a feature film would employ an advertising campaign consisting of posters, newspaper and radio ads, trailers shown in theaters and on television, and interviews with the directors and stars. The film would be made available to notable film critics and reviewers writing for major newspapers. The hope was that a positive review combined with a saturation of advertising material would drive audiences to see the film.

NOTE

In the pre-Internet promotion model, the filmmaker was generally not very involved. Indeed, there was a very clear separation between the artist and the promotional campaign. Some filmmakers chose not to be involved at all; they viewed promoting as "selling out" and looked down on the idea of a filmmaker hyping his own work; that was the work of publicists.

For the independent feature filmmaker, strategies similar to those of the major studios were used, but with lower budgets. Television was rarely used, because advertising time was prohibitively expensive. Ads in newspapers were less frequent and did not command much space, and reviews were

often in papers with relatively minor circulations. This is, in part, why smaller independent films seemed unimportant: their filmmakers didn't have the promotion budgets to compete against the major studios. The traditional promotion model for a short-film filmmaker was even more meager. Because short films didn't have a budget for it, advertising was generally nonexistent. If and when a short film was advertised, it was usually the result of the film being accepted to a film festival and the local newspaper running a story that featured a few of the films that were screening. A short-film filmmaker might stand outside the theater handing out flyers, but beyond that, there were not many ways for a no-budget short to reach significant numbers of potential viewers.

Enter the Internet. Suddenly people are connected in ways never before imagined. In a few years, the promotion model of all films, shorts included, has changed considerably. Although the traditional model is still used, the process has grown to include several major alternatives. Now trailers are posted online, Web sites are created for the sole purpose of advertising films; banner ads flash release dates across millions of Web pages. Most significant of all, however, is the advent of social networking and peer-to-peer communication. Word of mouth has always been one aspect of promoting a film, but the Internet has raised that concept to an entirely new level. It's far more likely today for someone to hear about a film from their Facebook friend, a tweet on Twitter, an email from a coworker, a trailer that spreads virally across the Internet, or a blogger review, than to read a review in any local or major newspaper. This might seem like a trivial, unimportant fact, but it's not.

> *Before the availability of the Internet, you could stand on the corner with a megaphone all day shouting about your film to people passing by, and your best-case scenario would be that you would be arrested for disturbing the peace and be written up in the "kooky stories" section of the local paper. Today, with a few clicks of your keyboard, you can pen your own story, advocate your film, and showcase your trailer, press pack, and other interesting components of your film—and you can reach millions of people. Oh, and one more thing: it's pretty much free.*

NOTE

Today, you can construct a promotional campaign as sophisticated and compelling as that of a major studio, and get the word of your film out to just as many people, and you no longer need a limitless budget to do that. Proof of this is everywhere: short films have made a huge comeback, as has independent cinema.

Filmmakers all over the world are availing themselves of the new modes of communication and taking advantage of the power of the Web. In fact, some argue that the younger, more "tech-savvy" generation of indie filmmakers has a great advantage over the older, traditional studios, because the younger generation is inherently more comfortable on the Web.

Another important cultural shift that has occurred as a result of the phenomenon of Internet-age promotions is that the filmmaker (especially the indie and short-film filmmaker) is now part of the promotional process—indeed many filmmakers are the *entire* promotional process. You—not a public relations expert—are getting the word out. The stigma of "selling out" or being overly concerned with self-promotion has decreased significantly. It's now acceptable for the filmmaker to self-promote; not only is it the most feasible option, it's also part of the new, transparent manner in which we live our lives online. There's no longer a wide degree of separation between our professional and private lives. We write about what projects we are involved in when we tweet or add a Facebook update. Self-promotion has become just another form of self-expression—we share reports of what we are working on in the same place that we share stories of what we did over the weekend. Everything seems to be interconnected now, and the key is to use this interconnectivity advantageously.

Now that there is less separation between you the "filmmaker" and you the "friend," it's important to maintain a balance; you can't spend all of your time talking about your project, or people will "tune out and turn off." The Internet has created amazing new opportunities for promoting short films, but you need to learn how to utilize it properly.

Putting Together Your Press Pack

The last chapter, "Deliverables," explained the various promotional materials you would need. This section will explore the ways you can incorporate those materials into your promotional campaign.

One sheet (poster)/DVD artwork/Postcards

Ideally, your poster and DVD cover will be designed by someone who knows something about graphic design, typefaces (fonts), and print layout. These will be the primary visual representations of your film; you want them to

have a professional appearance and to express the theme and style of your film. Study posters of features within your genre and consider that your audience will respond best to something that looks similar to those that you find yourself responding to. You'll post your one sheets anywhere you can when you start to promote.

If your film is accepted into a film festival, you'll want to post your one sheets all over the neighborhood in advance of your screening.

At popular festivals, it's common to see one sheets posted all over the city, often on top of each other, as each filmmaker tries to get the most exposure.

A postcard is a small printed flyer that can be mailed out or handed out to help promote your film. It should be postcard sized, with your one sheet artwork on the front. On the back, you have a few options. Some filmmakers print a synopsis of the film on one half of the back and leave the other half blank. On the blank side, you can write details of the screening: day and time and location (if promoting a particular screening) or the address of someone you want to mail the card to, or both.

Some filmmakers use printed labels to give their postcards a more professional appearance.

See Figure 5-1 for an example of a postcard.

Production stills

Your production stills (photographs taken during the making of your film) will be another of your most valuable visual assets. You'll post them on the Web and send them with emails; you'll use them at festivals, on print materials, and in many other ways. The best thing you can do is to shoot numerous photographs and take the time to refine them to achieve a professional polish. Frame grabs from the movie itself should be a last resort—as mentioned in the last chapter, these often have a low resolution, which is not optimal for print—but they are better than nothing. See Figures 5-2 and 5-3 for examples of production stills.

The stills should be an assortment of actors "playing the scene" and crew members (including you!) working on the set.

SINCERELY, P.V. REESE

a documentary film by philip swift

SPECIAL SCREENING

Dec. 29, 2009 @ 9PM
at the Lockview *thelockview.com*
207 South Main St.
Akron, OH

"The best movie ending I
have seen in forever.
Not even of all the
Bruce Willis movies
I know can I think of
a better ending..."
-Eric Pollock,
Movie Expert

Stick around after the screening
for a "casual" viewing of the
hour long epic "Dear Mothman,"
along with a meet and greet with
the filmmakers!

FIGURE 5-1. An example of a postcard for the screening of *Sincerely, P. V. Reese,*directed by Philip B. Swift. Courtesy Philip B. Swift. Used with permission.

FIGURE 5-2. The director, Jason Moore, and cinematographer, Alex Naufel, set up a shot while filming *Paradise, Nebraska*. Courtesy of Jason Moore. Used with permission.

FIGURE 5-3. Have a variety of production stills: color and black/white, crew shots and actors "in the scene." Actor Johnny Strong during a scene in *Don't Eat The Chili at the Detour Diner*. Courtesy of Diana Larsen. Used with permission.

Director's biography

You will use your director's "bio" in a number of ways. If someone from the press wants to interview you, they will request this so they can use it in the article. You'll use your bio on Web sites, emails, blogs, and cover letters. If it's your first time writing one, get some feedback from your mentor, professor, or a writer friend: your bio is one of the first ways people who don't know you will "meet" you, and you want to make an impression that sets you apart from the crowd in a favorable way.

Director's statement

With your director's statement you are telling people why you liked the project enough to spend a lot of time and energy making it. The hope is that if you can convince someone that your reasons for liking the project are interesting and reflect some of your passion, they will be inclined to like it as well.

Your statement will come in handy at festivals, where you're often sitting on Question and Answer panels. When audience members ask you why you made your film, you will have an intelligent and passionate answer all ready to give them.

See Figure 5-4 for an example of a director's statement.

Film synopsis

Don't overwrite! You want to generate intrigue without revealing the ending. Mention the main character and conflict, and set the tone. Remember your genre and study synopses of similar films so you can give your audience what they are expecting in terms of essential character and plot points. You should not attempt to describe the entire film; this is more like a written teaser. See Figure 5-5 for an example of a synopsis.

Trailer

The trailer was not included on the list of deliverables, because it is *not* usually requested by a festival or distributor, but you'll need one to help generate interest while you are promoting your film. Creating a trailer for a short film can be difficult, given there is much less material to work with than with a feature.

> "Sincerely, P.V. Reese" is a short documentary whose genesis can be traced back to 1993, the year that Philip received his first video camera as a gift from his grandparents in order to document a cross-county train trip. After that journey, the camera was used to make over 100 movies by Philip and his friends back in their hometown of Akron, OH.
>
> In the summer of 2009 Philip found himself in a place he hadn't been in 14 years: temporarily unemployed. His free time was used digging through his closet and unearthing those old videotapes and pouring over every minute, putting the vast majority of them online for his friends to see, some of them for the first time in over a decade. One familiar face that was omni-present in these films was Stephen Lionel Caynon, Philip's best friend who passed away from leukemia in 2004. It was impossible to ignore Steve in those films from the past, especially with his absence in the real world of the present. Then Philip's uncle died.
>
> James Baker Hall, writer, photographer, poet and teacher, passed away at the age of 74 and that event, coupled with his ever-growing online video memorial to the past pushed Philip to want to understand the moments in life when we find ourselves most vulnerable and aware of our own mortality.
>
> Philip set off to his hometown to ask his friends what they remembered about those old days and what it meant to see their friend live on forever in films with such absurd titles as "Der Cappuchino" and "Dear Mothman,".
>
> The end product is a film that begins as a comical and nostalgic view of the past while slowly reminding you that the harsh light of the present is allows looking back at you in the mirror.

FIGURE 5-4. Your director's statement should inform audiences about why you made the film, what influenced you, and what makes the film unique. Courtesy of Philip B. Swift. Used with permission.

> "Sincerely, P.V. Reese" is a short documentary film about growing up in Akron, OH and making films with High School friends. What begins as a nostalgic view of the past quickly becomes an examination of the lives of those effected by the unexpected death of one of their best friends who lives on forever in those ghostly VHS images.

FIGURE 5-5. A sample film synopsis. Courtesy of Philip B. Swift. Used with permission.

A "**teaser**" is often the best way to go when creating your trailer. A teaser does what it says—it teases. It doesn't have to be any longer than ten or fifteen seconds, it traditionally is not heavy on plot, and it does not usually incorporate an announcer's voice-over. Rather, it uses music, sound, a few shots, and the title graphic to set the tone and mood of the film without giving away any of the actual plot. Study teaser trailers of films in your genre to get an idea of what is effective and consider how you can incorporate facets of these into your own trailer.

TECHIE'S TIP

Behind-the-scene clips and bonus material

Additional video material is a helpful and fun way to promote your film. Short video interviews with you and your cast and crew taken on the set, during production, function like a video version of a production still: they get people excited by revealing behind-the-scenes moments. Other bonus material might be a *blooper reel*. Deleted scenes and formal interviews with cast and crew are also considered bonus material. You can use this material on the Web and later, on the DVD of your film.

KEY TERM:

Blooper Reel A series of outtakes in which actors flub their lines, crew members enjoy a funny moment, technical errors create a humorous interlude, and so forth.

Business card

Soon you'll be out promoting your film, and although you might not always have a postcard with you you'll always want a business card. Your card does not have to be fancy, expensive, or overly designed; simple, clean, and classy creates a businesslike, professional impression. Your card should have your name and your contact information, including your phone number and email address. Postal address is optional, as is your title.

NOTE

Some student and amateur filmmakers get caught up in what they should call themselves, because often they are not quite film professionals and might not be comfortable calling themselves a director, writer, or cinematographer just yet. It's perfectly acceptable to use just your name, or if you wish, give yourself the title of "filmmaker," because after all, you are one. Your email address should only include your name, and should not have any slang or unprofessional language. Industry professionals will not respond to dangerdude@gmail.com.

Later on we'll talk about Web sites and your Web presence. If you build a Web site, it's advisable to put that address on the card as well, and some people also include their Twitter handle.

It's not a good idea to overspend on your cards; there are many inexpensive options available. You might decide to change your card, to add or remove information, and you don't want to have a reserve of several thousand cards that display outdated information.

See Figure 5-6 for an example of a director's business card.

FIGURE 5-6. A sample business card for a director. Courtesy of Roy Larsen. Used with permission.

Creating your story

When you are promoting your film, in many ways you are promoting yourself and the story of making your film. In fact, your *personal story* is one of your most considerable assets, and it's one of the advantages you have over major studio filmmakers. The story of a major studio film is usually pretty boring: the studio spends an exorbitant amount of money, professionals come together and do their jobs, and the movie gets made. It's a business, and there is nothing especially exciting or different from one studio film to the next, as far as the process goes, unless the film exceeds its budget or an intriguing situation plagues a star publicly. As an independent filmmaker, your story is far more captivating. You don't have a lot of money, which means you have

more struggles and obstacles, and these are interesting to hear about. You make films stemming from a passion, not just to earn money, so the way you find ideas or arrive at topics is inherently more compelling.

Putting it all together

Once you have assembled all the elements of your press pack, you will use them in a variety of ways. Some of the materials will end up on the Web and some you will personally give to people you meet during the course of promoting your film. Be prepared to have both physical and electronic versions of just about everything in your press pack. Compile a single .pdf document of the main elements of the package. Use your one sheet as the cover page, and include the synopsis, director's statement, your bio, some production stills, and part of "your story." With all these electronic elements together in one .pdf file, you will have an electronic press pack that can be sent via email to anyone who requests it. Make a physical version of this as well. Print all the materials and put them into folders so you can hand them to people. The package doesn't have to be slick and expensive, but it should be neat, clean, and professional.

SUMMARY

In this chapter you learned what promotion is and why it's important. We looked at the difference between traditional promotional methods and modern, DIY-style methods, and hopefully you discovered that you're living in exciting times: you can promote your film on the same level as a well-financed studio, for very little expense. We reviewed all the important components of a professional-looking press pack, and you learned the importance of creating and using your personal story as a way to promote yourself and your film project. In the next chapter, we will build on this and begin actually promoting your film, both in the "real world" and on the Internet.

REVIEW QUESTIONS: CHAPTER 5

1. In your own words, describe what film promoting is and why it's important.

2. What are the main differences between traditional promotion methods and the new, DIY-style of promotion used by independent and short-film filmmakers?

3. List the necessary components of a professional press pack.

4. Why is it important to create your own personal story to promote your film?

1. Write a brief essay about the genre of your film and your audience. What are the expectations your audience will have about your film, and how does your film fulfill those expectations?

2. Write a rough draft of your personal story of making your film. Take us through the inception of the idea, the pre-production process, production, and post. What were the high points? What were your challenges? Write the paper as if you were telling this to someone face to face. Make it compelling, exciting, dramatic, and interesting. Make us really want to see your film.

Research/Lab/Fieldwork Projects

The following lab projects will help you prepare for the work you will be doing in the next chapter.

Projects for the Aspiring Feature Director, Aspiring Creative Crew Member, and Intermediate-Level Filmmaker

Take your first steps toward promoting your film by doing some or all of the following. Allow your more experienced filmmaker friends to help you prioritize and decide which of the following you should do right now:

1. Create your press pack—both electronic and physical, and share it with your mentor and experienced filmmakers and listen to their opinions.

2. Write your story and read it to your friends or filmmaking students. Get their feedback, and make adjustments. Remember, you want people to be entertained, so use all your screenwriting skills to make the story of making your film as interesting as you can.

Projects for the First-Time Filmmaker

Create a partial press pack consisting of your biography and your business card. Practice talking about your biography—even though you have not made a film, you can still have a story—the story of you getting ready to make a film!

PROMOTING IN THE "REAL WORLD" AND ON THE INTERNET

OVERVIEW AND LEARNING OBJECTIVES

In this chapter, you will:

- Begin promoting yourself in the "real world"
- Learn how to use the Internet to promote your film
- Learn about timing your promotional releases

Promoting Yourself in the "Real World"

Promoting yourself in the real world is different than promoting yourself on the Web. Both avenues are very important components to your promotional campaign. The advantages of the Internet are obvious—you can reach many more people online than you can in real life. It's in the real world, however, that the most significant moments happen: in the real world you screen your film, shake hands, make deals, and receive offers. So before learning about how to promote yourself on the Web, it will be beneficial to spend some time in the "real world." Promoting your film in the real world consists of talking to people face to face or on the phone, interacting with them person to person, usually one at a time. Armed with your press pack—your story, your postcard, your synopsis, your statement, and the lessons you will have learned from this book, you simply have to start talking to people. You can start with your friends and family, but soon you'll need to reach outside of the close network of people you know. Go through your address book and call every person listed. It's time to start getting the word out.

But what, exactly, do I say?

Part of being a good promoter is being actively social, being yourself, and being interested in others and the world around you. Two golden rules of promotion, for both the real world and the Web, are:

- Add Value
- Give More Than You Receive

What you DON'T say is "Hi Mr. So- and-So, I know it's been over a year since we talked, but I have a film screening and will you please come see it?" You can't just ask people for their time, and you can't just be a walking, talking billboard for your film.

Add Value

When it comes to talking to people and promoting yourself, adding value is about discussing things that are of value and interest to whomever you are talking to. It's the opposite of just talking about yourself and suggesting to people that they should come see your film. When you ask questions and genuinely share stories and conversation, you are adding value: you're talking *with* someone, instead of *at* them. It's understandable that you want to tell them about your adventures making your movie, and it's acceptable

to ask them if they'd like to see it, but you need to focus on making a connection, developing a relationship, and learning about what someone else is working on or what interests them.

SIDE NOTE

Adding Value is fundamental to developing a meaningful connection with your audience in today's world. With the old model, you would just put up your poster, pass out a flyer, and walk away. Audiences today are overwhelmed with opportunities for how to spend their time, and you'll need to create relationships and really connect with people if you want to be successful at encouraging them to see your film. Adding value is also a worthwhile general philosophy for building your business relationships as you navigate the complex world of filmmaking. If you can build a strong network of people you like, people you are interested in, people who like and are interested in you, you'll be happier, and you'll have a better chance at success. Filmmakers who don't take a true interest in the people around them and who simply expect the masses to flock to their films because of their own sheer genius are usually disappointed in the results of that strategy. Adding value is about going from a "me, me, me" model to a "we, we, we" model.

Give More than You Receive

In order to really connect with people and hope that they will want to connect with you, you've got to think about them more than you think about yourself. That might sound counterintuitive, because this is a chapter about promoting yourself, but it's true; you should strive to give back to your audience even more than you receive from them.

SIDE NOTE

Giving More than You Receive: Does this mean you should offer to attend every friend's art opening, band gig, poetry reading, or play? Yes, actually, it does mean that. You can't expect to be the only one to be on the receiving end of an audience; you've got to participate in the lives of your audience too. This doesn't mean that you need to clear your social calendar for the rest of your life and devote yourself to the lives of every single one of the people you invite to see your film. On some level, you need to be a participant in the social lives of those around you.

If you can't attend someone's event—a band's gig, for instance—at least you can take a genuine interest in hearing about it, or you can listen to a track on his iPod® or download it from the Web. After all, you're asking them to do the exact same thing.

> *The key here is that as you become an artist, you also must become a patron—someone who supports and contributes to art.*

Ask about people's lives and their work and their interests. Get to know them. Watch their films, attend their shows, and support others in the way you'd like them to support you. The more you reach out to your audience, engage them, and participate with them, the more readily they'll do the same for you.

The test screening

A prime example of a real-world promotion that includes the concepts of adding value and giving more than you receive is a test screening. Invite everyone you know to a screening of your film as it's getting close to being a finished piece. You are hoping that the film is effective, but you haven't screened it for a real audience yet, and there might be improvements that could still be made.

SIDE NOTE

When you invite people to a **test screening**, you're asking them to have a conversation with you, to participate in your process, and to give you their very valuable opinions. They are your friends and acquaintances and they are participating in a special event—they're not just nameless audience members at one of your formal screenings, they're invited guests, seeing something never screened before, and they might even have an opportunity to affect the finished film through their comments. It's a perfect win/win scenario for everyone; you not only start to get the word out about your film, but you do so in a consequential way. Chances are, not only will you get people excited about your film, but now these people will start to spread the word for you. After all, you just asked them to be a part of your story. Additionally, you just might get a piece of advice that will help your film.

Where to screen? *A good location for a test screening is someplace your friends and supporters will find it easy to go to. It needs to be large enough to accommodate a crowd, and it should have a screen and speakers large enough for it to be an "event." Don't hold it at someone's home or apartment unless it's the only option. Better to be at a theater, bar, coffee shop, or some other public space. If you are a student, ask your school. If your friends like to eat and drink, ask some local eating establishments if they will sponsor a screening party. You want to make the event fun for everyone.*

The elevator pitch

Sometimes you have only a few minutes to tell someone about your film, the basic plot, characters, and theme. Perhaps you step into an elevator and just as the doors are closing, in walks someone you know, someone to whom you want to show your film. After a brief, "Hello," you realize you'll have his attention for only a minute or two, so you boldly get right to the point and mention that you've got a film and you invite him to see it. (Not every opportunity in life lends itself perfectly to "add value" and "give more than you receive"!). The person is genuinely interested and asks what the film is about. The elevator is moving, and you've now got just a few moments to sketch some details. That's when you need your *Elevator Pitch.*

> **KEY TERM:**
>
> **Elevator Pitch** A synopsis of your film that you have honed down to just a few sentences, perhaps about thirty seconds long, and that you have memorized.

The elevator pitch is not something you just improvise: it's something you write, rewrite, and practice saying in the mirror until you have it completely memorized. It should be concise and enticing. The exact length of the elevator pitch varies depending on your project, but for a short film, formulate something in the twenty- to thirty-second range and adjust from there if you need to speak longer or if you should bring it to a close earlier. Don't overtalk it! Don't spoil the ending, or ramble on. On the other hand, don't cut it too short—you want to excite people and capture their interest. And above all, you must have this memorized. You cannot just extemporize: you'll sound unprepared, you'll sound confused, and your elevator friend will give you a friendly smile but will never see the film.

THE ELEVATOR PITCH: *AMERICAN SEOUL*

Producer Grace Rowe had to pitch her short film *American Seoul* on countless occasions. Here is her sixty-second elevator pitch:

"*American Seoul* is a short film about three vastly different Asian-American girls living in Los Angeles. Narrated and woven together by a fresh-off-the-boat Korean punk-rock chick, we glimpse into the world of a jaded actress dealing with the stereotypes of Asians in Hollywood, a hip-hop gangster girl who dreams of being a rapper, and a whitewashed beauty contestant who rejects her race entirely. It's funny, fast-paced, and visually striking, and ultimately it asks the viewer to consider her own ideas about race, identity, and American culture."

More "real-world" promoting

There are opportunities for you to promote your film in the real world everywhere. The more you connect with friends, colleagues, classmates, and workmates, the more you'll be able to share your story and promote your film. Every day presents new occasions for you, so you need be alert and ready for whatever favorable circumstances might come your way. When you are in "promoting" mode, be as social and active in your community as possible: go to parties, events, dinners, and gatherings of all sorts. Don't sit around at home unless you're going through your address book calling friends and trying to generate excitement for your film. Promoting in the "real world" is all about being connected with your audience so become outgoing and be sociable!

Promoting Yourself on the Internet

The Internet has become an invaluable tool for independent filmmakers. Promoting your film on the Web gives you the opportunity to share your story with thousands, if not millions, of people. Unlike a traditional advertising campaign, which can cost a studio millions of dollars, you can share your movie trailer and one sheet across the Internet for almost no expense. In this section some popular and effective ways to use the Web to promote your film are detailed, but the important thing to remember is that all the rules of real-world promotion still apply. In fact, the golden rules of "add value" and "give more than you receive" are even more important on the Web, because many of the people you reach out to will not personally know you. Because

you are reaching out to so many strangers, it's crucial that you find ways to stand out from the banner ads, pop-up ads and email spam that assault your audience every time they go online. You need to make someone's experience with you and your film a momentous one.

Promoting with Email

You might not be a heavy Internet user or perhaps are not familiar with the ins and outs of social networking sites like MySpace and Facebook, but you are probably a user of email, as most people are in this modern age. The advantage to email is that you can reach everyone in your address book—people who already know you—and they can peruse your pitch at their leisure. You'll want to do more than just send a mass email announcing a screening, however.

You must be very careful about how you use email to promote your film; if you send too many of them, pushing and prodding people to attend this screening and that, you'll be no better than a spammer and will likely lose fans, not gain them.

There are two approaches to using email; you might find one works better for you than the other.

Email Newsletter
An email newsletter is usually a page or less, and should be filled with interesting content like anecdotes, pictures, and information about an upcoming screening. Your first email newsletter might be news that you are getting ready to shoot, you're excited, and you are wondering if anyone would like to be involved. You include a picture of yourself, perhaps with your actors. This letter has value because you are initiating some discourse and two-way communication, and you're actually offering someone the opportunity to work with you. You'd be surprised how many people get excited about this.

> **KEY TERM:**
>
> **Email Newsletter** A letter you can periodically email to the people in your address book to update them on news of you, your film, and your story.

Send another email letter during or just after production, with a funny behind-the-scenes anecdote and some pictures from the shoot. Send another to announce your test screening. Each letter should be more than just a call to action for your fans—you should include information about your story that is funny, well written, insightful, dramatic, or interesting. Share your struggle, your joy, and your adventure.

The downside to this method is that you have not asked anyone for their permission to send these regular updates, and although your family might enjoy reading each one, that might not be true for everyone in your address book.

Be careful; most people will be interested in a few of email newsletters, but not everyone, and after too many emails, you begin to risk losing fans. You could consider a line at the bottom of your letter that reads "I'm not intending to overwhelm you with updates of my project, and if you'd rather I stop sending you these newsletters, please reply with "unsubscribe" in the subject line."

Email Announcing Your Web site / Blog / Podcast

Having a Web site, blog, podcast or other destination site on the Web that people can voluntarily visit is usually preferred—by both filmmakers and fans—than continual email updates. In the next section, you'll learn the details about how all these different promotional tools work, but the general idea is that instead of sending people unrequested email newsletters every week or so, you send out one (or two) "announcement" emails telling people about your project and include a link that can take them directly to your Web site, blog, or podcast. You let them know that there will be updated material every day (or week) and you invite them to click on the link and come see what it's all about. This way they can learn about you and your film at their leisure, when and if they like. It's much less invasive and very unlikely to turn anyone off. And, now that they have the link, they might return often to see if you are posting new material. All you need for this method is a Web site, blog, podcast or other such Web destination.

Your "Home" on the Web: your Web site

There are many ways to approach your film's promotional campaign using the Internet, but if you want to do it effectively, you need more than just a MySpace or Facebook page. You can and should avail yourself of every platform on the Web to publish the news of your story, but ideally, the news

all resides at one main location: your personal Web site. It's your home base on the Internet. No matter what new and exciting social networking site pops up next, or which one loses its luster, you'll always have your Web site, where your main information about you and your film will always be. If you don't want to buy a domain name and hire a Web designer to create a custom site for you, there are dozens of free services available to you, complete with free hosting, templates, and tutorials to help you build and maintain a basic Web site. Google has a service: Google Sites™, that is free, easy to use, and very intuitive, and there are others as well; explore your options and decide for yourself. Create a Web site for either yourself or your film project. A Web site for yourself will be a place for you to tell the world who you are and what you do. It should be career oriented. Your "self" Web site would be a home for your resume and demo reel, portfolio, biography, and contact information. Alternatively, you can build a site specifically for your film, which can exist purely to promote one particular project. Either type of Web site is fine, but the "self" Web site can encompass both aspects: if you build a site for yourself, you can easily have links on the main page that go to a separate page for your film. The advantage to this is that when you make another film you can add another link, and you've retained the same home base that people are familiar with. On your Web site, you'll be able to do a number of things. You can upload your one sheet, your film's synopsis, crew list, trailer; basically your entire press pack. You can update the site with screening dates and information, and later on you might even use the site to sell your film (more on that in later chapters). The point is, although you will certainly use other well-known social networking sites, you'll also want something that is permanent and professional, a single destination that you can invite people to visit. See Figure 6-1 for an example of a filmmaker's personal Web site.

Blogging

The term "blog" is the contraction of "Web log," which, as we learned in Chapter 3, really is just a Web site that is continuously updated with entries made by someone, usually surrounding a particular topic. Bloggers are similar to journalists; they report on information they find interesting. An important distinction, however, is that readers are able to post comments to each blog posting, and often the blogger will reply. This makes a blog an excellent venue to build your audience in a meaningful way: you can begin a dialog and make your project a communal one. Setting up a blog is just as easy as setting up a Web site—there are dozens of free blogging tools available on the Internet. If you create a blog, you can use it to specifically tell the story of your film and your adventures making and distributing it; or you can choose

FIGURE 6-1. Producer/Director Francisco Bello uses his Ropa Vieja Films Web site as a place to announce news, promote his projects, and build a network of fans, friends, and colleagues. Courtesy of Francisco Bello. Used with permission.

to make something else the focus of your blog. There are many different approaches, but some basic rules apply:

1. Blogging requires effort. Expect to update your site daily, or at the very least, weekly, so people will continue to return to the site, which is the whole point.

2. If you're blogging about your film project exclusively, you'll need to make sure that you are "adding value" with every post. Include pictures, get personal and honest, and maintain open communication with your audience. Ask questions, solicit feedback, and keep the experience a genuine exchange of information and ideas, in the nature of a conversation. If your posts concern only "you, you, you," the experience for your audience can get dull.

3. If you decide to blog about a different topic—for example, film in general, or your own personal views on life, or your personal film reviews—your blog works in a slightly different way. You are adding significant value: you are not just advertising your film; you are sharing thoughts, opinions, and information with your audience. A disadvantage is that your film project might get lost; how, exactly, can you interweave

your personal film project and your other topics? It's an issue bloggers have to navigate all the time. You need to be subtle and intersperse your "other" updates with your film updates so your audience won't be confused or worse, so that you will not appear disingenuous. You don't want to be regarded as someone who is pretending to blog about life in general but is really just promoting a film.

A blog that focuses on something other than your immediate film project can actually create a wider fan base and audience for you, rather than for any particular project. The most meaningful way to do this is to actually enjoy the process: you shouldn't be blogging just to make people like you. It gets back to "give more than you expect to receive."

4. Bloggers help other bloggers. If you want to be a blogger, become involved the world of blogging and read other blogs, and contribute by leaving comments. Become acquainted with other bloggers and interact with them. Often, a benefit of this is that other bloggers might mention you in their blogs. It's not a reciprocation that's automatic, however; the intent is that you are truly interested in each other and are not just cross promoting each others' blogs.

You should really like what other bloggers are doing and want to let other people know. Never be insincere on the Web: it can be very obvious, and it's a huge turn off.

See Figure 6-2 for an example of a filmmaker's blog.

Podcasting

Podcasting gets its name from the combination of iPod and broadcasting. ITunes and YouTube are the biggest Web sites offering podcasts, of which there are thousands covering every type of genre: TV shows, radio programs, video bloggers (knows as vloggers), lectures, live performances, and the list goes on. A podcast can be just about any type of media or material; the key component is that there are episodes being broadcast continually. Podcasts are free to download, free to upload, and are extremely popular with Web users, which is why podcasts are great tools for an indie filmmaker promoting his or her work.

FIGURE 6-2. Film maker Grace Rowe blogs daily about a wide range of subjects in order to stay connected with her supporters. Courtesy of Grace Rowe. Used with permission.

KEY TERM:

Podcast A series of audio or video files that are released episodically on the Web.

Think of a podcast as a video or audio version of an email newsletter or a blog. You can talk about the latest stage of your project, or video yourself talking about it, and share it with the world. You can upload pieces of your trailer, behind-the-scenes video clips, audio interviews with your cast and crewmembers; the possibilities are endless.

As always, the key to utilizing your podcast correctly will be to add value and give more than you expect to receive. Of course you'll be telling people when and where to see the film, but more than that, you'll be building a fan base of people interested in your story. To learn about how to create your podcast and host it for free on iTunes or YouTube, you'll need to do some basic Web research. It's all out there; thousands of other podcasters have paved the way. Watch some podcasts, especially those that are film related, and decide if it's something you are able and willing to do.

Creating a podcast will be a substantial amount of effort, and you should only undertake the task if it's something that sounds fun and rewarding. Nobody will subscribe to a podcast that is merely a few pieces of your trailer or a basic, "Hello, please watch my film." Your Web audience is looking for something more important than that.

Social networking sites: MySpace, Facebook, & Twitter

Social networking Web sites have brought people together and created Web-based communities in ways that are impressive and surprising. With an account on one of these Web sites, people can keep in touch with friends, reconnect with old friends, share pictures and information, and stay connected despite being geographically distant. Additionally, it's become easier to make new friends, to find new connections, and to network. Not surprisingly, these Web sites have become a valuable tool for independent filmmakers, and as you promote your short film, you'll be able to use them to share your story with a large number of people. As with the other techniques we've discussed in this chapter, however, there are some issues to consider when utilizing social networks as promotional tools.

Personal Page or Project Page

You might already have a personal page on one of the popular Web sites such as MySpace or Facebook. You can certainly use that site to promote your film. You can update friends about screenings or your progress in production or post-production. You can invite people to a test screening, share pictures from the set, or post a trailer and ask for feedback. One thing you'll want to consider, however, is whether or not you want a page specifically for your project or if you want to promote your project on the same page you use to connect and stay updated with your friends.

If you choose to use your personal page to let people know about your film, you must consider that it carries the same risk of oversaturation as is possible with an email newsletter; if you mention your film project too frequently, your friends will start to get tired of your advertising, and they'll tune you out. You will want to keep a healthy balance between your work and your personal life.

One approach is to create a social networking account for your film and keep it somewhat separate from your personal page. You can use your film page for updates that are film related, and keep your personal page free

from those updates. The benefit to maintaining two separate pages is that your online personal life does not revolve around your career. Some people feel this separation is helpful, others feel that they are so connected to their career and work that it's pointless to keep them separate. You should feel free to communicate either way; there's no harm in either approach, as long as you don't overwhelm people.

In addition to posting information and updates on your social networking sites, it's also to your advantage to drive people back to your main Web site, if you have one. MySpace, Facebook, Twitter, and other sites are temporary places to "hang out," as opposed to a personal Web site, which can be a "home." You might post some things on the social networking sites to entice people to follow the link to your Web site, where you post your first-rate material.

The great thing about social networking sites is that you are potentially connected to millions of people; it's so easy to connect and "friend" new people that you can potentially reach a world-wide audience. Keep that in mind as you post your updates and information; remember to add value and to give more than you expect to get! For example, if you are using Twitter, don't just tweet about your next screening, tweet about something strange, funny, or difficult that happened to you during the process of making or distributing your film. Interest people in what you have to say and maintain a dialog that is reciprocal. See the accompanying sidebar "IndieGoGo.com: promotion plus fundraising" and Figure 6-3 for examples of promoting using social networking.

INDIEGOGO.COM: PROMOTION PLUS FUNDRAISING SIDE NOTE

A great way to get the word out about your upcoming production AND raise a little bit of money at the same time is to promote your film using the Web site IndieGoGo.com. At IndieGoGo, you create a page for your project with all the relevant information: synopsis of your project, your bio, a director's statement, and an appeal to people for support. You can offer perks (a signed copy of the poster, even a walk-on part!), apply for fiscal sponsorship (tax-free donations) and if you reach your fundraising goal, IndieGoGo chips in an additional 5%. It's a perfect way to get your project going.

FIGURE 6-3. The IndieGoGo Web site for director Philip B. Swift's short film Sincerely, P. V. Reese. Philip earned nearly $700 in donations and also created a fan base of people interested in his project. Courtesy of Philp B. Swift and IndieGoGo.com. Used with permission.

Timing Your Promotions

Timing is everything. Especially when dealing with the release and distribution of your film. As you have learned from looking at the various distribution models, a film gets released to the public in stages: first on the festival circuit, then for broadcast, and finally for home entertainment and Internet. While there are exceptions to that particular model, one thing is very true: filmmakers consider the timing and release of their film and their promotional materials very carefully. You want to maximize the excitement and exposure of your film and time things so you attract the largest audience you can at just the right moment. In terms of promoting your film, the same rules apply: you want to plan out when you talk about your film and just how much you share with your audience. If you push too hard too early, you risk burning out your audience before the film is even completed. If you wait too long, you might not be able to create interest in the project. For example, if I sent you an email trying to get you excited about a film I made six years ago, you'd probably roll your eyes and think "um... no thanks". It's too late, the excitement and immediacy is gone. Or if I blog heavily about a film I'm considering making next year, you might think that it's just a bunch of hot air: that's too far away to get excited about.

Start early

Don't start blogging, tweeting, updating, emailing or calling when you're still in the writing phase, but once you get into pre-production, it's a great time to start getting the word out. Of course, you should be very sure that you are going to complete the film; if you get the word out and then fail to shoot, you'll not be doing your career much good. But assuming you are sure that everything is on track, starting to promote in the pre-production phase is a great idea. People will feel like they are getting involved with something exciting early on, and you'll attract a lot of attention and interest: people want to know if you'll be able to pull it off, it's exciting and dramatic. If you've already completed your shoot, you can start your campaign in the post process. And even if you're completed your film, you can take people on the journey of your distribution adventures. See figure the accompanying sidebar "IndieGogo.com: promotion plus fundraising" and Figure 6-3 for examples of promoting using social networking.

Phases of your film

Although we have not yet discussed all the phases of distribution your film will take, it's important to have a basic understanding of how to promote your film as it moves through your distribution model. In the beginning, you are promoting the idea of the film ("I'm excited to start production soon!"). During production, you're telling the story of your highs and lows, the struggles and successes of the creative process. Once the film is in the post-production phase, you're promoting the upcoming release to the public. During this stage, you might be promoting a test screening, and it's very likely that your important "premier" of the film will be at a film festival: you'll be promoting that screening. You'll continue to promote other screenings, encouraging audiences to come watch the film in the theaters. At some point, if you negotiate a broadcast distribution deal, you'll promote that and tell people when and where they can watch your film on television. Depending on your distribution plan, you will also eventually promote the release of your film to the home-entertainment market and on the Internet. At every step of the way, you'll be influencing people, investing them with interest in seeing the film, talking about the film, buying the film, and telling their friends about it. With all of these phases in mind, it's easy to see how important it is to add value and to give more than you expect to receive; it's a long process and you don't want to lose your audience.

Golden Rule of Promoting Your Film: Don't Release It!

It's crucial to note something extremely important regarding the promotion of your film: promoting does NOT mean releasing or showing the film in its entirety on the Web. When you're promoting, you are trying to create curiosity and interest so that people will see your film wherever you are showing it. You don't want to give it all away and just upload the film to YouTube. That's not promoting, that's releasing! You might very well release the film on YouTube, eventually, but not just yet. You'll want to wait and explore all of your other options first. As was mentioned in Chapter 4, the reason for this is that many film festivals, broadcasters, home-entertainment buyers, and Internet distributors will not want your film if you've already made it universally available via YouTube. Consider it: all the parties mentioned above are trying to drive audiences to your film at their venue. If a festival is promoting your film but anyone can see it on the Web, the reasoning goes that some people will rather just stay at home and watch it there. Same thing for a broadcaster: if Showtime is considering buying your film and airing it on their channel, how interested will they be if it turns out that your film can already be watched on YouTube? They won't be pleased. Many festivals stipulate in their application that your film cannot be available on the Internet, and most distributors operate in the same way. There might be a time and a place for releasing your film for free on YouTube or some other Web site, but for now, you want to hold off. You're trying to get the most out of your distribution experience, so in the beginning stages just upload trailers, pictures, interviews, and other "teaser" types of information. Invite people to experience your film at the screenings first, then suggest that they tune in to Showtime or HBO, or convince them to purchase the film at a paid Web site. Once all those options have been explored, it'll be time to do a free Internet release. Until then, restrain your impulse and promote your film one step at a time.

SUMMARY

In this chapter we looked at in-depth, specific methods you can employ to promote your film both in the "real world" and on the Internet. We looked at the importance of timing and what NOT to release to the public until just the right moment. Most important, you learned the two fundamental ideas behind good promoting: adding value to your audience while promoting, and giving more that you expect to receive. If you take only two things away from this chapter, take those two pieces of advice. Understanding those ideas will make a significant difference for you: you will avoid being perceived as overly self-interested and you will become involved with your audience in a deep, personal, consequential way.

REVIEW QUESTIONS: CHAPTER 6

1. What are the two most important concepts or philosophies of promoting yourself in the "real world" and on the Internet?

2. What is an Elevator Pitch?

3. Name as many Internet-based promotional techniques as you can

DISCUSSION / ESSAY QUESTIONS

1. Write a short essay about the differences between promoting your film in the "real world" and on the Internet. What are the advantages of each?

2. Why is the timing of your promotional campaign important? What are some important things to keep in mind when considering the timing of your campaign?

Research / Lab / Fieldwork Projects

The following lab projects will help you prepare for the work you will be doing in the next chapter.

Projects for the Aspiring Feature Director, Aspiring Creative Crew Member, and Intermediate-Level Filmmaker
Take your first steps towards promoting your film by doing some or all of the following. Allow your experienced filmmaking friends to help you prioritize and decide which of the following you should do right now:

1. Begin promoting your film in the "real world" by organizing a test screening.

2. Begin promoting your film on the Internet by creating one or more of the following:

 a. Email Newsletter or Announcement

 b. Film / Personal Web page

 c. Blog or Podcast

 d. Social Networking site page / account

Projects for the First-Time Filmmaker
Using the Internet, research one or more short films that are having a successful distribution run. Write a paper that studies one of these films in depth and analyze its promotional campaign. Identify which of the techniques discussed in this chapter the filmmakers are using and how successful those techniques seem to you. Are there other promotional techniques they are using? If so, what are they? Be as thorough and detailed as possible, and use this paper as a guideline for your own promotional plan when you are ready.

PREPARING FOR THE FESTIVAL

OVERVIEW AND LEARNING OBJECTIVES

In this chapter, you will:

- Learn about the role of film festivals in the distribution process
- Create a strategy for finding and entering film festivals
- Learn how to use Internet services like Withoutabox.com to research and enter film festivals

Film Festivals: Step Two of Your Distribution Plan

In the last two chapters, you took the first step of your distribution plan and began to promote yourself and your film. You started to think about your audience, you put together a press pack, and you began to consider the "story" of you and your film. You learned how to represent yourself and how to promote your film in the "real world," using screenings and networking techniques. You also learned about the powerful tools available on the Web and began to use those tools to promote yourself worldwide.

You have done a great deal of preparation so far, and your efforts are about to be rewarded. With the guidance of the next two chapters, you will begin the process of actually distributing your film to audiences. In this chapter, you'll learn about what film festivals are, how they work, and how you can participate in them. We'll cover the basics of finding festivals, creating a strategy for determining which ones to enter, and you'll study the process of actually entering a festival, step by step.

Let's review the importance of film festivals and how they fit into your distribution plan. Film festivals are the best places to connect with audiences and to promote yourself and your film. Every year there are thousands of film festivals around the world, and most of them program short films of all types. No matter what genre or type of film you have, it's likely that you can find a festival that will be interested in screening it. The more festivals at which you screen your film, the better: you're trying to create some buzz and some interest in your film and in yourself. Exposure is paramount—it will help get your short film sold and will give you a competitive advantage with your next film project. So you'll want to thrust yourself into the festival scene and really put forth whatever effort is required in order to get your film accepted into as many notable festivals as possible.

What, exactly, is a film festival?

A film festival can be as simple as one evening of films at a college or local theater or as elaborate as a two-week, multivenue event with hundreds of films, workshops, discussion panels and film-related happenings. Here are the answers to a few common questions about film festivals:

Who Organizes Film Festivals, and Why?
Most film festivals are nonprofit, grass roots affairs that are organized by people who are excited and enthusiastic about films. Film-festival organizers don't

necessarily work in the film industry, although many of them do. Because most festivals are held once a year, festival organizers usually have "normal" jobs, though they spend a good part of the year, in their spare time, preparing and organizing their festival. Some of the most famous festivals have full-time staff members, and can be mildly profitable, but most are simply big parties thrown by industrious film enthusiasts who find pleasure in putting a festival together.

Who Attends Film Festivals?

Film lovers, of course! Unlike cinemas and multiplex theaters that show the latest blockbusters, film festivals screen films that are usually outside of the mainstream culture; there is an avid audience for those types of films. In addition to attracting film buffs who enjoy watching unconventional films, festivals also attract people who work professionally in the film industry: actors, writers, directors, producers, and film-crew members. Not only are these people passionate about films, but it's also their business to see and learn about the latest films being made.

Who Screens Films at Film Festivals?

Most films entered and screened at film festivals are made by independent filmmakers outside the studio system. A Hollywood blockbuster rarely screens at a festival, although occasionally it can happen. Most of the time, the feature films screening at a festival will be submitted by a filmmaker hoping to do exactly what you are trying to do: win a prize, get some buzz, and hopefully get a distribution deal! Some of these filmmakers have an established track record and will show films featuring recognizable stars. Others will have made films that are outside the mainstream—or even blatantly avant-garde—and some will be first-time filmmakers hoping to launch their careers. Other filmmakers might screen films they do not intend to distribute but will still find an audience and perhaps create some buzz around themselves. Filmmakers with shorts are just as varied: every type and level of filmmaker will usually be represented at a festival.

What Happens at a Film Festival?

At a typically large film festival, you can expect to attend an opening party that all the filmmakers are invited to. Guests can usually buy tickets or perhaps will be invited by the festival organizers or the filmmakers. The opening night party is an opportunity to introduce and be introduced, to make the acquaintance of other filmmakers and festival organizers. Filmmakers will often wear their festival badges that announce who they are and what their film is, in order to quickly get to know each other. The next few days of a

festival will usually include full days and evenings of screenings at several different theaters. Festival goers will usually browse the *festival guide* to find the films they want to see. Following the screenings, there are often question and answer sessions with the filmmakers and the audiences.

——————
NOTE
——————

In addition to film screenings and Q&A sessions, most festivals will offer workshops and seminars, covering topics relevant to filmmaking: for example, a panel on fundraising or a seminar on current technology. Sometimes there are additional smaller parties and networking events on each night of the festival.

At the end of the festival, there is often an awards ceremony, if films are "in competition" (not all festivals give awards). After the awards ceremony, there is almost always a closing night party. As you can see, a film festival lives up to its name: it's truly a festive event.

KEY TERM:

Festival Guide A program of the schedule of events at a Film Festival. This will include a listing of film times and their venues as well as times and locations of workshops and seminars that cover topics of interest to filmmakers. Also included are film synopses and information about the filmmakers (this is why your bio and your film's synopsis are so important).

Film Festival Strategy: Finding and Entering the Right Festivals for You

As you plan to enter one or more film festivals, you will have a better chance of being successful (winning a prize, finding distribution, getting buzz, etc.) if you have a strategy. Without a strategy, you can still have a good time and might still find opportunities, but by doing some thinking and planning beforehand, you'll benefit even more.

The strategy you choose will be directly related to the level/type of filmmaker you are. As you recall, there are various approaches to distribution for: the Aspiring Feature Director, the Intermediate-Level Filmmaker, the Aspiring Creative Crew Member, and the First-Time Filmmaker. Let's look at the various options for finding and entering the appropriate film festivals for each of the filmmaker types.

Aspiring feature-director strategy

If you've made a film you believe in and you have done all of the work to prepare for this moment (deliverables, promotion, etc.), then you'll want to be shrewd about the next step.

Choosing your first film festival is significant: it's where your film will have its "Premiere," its first public screening. Premiering your film at the appropriate film festival can mean the difference between winning awards, doing well on the festival circuit, and getting distribution—or not.

Film Festivals look for and desire films that are "World Premieres." Screening a film that is a "World Premiere" at their festival creates increased marketing advantages and helps drive people to the theater, thus making their festival successful. It's often the case at the top festivals that a large percentage of the films screening will be "Premieres." So where should your film have its "World Premiere"? Hopefully, at one of the top film festivals. If your film premiers at Sundance, (considered one of the most prestigious festivals in the world), you will instantly establish a good deal of press and buzz. This press and buzz can help you get into a greater number of festivals and can also attract distributors. So ideally, you'll pick a top festival for your very first screening. Because the festival circuit is a worldwide affair, not every top festival is in America. See the accompanying sidebar "Top Ten Short-Film Festivals World Wide."

SIDE NOTE

TOP TEN SHORT-FILM FESTIVALS WORLD WIDE:

1. Cannes Film Festival (France)
2. Sundance Film Festival (USA)
3. Clermont-Ferrand International Short Film Festival (France)
4. Palm Springs International Festival of Short Films (USA)
5. Aspen Shortsfest (USA)
6. Los Angeles International Short Film Festival (USA)
7. Telluride Film Festival (USA)
8. South by Southwest Film Festival (USA)
9. Toronto Film Festival (Canada)
10. AFI Fest (USA)

Having your film accepted to one of the top film festivals will instantly give you and your film credibility and will be tremendously helpful as you enter more festivals and seek distribution. Of course, the competition is intense, so most filmmakers don't expect to be accepted, they simply do all that is necessary to be approved, then they anxiously wait and hope. Because festivals take place at different times of the year, you are likely to find one or two that are accepting submissions just as you are ready to apply. If you don't get accepted into one of the top ten festivals, your strategy will be to apply to the next level of film festivals—celebrated festivals with established reputations.

Because you are trying to get the most attention possible, your strategy will be to seek out and apply to the most prestigious festivals you can find. Once you exhaust those avenues, you can revise your plan and apply to the smaller, less prominent festivals.

Intermediate-level filmmaker strategy

For an intermediate level filmmaker who is still learning the ropes, it does not make a great deal of sense for you to spend money and time applying to enter the top film festivals; the competition will be formidable. Rather, you should do some targeted research to find the festivals that are suitable for you and your film. Many film festivals specialize in showing films in programs that are organized around a theme, genre, issue, or the social background of the actors and director. For example: a horror-film festival, an African-American film festival, or a comedy-themed festival. If you can find a festival that specializes in your type of film, your chances of being accepted are improved. In the next section, you'll learn how to use a very powerful Internet-based film-festival application service, Withoutabox.com, which will help you research festivals that are the right fit for you. Rather than targeting the most prestigious festivals, your goal will be to find any festival, prominent or small, that will accept your film.

Aspiring creative crew-member strategy

As a cinematographer, editor, or other creative crew member, you'll be in a support position as your director does the work of submitting your film to festivals. You can and should help the process by learning about the festivals and by doing your own research. You should find a festival that gives prizes in your area of specialty: editing, cinematography, or whatever your field. Encourage your director to apply to these so that you will have a possibility of getting an award for your work.

It's beneficial to be as knowledgeable about the various film festivals as your director is—consider that, for you, a film festival can be compared to a job market: there will be any number of directors and producers attending, and others who might see your work and want to hire you or suggest to someone else that they hire you. You'll want to be as involved in the film-festival process as you possibly can be.

First-time filmmaker strategy

If you've just made your first film, it's unlikely that it's ready for the festival circuit. You probably have some more refining to do on the content and craft of your work before it's ready for a wide audience You could certainly submit your film locally—to your school or neighborhood's film festival, however, if you feel it's ready to be seen. Screening at a local festival will offer several opportunities to learn and to achieve a modest amount of noto-riety; you will be able to see an audience reaction to your work, and you'll get some experience talking about yourself and your film. You might even win a school award.

Film-school and other local audiences are usually very supportive, so it can be a safer, more comfortable way to ease into the process of distributing your film.

If you don't have a completed film yet, you'll want to participate in as many festivals as you can, as an audience member. You can research film festivals and attend those near you. Watching as many short films as you can—paying close attention to the audiences—will help you develop your film vocabulary and will be immensely helpful as you make your first few short films.

Using the Internet to Research and Apply to Film Festivals

Before the Internet, applying to film festivals was a slow and tedious process. To find information about a festival, you researched film magazines or bought books that listed them. The application process was time consuming—each festival required its own forms, press kit, and screener to be sent. Tracking your entries meant creating a list of which festivals you had applied to and when, and waiting for a response from a festival was a matter of watching the

mailbox. Now, the process of finding and applying to festivals is much more streamlined, thanks to the Internet. A simple Google search will put lists and contact information at your fingertips in seconds.

Using withoutabox.com

Although it's possible to join Withoutabox.com and learn how to use the service on your own, the site is so robust and feature filled that the learning curve, while not difficult, might be daunting to someone with no film-festival experience at all. This section outlines some of the important first steps you'll take as you sign up and begin researching and applying to festivals.

Keep this book close at hand—you might consider referring to this chapter as you use the Withoutabox.com Web site for the first time.

Take note that the categories listed below do not necessarily become available to you in the order I'm presenting them (although most do)—you'll have to follow the prompts, do a little looking and clicking around, and investigate the site for yourself. Once you spend some time at the site, you'll come to be familiar with it—the interface is clean and intelligently designed. There are also FAQ pages and Forums where questions can be answered if you get confused. The following Figures, 7-1 through 7-11, illustrate various parts of the Withoutabox.com Web site. Use them to help you navigate the site as you go through the process of signing up and filling out the various forms for your film project.

Register

This part is as simple as any other Web site where you might register, you are just providing contact information and selecting a username and password.

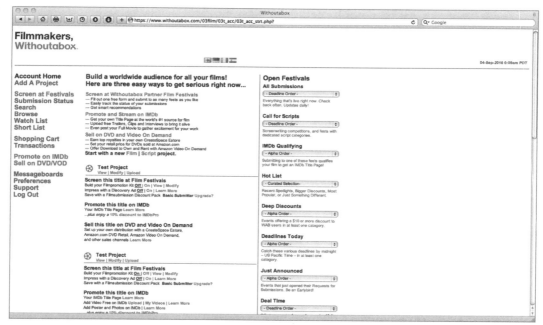

FIGURE 7-1. Withoutabox.com allows filmmakers to search, enter and track submissions to film festivals. Courtesy of Withoutabox. Used with permission.

Create a Project

A project is your film, and when you create this project, you'll essentially be filling out a long, complex form where you can enter dozens of pieces of information about your film. You'll be asked to describe nearly everything

about your film: dates, formats, synopsis, names of actors, crew members and so forth.

Keep in mind that this Web site is used by feature filmmakers—even well-known filmmakers—and they might have a LOT more information to offer about their films than you do for yours, so don't be overwhelmed by the quantity of information the form requests.

You can fill out only the parts that are relevant to your film, and if you don't know the information they are asking for, you can either ignore it or come back to it later. The most important information they will ask you, you'll know: film title, length, format, and facts such as those. Of course the more detailed you can be, and the more information you can supply, the better. If something doesn't apply, however, simply ignore it for now. Here are the main categories of information you'll complete as you create a project.

NOTE

There are over forty fields of information to fill out during the project building process. Rather than go into detail on every one, below are those that are the most important for you to thoroughly understand.

Synopses

Here you will be able to enter synopses of various lengths.

Genres

When you fill out your genres, click on anything that applies. Many festivals are "specialized" fests that screen films of one particular genre or another. The genres area is one of the ways Withoutabox.com will match you with appropriate festivals.

People

This is where you should add the names of the actors and key crew members of your film. Festivals will use this on their programs and printed materials if you are accepted, so don't leave anyone out! You might have a very small cast and crew list, but remember that because you are usually not paying any of the people who helped you, you need to list them in the credits of your film.

Screenings

If you have no screenings (as is normal when you start this process) your film will be listed as a "World Premiere." This is desirable to film festivals. On the other hand, festivals also like to see that your film has been accepted into other fests—it lends you credibility—so either way, you're fine.

FIGURE 7-2. Enter your synopsis in the field. A "logline" is a one-sentence synopsis. Notice the long list of items on the right. These will appear one by one as you go through the process of filling out your project form. The red circles indicate areas that were skipped. You can go back into the project at any time to edit/change areas. Courtesy of Withoutabox. Used with permission.

FIGURE 7-3. Select any and all genres that apply to your film to help Withoutabox.com match you with "specialized" film festivals. Courtesy of Withoutabox. Used with permission.

FIGURE 7-4. Giving credit to everyone on your cast and crew is essential, don't leave anyone out! Courtesy of Withoutabox. Used with permission.

FIGURE 7-5. If you have not yet screened your film, it is considered a World Premier. Courtesy of Withoutabox. Used with permission.

Formats

Festivals want to know what format you shot on and what format you have available to screen on. As discussed in Chapter Four: "Deliverables," every festival will have a different system for screening your film. The more screening formats you have available, the better, but don't worry about this too much. If you don't have the right format for the festival, you can always apply anyway and wait to see if you get in. Then, if you are accepted and decide that you really want to screen your film at that particular festival, you can take the next step and make a format that the festival requests.

FIGURE 7-6. There are several "Format" fields: shooting, exhibition, aspect ratio, and more. You might shoot on one format but screen on another, depending on the festival. Courtesy of Withoutabox. Used with permission.

Publicity

There are several publicity fields. Add your Web site link, indicate whether or not you have a trailer, and indicate that you will use the free "Withoutabox Online Film promotion Kit." In the unlikely (but lucky) event that you have a publicity agent, enter his or her name in that field.

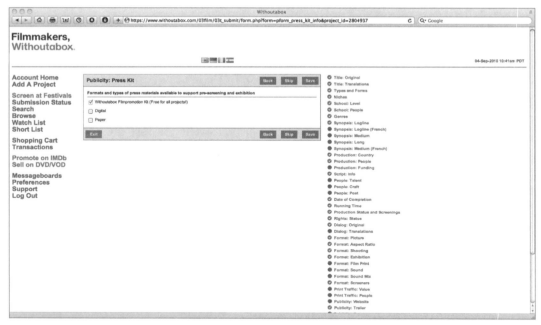

FIGURE 7-7. The free "Online Film promotion" kit is one of the many features that makes Withoutabox.com a valuable tool for filmmakers. Courtesy of Withoutabox. Used with permission.

Finishing the Project Form

When you have finished filling out the forty or so fields in the project area, the Withoutabox.com Web site presents you with a "short list" of film festivals it thinks might be right for you, depending on such variables as genre, length, whether or not it's a student film, and more. Feel free to investigate this list, but you actually have some more work to do before you are ready to start searching for and submitting to film festivals: you need to put together your online press kit.

Building Your Online Press Kit

Once you enter all the basic information for your film project, you'll be able to create an online press kit that will be available to any festival that receives your application (Withoutabox.com calls it an "online film promotion kit"). To get started, make sure you are at your "Account Home" page, and look for your project. Underneath the title of your film, look for "Build Your Film promotion Kit" and click on the "Modify" button. You will be presented with a page that allows you to upload various press elements that festivals use to promote your film.

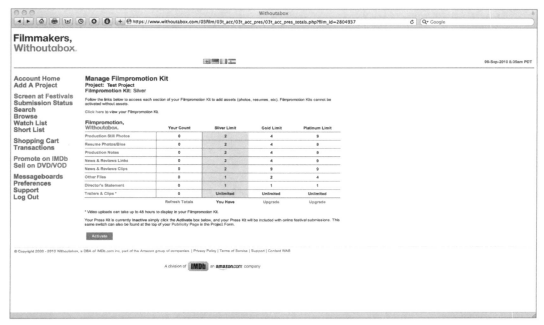

FIGURE 7-8. From this page, you can upload and manage all of your online press kit materials. Courtesy of Withoutabox. Used with permission.

Production Still Photos

The "on set" pictures you took of your actors "playing the scene" and of you and your crew hard at work.

Resume Photos/Bio

Upload your biography and a photo of yourself. You can also do this for the other members of your film: cast and crew.

Production Notes

Upload an anecdote or story from the making of your film—use the material you wrote in Chapter 5, "Promoting Your Film and Yourself."

News and Reviews Links

You probably don't have any reviews or news stories yet. If and when you do get some press, if there is a link to that story, return to your account on this site and add it to this area. This way, as your film gets seen and attracts press attention, you can share your notoriety with festivals.

News and Reviews Clips

If you have any scanned pictures or articles from the press, you will upload them in this area. As with the links area, update this section as you acquire them.

Other Files

Remember the electronic press kit you created in Chapter 5, "Promoting Your Film and Yourself"? This is where you can upload that .pdf file as a complete press package, which a festival can download with just one convenient click.

Director's Statement

Upload your director's statement here. Remember, your director's statement reveals why you wanted to make the film and what you are trying to communicate to your audience.

Trailers and Clips

Here you can upload the trailer for your film, behind-the-scene clips, or other bonus material such as a blooper reel, or formal interviews. Any and all of this type of video material is helpful to get festivals excited about your project. In order to upload your trailers or clips, you need to create a free IMDB (*Internet Movie Data Base*) account—see the next section on "Secure Online Screeners," because you will likely do both of these steps at the same time.

TECHIE'S TIP

You can upload your entire film so that instead of sending off a DVD to every festival you want to enter, you can simply upload once and each festival will be able to watch your film online. The amount of time and money you'll save not burning and sending DVDs is enormous.

Secure Online Screeners

In order to upload your Secure Online Screener, you must first register as a member at IMDB.com. After you register and link your Withoutabox.com project to your IMDB account, you can upload your film directly to IMDB. com, where it will be available for film festivals to view when considering your submission. Your entire film will NOT be made public—only festivals you apply to will be able to screen the film. Your trailers and clips WILL be made public, and will be available to watch on your IMDB page; you can use your IMDB page as part of your promotion process. For more information about IMDB, see the accompanying sidebar "Creating an IMDB Account."

CREATING AN IMDB ACCOUNT

During the process of building your project and online-press kit, Withoutabox.com will allow you (encourage you, actually) to build a page on IMDB.com (Internet Movie Data Base Web site) for your film and yourself. This is a great idea. IMDB.com is a huge resource for film buffs and filmmakers; it has an abundant collection of information about films. Having a presence on IMDB gives you some legitimacy and will help you as you promote your film. It's free, so there is no downside; just sign up!

Activating your Online Film promotion Kit

Once you have uploaded all of your electronic press materials, you can return to your account home page and turn it on. Look for the "On" button underneath your film's title. This will allow festivals access to your press kit as well as your secure online screener.

Researching Festivals

Once you have created your project and uploaded your materials for your online film promotion kit, you are ready to start searching festivals. The Withoutabox.com database of festivals is very extensive, and every festival has been indexed with keywords so that you can find festivals that are most appropriate for your particular film. On the homepage, once you are logged in, there is a list of twenty categories of film festivals you can quickly browse through, with headings such as Hot List, Deadlines Today, Just Announced, Deal Time, Diversity and Nice, and so forth. Use these pulldown lists to quickly find hundreds of festivals to apply to.

On the left side of the page are additional ways to find festivals. If you click on "Search" you can look for a particular festival if you know its name. Or you can "Browse" which will provide you another way to access all the festivals. Clicking on "Short List," will bring up a list (usually very long) of festivals that match your criteria: fests that offer short programs, fests that match your genre and niche, and so on. This is an ideal place to start. Under each film-festival listing, you'll see the keywords it's been tagged with, so you can quickly evaluate and see if it's worth looking into further. Clicking on any of the festival names will bring you to their page on Withoutabox.com, where you can learn everything there is to know about that festival, and submit to it, if you wish. The "Watch List" function is like a shopping cart or a wish list—you can add festivals to it and decide later if you want to submit to them or not.

FIGURE 7-9. The Withoutabox project home page lists many ways to search for festivals. Courtesy of Withoutabox. Used with permission.

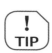

If you want to search for festivals that are nearby, so you can attend them easily, should you be accepted, enter the name of your city or geographical region in the search box. Any festivals with those words in their title will be displayed.

Submitting to Festivals

When you are ready to submit to a festival, Withoutabox.com will try to help you determine whether or not you fully qualify for the festival. Once the qualifying process is through (a few seconds), you'll see a list of potential categories you can submit to at the festival (feature, short, documentary, etc.). If you qualify for a particular category (for instance: short film or student film) you'll see a list of qualifications the festival has and a series of check marks indicating you qualify. The only problem with this process is that Withoutabox.com is a database, and sometimes when the data doesn't line up, the site will tell you that you don't qualify because it encounters

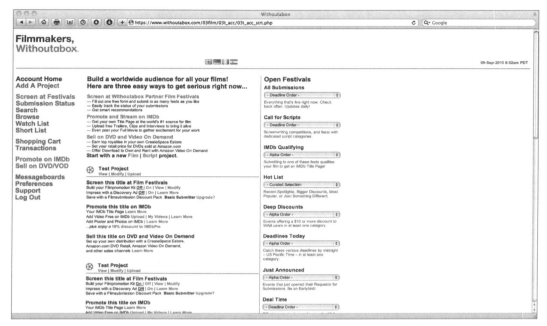

FIGURE 7-10. Here you can search, browse, check festivals you have placed on your watch list, and use the short list to see which festivals Withoutabox.com thinks are right for you. Courtesy of Withoutabox. Used with permission.

some mismatch between your project and the festival. Use your logic—if the qualify list generally looks good but there is a "fail" mark next to one of the pieces of information, just think about what it's asking for. For example, if your film is silent, with no dialog, you might see a "fail" next to "Dialog: Original." The qualify form thinks you don't have original dialog because you have NO dialog. This is just a database mismatch, and your film is completely and perfectly qualified for this festival. As the Web site clearly says, "Consider these warnings and you may absolutely decide to ignore them and apply anyway." It should be clear if you are failing something important, such as in a category for Animation. If you don't have an animated film, you'll see a warning in the animation category saying "you have: live action, they want: animation." Just scroll the page up or down until you find the live action category: this is the category at the festival that you should be submitting to.

The final step for submitting your film to a festival is to pay the submission fee and to submit your film for consideration. You can either pay online or send the festival a check, and you can either send the festival a DVD

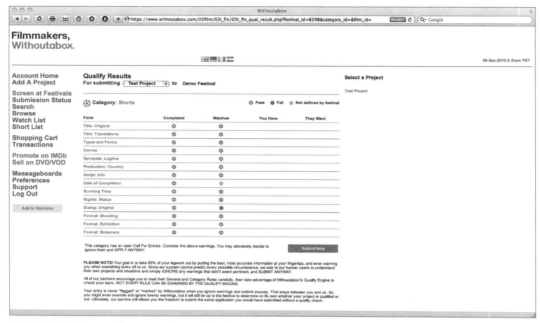

FIGURE 7-11. The qualify process takes much of the legwork out of the application process. Courtesy of Withoutabox. Used with permission.

screener or use the Secure Online Screening system, if the festival supports it and if you have a film uploaded to IMDB. For more information about submission fees, see the accompanying sidebar "A Word about Submission Fees."

A WORD ABOUT SUBMISSION FEES

As you will soon discover, festivals charge varying amounts for submissions. These fees are one of the primary income resources for a festival, and they are not refundable. Some festivals charge more, some charge less, and some might be free. The good news is that your submission fee helps the festival organizers put on the festival, so it's going toward a good cause. The bad news, for you, is that these fees can really start to add up if you are submitting to several festivals! You'll want to do your research, make a list of festivals you'd like to submit to, and then evaluate the costs. Don't just start submitting and paying submission fees before taking a look at what is out there.

Submission Status

Once you begin submitting your film, you will be waiting anxiously for news from the festival. The Submission Status button on the left side of the home page will take you to a status page where all of your submissions will be listed. For any submission, you'll see information about the festival and a color code will tell you where your film is in the process. If you get accepted, bravo!

If your film is not accepted, keep the faith. Fear not. Festivals are only one part of the distribution process. You might still find your audience on the biggest, most diverse distribution platform ever created: the Internet. Keep reading, keep your spirits up, and when we cover Internet distribution, you'll have the opportunity to get your film out to millions of people.

An easy, efficient way to keep up with news about upcoming festival deadlines is to sign up for Withoutabox.com's email newsletter, which will send you automatic updates on festival deadlines, new festivals, contests, and more.

In the following interview, filmmaker Philip B. Swift talks about his experiences navigating the world of film festivals for the first time.

SUBMITTING TO FILM FESTIVALS
Philip B. Swift
Filmmaker

Philip B. Swift is an emerging director who recently graduated from the Art Institute of New York City's Video Production program. He is currently the Digital Filmmaking Artist-in-Residence with Young Audiences New York. YANY is a nonprofit arts organization whose mission is to integrate arts into public school classrooms throughout New York City. Philip's film, *Sincerely, P.V. Reese*, is an introspective look into the lives of him and his friends, who were raised in the shadow of the dying rubber industry in Akron, Ohio. The film recounts the making of one of Philip's first films, an hour-long epic, shot on a VHS camcorder during his senior year of high school. At its heart, *Sincerely, P. V. Reese* is a documentary about loss, immortality, and friendship.

JM: *As you were starting to submit to festivals, did you have any sort of goal or plan in mind, or did you just kind of 'wing it'?*

PS: I had talked to several people about the best option for getting my film out there and the Web site, "Withoutabox.com" seemed to be the way to go. It's a great site to see what's out there and where your film will fit best, especially when combining it with some Internet research and message board digging looking for people's experiences at the specific festivals. However, this was after a long process of thinking I was done with the film, showing it to a small group, making changes based on their reaction, showing it again, making changes, etc. I went through 15 edits of the film before settling on the 35 minute version I submitted to several festivals, and then cut another 6 versions before ending up with a 19 minute version. This was after someone said to me that 35 minutes was too long to be a short and too short to be a long. The best advice from that point of view is look at the time limit the festival suggests and cut it in half, especially for short-film fests. If they have a 40-minute maximum, aim for a 20 minute cut or shorter. The programmers of the festivals are trying to get as many films into each block as possible, so the shorter the better. This may be hard to do, but it will probably result in a better piece in the end.

JM: *What was your approach to getting talent and music releases?*

PS: I was lucky enough to not have to worry too much about releases of any kind. Every person interviewed in the film is a friend of mine who had no problem signing a release. A friend of mine did all the music, and he was happy to donate his work to the film.

However, I have been working with a mentor of mine that has run into hurdles with releases because she wasn't prepared at the time of filming and it has been a hassle for her to go back and get them from people, now that she is in post-production. So I would emphasis the necessity of having the releases on hand the day of the shoot, just some boilerplate form that can be filled out there and buy you that peace of mind for later.

JM: *Are you aware that uploading the entire film to the Internet can hurt your chances of being accepted to some festivals? Did you put any of the material up, a trailer perhaps?*

PS: I was told early on not to put the entire film on the Internet based on the old idea of why pay for the cow when you can get the milk for free, but I did post short clips from the film on my indiegogo.com site in order to garner interest and support for the film. This was beneficial to the completion of the film because I had a small but steady stream of donations coming through indiegogo.com while I was in post-production. It wasn't that much, but enough to buy extra hard drives to back up the footage and a little to help with the festival submission fees.

JM: *You said you had a snafu with the DVDs - please tell that story, and end with any advice you'd give.*

PS: When the film was ready to be submitted to festivals, I went out and had professional DVD's made. I checked one of the disks before packing everything up and it played the film fine, the DVD menu worked, all seemed copacetic and ready to go.

I sent out three copies to festivals that I had hand picked based on the criteria, location, and even some vague connections I had. I also sent a bunch of DVDs out to friends and family, specifically those who were in the film or who helped to make it happen. A few weeks went by and I started to get these phone calls and emails from friends saying, "The film looked great, but it stopped playing after five minutes," and that seemed to be happening with almost every copy I had sent out. A few months after that, I got the first of three rejection notices from the festivals and due to their basic "yes/no" announcement system, I will never know if the film just wasn't good enough or if it was just those DVD's that wouldn't play. Lesson learned? CHECK EVERY DVD YOU SEND OUT.

JM: *What types of self-promotion have you done?*

PS: First of all, I can't emphasize enough the great asset that indiegogo.com has been. It's just a great site to promote your work within a community of like-minded filmmakers and its ability to connect with your Facebook account allows such easy, effortless fundraising that really helped me out and gave me the motivation to keep

working. The other thing I did after getting the rejection notices from several other festivals, was to skip that whole process and just create my own event to showcase the film. I believed that the film was good enough to play to a large audience and I needed to prove that to myself by showing it somewhere. The documentary is about this group of people from Akron, Ohio, my hometown. I was planning on spending the Christmas holiday there, so I made some calls and sent some emails and put together a screening of *Sincerely, P. V. Reese* at a bar in downtown Akron. That in itself would have been a success, but a week before the event I contacted the local newspaper and they did a great article promoting the event which resulted in over 150 people showing up to this bar on a Tuesday night. The film may have not been accepted by some film festivals, but it was accepted by the city of Akron.

JM: *Do you have any type of plan for seeking broadcast, nonbroadcast, or Internet distribution?*

PS: Currently, a shorter version of the piece is in consideration for the Vimeo Awards at vimeo.com. I have also been screening the film for high-school students, who have been highly receptive to it due to it's content and message. After showing it to several classes the response was so positive that I think that may be the audience the film was made for, and that's all right with me.

JM: *If you have learned anything from the process of trying to distribute this film, what is that and how will it affect your next project?*

PS: The obvious lesson learned throughout this whole process, my first time dealing with festival submissions, is to not let it get you down. Keep working, keep fighting for your film, keep showing it to anyone you can, and eventually you'll find someone it really connects with. Maybe it won't be at Sundance or Cannes or Spokane, maybe it will be in a high-school classroom that it finally finds an audience, but when it does it feels so good.

Note: A few weeks after this interview, the Akron Film Festival saw Philip's trailer on Vimeo. com. They liked it and asked Philip if they could include his film in the 2010 Akron Film Festival. Congratulations Philip!

SUMMARY

In this chapter you learned what film festivals are all about, how they work, and how you can participate in them. We covered the basics of finding festivals, creating a strategy for which ones to enter, and how to use Withoutabox.com to research and submit to festivals. Armed with this new knowledge, you should be ready to start taking steps toward actually distributing your film to audiences. The next chapter will explain what to do when you are accepted. Attending a film festival is a critical part of the distribution process: it's where the distributors are, and it's often where distribution deals are done. Follow the guidelines in the "Research / Lab / Fieldwork Projects" section below and start submitting your film today.

REVIEW QUESTIONS: CHAPTER 7

1. Why are film festivals a significant part of your distribution plan?

2. What does it mean to have a "World Premiere"? Why is choosing the right festival for your "Premiere" important?

3. Name as many of the top film festivals as you can.

1. In your own words, describe what a film festival is, who organizes film festivals, who attends, and who screens at a film festival.

2. What is Withoutabox.com and why is it such an important tool for filmmakers? What kinds of things can a filmmaker use Withoutabox.com for?

APPLYING WHAT YOU HAVE LEARNED

Research/Lab/Fieldwork Projects

The following lab projects will help you prepare for the work you will be doing in the next chapter.

Projects for the Aspiring Feature Director and Intermediate-Level Filmmaker

1. Using the appropriate strategy, sign up for Withoutabox. com, create a project, upload your film and online press kit, research film festivals and submit to your first festival. Present your experience to your filmmaking mentor or your class and share with them what you learned, what you found uncomplicated or challenging, and once you receive a response from the festival, share your results.

Projects for the First-Time Filmmaker

1. Sign up for Withoutabox.com, even if you don't have a film or if the film isn't ready to be submitted to festivals. Use the Web site to find some festivals in your area and make a list of their names and share it with your friends or your mentor. If possible, attend at least one!

AT THE FESTIVAL

OVERVIEW AND LEARNING OBJECTIVES

In this chapter, you will:

- Learn how to prepare for the "Big Night": your film's festival screening
- Use your promotion skills to drive audiences to your screening
- Learn how to set goals to maximize your opportunities at the festival

Congratulations, Your Film Has Been Accepted!

Receiving the news that your film has been accepted into a festival can be a highpoint in your life. In some ways, it is a validation of all of your hard work and efforts; someone thinks your film deserves to play to a real audience! If you are lucky enough to receive this news, then you have successfully completed Step Two of your distribution plan: getting your film into a festival. Attending a festival with your film should be fun, exciting, and creatively rewarding. Although you will likely be nervous, you should also feel very proud of yourself: screening your film at a festival is one of the major reasons for making a short film, and you did it. In this chapter, you'll learn some methods for maximizing your film-festival experience so that you can take steps toward the next level of distribution: the actual sale of your film.

Preparing for the "Big Night"

Before discussing the actual festival, let's organize a plan for what you should do once you are accepted; you'll get the good news a few weeks before the festival begins, and you should use that time to prepare.

Communicating with the festival

The first thing you should do is to establish an open line of communication with the festival coordinators or their staff. The person or people running the festival are very important allies for you, leading up to your screening. Because they are "running the show," they will have all of the pertinent information and knowledge of contacts that can be helpful to you. Make it a point to create a businesslike impression on them. Instead of simply replying to their email with a "Thanks," commence a dialog with them and discuss the following things:

Format
Double check the screening format requirements and discuss with the festival coordinators any information relating to your technical needs.

If they want you to send a film print, and it's your only one, you should arrange when and how they will return it to you. You should also try to schedule a meeting with the projectionist for the day of the screening, in order to do a test. Testing for audio and picture is the best way to ensure that your audience experiences your movie exactly as you want them to.

Volunteer Yourself

Convey to the festival staff that you will make yourself available to them if they are looking for people to sit on Question and Answer panels or to participate in discussion groups or workshops. Emphasize that you are at their disposal and want to support them in any way you can. It's a win-win situation: you are looking for as much exposure and publicity as possible, and they will likely be trying to find volunteers for just such situations.

Contact the staff members who are responsible for organizing the workshops and Q & As as early as possible—before other filmmakers have usurped those coveted chairs on the panels. Volunteering will also help you develop a closer, more personal relationship with the festival folks. If a news reporter or blogger should contact the festival looking for directors to interview, guess whom they'll call? That's right: you.

Ask Questions

Once you have established a line of communication, ask some key questions, organized into as few emails as possible. Learn what kind of events they have planned (parties, workshops, discussions). Ask if they are aware of any distributors or film buyers who might be planning to attend. If you are traveling from out of town, inquire about lodging and transportation. Most important, suggest to the festival staffers with whom you are communicating that you'd

like to meet them to say hi and to thank them in person, and ask where you will be able to find them (at the opening night party, perhaps?).

Promoting Your Screening

A few weeks out from your festival screening, you should begin promoting the event in the "real world" and online.

NOTE

Your goal will be to fill as many seats at the screening as you can. If the festival is in another city, find some friends and invite them to travel with you; make it a fun road trip. The extra laughing, clapping, and crowd enthusiasm that your "cheering section" can generate will be infectious and will add to the enjoyment of your film for the rest of the audience. If there are any distributors or buyers in the audience, this type of support can influence their opinion in your favor, so it's important to pack the house.

The methods you should use to promote your screening are the same as those shared in Chapter 6 (Promoting in the "Real-World" and on The Internet). In the real world, pick up the phone and start talking to everyone you know. On the Internet, use your email newsletter, podcast, blog, social networking site, or film Web site to update people on this part of your "story": you're in a festival! Use the power of the Web to reach beyond your immediate circle of friends: ask them to help get the word out to friends they might have in your destination city; you just might find that you'll have a new group of fans to meet at your screening.

Remember: Add value and give more than you receive

When talking to people about your film and the festival you're going to be in, remember the important elements of self-promotion we discussed in Chapter 6 (Promoting Your Film in the Real World and on the Internet): Add Value and Give More than You Receive. These ideas are keys to encouraging people to really follow through and attend your screening. Instead of asking people to support you by coming to your screening, try another approach: share the news of the festival and your screening, but add value by describing the festival and sharing provocative information about the other films, the workshops, the events, and so forth. Excite people with the idea of going to a film festival as an event, not just to support your own film. Many people have never been to a festival, and you'll get a stronger response from

them if you point out that they can have an entertaining weekend or evening. Mention the "big film" of the festival (a feature world-premiere, perhaps) or describe some of the films from previous years. Of course, you'd be thrilled for them to see your film, but concentrate on how enjoyable and exciting the entire experience is going to be for them.

> *Tell your friends online and in the real world that, in addition to coming out to see your film, you can all use the opportunity to catch up and spend time together. Use the screening as a way to bring together a group of people for a fun evening that might begin with dinner and end with a night out on the town. Let people understand that you are looking for an exchange of friendship, not a pack of groupies. By arranging an evening as something other than a "festival of you," you'll get a broader response from people. This is an example of "Give More than You Receive." You need to devote as much attention to your friends as you expect them to contribute to you. How can you make this experience fun and rewarding for your friends? Think in these terms and you'll get a far greater turnout than if you simply ask people to come to celebrate your "awesomeness."*

Flyers/Postcards/Swag

A few weeks before your screening is the time to make sure you've got some promotional supplies ready: your flyers, postcards, or other "*swag.*" As discussed in Chapter 5 (Promoting Your Film and Yourself), your postcards or flyers will feature your cover artwork (also known as your "one sheet") on one side and your screening location, date, and time on the other. If you need to get these created and printed, now is the time. You can mail the postcards in advance of the screening but you should also have a box of them to take with you to the festival so you can hand them out to the people you meet. Some enterprising filmmakers even create giveaway items like T-shirts, magnets, pens, key chains, or other inexpensive gifts that have their film title printed on them. If you are planning on using these types of promotional materials, give yourself plenty of time to create everything so you can avoid additional stress at the last minute.

Once at the festival, you will post your flyers, hand out your postcards, and give away your swag at every opportunity. You'll quickly see that it's quite a circus; five minutes after you post your flyer, you're bound to find someone else's poster posted directly on top of it. As you stand outside of screenings or events to distribute your flyers or swag, you won't be alone. Dozens of other filmmakers will be right there with you, some more daring and aggressive than others. Don't be surprised to see off-beat and unique marketing approaches by filmmakers desperate for attention: people in costumes and wild outfits. Although some filmmakers believe that any attention is good attention, it's best to leave the theatrics to others. More often than not, it conveys a message of desperation. If the movie is any good, why do you need all the fuss? See Figure 8-1 for an example of a film poster.

Refining your "story"

Hopefully, you have been sharing the "story" of your filmmaking experience with people as you have been promoting. As you recall, your story is a way to promote your film by sharing the humorous, exciting, challenging, and sometimes frustrating times you have had since embarking on the journey to create your movie. As your festival date draws near, it's important to make sure you can tell this story entertainingly. You will be meeting and talking to any number of people and, as part of your networking technique, you should have some comical "war stories" with which you are prepared to amuse your new acquaintances. That way, when someone asks about your film, you will have more to say than your two-sentence synopsis (which, by the way, you should also practice). There will be times when you will find yourself standing in a small group of filmmakers or other festival attendees, and you will need some relevant material to share if you are going to promote yourself. It will be beneficial to practice telling these anecdotes to your friends and family before the festival; being able to smoothly and self-assuredly relate your story will boost your confidence.

FIGURE 8-1. At the festival, your movie poster is one way to advertise your screening. Courtesy of Roy Larsen. Used with permission.

One important aspect of your story that you should be prepared to discuss is the artistic intent of your film. After all, a festival is a congregation of movie buffs, and many will consider it significant to really understand your theme, why you chose this story to tell, your cinematic influences, and where your film rests in the pantheon of other movies. You'll want to spend some time in introspection about the personal reasons you had for making this particular film, because people will ask you. Consider in advance that you will be surrounded by filmmakers and cinephiles who, collectively, have seen numerous films, read a fair share of books, and generally talk about film at a much more knowledgeable level than most people. It won't hurt to brush up on your film history, re-watch some of your favorite films, and practice conversing about the artistic elements of your film. In addition to sharing stories about the making of your film, you'll definitely want to be able to express your reasons for making the film, your expectations of the audience response, and your creative influences.

Interviews and press opportunities

Film festivals regularly work with local newspapers, bloggers, and even national and international publications as part of their own promotion process. If you have volunteered yourself to the festival organizers, there is a chance you will be contacted by someone from the press and be asked to do an interview. There is no paper or Web site too small; any occasion to discuss your film and yourself is an opportunity to increase your notoriety. Some interviews will be conducted over the phone, some will be in person, some might arrive in the form of a series of written questions sent to you in an email. Here is where you will use much of the material you collected as you prepared your press pack. Offer to give them whatever elements of the pack they would like: production stills, one sheet, and so forth. Have your electronic press pack ready to email, and also have a physical version ready to provide when you meet them. Point them in the direction of your Web site, blog, or other Web-based promotional areas. Because a consequential part of your press experience will be in the form of an interview, you should be prepared: memorize your story because now is the time to present it with flair.

Combine elements of your bio, your director's statement, and the story of you and your film to weave a compelling, entertaining narrative. Don't be glib, don't be a smart aleck, and don't try to sound overly witty or coy. Now is not the time to be an anti-establishment "artiste" who shuns the mainstream press: that technique will never work for an up-and-coming artist (in fact, it rarely works for established artists). Be punctual for the interview, be courteous to the reporter, and simply be natural.

At the conclusion of the interview, thank the reporter and ask him to send you a copy of the interview for your records (you will upload this as part of your ongoing promotional campaign). See Figure 8-2 for a photo of a film-maker doing a press interview.

FIGURE 8-2. A filmmaker is interviewed at the Sunscreen Film Festival. Courtesy of Brad Kugler. Used with permission.

Setting a Goal for the Festival

Attending your film festival is, on some level, your job. It's supposed to be enjoyable, and it will be, but it's also a professional experience. You are there

to advance your career, create new opportunities, and even potentially sell your film. It will be beneficial to set an achievable goal for yourself so that while you are there, you have something to actively pursue. Otherwise, you might find yourself overwhelmed, distracted, and unable to take action. After all, a festival can be busy, chaotic, and intimidating. Setting a goal will keep you focused.

Goals for aspiring feature directors

Your goals should be directed toward two important aspects of your distribution plan: finding distribution and screening at a greater number of film festivals. Both are achievable. You'll learn about distributors in the next chapter, but for now you should be aware that a film festival is the natural habitat of the distributor, so this is where you might meet one. A goal of yours should be to seek them out (the next chapter will give you information about how to interact with them); distributors will be at the prestigious festivals in greater numbers, but it's always possible that one might attend a smaller festival. You'll have to ask the festival coordinators and other filmmakers if they know if any distributors are in attendance; they will not generally advertise themselves. If you are exceedingly lucky, a distributor might approach you, having seen and liked your film, but you certainly can't rely on that. Make it one of your goals to investigate and see if you can meet a distributor, perhaps at the bar or hors d' oeuvres table at one of the festival parties.

Advancing the success of one festival into an invitation to the next one should also be of your goals. It's common for festival programmers to visit other festivals in the months preceding their own, looking for potential films. It's also common for festival programmers to select some films that they like and that they will invite to their own. Ask your festival contacts if they know of any other programmers who are attending, and be watchful for them at the parties, screenings, and networking events. (See Figure 8-3 for an example of a film festival party.)

If you do meet a festival coordinator, introduce yourself and tell him about your film. Ask him to try and make it to your screening, and be sure to exchange contact information with him (give him the business card you made in Chapter 5 (Promoting Your Film and Yourself). Follow up and see if he would like to invite you and your film to his festival. If he does, you'll be able to bypass the submission process and place your film directly into another festival.

FIGURE 8-3. Networking at a film-festival party is a great way to meet people, make connections, and promote your film. Courtesy of Brad Kugler. Used with permission.

SIDE NOTE

A Film-Festival Invitation. If your film is "invited" to a festival, it means the programmer really likes your film and wants to make sure you agree to screen it at his event. Now you have a bit of leverage, and you should use it to your advantage.

As you accept an invitation (you always accept!), here are a few things that you should discuss with the coordinator:

- Entry Fee: can they please waive it?
- Where in the program will it screen? Opening night is better than 8:00 am.
- Shipping Fee: can you use their FedEx account number?
- Lodging: will they pay for your hotel room?
- Screening Fee: do they have anything in the budget to pay a screening fee?

Be careful with these requests—you should *not* ask for all of these in your first conversation. You need to be able to judge the nuances of your situation. Is it

a prestigious festival with a large budget? Is your film winning awards? Do they desperately want your film? If so, then you can consider pushing for most of these perks. However, it's more common that a festival will be able to waive an entry fee but will not be able or willing to offer anything else. You should be confident enough to ask for one or more of these perks, but be thankful for whatever you are offered: it's a great compliment for a programmer to personally request your film.

Goals for intermediate-level filmmakers

Although it would be a thrill to be invited to another festival or to negotiate deals with a distributor, your experience at a festival is likely to be different from that of a filmmaker who is more established than you are. Your goal should be to concentrate on learning everything you can at this particular festival. You want to walk away with as many new experiences as possible—think of the festival as an enjoyable and educational opportunity. Peruse the festival guide and try to participate in nearly everything. Attend all the parties and networking events that you possibly can. Even if you are anxious (these affairs can be overwhelming at first), be present and put forth your best effort to network and socialize. Most of the other filmmakers there will be feeling just as nervous as you will be. Attend any workshops and seminars that are offered, and always remain for the Q&A sessions after a screening.

Intermediate-Level Filmmakers: by attending as many possible events during the festival as you can, by the end, you'll start to feel confident. You'll recognize a few other intrepid, like-minded filmmakers, and at some point you'll naturally seek each other out, because you'll have something in common: you keep showing up in the same places!

Even if you haven't been able to do a significant amount of networking until the end of the festival, by the closing-night party, you'll start to see results. You'll see familiar faces, they will see you, and because you've been to so many functions, you'll all have plenty to talk about. Networking at these events is paramount: you are trying to build a fan base, and you are also trying to build a base of peers and colleagues. You will learn more from other filmmakers than you would from any seminar you attend or book you read. Your goal for your first festival is to immerse yourself in the scene, learn as

much as you can, and to leave the festival with some new contacts, perhaps even friends. See Figure 8-4 for an example of a workshop at a festival.

FIGURE 8-4. Workshops, like this one at the Sunscreen Film Festival, are a great place to meet people and learn more about your craft. Courtesy of Brad Kugler. Used with permission.

Goals for aspiring creative crew members

Attending a festival that is screening your film is an excellent way to network and get yourself noticed. The terrific thing about attending a festival as a cinematographer, editor, production designer, or other such creative crew member, is that you will often be in a minority, surrounded by directors and producers. The fact is that most people at a festival, aside from non-industry movie buffs, are writers, directors, and producers. Creative crew members might attend a screening or two, but they don't display a strong presence on the festival circuit. If you can attend as many festivals as possible, you'll find that you're perceived as being "special," in a very positive way. You'll receive a significant degree of attention, and there will likely be a natural interest in your work. Help your director promote your film, but don't be afraid to promote yourself independently. You should have your demo reel with you or a business card with a link to your online portfolio. Attend as many screenings and introduce yourself to as many directors as you are possibly able to. Directors are always looking for new collaborators, and you want to develop

your circle of producers and directors so that this film will lead to your next one. See Figure 8-5 for an example of crew members participating in a Q&A session at a film festival.

FIGURE 8-5. Aspiring cinematographers and editors can find opportunities to promote themselves by taking part in Q&A sessions such as this one at the Sunscreen Film Festival. Courtesy of Brad Kugler. Used with permission.

Creative Crew Members, ask your director or producer to submit your film to festivals that give "Tech Awards"— awards for Cinematography, Editing, etc. This way, you have a chance to collect some awards for your contribution to the film!

Ask your director or the festival programmer to allow you to participate on a Q&A panel, either after your screening or as part of a stand-alone session. You'll want to be noticed by as many people as possible.

Goals for first-time filmmakers

Attending a film festival is one of the most advantageous steps a first-time filmmaker can take to improve the quality of their work. Because most of our understanding of the language of film comes from our history of watching features, when people first attempt to film a short, they inevitably make

some basic errors based on a misunderstanding of the art form. Shorts are very distinct from features in many ways: story structure is dissimilar, characters are developed in atypical ways, and the types of films that are successful are diverse. Watching as many short films as possible is an excellent way to become exposed to the language of shorts. At the festival, make note of what you like and what you don't like and what the audience response is. Listen to the Q&A sessions and be attentive to tips and hints about the process of making a film. What do all directors seem to agree upon? What appear to be common challenges? Outside of the screenings, you should also attend the workshops and discussion panels and parties. You can do some networking if you like, but at this stage you are just as well advised to listen and absorb rather than to expend time and energy building a network. Make this your goal: to leave the festival with a more solid understanding of what short films are all about, which ones play well to audiences, and what approach you are going to take as you set out to make your own.

Although every festival is different, most film festivals are looking for similar qualities in the films they accept. In the following interview, festival director Tony Armer shares his insights and gives filmmakers some valuable advice.

INTERVIEW

SUBMITTING TO FILM FESTIVALS
Tony Armer
Executive Director, The Sunscreen Film Festival

JM: Tell me a little bit about your festival.

TA: The Sunscreen Film Festival is organized by the St. Petersburg-Clearwater Film Society, which is dedicated to educating the public about the art of visual storytelling, enhancing opportunities for local filmmakers to develop their craft and art, and increasing the public's awareness and support of local filmmaking as a cultural and economic asset. Sunscreen offers more educational workshops and panels than nearly every other film festival in the country. In addition to screening great films, the festival puts on panel discussions, actor and filmmaking workshops, charitable fundraising events, student film showcases, economic development planning sessions and of course outstanding parties. We were voted one of the 25 Coolest Film Festivals in the Country by MovieMaker Magazine in 2009.

JM: What types of short films typically do well at your festival?

TA: The short films that do the best are the good ones. I know that sounds very simplistic but a good film is a good film regardless if it's horror, comedy, action, etc.

But if you're asking which are the favorite or most popular with audiences then those are the comedies. If it makes people laugh or feel good in any way those have the biggest appeal.

JM: What types of films don't do well, or are rejected?

TA: The bad ones. A film doesn't make it because it's not well made, the acting is bad or the story is poorly written. You can't hide bad filmmaking, and if it's bad everyone will know it. One thing about short films that filmmakers need to remember is the word "short". A short film that is 20 or 30 or 40 minutes can be very difficult to program because of it's length. But, if it's really good we try and find a place for it.

JM: What is your position on filmmakers posting their films online before submitting them to your film festival?

TA: In today's world it's just the nature of the business that people want to make their films available online. However if someone is planning on making the festival circuit we prefer if they wait until after they're done to put the film online. This may not be realistic as filmmakers are just trying to get eyeballs on their films. But it certainly adds punch to the film online if they can lead into the film showing festival laurels at having played in or won awards in numerous festivals. And to do that you need to be in the festivals first.

JM: Once they have been accepted, is it appropriate for a filmmaker to contact you and ask questions about the festival, or offer his/her services for doing press, panels, etc?

TA: Absolutely, we want filmmakers in the fest to be as involved as possible.

JM: Do you have advice for a filmmaker for promoting themselves at your festival?

TA: The filmmakers that have drawn the most people to their screenings are the ones that get out and meet the most people. A personal approach of introducing themselves to attendees at the parties, other films, and workshops really helps. People will attend the screening if the filmmaker is excited, passionate and relates well to people when they are out promoting their film. Talk to as many people as you can and follow up with them, remember their names become friends and really have a personal touch when promoting.

JM: Your festival has a reputation of running a great series of panels and workshops, can you talk about those?

TA: Sunscreen has more educational panels and workshops than nearly any other festival in the country. We bring in industry professionals from Hollywood to teach cinematography, screenwriting, producing, comics and film, distribution and finance, acting, and much more. Any filmmaker with a film in the festival can attend these workshops for free and I would say it is the thing our filmmakers enjoy the most. It gives them an opportunity to meet the movers and shakers from Hollywood on a personal level and really learn and make some good business connections.

JM: What formats are you screening films on?

TA: For simplicity's sake we have been screening DVD and Blu-Ray DVD the past two years. We of course can and still do screen 35MM and have done numerous tape formats in the past. But it has become simpler to do DVD. We do screen Blu-Ray so filmmakers can still screen from a Hi-Def format.

JM: Any closing words of advice to filmmakers making short films?

TA: If you make a good film it will be accepted to festivals, period. At the same time don't get discouraged if you get turned down from festivals because all programmers have different tastes. But if it is a good film it will get chosen to play. Don't get discouraged and just keep making movies.

Originally from Toledo, Ohio, it was in high school where Tony first developed a love for filmmaking, which developed into a fine television and film career since 1997. His work experience includes Hollywood feature films, documentary features, independent features, television pilots, and music videos. In 2005, Tony co-founded the Sunscreen Film Festival, an annual film festival held in St. Petersburg, Florida, and as the Executive Director, the festival is rapidly growing into one of the top film festivals in the country.

Navigating the film festival circuit can be fun but also overwhelming. In this interview, filmmaker Grace Rowe shares some of her experiences and provides some valuable advice.

NAVIGATING THE FESTIVAL CIRCUIT
Grace Rowe
Filmmaker

Grace Rowe is an award-winning writer, producer, and actress. Her solo show, *The Grid Life*, played to critical success at venues such as the HBO Workshop and The Complex Theater in Hollywood. Her short film, *American Seoul* was based on her feature screenplay of the same name, and has screened at over a dozen film festivals worldwide. Her latest movie, *I Am That Girl*, a feature film about a credit-card obsessed party girl who finds love and enlightenment in the Sierras, was nominated for the Grand Jury Prize at the L.A. Asian Pacific Film Festival and garnered her the Best Actress Award from the Yosemite International Film Festival. Grace is a lifetime member of The Actors Studio and is currently working her next feature film. Learn more about Grace and her work at www.gracerowe.com and www.iamthatgirlmovie.com .

JM: What were some of the ways you actively promoted American Seou *as it was doing the festival circuit?*

GR: This was quite awhile back so there wasn't the kind of social networking sites available to filmmakers to help spread the word like there are now. So mostly I tried to promote the film the old fashioned way, by making fliers and posters and papering the town. If I could, I would get to a festival early and try to meet other filmmakers and go to local bookstores and coffee shops and leave some fliers by the door or ask the owners if I could put up a poster. I also did as many interviews as possible, sometimes on local radio stations or with local newspapers. It's always good to contact the festival's P.R. person and let them know that you're available to do interviews. I told them I wanted (and needed!) as much press as possible. That helped since some filmmakers are shy and don't like to give interviews.

JM: You spoke on several panels and did several interviews with the press on that project. Can you talk about the value to doing those? Can you give any advice about how one might actively seek out these opportunities?

GR: I think finding as many avenues to talk about and promote your film is crucial to getting it seen. At most festivals there are a ton of films, let alone short films, and it's important for the audience to connect a face to the project. If someone feels like they know who you are as a person, they may be more apt to seeing your film. As soon as you find out you're in a festival, make contact with the festival programmer or their publicity person and tell them you would like to do as many press opportunities (including speaking on any panels) as possible. They'll be excited to hear how eager you are to be a part of the festival. Make sure you have a Web site up and put the URL on your fliers and posters. It doesn't have to be fancy, but at least have some good production stills on there, and if you can, perhaps a trailer or a teaser.

JM: When attending a festival that your film is screening in, do you actively network? Are there any basic strategies you can share?

GR: I love meeting other filmmakers since I'm also an actress and I think it's important to meet directors and producers who you may work with in the future. Other filmmakers can also be your biggest resources when you're working on distribution. I've been given great advice from fellow filmmakers and have based my decisions on whether or not to work with producer reps or sales agents and have even turned down a distribution offer based on other filmmakers' experiences with them. It's a small community, and

once you start a festival circuit, you'll likely run into the same filmmakers at different festivals. Get to know them. They will become a great resource for the future and they might even turn into close friends. As far as a strategy goes? I think it's important to stand out, mingle, and check out other films. You should support other filmmakers if you hope that they will support you. Also, it's a great way to approach someone, if you've seen their film. Also, be humble, be gracious, and be available. Don't disappear after your screening. Stick around and talk to people. Ask people to join your email list. Later you can send e-newsletters to people letting them know your future festival dates or releases. Building your email list is one of the most important things you can do at a festival.

JM: What general advice do you have about distributing a short film? Are there things you would do differently if you could do it all over again?

GR: I wish that I had known that *American Seoul* was going to be so popular. We really made the short to show investors what the feature film would look like and then by a fluke, we got into a film festival and that started us on a whirlwind tour of festivals around the world. The problem was, I didn't license any music because I didn't expect to sell it. But when people approached me about acquiring the film for different avenues, including television, I had to say no. The movie was very music-based, and every scene was edited to the music. To re-edit the movie would be more work than it was worth. I look at it as a calling card, but if I could do it over again I would've tried to find music I could actually use. When I made my first feature film, *I Am That Girl*, I made sure not to use music I couldn't afford. It was still tricky, but now I own the rights to the entire movie. That makes a big difference when it comes down to distribution, even if you plan on selling the movie yourself. If I made another short film, I would really think about where I wanted to see it go. Do I want to use it as a calling card? Do I want it to play on Internet sites like YouTube or FunnyOrDie? All those questions will determine certain aspects like how long the film should be, how much the budget should be, which trickles down to decisions regarding how many locations or actors you can afford.

Since it's more than likely that you won't get rich off of selling a short film, make sure you don't break the bank. I think that the days are gone where your average filmmaker is making a short for $25,000. With digital formats, you can now make a feature for that amount of money. So if you're going to spend that kind of cash, then you may have to realize that you may not recoup your money but if it's good enough then maybe people will take notice and invest in your next film. You just need to decide what your end goal is and then work backwards from there. I know that some people may think that way of working inhibits the creative process, but I disagree. If you're going to be a filmmaker and survive in this business, you also need to be a business person. Once you know your boundaries and your goals, you can let your creativity run wild.

SUMMARY

In this chapter you learned how to prepare for your film's screening at a festival. You learned how to use your promotional skills to drive audiences to your screening, and how to set goals in order to maximize your opportunities at the festival. Attending a festival with your film can be one of the most exciting times of your life, and by following the lessons in the chapter, you will be able to make the most out of this incredible moment.

1. What are some important things to do once you learn your film has been accepted into a film festival?

2. When communicating with the film festival, what are some things you should discuss?

DISCUSSION / ESSAY QUESTIONS

1. How should you apply the principles of "Add Value" and "Give More than You Receive" when promoting your film at a film festival?

2. Write a short paper discussing the artistic intent of your film. In the body of the paper, answer the following questions:

 a. Why did you choose to make this particular film?

 b. What is the meaning or theme of the film?

 c. What are some artistic influences on this film?

 d. What were you hoping the audience would experience or get out of this film?

Research/Lab/Fieldwork Projects

The following lab projects will help you prepare for the work you will be doing in the next chapter.

1. Depending on your filmmaker level, set a goal for the festival and record the goal in your journal or production book. Do your best to achieve that goal at the festival, and report back to the class or the instructor after the festival. Be prepared to discuss the following points:

 a. Did you accomplish any of your goals for the film festival?

 b. What did you learn at the festival?

 c. What was your favorite film at the festival, and why?

 d. What was your favorite moment of the festival, and why?

PREPARING FOR THE SALE: THE LANGUAGE OF A CONTRACT

OVERVIEW AND LEARNING OBJECTIVES

In this chapter, you will:

- Review general terms and concepts related to selling your film
- Understand the specific language used when negotiating with distributors, sales agents, and buyers
- Develop a strategy for interacting with distributors and buyers

Let's Make a Deal

Up to this point, we have talked about distribution and sales in general terms, but in this chapter we will look into the specific terms, concepts, and strategies surrounding the process for actually selling (licensing) your film. It's a world full of possibilities, and it can seem a little overwhelming and complex when you start to deal with the specifics of contracts and negotiations. Distributors speak a language all their own. It is a specialized language that combines terms from feature filmmaking and contract law. You need to have a solid understanding of these terms so that you can properly communicate with the people trying to help you sell your film. You also need to know exactly what the contract you are about to sign actually says and means. This chapter will introduce you to all the major legal and filmmaking terms and definitions you are likely to hear as you negotiate your sale. In the next chapter, we'll build on this foundation and you'll learn how to locate distributors, how to approach them, and how to negotiate with them. But first, let's review some essential concepts:

Broadcast distribution: Step 3 of your distribution plan

Chapter 3 (Distribution Goals, Plans, and Models), introduced various distribution models, and suggested that you follow the "Hybrid Distribution Plan." This plan has five points, the first two of which you have already completed:

1. Promote your film and yourself .

2. Submit to festivals and attempt to "do the festival circuit."

3. Contact distributors and attempt to negotiate traditional broadcast distribution deals.

4. Depending on the success of the above steps, either negotiate an Internet release of your film through a distributor or release on the Internet using DIY methods.

5. Leverage your success (no matter how much or how meager) into momentum for your next project.

As you can see, you are ready to undertake Step 3. "Attempting to negotiate traditional broadcast distribution" means licensing your film to cable and network television companies.

Cable and network television deals are usually the most profitable deals a short-film filmmaker can make, and are considered the most prestigious. Although racking up thousands of hits on a Web site is cool, nothing really trumps having your film screen on television, where the "big boys" play. A deal to have your film screen on HBO, Showtime, the Sundance Channel, or the Independent Film Channel is widely recognized as a tremendously successful achievement.

<div align="right">

NOTE
</div>

Selling vs. Licensing

When we talk about selling your film, we are referring to any and all ways to profit from your movie. To be particular about it though, there are specific differences between *Selling* and *Licensing*. When you license the rights to your film, you are giving a television company permission to screen your film and profit from the screening (remember, they make money by airing commercials before and after your film). The actual place (channel) it screens, how many times it screens, how much you are paid, and over how long a period of time they get to screen the film are worked out in a legal contract. The only time you "sell" your film is when you sell a DVD or a digital file of your film to an individual person. When you sell a DVD or digital file, the purchaser will own that DVD or digital file, but they are not allowed to sell tickets and screen it for large crowds; it's for their private viewing pleasure only. So when you hear someone say, "I just sold my film!" that filmmaker means he made a licensing deal, or sold a DVD or digital file, or a combination of both.

KEY TERM:

Selling and Licensing *Selling* is industry slang for *any* type of deal that involves money for your film.

Licensing is similar to renting: a television network will pay you to screen the film, but they are not buying it outright.

Promoting on the Web: Trailers only!

At this stage of your distribution plan, you are heavily promoting your film both in the real world and on the Web, but you have not screened the entire film anywhere but at a film festival. The settings for viewing short films, features, and television shows are changing rapidly, and for many of you, the

Internet might be the primary place you watch media, but until televisions and broadcast companies completely merge with the Web, TV still provides the most significant venue for you.

NOTE

At the risk of sounding redundant, this point is crucial: it's understandable to have a strong desire to upload your entire film to the Web the minute it's done, but doing so might immediately forfeit any chance you have of securing a television broadcast deal, which can reimburse you in the thousands of dollars and would provide major leverage for your career. You'll know soon enough if a broadcast deal is in the cards for you: stay patient, follow the process, and one of two things will happen: either you won't make a broadcast deal, leaving you free to go to the Web, or you will make a deal, and when you do, you will earn both money and prestige. After having made the deal, you can release on the Web at a later time.

Deliverables: Standing by

You are about to approach and negotiate with the people who might actually pay you money to screen your movie to thousands, if not millions, of people. They are businessmen and businesswomen. They will expect you to operate in a professional manner, and the very first thing that they will want to know is the status of your deliverables. You must be able to tell them you own all the rights, and that you possess the paperwork to prove it. Without deliverables such as music rights and talent rights, you will not only lose the sale, you might lose credibility. Don't even bother contacting a distributor if you don't have these in hand. You'll need your press pack as well: distributors will request almost everything on the list, from cover art to director bio to cast and crew credits. Also, you'll want your business cards to be already printed, and of course the film, in as many formats as you have.

Festival success: Is it crucial?

As already mentioned, a majority of broadcast distribution deals are made with films that have been successful on the festival circuit. What, exactly, does that mean? Winning prizes at every festival you enter? How about winning just one prize or being invited to several festivals? If you have won a prize or are being accepted into multiple festivals, your film is probably successful, and could certainly be ready for broadcast distribution. What if you've been accepted to only one or two festivals, or what if all the festivals you have screened in are small, low-key affairs? You might find a distributor

who believes enough in your film to help you, but you might not. Generally, people who are in a position to make broadcast deals want the work to have been "vetted" by the festival circuit—in a sense it "proves" that there is an audience for the film. It makes it easier to sell. Without some prizes or a list of known festivals you have screened at, your chances are difficult to predict. That doesn't mean, however, that you should skip this step.

If you believe in your film, then you should do everything in your power to promote it. As long as the film is not a total disaster, you won't damage your career with your attempts. There are plenty of examples of films that have made broadcast deals without a having had a notable festival run.

Understanding Distribution Language

Now that we've done a quick review, let's look at the terms that you will need to be familiar with as you interact with people in the distribution world. These are the types of words you will see used on agreements, memos, and contracts you'll be signing. Armed with an understanding of these terms, we'll be able to explore the best strategies to take when negotiating for a sale.

Distribution company (distributor)

A distribution company acts as a middleman between a filmmaker and a film buyer. Often called a Distributor, the company will have two main divisions: acquisitions and sales. The acquisitions division will seek out directors with films and the sales division will present those films to film buyers. The film buyers pay the distributor, and the distributor splits that money with the filmmaker. The reason why filmmakers need distributors is that most filmmakers do not have relationships with film buyers, and film buyers usually want to buy packages of films, not just one film at a time. The distributor helps connect these two parties and will bundle films from multiple filmmakers into packages that interest buyers.

Sales agent

A sales agent operates in the same way a distribution company does, but is a one-person operation, as opposed to a larger company. You are just as likely to negotiate with a sales agent as a distribution company.

Film buyer

A *film buyer* is someone who purchases films so that their company can screen them and in some way earn a profit from them. For example, if someone at PBS decides they want to run a two-hour program showing short films, they will ask one of their film buyers to acquire short films. A film buyer will call a distribution company or a sales agent and the negotiations will begin.

KEY TERM:

Film Buyers Although they are known as film buyers, the term is just slang for film "licensing," because what they really do is pay for the *rights* to screen a film.

Distribution platforms

A distribution platform is a term used to describe the way an audience watches your film. There are film buyers working for companies on every different platform, and distributors have relationships with all of them. When you make a deal with a distributor, he will attempt to sell your film to buyers on all or most of the platforms below, thus making you (and them) the most amount of money they can. Following are the major distribution platforms for a short film, with brief explanations.

Broadcast
As mentioned above, the broadcast platform consists of network and cable television. Television companies and networks purchase licensing rights for short films and often bundle them into programs, much like a film festival. Other times, shorts are used as interstitials between longer films. Some broadcast companies that buy short films in the United States are the Sundance Channel (owned by Showtime), the Independent Film Channel (IFC), and the Public Broadcasting Company (PBS). The broadcast platform is even wider internationally than it is in the United States. There are dozens of foreign television companies that buy short films.

Home Entertainment
This platform includes DVD sales and rentals through companies like Blockbuster®, Amazon®, and Netflix®. In addition to major corporations that sell and rent DVDs, there are also smaller art-house and independent-oriented DVD sales and rental companies that offer shorts to film aficionados. Small

organizations like Cinema16 and Film Festival Collections buy, bundle, and release short-film collections on DVDs. Home entertainment also covers VOD, or Video On Demand. Renting movies through cable channels such as Movies On Demand is known as VOD. Now that video is widely available on the Internet, VOD has become available through services such as Apple's iTunes®, Amazon's Video On Demand, and Netflix's "Watch Instantly." Sometimes these services are also referred to as Internet Platforms.

Educational

The Educational platform refers to films that can be licensed by schools (elementary through high school) and used as an educational tool in the classroom. Ever watch a documentary about Eskimos in class as a kid? Your school paid money to screen that film. Once a thriving market, it's been somewhat diminished as the Internet has become a fast, free, and comprehensive teaching aid. Still, shorts that deal with social issues such as gender, race, sexuality, politics, religion—movies that can start a discussion in a classroom—do find occasional distribution. Short documentaries can also find success on this platform.

Internet

The fastest growing new distribution platform is the Internet, and it seems inevitable that it will someday overtake or merge with traditional television as our primary way of viewing media of all sorts. Currently however, there are still limits of bandwidth, which makes viewing short films on the Web a very different experience than viewing them on television.

> *Although the sheer amount of content available on the Internet is vastly more than what is available on broadcast television, the viewing experience is still not quite as desirable. Screens are smaller, audio not as rich, and download times still prevent a user from having a seamless, comfortable, cinematic experience. Until viewing video on the Web becomes an experience that is as high-quality and uncomplicated as television, it will remain a secondary player, at least in terms of generating prestige and revenue for filmmakers.*

NOTE

The Internet provides literally thousands of viewing experiences and distribution options for short films. We have grouped them into two large areas, to be discussed in detail in the upcoming chapters. The two main areas of Internet distribution are: Paid and Non-Paid. Paid means that there is a formal system in place for the filmmaker to make money screening the film on the Internet and Non-Paid means the film is given away freely to anyone

who wishes to watch it, with the hopes of building a fan base and gaining a reputation as a filmmaker to pay attention to.

Mobile

Mobile distribution via phones, portable games devices, and tablet computers (iPad®, etc.) is becoming a significant option for the distribution of short films, but the model for how it actually operates changes as rapidly as each new technological advance is made. Mobile distribution used to mean licensing short films to cellphone companies such as Verizon®, T-Mobile®, or AT&T®. The telephone companies offered short films to their subscribers as value added content: if you were their customer, you could opt to access and watch short films as part of your monthly phone service.

TECHIE'S TIP

With the ultrahigh-tech "smartphones" in use today that can access the Internet using fast cell networks like 3G or 4G or wifi hot spots, the mobile platform is evolving into a subset of Internet distribution. Instead of phone companies buying short-film content and giving it directly to their subscribers, they are now partnering and sponsoring mobile-only short-film festivals and contests. This means that instead of approaching AT&T directly, a filmmaker is more likely to get involved with an event, contest, or mobile phone festival sponsored by AT&T.

There will be details about mobile distribution in the upcoming chapter.

Theatrical

Although you screen in a theater during your festival run, film festivals are not considered a distribution platform because you are not earning money for the screening. Technically, "Theatrical" distribution refers to screening in a movie theater for an extended period, with theater owners charging for tickets. Theatrical is the largest platform for feature films—it's where you'll hear expressions such as "opening weekend" and "box office hit" and "blockbuster movie." As a distribution platform, "Theatrical" is virtually nonexistent for short films. Very few short films ever make a theatrical deal. When was the last time you paid for a ticket and saw a short film in a theater, outside of a film festival? Occasionally, a short film can get theatrical distribution, but it's usually part of a group of shorts, like "Oscar-Winning Short Films," or "Animated Shorts." These theatrical deals are usually limited engagements, meaning the group of films screen for just a night or two at one theater. It's almost unprecedented for a short film to get a wide, national, extended theatrical release. "Theatrical" has been included in this list because it's a very

common term used in the world of distribution, although it's really used only in relation to feature films.

Other Distribution Platforms

Distribution platforms evolve and mutate quickly. Some platforms, such as airlines, come to an end or change. Although airlines used to buy short-film packages for in-flight entertainment, most airlines are moving toward broadcast television, which they offer on seat-back monitors. Don't be surprised to see new platforms emerging. Mobile gaming devices such as PSP (Portable Sony Playstation) are utilizing marketing techniques similar to those of mobile phone service providers and are sponsoring short-film contests and events. Even film festivals are starting to explore distribution options: recently celebrated film festivals like Sundance and TriBeCa have looked for ways to get into the distribution game. Sundance has sponsored mobile-phone events at its festival, and TriBeCa recently partnered with a cable television company to offer some of the festival films over VOD during the two-week event. It's wise to keep your eyes and ears open for emerging platforms and opportunities. Technology is driving new and different venues, and it's all happening quickly.

Territories

A territory is where, geographically, your film plays. Buyers operate in certain territories, and when they license film rights, they license for those territories. A buyer might license your film for a large geographic region, like North America, Europe, or Asia, or they might buy your film for one or more individual countries, like Italy, France, or Brazil. In the United States, we use the terms Domestic and International distribution to differentiate between distributing for the fifty states versus distributing to a foreign country. In the world of short-film distribution, International sales of your film are likely to be just as high, or higher, than domestic. In part, this is because of the thousands of outlets for short films around the globe and the fact that in this day and age, it's easy to communicate with buyers in those markets.

Exclusivity

When film buyers purchase rights to screen films, they will want to be the only platform in their territory to screen it. They'll want exclusive rights. This is a type of protection for them. For instance, if you license your short film to Showtime, they will want to be the only television station showing your film in the United States. If HBO is also showing it, Showtime won't be the only

place to see your film, and they could lose their audience. Showtime is trying to make money—by selling commercial air time—and they need to protect their programming.

SIDE NOTE

Exclusivity A good way to understand the exclusivity aspect of distribution is to imagine a hugely successful blockbuster film. After screening in theaters, selling DVDs, and renting the film, it's finally time for the film to air on television. The network that pays for the rights to air that blockbuster film is going to be very excited: there will be a vast audience waiting to see it for the first time, or to see it again. The network will sell commercial air time and will promote the event: "Friday night at 8:00pm, the television premier of Super Big Blockbuster!" Lots of people will tune in, and they will be able to sell the commercial time for a lot of money. What if, however, five other TV stations *also* schedule to screen the big blockbuster that night? Or worse: if they screened it Thursday night? Not as many people would watch the first network, and they couldn't make as much money. So TV networks want to be the ONLY one screening the film. They want it exclusively. Even your short film!

Exclusivity across platforms

Depending on your deal, a buyer on a particular platform (say, broadcast television) will *only* want exclusivity on their platform and territory and won't care if your film is distributed on other platforms (say, Home Entertainment) or in other territories (say, a television broadcast company in Europe). In the case above, where you have sold your short film to Showtime, Showtime would not consider the sales of your DVD competition, nor would it consider a foreign TV station screening your film competition. That would be acceptable to them. They just want exclusivity on their platform (broadcast TV) and their territory (the United States). Could you sell your DVD in the United States? Yes, it's on a different platform. The only thing you can't do is sell your film to other TV stations in the United States. There is, however, one very big exception: most broadcast television buyers will *not* want you to sell Internet rights during the term for which they have contracted to screen the film on their TV station.

Exclusivity among distributors and sales agents

Distributors and sales agents also use the concept of exclusivity in their agreements with filmmakers. Some distributors want exclusive rights to sell the film, meaning the filmmaker can deal only with them. Others will want exclusive rights only in certain territories (the ones they operate in). Again, they are simply protecting their business interests. If a filmmaker had agreements with two competing distribution companies, it would potentially lessen the amount of money either company could make. So most of the time, deals between distribution companies and directors are made exclusively. The same territory concepts work here just as they work with buyers: you could potentially have one distribution company in the US and another one in Europe.

Nonexclusive

Nonexclusive, in relation to buying and selling films, means that a filmmaker is free to sell the film to other buyers in the same territory and on the same platform. This is rarely agreed to by a buyer, and most will stipulate in their contracts that they will own the rights exclusively. Although most filmmakers would usually prefer to make all of their deals nonexclusive, so they can sell their film to whomever they can, wherever they can, whenever they can, it rarely occurs. The one place nonexclusive deals are more common is on the Internet platform. Some small Web sites who can't afford to pay premium prices for films will agree to a nonexclusive deal, allowing the filmmaker to deal with other Web sites.

If all this language about exclusivity seems overwhelming, don't worry. We will review these concepts in the following chapter, and once you've had some time to consider and discuss these terms, it will all start to make sense.

> **KEY TERM:**
>
> **Term** The length of time for which a buyer purchases the rights to screen a film is called the *term*. A buyer might want the term to be six months, one year, two years, or more. During the term, whoever owns the rights to the film usually has exclusive rights.

Term

If Showtime wants a two-year term for your film, during that term you will not be able to offer the film to another television station in their region. You could, however, license the rights to foreign television stations during that term. Distributors and sales agents use the same word when drawing up a contract with a filmmaker, in order to come up with a length of time the distributor or sales agent will have to try and sell the film. During the term of your agreement with a distributor, you will not be able to make a deal with another distribution company or sales agent (because the distributor or sales agent will want to be the exclusive representative of your film, at least in the territory where they operate).

Fee

The fee is the amount of money you are paid when you license or sell your film. A fee can be a one-time payment that is paid upon the signing of a contract, or it could be a periodic payment sent to you every few months. Periodic payments are more common on the Internet platform, where fees are paid in proportion to ad revenue the Web site earns or views that a particular film generates. For example, a Web site might send you a monthly check that varies in amount depending on how many people watched your film. Sometimes, a filmmaker is given an advance against future fees. The advance, issued in the form of a check, is considered pre-payment for future earnings. A Web site might give a filmmaker a $500 advance against future monthly earnings based on views. Each month, the revenue earned by the filmmaker would be subtracted from that advance, until the revenue exceeds $500. At that time, the filmmaker would begin to receive whatever monthly fee he is entitled to, based on the number of views his film is generating.

While there are no set fees for short-film deals, a common figure for determining how much a broadcast buyer will pay for a short film is between $100-$500 per minute, but this should not be considered a completely reliable figure in every case. Short-film distribution deals will never make you rich, however, in some cases, it's certainly possible to earn several thousand dollars. If your film is licensed on several platforms across many territories, your fees can really start to add up!

NOTE

Release window

Consider a typical feature film: first it plays in theaters, then a month or two later it stops playing in theaters and becomes available for rent or sale on DVD. Sometime later, it might play on broadcast television. The common belief among distributors is that releasing a film in separate "windows" allows for maximum profits on each platform. This notion is changing, however, and narrower *release windows* are becoming common.

> **KEY TERM:**
>
> **Release Window** A film's release window describes the schedule on which a film is released across various platforms, or the length of time between release on one platform to another. A film is rarely released on all platforms at the same time.

In some cases, feature films are released "Day and Date" on multiple platforms (released for theatrical, DVD sale, and rental all on the same day). Short films have their own set of release windows, but they are usually fairly simple. The two main platforms of release for a short are broadcast and Internet, so a film usually plays on broadcast television first, and later is released on the Internet. Home entertainment, educational, mobile, and other platforms are not seen as major competitors to either broadcast or Internet releases, so filmmakers are usually free to pursue those deals whenever they like. Remember: a broadcast buyer will not want a film to be released on the Internet during the term for which they have purchased the rights, because they will assume that if a viewer can easily watch the film on the Internet, they will be less likely to watch it on television. This is why the distribution plan in this book focuses first on securing a broadcast distribution deal and then moves to the next release window, the Internet. It should be noted that this is only one type of distribution strategy. Other distribution strategies take

the opposite approach: they release first on the Internet, hoping they create so much Internet buzz that a broadcast buyer will want to capitalize on all the excitement and license the film for their television station. But this is usually the exception, not the rule. You should stick to the distribution plan suggested, which follows more traditional release windows: first broadcast, then Internet.

When your film does well on the festival circuit, you can expect that you will soon have the opportunity to meet and negotiate with distributors. To share some insight about what it's like to experience this type of success, in this next interview, filmmakers Tim Sternberg and Francisco Bello share the story of their film *Salim Baba*.

SALIM BABA: A CASE STUDY
Tim Sternberg and Francisco Bello
Academy Award Nominated Filmmakers

Salim Baba is an OSCAR®- and Emmy-Nominated short documentary film directed by Tim Sternberg and Produced by Francisco Bello. The film follows Salim Muhammad, a 55-year-old man living in North Kolkata, India, who makes a living using a hand-cranked projector to screen discarded film scraps for the kids in his surrounding neighborhoods. A celebration of one man's passion for film, *Salim Baba* grew from a simple labor of love into a film that captured the hearts of audiences around the world. It has screened at over seventy-five film festivals world wide, winning awards at many of them. It has also screened on Cinemax, Canal Plus, and EBS (Korea).

JM: Tim and Francisco, can you tell me a little bit about the early stages of your film, when you started to get a sense that you had something special?

FB: Well, we were in post-production, working on this one kernel of a scene, where Salim is editing clips of film together in his apartment with his sons, just using a rusty razor, some old shears, and we started showing the scene to our friends. They all responded very positively, they said "You've really got something here." So we were encouraged. Of course like anyone we wanted to enter the film into Cannes, or into Sundance. At this point we were also thinking of ways we could raise some money, just to kind of sustain ourselves and pay for some of the expenses from making the film. So we applied for fiscal sponsorship from the IFP (an initiative from the Independent Feature project which allows filmmakers to align their fundraising with a non-profit, so donors can get a tax deduction for supporting their project). We showed a trailer of the film at our fundraising event, and we were able to raise a little money, but more importantly, it put us on the radar of some industry people. That's when the film started to come alive.

TS: After the fundraising event, the Cannes deadline was coming up. To qualify, the film had to be less than fifteen minutes. So we had to really cut the film down to its essentials. While we didn't get into Cannes, it forced us to get rid of anything in the film that didn't belong to the story.

FB: So now our film was running along at this very brisk, entertaining pace, and people were telling us, "Wow, this is really good, I wish it was longer." And that's just the point. We didn't want to fall into the trap that a lot of filmmakers make by adding a few more minutes to it. There's a big difference between fifteen and twenty minutes. And it wasn't easy, but having that Cannes deadline and time requirement really forced us.

TS: We just looked at the calendar and thought about what was coming up. We knew we should try to open the film at a big festival, and hopefully if it got in, the film would kind of take on a life of its own after that. So we got into Tribeca, and that was good. And then we got into Telluride, which was a real honor. Then Palm Springs, where it won second place, then it won at Woodstock. We got into IDFA (International Documentary Film Festival Amsterdam) and they flew us out. There was a film market there, and we made a sale to Canal Plus.

JM: How did that actually happen, how did you meet someone from Canal Plus?

FB: The film had been doing well, and festival programmers knew about it, and one of them knew someone in acquisitions at Canal Plus...

TS: I was at IDFA, and I was at a party, and met this woman, she was very positive, she really responded to the film. She gave me her card, and said to get in touch. She said "Look sometimes it takes me a while to get back, don't take it personally, the holidays are coming up, but just stay on me, I'd like to see if I can get this on Canal Plus." All of these things, they kind of just happened slowly, and organically, as people responded to the film. Then someone at Sundance called us, they had seen the film at Palm Springs, and then right as Sundance was ending, we got nominated for the Oscars. We had submitted to the Oscars, and had done all the paperwork to get qualified...

FB: The International Documentary Association in Los Angeles have sort of a curated series, called DocuWeek, that in its format allows films to qualify for Oscar consideration. At the time, for a documentary short, you had to be on film, so we had to get a 35mm print made.

TS: So we got these beautiful prints made, and it's sort of like a fairytale, you know, because to make a short documentary, that's kind of like the kids' table in the world of filmmaking. We screened at DocuWeek, got shortlisted, and then found out we had been nominated for the Oscar while we were at Sundance.

FB: Once we had learned we were nominated, I was introduced to an executive at HBO who gave me her card and said "we like nominated films." This eventually led to our broadcast deal with HBO for the film to screen on Cinemax Reel Life, a documentary series. That's when things really started happening and doors started opening. By the end of it all, *Salim Baba* played at over 75 festivals all over the world, and we just thought let's keep showing it, just keep showing it. So at a certain point, we wised up. We had some local and regional festivals inviting us to screen and we started, you know, asking for a small fee. And we always worked it out, sometimes festivals didn't have a budget, and we would just screen it, but a lot of them did pay, because they saw a value there.

TS: Listen we were not greedy, it was never about the money, but at this point we had spent everything out of pocket, there were bills to pay... and every little thing helped.

We started getting a few hundred dollars here, a few hundred there.

FB: The Oscars were great, we didn't win, but it was amazing. After the Oscars, the festivals continued for a while, we did a lot of great documentary specific festivals like True/False, Full Frame. At that point, HBO had said they were going to show it, we had the Oscar nomination, the pressure was off. Now we were just showing it and having fun.

JM: During this time, besides sending the film to festivals, did you do anything like self-promotion to help get the word out?

TS: There were a lot of little things that we did along they way that helped us create and keep the momentum going. Stuff like creating an LLC (business), which we needed to do to apply for fiscal sponsorship, which then allowed people to donate money to us. The Web page we built helped festival programmers find us as they started hearing about the film.

FB: Simple things like having an email address that was separate from our personal address—it helped give the film its own persona, and made it all more professional. It's not hard to do, but it's important—just having a place on the Web where people can go and learn about the film, get excited about it, see where it's played or what screenings are coming up.

TS: After we premiered at Tribeca, it was a good four or five months of really working hard, reaching out to people, calling, emailing, sending out mailers. It felt a little like a full-time job sometimes. But then the momentum started going. We called everyone, we really pounded the pavement. I mean really, you have to get yourself out there. Nobody is going to do it for you. You have to, with some tact and grace, hopefully, spend some time to put your film out there and try to get it seen. In this day and age, with a million shorts on the Internet, you have to just get it seen. Try and get people who you like, who you respect and trust to see it. Who knows who they know? That personal connection, I think, is much better than the Internet.

FB: It's also not only the people you know directly, but for instance, I was looking for archival footage to cut into the film, so I was here, in this (Indian) neighborhood, looking for some old Bollywood films. And I realized, this is our audience! So I got in touch with some arts NGOs, who have connections to the Indian community, and we reached out to them and connected with them.

TS: We had five different translators working on the film, who all got interested, and they started telling their friends, and we invited them all to the fundraising screening.

FB: This is something that you hear a lot about from media marketers, and there is nothing wrong with it—you want to make your film as universal as possible and it's important to find your audience, find groups of people who will enjoy your film, and find a way to get it on their radar.

TS: Also, another thing we did, this might be more aesthetic and technical, is that we really, it's probably our post background, but we didn't leave things to chance in terms of the sound and the music. The sound editing seems simple but is very complex, with a lot of different layers of music and effects. You know the film is about this guy showing films on these little rickety speakers on location throughout the city, and in real life it sounds terrible. But we recorded him well, and we got the reel of film that he was actually showing, and we digitized that, so we could have it clean in post. We really tried to think ahead about the end process: how are we going to mix the film with all of these potential elements. While shooting you need to be conscious of things like this.

FB: I mean, you can have the most amazing, well-thought-out festival strategy, but if the film doesn't hold an audience, it's not going to go anywhere.

ACADEMY AWARD® Nominee Francisco Bello studied at the Cooper Union School of Art, and has worked in the post-production of films by Kevin Smith, Michael Moore, and George Butler, among others. Francisco launched Ropa Vieja Films LLC in 2007 with *Salim Baba,* which has screened in over 75 festivals worldwide including Sundance, Telluride, IDFA, Woodstock and Tribeca. In 2008 *Salim Baba* was Nominated for an ACADEMY AWARD® for Best Short Documentary, followed by a News & Documentary EMMY Nomination in 2009. Most recently, Francisco produced and edited *War Don Don* which won the Special Jury Prize at the 2010 SXSW Film Festival, and for which he was awarded the first Karen Schmeer Award for Excellence in Documentary Editing. He also recently completed his directorial debut commissioned by HBO Documentary Films, *The Spirit of Salsa* which premiered at the 2010 Tribeca Film Festival.

ACADEMY AWARD Nominee Tim Sternberg started working in the editing rooms of Francis Ford Coppola's American Zoetrope Studios in San Francisco while still in high school. After moving to New York he's worked in positions as diverse as sound effects recordist on Nora Ephron's *Sleepless in Seattle* and Robert Benton's *The Human Stain,"* music editor on Milos Forman's *Goya's Ghosts,* re-editing the 1992 Academy Award

winning *Mediterraneo* for US release and acting as script consultant for the IFP and American Zoetrope. Most recently he directed "The Spirit of Salsa" for HBO that premiered at the 2010 Tribeca Film Festival. *Salim Baba*, shot in four days in Kolkata, India, was his first film as a director. It was nominated in 2008 for an Oscar in the Best Short Documentary category and in 2009 for a News and Documentary Emmy in the Best Arts and Culture Documentary category.

SUMMARY

In this chapter, we covered the important things you need to know in order to get ready for the sale of your film. We reviewed some areas that were covered in earlier chapters, and you learned how to speak like a distributor. Learning these terms and reviewing the key distribution concepts are extremely important: in the next chapter you will actually begin interacting with distributors, buyers, sales agents, and other film professionals. Although it's likely to be exciting, it's also guaranteed to be a little intimidating. Everyone you talk to will know this side of the business thoroughly, but you'll be managing it all for the first time. Distributors are happy to do business with you provided they don't have to guide you through the entire process. So make sure you know these terms and concepts before you make your first phone call or write your first email to a distributor. You want to be prepared and informed so that you can wisely and confidently negotiate for the deal that is best for you.

Intermediate-level filmmakers, creative crew members, and first-time filmmakers

This chapter and the upcoming chapters on selling your film are obviously geared toward advanced filmmakers with the experience and type of film needed to make a sale. That doesn't mean that you should skip these chapters, however. In addition to preparing you for the time when

SUMMARY

you might make your own sale, there is value to thoroughly understanding this side of the business. Intermediate-level filmmakers, you will find yourself at this stage before you know it. Creative crew members, you'll benefit from understanding this process and you'll be able to offer your directors valuable advice should they be negotiating the sale of your film. First-time filmmakers, if you begin the process of making your first film armed with all of this advance knowledge, you'll be in an advantageous position to make a film that is ready and able to be sold when the time comes.

REVIEW QUESTIONS: CHAPTER 9

1. When you "sell" your film, you are not really selling it, you are licensing it. What does that mean?

2. Why is it important to have some success on the festival circuit before attempting to sell your film? Do you always have to have festival success first?

3. What is the difference between a distributor and a sales agent?

4. What is a film buyer?

5. Name the six major distribution platforms.

6. What is a distribution territory?

1. How do release windows affect the distribution of feature and short films?

2. What is exclusivity? Why are buyers and distributors so concerned with exclusivity, and why do filmmakers generally prefer nonexclusive deals?

APPLYING WHAT YOU HAVE LEARNED

Research/Lab/Fieldwork Projects

The following lab projects will help you prepare for the work you will be doing in the next chapter.

1. Gather all of your deliverables and have them standing by, ready to send or hand over to any distributors, sales agents, or buyers who request them. The complete list of deliverables is available in Chapter 4 (Deliverables). The most requested deliverables will be:

 a. Actor releases

 b. Music releases

 c. One-sheet / DVD cover art

> **d.** Film synopsis
>
> **e.** Directors statement
>
> **f.** Complete cast and crew credit list
>
> **g.** The film itself (in various formats)
>
> **2.** Continue to promote your film in the real world and on the Internet. Let your fans know that you are about to enter the world of sales and distribution. Sprinkle your Webpage, blog, or newsletter with some of your newfound language.

BROADCAST DISTRIBUTION

OVERVIEW AND LEARNING OBJECTIVES

In this chapter, you will:

- Understand the big picture and general strategy of securing a broadcast distribution deal for your short film
- Learn how to find and approach distributors and sales agents
- Learn how to negotiate your deal
- Discover how to directly approach buyers

Broadcast Distribution Overview

Now that you are familiar with the language of the deal, we can delve into the really interesting part of this book: the particular aspects of how you will approach and deal with the people who can help you sell your film. Make sure you are comfortable with the terms discussed in Chapter 9 (Preparing for the Sale: the Language of a Contract), and feel free to go back and refer to that material while reading this chapter. From now on, I'll be using those terms and concepts frequently.

In this chapter I'll cover how to approach distribution companies, sales agents, and broadcast film buyers, with suggestions for how you can negotiate your deal with them. First, let's consider the entire scheme of the situation so you can get an idea of the general strategy you will use during this part of the distribution process.

1. Submit your film to a distribution company or sales agent

You'll research and find various distribution companies and/or sales agents and submit your film to them. They will look at your film and decide whether or not they feel they can successfully sell it to buyers with whom they have relationships. Depending on their size, experience, and overall commitment to quality, a distribution company or a sales agent will have relationships with many buyers on many different platforms in various territories. If they like your film and want to distribute it, then they will negotiate a deal with you.

2. Negotiate a deal

When the distribution company or sales agent decides to try to sell your film, they will present you with a contract that will outline the deal they are prepared to strike with you. The contract will spell out the details on the following items:

1. Fees: how they propose to divide any profits made from sales of your films on the various platforms and in the various territories they will sell to.

2. Territories: in what territories they will try and sell your film.

3. Exclusivity: for which territories and platforms they will want to have the exclusive rights to your film.

4. Term: the length of the contract.

5. Deliverables: what they expect you to deliver to them upon signing the contract.

You will consider the details, negotiate with the company, sign the contract, and deliver your film and deliverables to the company.

3. Continue the process for all worldwide territories and platforms

After successfully negotiating with a distribution company or a sales agent for a particular territory, you'll continue to approach other companies or agents in other territories and on various platforms. You want to take advantage of the worldwide market for short films, and although it's possible that your distribution company or agent will ask for worldwide rights to distribute your film, it's unlikely. Most companies and agents have relationships only with buyers in their nearby territories. For example, a distribution company based out of New York or Los Angeles will likely want domestic distribution, but the chances are slim that they'll also ask for foreign rights.

4. Explore contacting buyers directly

Depending on a number of issues (strategic decisions, success with distribution companies) you might also approach film buyers directly. Often, filmmakers put together multiple deals, some with distribution companies, some with buyers.

Finding and Approaching Distribution Companies and Sales Agents

Armed with your film, deliverables, press pack, knowledge of the language of the deal, and hopefully some festival experience, you're ready to start approaching distribution companies and sales agents about licensing your film. With all the careful preparation you have done up to this point, the next stage is actually quite straightforward. You'll do some research to find distribution companies and sales agents, put together a package consisting of your film and a few other items, and send it. The process is somewhat similar to researching and submitting to film festivals, although there is no online service like Withoutabox.com available for this yet. So the first key question becomes: how to find them?

How to find distribution companies and sales agents

In North America, there are dozens of distribution companies specializing in short-film distribution and just as many independent sales agents. The names and numbers of every company are difficult to catalog, because, like any other type of business, companies come and go. At the end of this chapter, you will find a list of some of the better-known short-film distributors; it is, however, just a small sampling, and you must be prepared to do your own research. Researching is part of the filmmaking process; it teaches you about the industry and helps you discern which company is best for you. Some are predominant in the field and experienced, and some are smaller and more recently established. Each filmmaker and his film will be best served by a particular type of company, and you need to go through the process of discovering exactly what type of company feels like a comfortable fit for you and your film.

Internet Research

When you are researching and looking for companies, you'll do most of your work on the Internet. Use a search engine such as Google and enter search terms such as "short-film distribution companies" and "short-film sales agents." Your Internet search efforts will, no doubt, amass an exorbitant amount of information on short-film distribution, and if you look carefully, you'll find names of companies, sales agents, and their contact information. There are hundreds of Web sites devoted to short-film production and many of them cover short-film distribution. Nestled among these sites are links, discussions, and contact information for many short-film distributors. You'll want the names and addresses of a contact person at the company because you'll be sending them a DVD and other items in the mail. While researching, it's a good idea to take notes about each company (anything is relevant: where they are based, how long they have been in business, what films they have distributed, what they specialize in, what their vibe seems to be, etc.). Listed below are just a few of the many Web sites devoted to short films that provide information about making and distributing shorts:

- Thesmalls.com
- Shortfilmcentral.com
- Shortfilms.com
- Shootingpeople.org
- Triggerstreet.com

- Filmmaking.net
- Futureshorts.com

Film Festivals and Markets

Film festivals are the natural habitat of distributors and sales agents, because it's a perfect place for them to scoop up fresh material. If your film wins a prize at a major film festival, you can expect distributors and sales agents to appear instantly, hoping to get you to sign with them before you sign with someone else. Even if you don't win a prize, or are not at a major festival, you should be on the lookout for distributors at festivals. You can ask the festival organizer if any distributors will be attending, and you can look for them at screenings, parties, or networking events (read everyone's name tag carefully, they might just be a distributor). Ask other filmmakers at the festivals, too—they might be able to introduce you to someone. Distributors are affable people: they are enthusiastic about films, and they're always looking for an interesting project.

An excellent place to meet distributors is at festival Q&A panels and workshops. Understandably, distributors are a valuable commodity to film-festival programmers, and they are constantly being asked to sit on panels and participate in festival workshops. It's a chance for them to promote their company or service, so it's a win-win situation for everyone. Attending these panels is an opportunity not only to learn more about the process, but also to actually meet distributors face to face.

KEY TERM:

Film Market A sales event that is run during the course of a festival as a way for distributors, buyers, and filmmakers to formally connect and do business. Many of the large film festivals run film markets.

Two of the most well-known short-film markets are the market at the Palm Springs Short-Film Festival and the market at Clermont-Ferrand in France. Typically, a festival that also runs a market will enroll every film being screened at the festival into the market (for no additional cost), therefore, many filmmakers submit to festivals with markets, for the obvious reason that there is a much greater chance of selling their film at such an event. Your first film-market experience might be exhilarating and a bit overwhelming: you'll observe the business side of buying and selling films first hand, and when you do, you'll realize that the short-film distribution business is booming.

World-class Film Markets. Film festivals such as the Clermont-Ferrand are distinguished by world-class markets. The market venue features separate video stations in private viewing rooms where film buyers can watch all the films, which are hosted on high-tech video servers. They can search for category and genre type, get filmmaker bios, and arrange face-to-face meetings. This makes life easier for the buyers: they don't have to sit through countless hours of screenings, they can sit at one monitor and have every film available to them instantly; they can watch hundreds of films, one right after the other, often watching only the first few minutes before deciding to reject and then moving on to the next. They are at the market on business, and must be as efficient as possible with their time. Don't expect to see many distributors or buyers at your actual screening, because most will be in the "back rooms," but you never know—some still enjoy the experience of being part of an audience and viewing films on the big screen.

At markets there are also expo-type areas where buyers and distributors set up booths with video screens and catalogs so they can sell and buy hundreds of short films. The market is geared mostly toward distributors selling catalogs of films to buyers. Distributors can arrange special screenings in huge, state-of-the-art theaters and invite film buyers from around the globe. There are parties, meetings, and events, and many deals are negotiated. A film market can be a great place to sell your film, so if you can, seek out festivals with markets and jump into the fray. You won't be wearing a sandwich board reading "film for sale," of course, but for your festival screening, you'll try to pack the theater with fans of your film, you'll network with everyone you can, and you'll hope that a distributor watching films in the "back rooms" will see yours and like it.

Networking to Find Distributors

A great way to meet a distributor is to be introduced to them personally by someone. Distributors see a countless number of short-film submissions, and one way to create an impression is to meet a distributor in person through a mutual friend or acquaintance. As you network at festival screenings, workshops, and parties, talk about distribution and find out what others know. If someone you know has recently struck a deal with a distributor, don't be afraid to ask for the name of the person they dealt with. Most of the time, a fellow filmmaker will freely share this type of information. Most of us realize that the success of our film is independent of yours, and although it might seem as if you are competing with everyone else, in reality, there is room for everyone.

You can also reach out to your online fans who have been following your blog posts and social-network updates. Imagine all those people who have been reading about your film. Start to post your musings about your quest to find distribution; they might be able to help. It could be that a friend of a friend of a friend actually knows a distributor, and might be willing to help connect you with him. That's the genius of using social networking to promote your film—you tap into all sorts of possibilities.

International Distribution Companies

Audiences overseas have historically been strong supporters of short films. Make sure you research companies that can help you get your films into foreign markets; often times these markets are the most lucrative. When doing your research, use a search term such as "international short-film agents" or "short-film distribution in Europe" (or "Asia," "South America," "France," "Japan," etc.). Although it might seem daunting to try to contact foreign distributors, it shouldn't be. The World Wide Web is all about connecting people, and you'll see that it's not that different from contacting someone in the USA.

As you do your research and compile a list of companies you want to approach, it's important to realize that the market for short films is just as wide, if not wider, overseas than it is here in the United States. Part of the reason for this is simple geography: there are many more film viewers abroad than there are domestically.

How to approach distributors and sales agents

It's of benefit to compile a long list of distributors and sales agents first, and then start approaching them. Don't worry about whom to approach first; you should approach distributors with an all-out "blitz." If you wait and just send out one or two reels at a time, hoping to be able to sell your film to the top companies first, the process will take too long. It's normal for your film to sit on the desk of a distributor for several weeks before they get to it. So put your list together, and get ready to do some mailing.

When you send your film to a distribution company or sales agent, it's essential to make a businesslike first impression. Your package will sit next to dozens of others, and distributors will not waste their time looking at a short film if they suspect that the film or filmmaker isn't ready for distribution. Your package must be professional in appearance. If something about your package sends up a red flag, there is a chance that the distributor will not even bother to watch the film.

Cover Letter

Before a distributor watches your film, he will briefly glance at your cover letter to learn who you are, what the name of your film is, and most important, whether or not he should bother watching. If your cover letter is unprofessional, a distributor will reason that your film is also, and he'll toss it in the garbage and move on to the next film. Your cover letter should be written with the same care you would take when writing a cover letter to a prospective employer. It should be in a business format, and you must take care to triple-check your grammar and spelling. Quadruple-check the spelling of the company and the name of the person you are sending the letter to! The body of the letter should be pointed and concise. You both know the reason for the letter; so don't offer an explanation of why you are sending your film, other than to simply say that you would like to submit the film for their consideration. You can certainly tout the success of the film—a few sentences about how well it has done will increase the chances of the film being watched—but don't convey your opinion of why the film is "good." Describe the film using your best and shortest synopsis that you have written for your press pack. You want to sell the film without sounding desperate or self-absorbed. Brevity is the key. The ideal length for the body of your cover letter is about one-half page. See Figure 10-1 for an example of a cover letter.

Press Pack

Believe it or not, when sending your film to a distributor or sales agent, you don't want to include everything that is in your press pack. A press pack is mainly for the press, and distributors will not be interested in much of this material at this stage. They are interested in only one thing: can I sell this film? The way they will determine that will be by evaluation of the film itself, and to some degree, an evaluation of any success the film has already had on the festival circuit. Including behind-the-scenes pictures or cast and crew credit lists will not help here. Including your biography, résumé, and director's statement might help, but it also might hurt.

Your Street Address
City, State, Zip Code
Telephone Number
Email Address

Month, Day, Year

Mr./Ms. Firstname Lastname
Title
Name of Company
Street Address
City, State, Zip Code

Dear Mr./Ms. Lastname,

Enclosed please find a DVD screener of my short film, "Your Short Film Title". "Film Title" is a "running time in minutes" short film about "very short synopsis here, 1-2 sentences".

"Talk about festivals, awards, positive reviews or other success stories, if applicable".

I appreciate you taking the time to review my film, and hope you enjoy it. If you are interested in it, please contact me at the above address, and I would be happy to talk more about the film, your company, and how we might work together.

Sincerely,

Your Signature

Your Name

FIGURE 10-1. When writing your cover letter, you must use a proper business format, keep the letter brief, and triple-check your spelling. Courtesy of Jason Moore. Used with permission.

If you are relatively inexperienced, your bio and résumé will hurt you by signaling to the distributor that your film might not be ready. If your director's statement is not pitch-perfect, you might do yourself a disservice.

With distributors, less is more. You are trying to get your DVD in the player as soon as possible, without signaling anything untoward. You do not want the distributor to watch the film with a false preconception that it might not be first-rate and he will not be able to sell it.

The DVD

Your DVD should be packaged in a hard case with cover art so that it looks like a DVD for sale or rent in any store. You don't have to have incredible photos or exceptional graphic design, but the more professionally

designed the cover appears to be, the better. One easy way to judge a film's qualities is by the cover art and overall package design. If the cover art and design is amateurish, it's usually a sign that the film is, too.

Follow Up

It's okay to follow up your package with an email or phone call, but be sure to be as professional as your letter. If it's been more than two weeks since you submitted your film, there are two likely scenarios: either the distributor is busy and has not had a chance to watch your film, or the distributor has watched your film and did not yet send you a rejection letter. Your follow up might clarify the situation, but don't expect that it will necessarily be beneficial. If the distributor is busy, there is nothing to do but wait. If they have rejected you, they might respond to your call or email or they might not. If you are polite and get to the point, there is no harm done, and it might ease your anxiety to discover what is happening.

Negotiating a Deal

If a distributor likes your film and wants to try to sell it, you'll soon get a phone call, letter, or email with the good news. Selling your film takes you up to the next level, and advances your film career. It's also potentially going to earn you some money, and of course, you are going to be elated. After all the long hours of hard work, hearing that film professionals think your work is of saleable quality is a reward more valuable than the money you might earn.

First contact

The distributor will likely start the conversation by praising your film and will then immediately want to know the status of your deliverables and film rights. This is where you want to be able to tell them that you have all the rights secured.

> *If you don't have the music, script, or talent rights, the phone call from the distributor might end as quickly as it began. Unless you have a solid plan on how to fix any of those issues, you are dead in the water. No broadcaster will buy a film from the distributor if the rights are not all locked down by the filmmaker. So, as I've said all along, you've got to have those rights secured.*

NOTE

Once that crucial issue has been positively confirmed, the distributor might tell you about their company and what they do, and what they can offer you. Listen carefully and take notes if you can. You can ask questions, and you should. You want to get a sense of what the company can do for you, what their experience is, and what level of commitment you can expect from them. Some questions you can ask are:

- How long has your company been in business? How long have you been with them?

- Are there any recent short-film sales you have made? (You probably won't recognize the names of these short films, unless you are really doing the festival circuit and know what is out there. Still, it's good to know.)

- What is your strategy for selling my film? What territories and platforms do you think it will do well in? You want to hear what they think of your film, what its selling points are, and how they think they can sell it. Every film is different: some have great stories, others

have amazing visuals, and some rely on strong humor. Each type of film will do well in some territories and platforms and not as well in others. You might not know how your film can be marketed and sold, but it would be good to hear from your distributor that *they* know.

Listen carefully to the answers, and take notes. Keep the conversation friendly and professional. At some point, the distributor or sales agent will probably tell you that they will email you a deal memo, contract, or some sort of documentation outlining the deal they are willing to offer. Thank them and say that you'll review everything and get back to them promptly. *Don't agree to anything until you have read their offer on paper!*

The contract

Distributors understand that most short-film filmmakers are not contract lawyers, and that many filmmakers might be seeing a deal memo or contract for the first time. They will likely send over a document that outlines in basic language what they are offering, with regard to all the items we've talked about: Fees, Exclusivity, Territories, Term, and Deliverables. They will also have a longer, more complex legal document that is the actual contract. Read over what they are offering, and if you don't understand something, or if you have a question, make a note. You can go back and ask questions for clarification, but you want to be organized when you do, rather than calling or emailing multiple times. If you like, you can ask a lawyer to look at your contract, but in most cases, you will be able to work through the fine points of the deal yourself. And, unless you know a lawyer willing to do it for free, the cost of having a lawyer review the contract will probably exceed the money you'll make on the deal. See Figures 10-2 through 10-5 for an example of a contract between a distribution company and a filmmaker.

 Note: This contract can also be found on the companion DVD.

Negotiating

You can and should discuss all the points of the deal with your distributor and make sure you are comfortable with the contract they are offering. Usually there is not a lengthy dialog between a distributor and a filmmaker over a contract, perhaps because most filmmakers are so thrilled to get their film distributed that they take what they can get, but also because most distributors are working on a fairly thin profit margin and cannot afford to increase their offer. There is always room for a conversation, questions, and counteroffers, however, as long as these negotiations are executed with

AGREEMENT

THIS AGREEMENT,

Jason Moore, located at 1920 Euclide Street #4 Santa Monica California 90404 USA (herein «the Producer»).

and

Talantis Films, a private limited company registered at the RCS of Paris under the number 98B11926, located at 30 rue Gassendi, 75014 Paris, France, represented by Sylvain Chivot.

WITNESSETH

WHEREAS the Producer owns and controls the copyright of the short-film entitled "Paradise Nebraska" by Jason Moore (herein «Film») and desires to sell the broadcasting rights to the Film in Europe (defined by the EEC law), in Switzerland, in United States of America, in Latin America, in Brazil, in Canada, in Australia, in New Zealand and in Japan.

WHEREAS Talantis Films desires to provide sales representative service to the Producer for the sale of the Film in Europe (defined by the EEC law), in Switzerland, in United States of America, in Latin America, in Brazil, in Canada, in Australia, in New Zealand and in Japan.

NOW, THEREFORE, the parties hereto agree as follows:

I. SALES REPRESENTATIVE SERVICE

1 The Producer appoints Talantis Films as his non-exclusive sales representative during the Term of this Agreement for the sale of the Film through all media support in United States of America.

2 The Producer appoints Talantis Films as his exclusive sales representative during the Term of this Agreement for the sale of the Film through all media support in Europe (defined by the EEC law), in Switzerland, in Latin America, in Brazil, in Canada, in Australia, in New Zealand and in Japan.

II. SALES COMMISSION

The Producer will pay to Talantis Films a sales commission of twenty five per cent (25%) of the paid value of the Film as stated at the Paragraph IV.

FIGURE 10-2. An example of a contract between a Distribution Company and a Filmmaker (page 1). Items covered on this page: the fact that the filmmaker "owns and controls the copyright," the fact that the contract shall be exclusive in Europe and other territories, and nonexclusive in the United States, and that the commission paid to Talantis will be 25%. Courtesy of Jason Moore and Talantis Films. Used with permission.

III. METHOD OF PAYMENT

Talantis Films will remit the payment to the Producer via international Money Order as direct deposit in French currency into the Producer's bank identified as Bank of America Westwood Village Branch # 0099-930 Westwood Boulevard, Los Angeles, CA 90024, account number: 09149-00380, sort code: 121000358, account name: Jason Moore.

IV. REPORTING BURDEN

A. Talantis Films will provide to the Producer a copy of the deal memo with all the acquisition conditions of the broadcasting rights of the Film proposed by the Buyer and the affiliated contract number.

B. Talantis Films will render to the Producer on a calendar quarterly period basis commencing with the quarter beginning upon execution of this Agreement and for so long as Talantis films receives collections under this Agreement, a statement in detail on a territory by territory basis showing collections received and all government taxes and commission deduction made by Talantis Films. Such statement will be delivered after the end of the applicable period and shall indicate Producer's share.
After having received an invoice from the Producer, Talantis Films also shall remit Producer's royalty payment to Producer with the statement. Talantis Films' commission shall be deducted at the same time as Producer is remitted its payment as stated at the Paragraph II and III.

C. The Producer will provide to Talantis Films all the information regarding the proposition made by a third to promote the Film on Internet.

V. REORDERS

During one (1) year following expiration or termination of this Agreement, the Producer will pay to Talantis Films the sales commission as stated in Paragraph II:

- for new orders of Film from the Buyer to the Producer or Talantis Films secured prior to expiration or termination of this agreement and resulting directly from Talantis Films' sales representation.

- for reorders of the Film from those Buyers whose prior purchase(s) the Film from as evidenced in prior invoices and orders.

VI. MARKETING SUPPLIES

The Producer will provide to Talantis Films the following materials relating to the Film:

- three VHS videotapes in PAL or NTSC
- one a Beta Master videotape in PAL upon a sale proposition.
- the technical characteristics

FIGURE 10-3. An example of a contract between a Distribution Company and a Filmmaker (page 2). Items covered on this page: how the fee will be paid, and how often reporting of fees will be done (quarterly), how re-orders will be handled, and what deliverables are required. Courtesy of Jason Moore and Talantis Films. Used with permission.

- the English synopsis
- the artists' biographies
- the still photographs
- the festival awards and the identification of prior and existing markets and carriers

VII. SUBTITLES

A. The Producer will furnish to the Talantis Films a French subtitled or dubbed version of the Film if it exits.

B. If the Buyer takes the financial charges of the subtitles or dubbing, the Producer will furnish to the Talantis Films a spotting list of the Film and accepts the creation of subtitles or dubbing without any financial consequences for either contracting party. Talantis Films will furnish to the Producer all the financial conditions made by the buyer to acquire the subtitled or dubbed version from the buyer.

C. If the Buyer does not take the financial charges of these subtitles or dubbing, the Producer will furnish to Talantis Films a spotting list of the Film and Talantis Films will render to the Producer price quotations for subtitles or dubbing for the Film prior to ordering subtitles or dubbing. In case the sale covers the subtitles payment, the Producer can decide to pay for subtitling or dubbing the Film after first inspecting written subtitle translation(s) to ensure adherence to the artist(s)'s intention(s) and broadcast standards.

VIII. TERM OF THIS AGREEMENT

This Agreement shall continue in full force from September 1, 1999 for a Term of two (2) years and will expire on September 1, 2001. Upon expiration, the parties hereto shall have no further obligation to each other except as noted in Paragraph V.

IX. CONFIDENTIALITY

Talantis Films and the Producer each represent and warrant that they shall not disclose to any third party (other than their employees, in their capacities as such) any information with respect to the financial terms and provisions of this Agreement except:

1 to the extent necessary to comply with the requirements of any guilds or unions,

2 to the extent necessary to comply with law or the valid order of a court of competent jurisdiction in which event the parties so complying shall so notify the order party as promptly as practical (and if possible prior to making any disclosure) and shall treat such information confidentially),

3 as part of its normal reporting or reviewing procedure to its parent company, its auditors or attorneys and such parent company, auditors or attorneys, as the case may be, agree to be bound by the provisions of this paragraph, or

4 in order to enforce its rights pursuant to this Agreement.

FIGURE 10-4. An example of a contract between a Distribution Company and a Filmmaker (page 3). Items covered on this page: partial list of deliverables (from page 2), terms regarding subtitles, the term of the contract (two years), confidentiality terms. Courtesy of Jason Moore and Talantis Films. Used with permission.

X. TERMINATION

After one (1) year of canvassing period with less than three sales of the Film by Talantis Films or in case of non-respect of the obligations mentioned in this Agreement, either party may terminate this Agreement at any time upon giving thirty (30) days prior written notice to the other party. Said notice shall be given to signers of this Agreement.

In the event of termination by the Producer, Talantis Films will be entitled to sales commissions earned for sales made prior to the date of termination and within the period governed by the terms of Paragraph V.

In the event of termination by the Marketer, Talantis Films will be entitled to sales commissions earned for sales made prior to the date of termination and within the period governed by the terms of Paragraph V.

Upon expiration, the parties hereto shall have no further obligation to each other except as noted in Paragraph V.

XI. LAWS GOVERNING/EFFECTIVE DATE

A. This Agreement is governed by and construed in accordance with the French laws and ruled by the Paris Court.

B. The terms and conditions of this Agreement are effective as of September 1st 1999 regardless the place, time and date signed by the parties.

XII. ENTIRE AGREEMENT

This Agreement and the Attachments hereto contain the entire agreement between the parties, and no representation, provision, warranty, term, condition, promise, duty or liability, expressed or implied, shall be binding upon or applied to either party, except as herein stated. No amendment or modification of any term, provision, or condition of this Agreement shall be binding or enforceable unless in writing and signed by each of the parties.

IN WITNESS WHEREOF, the parties have executed this Agreement as the date hereof.

Dated on September 1, 1999

Jason Moore
The Producer

Sylvain Chivot
for Talantis Films

FIGURE 10-5. An example of a contract between a Distribution Company and a Filmmaker (page 4). Items covered on this page: Termination clause, governing laws of the contract, and a statement saying that this is the entire contract. Courtesy of Jason Moore and Talantis Films. Used with permission.

professionalism and respect. This is not the occasion for haggling and tactics, it's about creating a positive, genuine relationship with someone who can actually move your career forward.

Negotiating Fees

Distributors and sales agents will be trying to license your films to buyers on as many platforms as they can, and when they do, you will get paid by that buyer, and the distributor or sales agent will take a fee. Often, film buyers have basic, set prices for films. Every deal is different; a standard formula that has been used in broadcast distribution, for shorts, is between $100–$500 per minute, for each deal and/or buyer. Because film buyers often have set prices, this gives distributors less room to negotiate with filmmakers. Often a distributor will offer a profit sharing ratio: it could be 50/50, 60/40, 70/30, or in that range. Some times the larger share of the money will go to you, other times it will go to the distributor. They rationalize this because they do the largest share of the work to sell the film: reaching out to buyers, negotiating the contracts, supplying buyers with deliverables, doing the accounting, and so forth. There are overhead costs associated with running a distribution business, and they have to make money too. Often, the profit sharing ratio is not really negotiable, but you can try.

Although it will be thrilling to get that first check in the mail, distributing your short film is not about making money; it's about the prestige of achieving success and using that prestige to further your career.

Sometimes a distributor will offer you an *advance*. For example, if you receive a $500 advance, and they then sell your film for $1000, and your agreement is a 50/50 split with the distributor, then you won't receive any more money: the advance was an interest free loan "borrowed against" that fee of $1000, 50% of which is $500. If, however, they go on to license the film to another buyer for another $1000, then you'll soon see a check for $500 in the mail.

KEY TERM:

Advance An amount of money that a distributor pays to you as an incentive to sign with them. It is usually "borrowed against" future sales, meaning, it's a loan against the money they think they will be able to make for you.

Negotiating Exclusivity, Platforms, and Territories

A distributor will want you to be exclusive with them in the territories they represent and on the platforms they represent. If you sign with a big North American distribution company, they will likely want you to be exclusive with them on all platforms in North America, and might even want worldwide Internet exclusivity. This implies that once you sign with them, you can't sign with any other distribution company that will try to license your film on any North American platform or the Internet. This is the only way they can make money, usually, so negotiating nonexclusive deals is not often possible. There are, however, many territories where you will still be at liberty to try to distribute your film. Once you sign a North American deal, you can start looking for a European deal—or perhaps several deals in Europe with distribution companies working within individual countries. You might do a deal with a North American company for all North American platforms, and then sign several deals with individual sales agents in France, Germany, Italy, and other areas.

Some distributors might want exclusive rights only to certain platforms, leaving you free to make deals with other distributors or buyers on platforms they don't represent. For example, it's possible that a distributor might specialize only in broadcast, home entertainment, and Internet. They might not have connections in the educational market, or the mobile market. In that case, you'd be free to continue trying to sell your films on those platforms, regardless of the fact that they are in the same territory, because your distributor does not want exclusivity on them.

One thing to be cautious of is any company wanting worldwide exclusivity on all platforms. That will tie you to that company only. Are they really that big and global? They have relationships with broadcast buyers in every country, all over the world? It would be best to be cautious about signing a contract like that. Most distribution companies have relationships with broadcast buyers only in their own country, or perhaps region of countries (Europe, South America, and so forth).

Negotiating Internet Deals with Distributors and Sales Agents

You should expect that most distributors and sales agents will want the option to try and sell your film on the Internet. Although this chapter is centered on broadcast distribution, when it comes to contracts with distributors, you'll need to be prepared to negotiate the Internet rights. Of course you want

your film on the Internet, that's where everyone in the world can see your film. You don't want to relinquish total control of your own film, however, especially if the term of the contract is long. If the distributor wants a multiyear term, it could be years until you have the right to put your film up on the Web wherever you want to. The advantage is that your distributor will be trying to put it on the Internet for you, and will make money for you in the process. Still, many filmmakers today want to have control of their Internet rights; they see the value of being able to put their films on giant video sharing sites such as YouTube, Google Videos, Vimeo, and the others. Additionally, it's possible to put your film on many paid Web sites yourself, without help from a distributor, and in that case, you won't need to split profits, however, some Web sites, especially the prominent ones such as iTunes®, are difficult to work with if you don't have a distributor. This will be discussed thoroughly in the next chapter; for now you need to know that as you assess your situation carefully, you must consider this: it's all about the Term of your contract:

Negotiating the Term

Your distributor will suggest a term for your contract, which can be anywhere from one year to five years, in most cases. If you sign a two-year contract with the distributor, you're working with them for two years, and your film will be tied to them on the particular territories and platforms agreed upon. A term will never be shorter than one year—it takes months for a distributor to get your film into the hands of all the buyers they work with. A reasonable approach is to ask for a one-year term with the option to re-sign at the end of the year. This allows you to evaluate the relationship and either terminate it if you're not happy or re-sign if you are. The term is especially important when considering your agreement on Internet distribution. If you sign a two-year contract and they have the Internet rights, you will not be able to put your film on the Web until the two years are up. If things are going well, that's fine, but what if they are not having success distributing your film? You might decide you'd be just as happy getting it up on YouTube and getting some buzz, but they might not be willing to do so, if there is no money in it for them. Generally, distributors want to support their filmmakers in any way they can, and hopefully you work together toward mutual success. You want to look out for yourself, however; signing a long-term contract has plenty of advantages for the distributor (gives them more time to keep trying to sell you) but does have some disadvantages for you (if they are not successful, your hands are tied). So always try to negotiate for a one-year term with the option to renew. Otherwise, ask if you can have an option that if both parties

agree, the contract can be voided. Sometimes they will agree to this: if the film is not selling, they realize you might want to explore other options, and often they understand that. Most distributors won't want to keep you in a deal you are unhappy with. You've got to discuss all of these issues with them before you sign the contract!

Approaching Broadcast Buyers Directly

Although working with a distributor has its advantages, approaching broadcast television buyers directly, without a distributor, can be advantageous in some situations. The obvious advantage is that you don't have to share your licensing fee. If you and a buyer can negotiate a contract, then all the money is yours to keep. Considering that some distributors take 50% or more of your profits, that's a significant increase in revenue. You will, however, have to research and approach every buyer yourself, as opposed to sitting back and letting your distributor do the work. Another disadvantage is that buyers might be slightly less willing to walk you through the process of the contract, deliverables, and everything else that's involved. Whereas distributors deal with filmmakers all the time and understand that many filmmakers need the process explained, buyers deal primarily with distributors, so they are not used to having to lead someone through everything. That said, approaching broadcast buyers directly is common, and can be a great way to distribute your film. There are a few things to consider:

Finding broadcast buyers

In North America, the list of broadcasters buying short films on a regular basis is pretty short. Network television stations (ABC, CBS, etc.) don't regularly buy shorts, but cable companies like Showtime, HBO, IFC, and PBS do, and so do dozens of smaller regional cable channels. Finding the buyers involves a bit of research, but using search engine terms such as "short-film cable television buyers" will provide some contacts. Lists of buyers and contact information for them are available, but they are always changing, so you have to invest some time in this type of research. Networking, attending markets and festival workshops, and searching filmmakers' Web sites are the proven methods for locating and contacting buyers. A distributor would use as a selling point for their own services the fact that it takes work to track down buyers.

*Buyers exist and the Internet makes it easier than ever to find them.
A short Internet search recently led me to the contact information
of a local PBS station, WNET in New York, and from there it
would be a matter of emailing and asking for the head of their
Programming department. Generally, you'll have more luck with
smaller broadcast companies than with big ones. There are plenty
of international film buyers out there, and contacting them is no
different than contacting a domestic buyer—you can assume that
if they are in the international film business, they will understand
your English, and of course if you can communicate in their native
language, all the better.*

<div style="text-align: right;">

NOTE

</div>

A list of several international and domestic short film buyers is included at the end of this chapter, however, the list is not exhaustive and the companies listed can come and go, contact information might change, and so forth.

The contract

The contract with a buyer will concern only that particular broadcaster (a network or cable-TV channel) and will focus on similar issues of term, fee, territory, and exclusivity. The broadcaster will likely want an exclusive deal for the broadcast platform in their territory (but in some cases they might be willing to do a nonexclusive deal) for a term of one to two years. The term could be less if they are planning only a one- or two-occasion event such as for a themed short-film program. They will very likely not want the film to be on the Internet, but might not care about other platforms such as Education or Mobile. They might find it acceptable for you to do some Home Entertainment deals for DVD sales, but will probably not want your film available for On-Demand, because they see that as direct competition. All of these contract items are negotiable, but as with distributors, buyers usually have a fairly set contract and may not be willing (or able) to negotiate broadly.

Getting paid

Getting paid from a buyer is usually fairly straightforward. They will probably offer a per-minute fee to be paid upon delivery of the signed contract and film (in whatever format they request, probably Digi-Beta or some other professional tape format). There are no advances or per-view payments, just a one-time licensing fee.

In the following interview, distributor Sylvain Chivot shares his advice and experience with regard to acquiring and distributing short films.

INTERVIEW WITH DISTRIBUTOR SYLVIAN CHIVOT

Sylvian Chivot is a distributor at Talantis Films, France, and is a producer at Talantis Productions.

JM: *What general advice do you have for someone looking for a distributor?*

SC: Look for a distributor who has a variety of art styles in their catalogue, because this gives them the most opportunities with international buyers. It's a good idea to have a phone conversation with a distributor before signing with them, to see how they work. Avoid a distributor who says they have more than three hundred films in their catalogue, because it will be difficult for him or her to give your film the attention it needs. Be careful with beginners too, and make a one-year contract at the most, with an auto-renewal option. You should expect that commissions (what the distributor takes from the license fee) is somewhere between 35% and 50%. You should ask if they will provide a quarterly period report, which is standard. Don't try to argue too much on the contract if what they are offering is too far from what you want. A distributor won't spend very long going back and forth, because the money is not high enough to debate. Hassling a distributor over a few percentage points or who pays for the copies is a waste of time.

JM: *What types of short films are you finding success with?*

SC: The main target today is the teenagers, so popular films (not art films) are doing well. Comedies that are not too talky (do better internationally). CGI Animated films, Sci-Fi, Thriller, Horror and Special Effects like *405* and *Pixels*. Films should be visual, musically good, and have good actors. Don't work with people who want to be actors, you need people who are already good actors! A short film never has enough money for crew or the set, but good actors can make your audience forget your low budget. Good acting will appeal to the imagination of your audience.

JM: *How involved do you get with Internet distribution?*

SC: The main money still comes from TV broadcasters, but the Internet can make money thanks to commercials, like on YouTube. My company, Talantis, has a channel showing short films featuring animation and special effects. We can make some money there through the ad-supported model YouTube has created. Other Internet Video On Demand sites won't earn you much money, unless the company will offer a Minimum Guarantee of about $1000, because after that, there will not be much revenue. With YouTube, we can put a film on the site, and if a TV broadcaster wants to acquire it, we can easily restrict access to that film in the territory the broadcaster is in, so there is not much of a conflict between Broadcast and Internet.

JM: *What is the value of working with a distributor rather than trying to approach buyers directly?*

SC: Usually one single film doesn't interest a buyer, they prefer to acquire a package. A distributor will collect films from multiple filmmakers, then bring a package of films to the buyer.

JM: *What are some tips you can give to filmmakers who want to make a film that can be distributed?*

SC: Running time should not be over twelve minutes. For international sales, not too much dialogue. Good rhythm, very visual, good acting, good music. Your DP is a very important part of the success of your film, it should have a good look to it.

JM: *What is some advice for filmmakers as they approach you with their film?*

SC: An email presentation with a few good pictures can help get things going. A good synopsis is very important. Put a nice sticker on the DVD and make sure to mark it with the title of the film, length, director's name and contact information.

JM: *Thanks Sylvain. Is there anything else you would like to add?*

SC: A short film is a good way to work toward directing a feature film. Think about writing a feature film script after your first or second short film. Try to start making your first feature after three short films. You don't want to risk wasting time and money making too many short films when you could be looking for money for a feature!

SUMMARY

In this chapter we focused on obtaining the first of your professional successes: broadcast television distribution. You learned the details of the filmmaker/distributor relationship, how to research and find them, and how to approach them. You also learned what to expect when it comes to contracts, and how best to negotiate a deal for your film that is mutually beneficial for you and your distributor or buyer. You also learned how to approach broadcast film buyers directly.

Remember that when making a deal with a distributor for broadcast distribution, you might also need to negotiate other platforms such as Internet, Home Entertainment, Mobile, and so forth. In the next chapter, there will be further details concerning the nature of these platforms and what you can expect, so although you should start your research and preparation, don't actually send your film to distributors yet. There's more to be learned and you want to be completely informed as you embark on your new venture.

REVIEW QUESTIONS: CHAPTER 10

1. There are five key points that you must understand when negotiating a contract with a distributor. Name as many of them as you can.

2. What are the three common ways you can meet distributors? Explain the process of each method in as much detail as possible.

3. What are the three important elements of the package you send to a distributor? What are the key things to consider for each element?

DISCUSSION / ESSAY QUESTIONS

1. In your own words, describe the filmmaker/distributor relationship. What are the four basic steps a filmmaker takes when working with distributors, sales agents, and film buyers?

2. Based on what you've read, write a short essay describing your philosophy toward negotiating a deal with a distributor. What kind of a deal are you looking for? Specifically, what is most important to you? What parts of the contract are you most curious or concerned about? How would you like to see the negotiation conclude?

Research/Lab/Fieldwork Projects

The following lab projects will help you prepare for the work you will be doing in the next chapter.

1. Research distributors, sales agents, and film buyers and compile a list with their names, contact information, and notes about the company. The list should include, at a minimum, ten distributors and ten buyers.

2. Write key talking points and questions to use during your "first contact" phone call or email exchange. Do a mock phone interview with a friend or experienced filmmaker or a film student, with the other person playing the part of the distributor. Practice speaking in a professional manner, and ask appropriate questions.

3. Write the cover letter that will accompany your film when you begin to approach distributors. Refer to the points made in this chapter and work with your mentor to make this letter perfect.

Distribution Companies and Short Film Buyers: a Partial Listing

Included below are two lists of some short film distribution companies and short film buyers. There are both domestic and international companies listed. Several more companies exist, and you can find them by using the basic research skills I've described in this chapter; you must research each company carefully before submitting. Read about what they do, who they are, what their submission rules are,

and what types of films they are interested in. You'd be ill advised to send an email or send in a submission without understanding everything you can about the person or company. Good luck, and be persistent.

ON DVD

NOTE *The following lists can be found in Appendix A or on the companion DVD. A sample of each list is included here. This is a partial listing of domestic and foreign short film distributors and buyers. Do your research before approaching anyone on this list! Courtesy of Jason Moore. Used with permission.*

Short Film Distributors - Domestic and Foreign

Canada
Ouat Media
www.ouatmedia.com
2844 Dundas Street West
Toronto, ON, M6P 1Y7 CANADA
Tel: +1 416 979 7380

England
Dazzle
hwww.dazzlefilms.co.uk
Unit P102, Penn Street Studio, 23 - 28 Penn Street
Hoxton, London, N1 5DL, UK
T: +44 (0)20 7739 7716

United States
Cinetic Media
www.cineticmedia.com
555 West 25th St. (4th floor)
New York, NY 10001, USA

Indiepix
http://blog.indiepixfilms.com/
31 East 32nd Street #1201
New York, NY 10016, USA

Omni/Filmgrinder
www.omnifilmdistribution.com
Linda Cavatto
1107 Fair Oaks Avenue #816
South Pasadena, CA 91030

Shorts International
www.shortsinternational.com/
Acquisitions:
Linda Olszewski
P.O. Box 2514, Toluca Lake, CA 91610, USA
E: linda@shortsinternational.com

Strand Releasing
www.strandreleasing.com
6140 W Washington Blvd
Culver City CA 90232
T +1 310 836 7500

Short Film Buyers – Domestic and Foreign (*Selected*)

Australia
Special Broadcasting Service - SBS
14 Herbert St. NSW 2064 Artarmon - Sydney Australia
Tel. : +61 2.9430.3602
www.sbs.com.au

Lien Aguilar - Short Film Acquisitions
lien.aguilar@sbs.com.au
Broadcasts in 65 languages. Short film acquistions: seeks films for the program "Eat Carpet," maximum running time: 20′. All genres. Films must be in English or subtitled. Period of license: 3 years. Territories: Australia. Fee per minute: AUD$120.

Canada

Movieola Short Film Channel

For short film acquisitions: Running time between 30′ and 40′, all genres (fiction films, animated films and documentaries), films must be in English or subtitled, 2- to 4-year contract , non-exclusive broadcast for Canada, via cable and satellite, fee per minute: between 20 and 35 Euros.

M6P 1Y7 Toronto Canada Tel. : +1 416.492.1595

info@movieola.ca www.movieola.ca

Jennifer Chen - Head of acquisitions, Programming Director

Jennifer.Chen@tvchannelzero.com

France

Canal+ France

1, place du Spectacle 92130 Issy-les-Moulineaux France

Tel. : +33 1.71.35.35.35 For short film acquisitions:

Lorraine Sullivan - Film Acquisitions

lorraine.sullivan@canal-plus.com

Maximum running time: 30′ - but 15′ and less preferred

License Period: 1 year - exclusive - unlimited broadcastings

Broadcasting Territories: France - French speaking Swiss - Dom Tom Broadcasting ways: Satellite - Cable - Terrestrial - Internet - VOD Price per minute: between 250 and 800 €

Shorts TV - Shorts International

Tour Ariane 5, place de la pyramide 92800 Puteaux France

Tel. : +44 207.613.5400

www.shortsinternational.com

Julien Hossein - Representative

julien@shortsinternational.com

Germany

NBC Universal Global Networks

Theresienstr. 47a 80333 Munich Germany Tel. : +49 89.381.99.0

www.nbc-universal.de

Bjoern Fickel - Acquisitions

Bjoern.fickel@nbcuni.com

Great Britain
Spafax UK
the Pumphouse 13-16 Jacob's Well Mews
W1U3DY Londres, Great Britain
Tel.: +44 2079062001
www.spafax.com
Sophie Wesson - Acquisitions
swesson@spafax.com
Activity: Sells programs to airline companies
Maximal Running Time: 30', but flexible
 Types: every type, but no politic or religious themes, in order to suit all the
customers – airline issues/crashes
Version: English subtitles obligatory
Length of contract: 6 months
Territories of broadcasting: the World
Broadcasting ways: On airline companies' partners
Price per minute: to negotiate

Italy
NBC - Universal Global Networks Italia
Via Po, 12 00198 Rome Italy
Tel. : +39 06.85.209.441
www.studiouniversal.it
Vincenzo Scuccimarra - Acquisitions
orsola.clausi@nbcuni.com

Spain
Canal 9 - TVV
46100 Burjassot (Valence) a
Tel. : +34 96.318.30.00
www.rtvv.es
Vicente Suberviola Lloria - Programming and Acquisitions Director
suber@rtvv.es
Running Time: between 5' and 15'
Types: Comedy and animation - more rarely: Drama, fantastic, musical comedy, documentary
Version: English or English subtitles + List of Dialogs
License Period: 1 year
Price per Minute: 150 € Acquire more or less

United States

Atom Films
225 Bush Street - Suite 1200
San Francisco, CA 94104
Tel.: 415.503.2400
www.atomfilms.com

Eurocinema (USA)
4045 Sheridan Ave -#390
Miami, FL 33140
Tel. : 704.814.6965
www.eurocinema.com
Steve Matela - Vice-President
stevem@eurocinema.com
TV Channel. For short film acquisitions: Films of all genres and running
times, films must be in English or subtitled, 5-year contract renewable for
4 years

Kqed
2601 Mariposa St., San Francisco, CA 94110
Tel.: 415.553.2218
www.kqed.org
Scott Dwyer - Programming Director
sdwyer@kqed.org
For short film acquisitions: Running time between 2' and 26'. Genres: fic-
tion. Films must be in English or subtitled in English. License period: 3
years non-exclusive for California. Fee per minute: US$100.

Swamp - Southwest Alternate Media Project
Houston, TX
Tel.: 713.522.8592
www.swamp.org
Mary Lampe - CEO
mmlampe@swamp.org

NON-BROADCAST DISTRIBUTION

OVERVIEW AND LEARNING OBJECTIVES

In this chapter, you will:

- Learn about non-broadcast distribution platforms such as Internet, Home Entertainment, Educational, and Mobile
- Understand how to negotiate non-broadcast platforms with your distributor
- Learn when you should move into DIY distribution

Non-Broadcast Distribution Platforms

In the last chapter, you learned about broadcast distribution and how to find, approach, and negotiate with distributors and buyers. You studied the major elements of a contract, including platforms, territories, fees, terms, and exclusivity. The focus of the last chapter was on understanding the broadcast distribution platform; in this chapter we'll cover other platforms, considered "non-broadcast," such as the Internet, Home Entertainment, Educational, and Mobile. These are called "non-broadcast" simply because they are platforms that deliver media to audiences in ways other than via the traditional television and cable networks. These additional platforms will likely be included on your contract with a distributor, and you'll want to understand what they are and how they work so you can negotiate the best arrangement for yourself that you can.

NOTE

Although the broadcast distribution deal is considered to be the more prestigious and is likely to be the most lucrative, it's not the only significant venue. Various other platforms offer you the chance to increase your earnings and to gain additional exposure. In fact, with television and the Internet converging rapidly, the Internet deal might soon become just as important, or more so, than the television broadcast.

Securing Internet distribution (Either with a distributor or DIY style): Step 4 of your distribution plan

Most people are familiar with watching video on the Web. We've seen funny videos on YouTube, we've watched TV shows on Hulu™, we've rented or purchased movies on iTunes, and we've received viral videos in our email inboxes. Some of you, might have downloaded movies using peer-to-peer networks such as Bittorrent. The Internet is a huge repository for media, and now, as a filmmaker, you will have the chance to tap into it. Welcome to Step 3 of your distribution plan: securing Internet distribution.

Video on the Internet has become more prevalent in the last few years, and the number of outlets for short films has grown exponentially. The timing could not be better for your career: never before have there been so many ways for you to get your film seen and even sold! With the ever-increasing number of opportunities, however, the competition has also grown exponentially; you

need to make wise decisions from a clear and thoroughly knowledgeable perspective. The foremost challenge will be to simply stand out from the crowd, but you also must understand the differences among the myriad of Web sites, and form your strategy based on that comprehension. When do you release the entire film? Where? Should you allow your distributor to make your Internet deals or should you do them yourself? Should you give the film away or try to get paid? Can you put the film on multiple Web sites at once? What is the most reasonable and intelligent plan for this platform? In this chapter, and the next, we'll explore the Internet in detail so you can answer these questions and take advantage of all the Web has to offer.

Because there are so many options available to you on the Internet, the most helpful way to understand them all is to categorize them. I've divided Internet distribution into three categories:

- *Paid Internet deals through a distributor*

- *Paid Internet deals done DIY (do-it-yourself) style*

- *Unpaid Internet deals done DIY style*

NOTE

In this chapter, we will look at paid Internet deals through a distributor. In the next chapter, we will look at the other two types of DIY distribution.

Paid Internet deals through a distributor

Currently, although there are hundreds, if not thousands, of Web sites featuring feature films, TV shows, and short films, one seems to be universally regarded as more prominent than the others: the iTunes Store. Accessed through the iTunes application for Mac and PC, the iTunes store has, in a relatively short time, revolutionized video on the Web (and in the home, through Apple®TV). With departments for music, television, movies, podcasts, audio books, eBooks, and applications, iTunes has grown from an online music store to a giant media outlet. The volume of sales is staggering: customers have downloaded over ten billion songs, the iTunes music library is the largest music catalog online, with over eight million songs, and video rentals exceed 50,000 videos a day. Needless to say, it's the prime destination that most short-film filmmakers target. Unfortunately, getting your short film into the store is not easy. Individual submissions are not accepted by iTunes, so going through a distributor is just about your best prospect.

If your distributor wants to handle the Internet platform for your film, you want them to be talking about iTunes. Your distributor will work out the pricing structure and term with Apple, but generally you can expect Apple to take a small percentage off the top, leaving you and your distributor to split the remaining profits from iTunes Store's sales and rentals.

The obvious upside to getting your short film into the iTunes Store is the sheer numbers of customers that click their way into the store every day; the only downside is that your film can get lost in the shuffle. Apple promotes only the most popular movies, so viewers will have to search and browse quite a bit to locate yours. You understand by now, however, that it's not all about money: it's prestigious to have your short film on iTunes.

Although the iTunes Store does have relationships with other short-film distributors, the distribution company "Shorts International" currently has the strongest relationship with iTunes; so if this destination is important to you, submit your film to them.

The iTunes Store has a reputation for being fairly selective, so beware of distributors bragging that they can "get you into the iTunes store."

Read the fine print: most companies cannot guarantee entry, only that they have a relationship with iTunes and can persist in placing your film for consideration. That said, just to be in the queue to be considered by iTunes is difficult enough, so a distribution company that can do this for you does have leverage over those that can't.

Although there are many other Internet options for distributing your film, you don't need a distributor for many of them. Aside from the iTunes Store, you can self-submit your film to just about any Web site or company on the Internet. Because there are a number of sites that can help you profit from your film, you want to be careful about allowing your distributor to handle these other deals. Why? Well, because you'll potentially be losing a bit of profit. For example, the online video site Babblegum.com, (Babblegum and many others will be discussed in great detail in the next chapter) will allow anyone to submit their short film and if it's good enough, they will host the film in a "for-pay" model. Ads will be played before and after your film, and revenue generated from those ads is split 50/50 between Babblegum and the

film owner (you). If your distributor submits your film, you'll have to split your 50 percent with your distributor. It doesn't make much sense to let a distributor field this type of deal unless you don't want to take the time and effort to research and submit yourself.

Home entertainment

Home Entertainment, as discussed in Chapter 9 (Preparing for the Sale), covers Video On Demand and DVD Sales/Rentals. The lines between Home Entertainment and Internet distribution are blurring, with the two platforms beginning to merge, so in some cases it's difficult to discern exactly in which category a specific platform really is. The iTunes Store, for example, is generally thought of as an Internet platform, because the entire catalog of media is available "on the Web" (actually, it's on Apple's servers, accessible through the iTunes application, not the Internet). In many ways, however, iTunes is "Video On Demand," offering an experience similar to that of the cable channels that allow you to rent a movie and charge the fee to your cable bill.

The term "VOD" used to refer only to the cable interface, but as iTunes, Hulu, Amazon, Zune, and others have started offering ways to pay for Video On Demand, Home Entertainment and Internet platforms are becoming more difficult to tell apart. Whereas in the past, the term Home Entertainment used to cover all VOD, now the various VOD services are spoken about as separate entities. You hear terms such as "Cable VOD" when talking about renting movies from cable channels. You hear "iTunes" to refer specifically to Apple's VOD, you hear Amazon VOD to specifically refer to Amazon's service. The lines are blurring with Hulu, Zune, and, of course, YouTube and all the other hundreds of Web sites, which are, in effect, doing Video On Demand.

As mentioned in the section above, the various other Internet options will be covered in the next chapter, so in this section, we'll discuss cable VOD only. It will be a short discussion, because there are no longer many outlets for short films on cable VOD. Cable VOD used to be a viable outlet for shorts, but in the last several years, as the Internet has grown, the cable VOD market has changed. Currently, cable VOD in the United States is mainly a platform for theatrical feature films and straight-to-video feature films. Don't be overly concerned; as the cable VOD market for shorts has dissipated, Internet VOD has usurped its place expansively.

DVD sales and rentals are also considered part of the Home Entertainment platform, and here again, the lines are blurring due to the rapid growth of the Internet. Several years ago it was common for distribution companies to package groups of thematically similar short films into DVD compilations and to sell them to video rental stores. With a number of rental stores going out of business and on-line viewing growing, these DVD compilations are not as popular any longer. There are still a handful of companies making DVD compilations, and it's possible that your distributor might have relationships with them. Cinema 16, Shorts!, and a few other organizations still regularly put out DVDs, but the bulk of DVD sales has shifted from a distributor-driven platform to a DIY platform. Now, because of the Internet, just about anyone can sell a DVD over the Web—and millions of people are doing just that. Services such as Amazon's "CreateSpace" and several others

allow filmmakers to sell their DVDs directly to the public. There is less demand for short film compilations simply because audiences are now able to get short films in so many other ways. Times are changing; but for short-film filmmakers, as the old distribution platforms close, new ones open, and the new platforms are quite broad.

When negotiating with your distributor for the Home Entertainment platform, ask them to give you an idea of some of the specific buyers they will be approaching. You might find that international cable VOD and DVD sales/rental markets are a bit stronger than domestic ones, which is yet another reason for embracing foreign distribution deals.

Educational

The educational platform for short films is a very specific niche. Educational films are used in the classroom as an instructional method. They can be documentaries, training films, or any type of film with a primary goal to help teachers educate their students. On first consideration, it might seem that a traditional, narrative short film would not fit into this market, and indeed, most do not. If, however, you have a short film that can help illustrate a learning objective that a teacher is teaching, the educational market might be a viable platform for you. Narrative short films that have the appropriate type of message can be a creative and entertaining way for teachers to spark conversations and debates on a variety of educational topics. Films that deal with issues such as gender, race, health, sexuality, politics, or other social issues can find distribution in this market. Films focused on children's themes are also popular. Short documentaries have an even greater chance of success than short narrative films because their initial objective is to educate.

Films that are able to sell on this platform must be suitable for classroom audiences; nudity, adult language, excessive violence, and the like are guaranteed to disqualify your film.

Although most narrative shorts are not suitable for the educational market, those that are could enjoy substantial success. The distribution network is very widespread; consider the hundreds of thousands of schools across the United States. If your film can tap into the educational market, you could

see significant revenue. It's likely that your distributor will instantly recognize potential for the educational market and inform you, and you'll want a distributor who has the appropriate connections if that is the case.

The educational-film platform is wide enough that there are dozens of distribution companies that deal only with educational films. One option for you, if your film meets the educational platform criteria, is to approach these companies with your film in the same way you would a traditional one: write a professional cover letter and send your film. They operate in the same way a traditional distributor does. Research educational distributors by using a search engine and enter "educational distribution for short films" or "educational-film distribution companies." A sample listing of educational-film distribution companies is included at the end of this chapter.

Some filmmakers don't find traditional distribution but do very well on the educational platform, and others are able to find success here in addition to other platforms. If you feel your film has a chance of succeeding on the educational platform, take the time to pursue this venue: you might sign some lucrative deals. The fact that you'll also be facilitating the education of students in classrooms across the country is also a considerable incentive.

Mobile

Like the Home Entertainment platform, the Mobile platform for short films is changing rapidly. Mobile entertainment is sometimes referred to as the "fourth screen"; the first screen is the movie theater screen (theatrical), the second is the television screen (broadcast), the third is the computer screen (Internet), and the forth is mobile phones and portable media players. Mobile entertainment started out as "value-added" content that a mobile-phone provider such as Verizon® or AT&T™ would offer its customers as an incentive to subscribe to their phone service. Before phones could easily connect to the Internet, phone companies provided users with access to entertainment content available on their cellular networks. This content was usually in the form of short films and videos, most of them of very poor quality, and was usually produced specifically for the phone network.

There are a few companies that still specialize in distributing mobile content. MDistribute®, for example, offers services for both filmmakers (upload your films and set a price) and film buyers (buy films for a set price, then offer your subscribers the content). Most of this content is delivered to foreign cellphone subscribers as an additional subscription service they can add to their existing phone plan, and the subscriptions usually offer more than just video, they also include ringtones, wallpapers, and games. Although technically the content might be called "short films," in reality they are similar to low-budget, low-concept comedy scenes specifically filmed for the mobile market. HungryFlix® also specializes in distributing mobile content under the same business model of connecting filmmakers to their audiences. This company has a broader array of content and there are a multitude of short films for sale. In either of these cases, you would not need a distributor to negotiate the deal, you can approach the companies directly, and the process is as simple as registering at the site, uploading your film and cover art, and setting a price.

The mobile market is expanding every day, and if your distributor has relationships with buyers of mobile content, then you should certainly allow them to handle this platform. Given the rapid merging of the Internet and mobile platforms, however, you might be just as well suited to handle this platform yourself. Let your distributor make their case and present their plan, and make an informed decision based on what you now understand about these platforms.

TIP

Other non-broadcast platforms

Wherever there is a video screen and an audience, there is potential for distribution on some level. Distributors have found outlets for short films in a wide variety of places other than the most common, which we have already discussed. Deals have been made for short films to play on airplanes, in hotel rooms, in kiosks, restaurants, at conferences and public gatherings, and any number of venues. Distributors have a knack for finding creative ways to earn money from their short-film catalog, so don't be surprised if your distributor has ideas for your film other than those we have discussed. Generally speaking, any outlet for your film is a viable outlet, and if you can earn money and gain exposure, even if the film is playing in an unusual venue, you should probably take it. Ask your distributor what other platforms they have experience distributing too, and work with them to do what you can to get your film out there!

When to Move to DIY Distribution

We are now concluding the portion of this book that covers working with distributors and sales agents in order to secure a broadcast deal. In addition to showing you how those arrangements work and what you need to do in order to negotiate an agreement for yourself, this chapter focused on the diverse platforms where a distributor might want to sell your film. As you can see, there are many excellent reasons to want a distributor for your film; there are also several opportunities for you to pursue on your own. The Internet is the platform with the largest potential for making your film available for viewing by a vast number of people and it's almost entirely a Do-It-Yourself business model. Let's look into how to move from the distributor part of the distribution plan to the DIY part.

The Internet release window

For several chapters you have been warned not to upload your film to You-Tube or any other Web site before it's time. Film festivals, distributors and broadcast buyers can turn you away if you have uploaded your film to the Internet. So when is the right time to release on the Web? *After your film*

has run its course on the festival circuit and after your film has completed its broadcast run. For the most popular short films, that might mean up to two or three years after their world premier. The festival circuit can last about a year, and some of the top broadcast buyers can ask for up to two years of exclusive broadcast rights to the film. That might seem like a very long time for the film to not be on the Web, but if you ask any filmmaker what those years were like, they would likely tell you, "Awesome!" If your film is doing well on the festival circuit and regularly screening on television, you are living the dream, and playing on the Web can come after all of that. Screening in festivals and watching your film on broadcast television is still the greatest measure of success that many short-film filmmakers aspire to. With the tremendous potential of the Internet, however, anyone with a film and the drive and determination can find success on the Web that rivals that of the festival circuit and broadcast platform. There are many stories of films that did not do well in festivals and did not get broadcast distribution, but found huge audiences on the Web, and were lucrative. If your film had a festival showing or two but did not "blow up" the festival circuit, don't despair: it's entirely possible that your audience awaits you on the Internet. If your film did not get a broadcast distributor, it might be that the demographic of your audience doesn't fit the broadcast model. Genre films, lower-budget films, films with edgier or adult themes might find more success on the Web than at festivals or on television. With the vast number of people watching films on the Web, almost every film can find its audience. So, to review: the Internet release window occurs when the festival circuit is over and the broadcast window term has expired. For those of you with distribution deals, you will be considering whether or not to allow your distributor to be involved with your Internet distribution (although you have to make this decision initially, not later). Remember that the advantage to having the distributor handle the Internet is that they might be able to place you into iTunes, and also that they will do all the legwork for you. The disadvantage is that you might be sharing profits unnecessarily because so much of the Web is available as DIY.

For those of you ready to move into the Internet DIY phase, all of your possibilities, from for-pay models to for-free models, and everything in between, will be explored in detail in the next chapter.

SUMMARY

In this chapter we covered non-broadcast distribution platforms such as the Internet, Home Entertainment (VOD and DVD sales/rentals), Education, Mobile, and others. The primary purpose of the chapter was to inform you of how these platforms work so that you can negotiate the most beneficial deal for yourself with your distributor, because it is likely that in addition to handling your broadcast platform, your distributor will want to handle some, or all, of these other platforms. In the same way you learned to contact broadcast buyers directly (in the last chapter), you also learned that there are some ways to approach non-broadcast buyers directly, and you learned that the Internet is made up almost entirely of DIY-style distribution solutions. We reviewed the Internet release window so that you will know when to release your film on the Web. Finally, the concept of DIY distribution on the Internet was introduced and will be covered in detail in the next chapter.

In order to be as knowledgeable as possible regarding all of your options, you should continue reading before entering into negotiation of any distribution deals. The Internet offers so many options that you'll be better served by really understanding that platform before negotiating the rights to your movie with a distributor who will be confidently knowledgeable of all facets of the Internet platform.

1. What are the four types of non-broadcast distribution platforms discussed in this chapter?

2. What are the three common types of Internet distribution types discussed in this chapter?

3. What does the term VOD stand for? Name some examples of VOD.

4. What qualities does a film need to have in order to succeed on the Educational platform?

5. When is the proper time to release your film onto the Web?

DISCUSSION / ESSAY QUESTIONS

1. In your own words, describe the ways that the Home Entertainment and Mobile platforms are changing. What is the major factor, and is the change helpful or hurtful to a filmmaker with a short film to distribute?

Research/Lab/Fieldwork Projects

The following lab projects will help you prepare for the work you will be doing in the next chapter.

1. On the Internet, research distributors and buyers for the Home Entertainment, Educational, and Mobile platforms, and make a list with their names, contact information, and notes about the company. (You will research Internet companies in the next chapter). Try to find ten companies on each platform.

Educational Distribution Companies: a Partial Listing

See Figure 11-1 for a partial listing of some educational distribution companies. There are dozens more; you'll need to do your research to find them. As usual, learn what you can about the company before you contact them, and draft a professional cover letter to include with your DVD.

Educational Film Distributors and Buyers

Energized Films
www.energizedfilms.com

Fanlight Productions
www.fanlight.com
32 Court Street
Brooklyn, NY 11201
(718)488-8900

Green Planet Films
www.greenplanetfilms.org
21 Columbus Avenue, Suite 205
San Francisco, CA 94111
(415)377-5471

New Day Films
www.newday.com
Karen Kox
190 Route 17M, P.O. Box 1084
Harriman, NY 10926

FIGURE 11-1. Below is a partial list of short-film distributors and buyers in the educational market. Courtesy of Jason Moore. Used with permission.

These lists can be found in Appendix A or on the companion DVD.

NOTE

ON DVD

DIY DISTRIBUTION ON THE INTERNET

OVERVIEW AND LEARNING OBJECTIVES

In this chapter, you will:

- Review Step Four of the Hybrid Distribution Plan: Secure Internet Distribution (Either with a Distributor, or DIY Style)
- Learn the definition of DIY distribution
- Understand how to work with Web sites that will screen and sell your film on a "for-pay" model
- Learn about the middle ground between "for-pay" and "no-pay" distribution (contests, peer review, and social networking)
- Understand the concept of VODO (Voluntary Donation) and how it applies to your distribution plan
- Determine the best companies to work with during the "no-pay" part of your distribution plan
- Understand how the concepts of "Exclusivity" and "Territories" apply to the Internet

Securing Internet Distribution (Either with a Distributor or DIY Style): Step 4 of Your Distribution Plan

In the last chapter, you learned about negotiating Internet distribution deals with a distributor or sales agent. You also learned that there are many opportunities for DIY distribution on the Web, and that, depending on your success with broadcast distribution, you might at some point want to move into DIY mode. In this chapter, you will learn exactly how to do that: how to take control of your film and create your own success.

DIY Explained

The concept of DIY has been around for many years; independent filmmakers in the 1960s and 1970s used DIY techniques to make movies outside of the studio system. Now, with the growth of the Internet—and specifically with the power of social networking—DIY distribution is becoming extremely popular. Web sites such as Facebook, YouTube, Twitter, Foursquare, Kickstarter, and hundreds more are connecting filmmakers with their audiences in new ways, making it possible for artists to distribute their work—and get paid—in ways never before available.

NOTE

DIY: Do-It-Yourself film distribution refers to the act of managing all or most aspects of distribution on your own, without a traditional distribution company or sales agent. Instead of relying on someone else to get your film in front of audiences, you do it. Instead of allowing someone else to structure the payment deals and manage income, you do that. Instead of waiting to see if someone else thinks your film is "worthy" of distribution, you take responsibility and control and put the film out wherever you can.

You have already been distributing DIY style: in Chapter Three (Distribution Plans and Models), you were advised to use the Hybrid distribution plan in order to take advantage of the best of each of the traditional distribution and DIY techniques. Step One of the plan was to promote your film and yourself: that's a DIY method. A traditional method would have you wait for the distribution company to create interest (which might work for feature films, but never works for shorts). Approaching buyers yourself is also a DIY

type of approach. With the burgeoning possibilities of the Internet, you'll be able to employ a variety of other DIY techniques to promote your film and perhaps earn some money. The primary idea is that you'll be more involved with your film sales than you have been already; because you've got a comprehensive understanding of distribution, buyers, and the overall concept, this step will seem a natural progression for you.

Types of DIY techniques we will explore

There are several different DIY approaches we will examine in this chapter:

- Working with Web sites that offer you some type of "for-pay" model

- Working with Web sites that host your film, do not offer money, but do offer some interesting opportunities such as contests with prizes, peer review, and networking

- Giving away your film for free but utilizing the VODO (Voluntary Donation) method

Once we cover these three main techniques, you'll learn other interesting ways to utilize DIY techniques to advance your film and reap the maximum benefits from it.

Web Sites with a "For-Pay" Model

We know that the iTunes store is an extremely desirable place to sell your short film, but given the difficulty of having your film accepted there, what about other Web sites that offer audiences short-film content and can pay the filmmakers some money? There are several, and they each work a little differently.

YouTube.com

By far the largest video Web site on the planet, YouTube hosts millions of videos and serves countless audience members every day. If your film "goes viral" on YouTube, you could have people in every country in the world watching your film. Occasionally, if there is enough buzz and interest, the author of the video can gain exposure, earn money, and advance his career. On YouTube, it's as likely as not that the next popular video will be a UGV (User-Generated Video), but occasionally narrative work rises to the top and gains exposure.

For most filmmakers, YouTube is not a first choice of Internet distribution simply because the site is geared toward UGVs (User-Generated Videos) rather than films. YouTube does offer some interesting options for filmmakers, however, and they are constantly searching for avenues into the film-distribution market.

YouTube Channels

YouTube will allow you to build your own personal "channel," which functions much as your own personal Web site. There you can upload and organize multiple videos, post information about yourself, and communicate with people who comment on your videos. When you send people a link to your video on YouTube, make sure it's a link to your personal channel. Viewers will have a chance to look at bonus material from your film (behind-the-scenes footage) or other films or projects you have uploaded. Viewers can subscribe to your channel, and they will receive a notice every time you upload something new or send a message out to your subscribers. This is an excellent way to build a fan base.

YouTube Partner Program

YouTube is constantly searching for ways to expand their Web site, and to do that they need to partner with their content creators: that means you!

YouTube Partners can actually earn money from their videos. You can apply to their partner program if you meet certain specifications: you must own all the rights to your work, and you must declare yourself to be a "professional content creator." Essentially, they prefer to work with people who are committed to uploading high-quality material. They don't want to partner with a young kid uploading "cat on trampoline" videos. If you own all the rights to your film, you should consider applying; if accepted, you can work with YouTube in a few ways. Currently, YouTube has two revenue-generating programs for its Partners: AdSense and Rentals (Beta).

AdSense

AdSense is a program in which you can enroll after you have been accepted into the YouTube Partner program. With AdSense, you earn money from ads being placed at the beginning and end of your film. In order for you to be accepted to AdSense, you will need many thousands of views of your film at the time of enrollment; for this reason, many short-film filmmakers are not accepted to this program. If you have a popular film and are getting views, subscribers, and visits to your channel page, YouTube will accept you into the AdSense program. You will receive a portion of the revenue that YouTube earns from ad sales on your film—the revenue amount is directly related to the number of views your film receives, so it can be anywhere from a few pennies to a few thousand dollars. Some short-film distribution companies use this as another platform for the short films they represent: they create a channel, sign up filmmakers, earn revenue through AdSense, and distribute that revenue back to their filmmakers.

YouTube Rentals (Beta)

Currently, YouTube is experimenting with an On-Demand type service that allows you to rent your videos. This is a major step for a company like YouTube because the reason the site is so popular in the first place is that it is completely free. Like the AdSense program, YouTube is looking for professional content creators and there is no guarantee that they will accept you. If you are accepted, you can set your price and YouTube will share part of that revenue with you. The program is still in "Beta," which means it is in a testing phase. If the program becomes popular, YouTube will roll it out and really promote it. Given the success of Netflix, Hulu, and Amazon On Demand, it's likely that YouTube will take this new rental service as far as possible. You should follow the development of this closely.

Although most short-film filmmakers do not make money on YouTube, it certainly is possible, and YouTube is constantly exploring new avenues of online distribution. At the very least, if you are considering YouTube as an option for your Internet distribution, you should build a channel and drive traffic there. It's the best way to build a fan club, get subscribers, and reach out to the enormous YouTube audience. If your film takes off and you start to get some real numbers clicking on your channel, you can investigate the AdSense and Rentals program to see if it will make sense for you.

IndieFlix.com

IndieFlix is an interesting site that functions somewhat as a distributor, how-ever, they do not manage any other platforms than the Internet. They are semi-selective; they state that your film should have been an "official selec-tion" at a film festival, but they often will review most items that are submit-ted to them. They claim to be very "filmmaker" centered, and judging by the wide variety of options they offer, they do seem to be just that. They offer both features and shorts on their Web site. Here are some of their selling points:

1. They host films and offer them to the general public to rent or to buy. They split those profits with you 70/30, with the 70 percent going to you. There are additional pricing details, but overall, it's a very filmmaker-friendly split.

2. They have relationships with iTunes, Joost, Snag, Amazon, and Hulu, and can help you get your films on those other platforms if you like; or you can decline.

3. They are completely nonexclusive, leaving you free to make deals with any other company you like.

In order to offer your film for rent, you'll upload a Web-compressed version of your film, along with cover art, synopsis, and so forth, and they will put it in their film gallery. They share profits on the rental fees. On the sales side of their plan, they offer a service, commonly used in many DIY approaches, called DVD Fulfillment.

DVD Fulfillment

DVD fulfillment is a way many Web sites help you sell your film to your audi-ence. Although some sites offer Digital Sales, (as iTunes does; a QuickTime movie or some other type of digital file can be downloaded), most use the

DVD-fulfillment method, which delivers actual DVDs to your customers. You create DVDs and send them in bulk quantities to the fulfillment company, which then takes online orders for the DVDs from people and ships them to the customer. The company receives some money for its services. A variation of this model is to upload DVD-ready files and artwork, and the company makes the DVDs for you; obviously, in this model, the company assumes a greater percentage of the profit.

Overall, the IndieFlix offer is generous, and all of their requirements and information are clearly laid out on their Web page. You should give this company some serious consideration.

Amazon's CreateSpace.com

Amazon has entered the market of Video On Demand, and they are a direct competitor to iTunes and Netflix. Through the Amazon Video On Demand section of the Amazon store, they offer Web surfers a variety of features and short films to buy or rent. Any filmmaker can use the CreateSpace.com Website to create an account and sell their films through Amazon Video On Demand. Millions of people visit the Amazon store every day, so putting your film into their service greatly increases the chances of it being viewed, and perhaps purchased. CreateSpace is just as filmmaker friendly as IndieFlix; anyone can use their service, with a few caveats. On the DVD-fulfillment side of their service, it's straightforward: you give them DVD-ready files and they take care of the rest. You can set your own DVD price, and they take a portion of your sales; there is no setup fee, and the process is fairly straightforward. The Amazon On Demand side of their service offers films for rent or as download to own (a digital file). The profit sharing here is a simple 50/50 split.

There is one restriction to the On Demand service, however, that will be detrimental to some short filmmakers: a minimum time limit of 20 minutes. Amazon currently is focused on working with the feature-film community, and perhaps they are wary of the sheer numbers of submissions they might have to manage if they have no minimum time limit. Imagine if every person with a YouTube video began submitting their "cat-on-trampoline" projects: Amazon's staff and video servers could be overwhelmed. The time limit applies only to the rent and download-to-own service, however; anyone with a short film of any length can still use their DVD-fulfillment service.

NOTE

Overall, it's a reasonable DIY solution for some filmmakers; the Amazon brand name alone is a significant selling point.

All of these features are fully integrated into the withoutabox.com site (they are partners), which is extremely convenient. You can begin exploring your options with Amazon directly from your film's project page on withoutabox.com.

One aspect to take into consideration is the pricing structure: selling DVDs at very low prices ($10 or less) is not very profitable for you, based on Amazon's business model. The way Amazon deducts fees and splits revenues with you is based on a $20 or $25 sale price for your DVD. They assume a flat fee of about $5 per DVD, plus a percentage of the sale price (15% if it sells on the CreateSpace e-store, 45% if it sells on Amazon). For a short-film filmmaker, a $20 price tag on a short film might be too high, thus driving down sales. But if you sell your DVD for $10, after Amazon's fees you could be making only about fifty cents! The only really profitable way to sell DVDs with CreateSpace is if the DVD price you set is $20 or higher.

One creative maneuver is to offer several short films on one DVD as a "collection," something Amazon is perfectly fine with. You might consider working with some fellow filmmakers and pooling your assets to make a DVD with plenty of content, thus deserving a higher DVD price. Or, you can "add value" to the DVD by including bonus features such as behind-the-scenes footage, director's commentary, and so on. Another option, once you have made several short films, is to make a compilation DVD of all of your work; this might warrant a higher price for your DVD.

Ultimately, it's up to you to decide how you want to price your film, and this service has a lot going for it: it's easy to use and it's associated with a well-known brand name and a very popular online store. For these reasons, it's worth seriously considering. Hopefully in the future, they will reduce the minimum time limit on their On Demand site, thus creating an even more attractive option.

Babelgum.com

Babelgum is an online film and Webisode site that is geared toward "professional content creators." What does that mean? It means they don't play

User-Generated Videos such as the ones popular on YouTube; they are interested in narrative stories like your short film. You can submit your film and if they take it (they take most), they will offer your film for free to anyone surfing their site. Their revenue model is advertising driven; a paid advertisement is played at the beginning of your short film and another at the end, and they offer you a 50/50 split of that ad revenue, calculated by the number of times people watch your film. Encourage enough people to watch your film here, and you'll see some money. The benefit to this service is that your audience views your film for free, so generating traffic to this site requires less convincing than to some of the other sites (assuming your audience prefers to watch their movies for free!). The disadvantage is that the revenue you can expect is never going to be as much as that which you would earn from a direct sale or rental of your film. Like most of these DIY-style Web sites, Babelgum is nonexclusive, so you don't necessarily have to choose one site over another. See Figure 12-1 for a screenshot of the Babelgum.com Web site.

FIGURE 12-1. Babelcom.com offers filmmakers a 50/50 split on ad revenue and is nonexclusive; as far as Internet deals goes, this one is fairly reasonable. Courtesy of Babelgum.com. Used with permission.

Revver.com, Openfilm.com, HungryFlix.com, MDistribute.com

These Web sites offer variations of the "for-pay" deals we have already discussed. Revver is a bit more UGV driven, but does feature short films; it works on the ad-revenue model. Openfilm also operates on the ad-revenue model, and has relationships with other outlets, such as TiVo®. Every week, a handful of films, some of them shorts, are selected to be highlighted on TiVo's service, which is an attractive bonus, considering TiVo serves about eleven million homes! HungryFlix and MDistribute focus more on the mobile platform; they also have equitable revenue sharing models.

There are several other Web sites that use a "for-pay" model; in true DIY fashion, you'll need to put forth some effort and do your research.

Web Sites Geared Toward Filmmakers

A Web site such as YouTube, which we will explore again later in this chapter, serves one main purpose: to showcase videos to a large audience on the Web. As a filmmaker, your primary reason for putting your film on their Web site is for others to see it, and perhaps to generate some excitement or buzz around your project.

Although there are plenty of film sites similar to YouTube, there are also a new host of Web sites that bridge the gap between "for-pay" models and "for-free" models. These Web sites don't offer any type of revenue sharing for filmmakers; the films are hosted for free, without ads. The sites themselves are more than just a place for people to click and play videos; some incorporate social-networking services that allow filmmakers to comment, review, and connect with each other. They are more "filmmaker" centered; often their main audiences are other filmmakers. Many have bulletin boards where members can post job opportunities, casting breakdowns, crew hire notices, and equipment rental and sales ads. Other sites have contests and festivals specifically for their members, many with cash prizes. This "added value" methodology on the part of a Web site is genuine DIY philosophy: the site owners, hoping to grow their business, are adding value and enticing you, the filmmaker, to upload your film on their site because of all the additional services they offer. It provides a feasible way to network, meet other filmmakers, promote yourself, and get your work seen by those in the same industry as you.

Following are a few of the Web sites in this category:

Triggerstreet.com

Triggerstreet was founded by the actor Kevin Spacey and his producing part-
ner Dana Brunetti as a site to showcase and discover emerging writing and
directing talent. The site revolves around the idea of informed, critical peer-
to-peer reviewing. All members are encouraged to participate not only by
uploading their films and scripts but also by actively watching, reading, and
critiquing other people's work. The site aims to elevate everyone's creations
and has an elaborate and creative system for submitting and reviewing sub-
missions. There are also site-sponsored contests, some with cash prizes. It's
a highly regarded Web site by the industry, and one of the best examples of
this type of arrangement.

TheSmalls.com, ShootingPeople.org, Raindance.tv

All of these Web sites showcase short films within a social-networking
model. Members create personal accounts and can upload their films, demo
reels, and résumés. These are communities of filmmakers, and there are
bulletin boards, film articles, and multiple ways for members to connect to
each other. There are large forums for discussions of various filmmaking
topics—including a great deal of information regarding distribution. These
sites offer contests and unique opportunities for filmmakers to participate
in sponsored projects, many of which offer cash prizes. They will send you
email updates every day and the sites can be a very valuable resource for an
independent filmmaker. The Smalls is slightly more focused on watching
short films, Shooting People is a bit more concerned with networking, but
both present basically the same thing: they combine a short-film destination
with valuable tools, resources, and opportunities for filmmakers. Raindance.
tv is similar, but a little smaller and less robust, compared with the other two
sites. See Figure 12-2 for a screenshot of the Shooting People Web site.

Atom.com

Atom has been a pioneer in Web video, and several years ago when it was
atomfilms.com, it was the largest and most professional short film Web site
on the Internet. Atomfilms licensed short films, using the ad-revenue model,
and even worked as a distributor for their filmmakers, creating Atom DVDs
for sale or rent in stores and placing short film collections in many interna-
tional territories. Atom was then acquired by MTV and has since changed
its business model. Gone are the hundreds of quality short films, replaced

FIGURE 12-2. The Shooting People Web site is a good place for filmmakers to network and share their short films. Courtesy of Shootingpeople.org. Used with permission.

by "funny videos" that, while not artistic, are a simple diversion for a Web surfer. The company is still going strong, however, and if you have a short, funny film, you can upload it into their weekly "tournament," which pays cash prizes for the entry that wins the most votes. Atom is also engaged in developing original Web shows, so if you get involved in the Atom community, you might find opportunities to pitch show ideas and be paid to make projects directly for them. In my opinion, this is a step down from what they used to do, but there is substantial of evidence that indicates that what they are selling, people are buying.

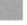 VODO (Voluntary Donation)

Now we are going to start looking at your "no-pay" distribution options. Hopefully, by now you have learned that this should be your last option, given the multitude of other opportunities available to you, though actually, there is a way for you to make some money even while giving your film away for free. The concept, which is becoming more and more popular among independent filmmakers, artists, and musicians, is called Voluntary Donation. The concept is that you freely give your film to anyone who wants it, let

them watch it, download it, own it, even give it to their friends (for free). In return you ask that if they enjoyed the experience of watching your film, they should donate money to you in an amount of their choice, or of your suggestion. Setting up a VODO style of distribution is very simple:

1. Create a PayPal account so that people can easily send you money through the PayPal service. For more about PayPal, visit their Web site, *www.paypal.com.*

2. Add a short trailer to the beginning and end of your film requesting that people donate using your PayPal account. The trailer can be text only, or can feature you talking directly to the camera.

Now, wherever your film plays for free, you audience will see your trailer and, perhaps decide to donate to you. This is yet another way that the Internet has revolutionized independent filmmaking. The PayPal service, which allows your audience to quickly and easily send you money, has provided indie filmmakers a way to collect money, even very small amounts, from audiences all across the globe.

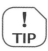

As you start to look at which sites you might use to host your film for free, consider using the VODO technique to humbly request a small donation. Consider this: if one million people saw your film and each donated just one cent, you would earn ten thousand dollars.

Web sites with a "no-pay" model

Web sites that work under a "no pay" model are all over the Web. Anyone can upload a film or video and share it with the world. For some people, just having their work on the Web for audiences to see is enough, and that might be the case for you.

you want them not only to like your movie, but also to get to know you, maybe tell a friend or two about your film, visit your Facebook page or personal Web site, read a little about your process, and so forth. You want them to be looking forward to your next project. You want them blogging or tweeting about you. You want to develop a relationship with your audience. Doing so will have positive, long-lasting effects: the larger your network of fans, the better your chance of having a successful next film. If everyone who sees your film for free on YouTube were to add their name to your email list, then the next time you finish a project, or were looking for help, or were raising funds for another project, you'd have a wide fan base of people to resource. A few things you want to be sure to do:

1. If possible, create your own page or channel on whatever site you are posting to (for instance, YouTube). Make that page as robust and informative as possible: use your press pack and add as much information as you can; your personal story, production stills, etc.

2. Keep the page active, not static. Don't just upload your film and never come back. Keep adding new things and have a presence on the page. Add updates and respond to comments people leave.

3. Drive people to your personal Web site or Facebook page. If you have a home base on the Web—a place where you want people to go to learn more about you—make sure that suggestion is on your page somewhere.

Let's look at some of the top "no-pay" Web sites:

Vimeo.com

In the last few years, Vimeo has emerged as the artistic alternative to You-Tube. In addition to short films, Vimeo is home to interesting animations, motion graphics projects, and beautiful, high-definition video work. Vimeo attracts a much smaller audience than YouTube, but it's a discerning one. It's an up-scale Web site, a place where your short film will be nestled among other fine-quality works of art, as opposed to being stuck between "dog eats pizza" and some video blogger. As with YouTube, you'll want to make your own page, keep it updated as frequently as you can, and respond to comments to keep the page "alive."

Facebook.com, MySpace.com, Your personal Web page

Other options for posting your film online for free are some of the most obvious: the Web sites you have been using all along to promote your film.

When it comes to social-networking sites like Facebook and MySpace, there is a good argument for, eventually, putting your entire film up on your page (or the page you made to promote your film). After all, if you have been updating all of your friends about the progress of your film, it's a natural climax to your story to finally post the film. One way to do this is to simply post a link to your film on your Facebook or MySpace page, but a better way is to actually embed the video itself directly into your page.

The advantage to posting the film directly on your social-networking site is that instead of having to travel "off site" to view your film, anyone who sees your message telling them the film is finally available can watch it without navigating away. It might seem like a minor thing, but it's not. Most of the time, Internet surfers like to choose their destination and click around within it, so if they're on Facebook, they tend to want to stay there, if they are on YouTube, they want to stay and watch videos there. Having the video someplace convenient for your audience could mean all the difference. If people see that your video is up but don't have time to watch it one day, the next time they return, it's still there, waiting for them! Putting the film into a spot where all of your friends regularly go is a great way to get views. Embedding your film into your page is not complicated, and there are plenty of tutorials available on the Web. Do a Google search for "how to embed video onto my Facebook/MySpace page."

TECHIE'S TIP

Putting the film on your personal Web site is not a bad idea, but your personal Web site should be a secondary destination. You'll have your résumé, your biography, all the ancillary press materials, and when someone is interested in learning more about you, your Web site will be there for them. You are far less likely, however, to get people to navigate away from what they are doing to go watch your film on your Web site. It's not advisable that your "big premier" on the Internet be on your Web site. Rather, you should premier it on one or all of the Web sites we've discussed in this chapter. Once you've done that, then you can also put it on your own Web site.

Other Web sites

The Web sites discussed here are just a sampling of what's available to you, and the Internet is changing and growing so quickly that any given site can

be gone in a day, only to be replaced by two new sites. So you'll have to research to discover what is new, what has changed, and what has closed. Also, not all Web sites are shorts friendly. Some well-known sites have yet to embrace short films, but that doesn't mean they won't in the future. Below is a short list of some other well-known Web sites, which at this time are not viable for short-film distribution, for various reasons:

Netflix.com

As of now, Netflix does not offer short films outside of a few traditional Hollywood short-film collections. Keep checking back on it, though.

Hulu.com

Rumors about Hulu embracing short films have started to surface, but at the moment, it's mostly television with some feature films. Keep checking though, soon Hulu might expand its catalog, and given the strong brand recognition, Hulu would be an ideal destination for your film.

Sling.com, Current.tv, Blip.com

These well-known video Web sites have TV episodes, UGVs, and journalism-type videos, but no shorts as of yet.

Bittorrent

While peer-to-peer file sharing counts for a huge majority of movie downloads on the Web, a majority of those downloads are illegal downloads of popular feature films. Some feature filmmakers have embraced this platform by "giving away" their film (and asking for VODO in return) but as of yet, this is not a viable platform for shorts.

Exclusivity and Territories on the Internet

As you develop your distribution plan for the Internet, you will likely want to release your film on as many Web sites as you can, in order to put it in front of as many audience members as possible. Depending on what types of distribution deals you have already put into place, you might or might not need to deal with exclusivity and territories. If you are going a purely DIY route and have no other agreements with broadcast distributors, sales agents, or buyers, then all you need to do is check with each Web site about their position on exclusivity. Many, if not most, video Web sites consider themselves nonexclusive. Because the Internet is available to anyone around the globe, Web sites don't usually deal with territories: the Web is just one vast territory.

If you have some existing agreements with distributors, you'll want to be careful about how you proceed on the Internet. As you know, many broadcasters will not want your film on the Web until your term agreement with them is expired. You might, however, find that you have some foreign deals, and it is occasionally possible for a Web site to block your content from being available in that country. It's possible for you to negotiate a broadcast television deal with, for instance, Germany, and also put your film on the Web, as long as the Web site hosting your film is able to essentially "turn off" your film in Germany. Not all Web sites offer this service, but some do.

SUMMARY

In this chapter you learned about the wide array of possibilities available to you for using DIY distribution techniques on the Internet. We covered the three main Internet models that the various Web sites employ: a "for-pay" model, a model that doesn't pay but that does offer opportunities and value for filmmakers, and a "for-free" model. Each of these models has benefits, and we covered some of the most successful Web sites in each category.

Over the past few chapters, you have been advised to "keep reading" before setting out to make contact with distributors, sales agents, and buyers. Now that you understand all of the options, you are ready to get to work. You can create a plan, approach companies, and negotiate your deals with as much understanding about the process as anyone else. Remember, there is no single correct way to put your deals together, every film and filmmaker will have a different set of objectives and will, of course, have a completely different film.

In the last several chapters, we have covered four steps in your Five-Step Hybrid Distribution Plan, and there is still one step left. Let's review:

1. Promote yourself and your film on the Web in a variety of outlets. (Completed!)

2. Submit to festivals and attempt to "do the festival circuit." (Completed!)

3. Contact distributors and attempt to negotiate traditional broadcast distribution deals. (You are now ready for this)

4. Depending on the success of the above steps, either negotiate an Internet release of your film through a distributor or release on the Internet using DIY methods. (You are ready, and will do this in time.)

5. Leverage your success (no matter how much or how meager) into momentum for your next project. (At the end of the cycle.)

We will be covering the fifth step soon, but before we do so, there are a few other things to be explained to you, and they are ahead. In the next chapter, you'll learn ways to distribute content other than short films: such as Webisodes, action videos, music videos, and more. In Chapter Fourteen, for all of you cinematographers, production designers, editors, and creative crew members out there, how to distribute a demo-reel will be discussed. Finally, in Chapter Fifteen Step Five of the distribution plan: using your success to gain momentum for your next project.

REVIEW QUESTIONS: CHAPTER 12

1. In your own words, describe DIY distribution on the Internet. Don't just say, "doing it yourself"— be specific and give examples.

2. What are the three main types of Web site models / DIY techniques that we covered?

3. What does DVD fulfillment mean?

4. Define VODO.

1. What are the pros and cons of the three main Web site models covered in this chapter? Which are you more interested in exploring?

APPLYING WHAT YOU HAVE LEARNED

Research/Lab/Fieldwork Projects

The following lab projects will help you prepare for the work you will be doing in the next chapter.

Research Internet Sites
In addition to researching the Web sites covered in this chapter, spend some time and come up with a list of several others in each of the three models that we have looked at. Gather notes on contact names and email addresses, information about the deal structures, and your personal notes on the content and services each site offers its filmmakers and its audience members. Prioritize the list so you know whom you want to approach first, second, third, etc.

Begin Approaching Distributors, Sales Agents, Buyers and/or Web Sites
Now that you are completely informed about all areas of short-film distribution, you are ready to send your film and cover letters to distributors, sales agents, and buyers. Or, if you have decided to skip directly to a DIY model of Internet distribution, you are ready to contact Web sites. Begin the process and keep track of whom you submit to, when and if they respond, and so forth. Stay organized, be patient, and always maintain professionalism.

DISTRIBUTING ALTERNATIVE CONTENT

OVERVIEW AND LEARNING OBJECTIVES

In this chapter, you will:

- Discover the types of alternative content projects that can be distributed
- Create a distribution plan for alternative content projects

Alternative Content

In Chapter Two (What Types of Projects Can be Distributed, and Who Can Participate?), you learned that in addition to short films, there are other types of projects that you can distribute in order to help you get your career under way. Although these types of projects might not be able to bring you the acclaim and "fortune" of an award-winning, well-distributed short film, they can help launch your career. Before we get into the various distribution opportunities, let's review some of these projects and determine why you should consider trying to distribute them.

Career paths

For a typical novice filmmaker, the short film serves an important but singular purpose: it prepares you to work in the feature-film industry. The process of making a short film can teach you general skills that are applicable across many areas of film and television, and it helps you hone the art and craft of narrative (or documentary) filmmaking. A short film will set you on a career path that might lead to any number of places, but its primary purpose is to advance you toward the world of feature-film production. Although that sector of the film and television industry is certainly popular, there are many other areas that are just as creative, interesting, and rewarding. For each other potential career area, there are appropriate projects that can be more valuable than a short film, in terms of preparing you for that type of work. Let's look at some examples:

Episodic Television/Webisodes

The television production and post-production industry is enormous, with hundreds of career positions available: director, writer, show runner, editor, and camera operator, to name a few. The positions might sound identical to those in feature films, but they are actually fairly different. The structure, pacing, and style of television shows are unique and require an insight and understanding that takes years to develop. It's unusual for people to work simultaneously in both feature films and television. The art, craft, and business of each type of work have enough subtle differences that one typically trains for and works in just one of these areas. Although a short film does teach you some of the basic toolsets you'd need to pursue a career in television, it's not the ideal calling card for this industry.

The ideal project for a student to produce in order to help their television career is, actually, a television show. With many schools offering classes in studio-television production, and with many of the popular shows being shot single-camera style, it's easier than ever for students to make their own scaled-down television shows. The running times might be shorter, and student budgets are obviously a fraction of what the networks spend, but greater numbers of students are shooting television-style projects with the idea of ultimately working in television production.

With the rise of Internet video, there is a brand-new phenomenon that is not only widely popular, it also has a strong potential for distribution: the Webisode. A Webisode is similar to a television episode (a part of an ongoing series) made for the Web. A Webisode can be a spinoff from a mainstream TV series, such as *Rookie* from the TV series *24* or *Interns* from the show *Scrubs*. A Webisode can also be original material airing only on the Web. Although Web-only Webisodes are fairly new, and none have crossed over into mainstream TV, momentum in this field is gathering. Increasing numbers of independent filmmakers are filming and posting their own Webisodes, and the industry has noticed.

Not only can Webisodes prepare you for work in the episodic television world, they can prepare you to work in the Webisode world, which is becoming a major format that soon enough will be its own industry.

In this chapter, we'll look at various ways to promote and distribute your episodic television show and/or Webisode(s) in order to prepare you for this type of career.

Spec Commercials and Music Videos

Other popular career opportunities in the television industry are available in the world of commercial and music-video production. In the same way episodic television requires a different skill set than narrative filmmaking, so do these two fields. Although a television commercial might sometimes appear to be similar to a very, very short movie, working in commercials requires an understanding of advertising, marketing, and brands. Music videos also have their own set of skills, notably a strong sense of visual style and a keen grasp

of editing and post-production techniques. The potential for distribution of these types of projects is more limited than a Webisode or a short film; we'll discuss exactly the best options for each one.

Action-Sports Videos

This subset of the sports-television industry exploded in the mid-nineties as surfing, skateboarding, and BMX culture made their way into the mainstream through ESPN's broadcast of the X Games. Since then, producing, directing, and editing action-sports videos have become viable career paths for some "x-minded" students. These types of videos have a proven potential for distribution.

Other Career Paths & Projects

Other projects you might produce on an amateur basis or in film school can help your career in less specific ways, but they can still be beneficial and some can even be distributed. For an aspiring editor, creating a *remix, mashup, or lip dub* video can demonstrate your editing skills. A funny, original, or otherwise compelling amateur video could help you get noticed in the ever-growing online Web video community. Even a well-produced vlog might be the launching pad for a career. We'll look at these types of videos and what opportunities there might be for distribution, even if the career path they lead to has not yet been fully considered.

KEY TERM:

Remix, Mashup, Lib dub Millions of YouTube content creators have brought about new forms of video and audio as they upload, share, and interact with each others' work. YouTube video makers might download someone's video, re-edit it, add new music, and reimage it in order to create something new. A *remix* is a term generally applied to a song: an artist's original track is re-edited (or re-mixed) and given a new style: faster tempo, different rhythm track, or modulated vocals. A *mashup* generally combines two different songs in order to create a completely new song; this technique can also be applied to video, such as when a user intercuts two music videos in order to create a mashup of both the song and the video. A *lip dub* is another form of user-generated video: the creators will perform to a popular song by lip syncing to the music. Often these lip dubs are quite ambitious, featuring complex camera moves and heavily choreographed dance sequences.

The Alternative-Content DIY Plan

The distribution plan you created for a short film was based on well-established film distribution models. Your hybrid distribution plan blended classic film distribution strategies such as submitting your film to festivals and looking for broadcast distributors with DIY strategies of self-promotion and Web distribution. Creating a distribution plan for alternative content will follow the DIY portion of your plan, because there are no real opportunities for these alternative projects to find broadcast distribution or success on the festival circuit. Here is a suggested plan to follow when attempting to distribute any of the types of projects we have discussed in this chapter:

1. Promote your project and yourself.

2. Distribute your work on the Web, DIY style.

3. Leverage your success, no matter how great or how small, into momentum for your next project.

This plan is simple, doable, and hopefully the steps are familiar to you, because you've already read Chapters One through Twelve. Let's look at each step in the context of these types of alternative projects.

Promote your project and yourself

You'll use all the techniques you learned in Chapter Five (Promoting Your Film and Yourself) and Chapter Six (Promoting Yourself in the Real World and on the Internet). This includes creating a press pack, writing the story of you and your project, and utilizing both "real-world" and "on-the-Internet" techniques to excite people about your work. It doesn't matter if your project is a music video, a spec commercial, a Webisode or something else—whatever it is, you can use the techniques we've discussed to promote it. Techniques you can use here, as a reminder, are:

- A test screening: generate interest, excitement, listen to feedback, and begin to build a "fan club" of friends (and friends of friends).

- Elevator Pitch: practice selling your project in only one or two minutes. Hone in on the most important part, and make it sound exciting, creative, and fun.

- Social Networking: whether it's an email newsletter, a blog, a podcast, or a project site on Facebook or MySpace, use the social networks to promote and advertise.

- Timing: start your promoting early, and keep updating your audience as your project progresses. The climax of your "story" will be the release of your project on the Internet.

- Don't upload the entire project too soon: although you don't have to worry about violating a broadcast contract, you still want to give consideration to when you finally "premier" your work. Tease your audiences with a trailer for a while, and wait until you have the right Web site and the perfect timing to let everyone know the project is finally available in its entirety.

Know your audience

A vital aspect of successfully promoting your alternative-content project is to understand to whom you should promote it. Identify the audience for your genre/category and make sure they factor into your promotion process. If you are promoting your Webisode, get involved in online conversations about other Webisodes, and let other fans know about your own project. The same goes for any type of alternative content: go where the fans are, become part of the conversation, and then create a little buzz about your own work. In this way, you will be talking about your project to groups of like-minded people.

Distribute your work on the Web, DIY style

Because there simply are no real broadcast or festival opportunities for alternative content, you will be working entirely on the Web, using the DIY techniques we have discussed. As a reminder, the first step is to research Web sites and determine in which of the following three categories they belong:

- For-Pay Web site

- No Pay, but Opportunities

- For-Free Web sites

For alternative-content projects, there are not really any "for-pay" Web sites, but there are many Web sites with opportunities, and many Web sites that allow you to post your project for free. With each type of project, there are slightly different approaches, so let's look at each type of project individually.

Webisodes

If you have a multiple-part Webisode series, you are going to have a lot of fun releasing it to your audience. It's a great time for this type of project—the Webisode "genre" is in full bloom, and people are anticipating the next exciting craze.

SIDE NOTE

Webisodes If you play your cards right, you can turn the success of your Webisode into meetings with broadcast television producers looking to develop work for TV. Even if that doesn't happen, you are tapping into an exciting new area of entertainment. Popular sites on the "for-free" model are YouTube, Vimeo, Facebook, MySpace, and Blip, and you should certainly upload your videos there. The most exciting news about distributing Webisodes is that iTunes will allow you to upload them to the "Video Podcast" section of their store (as long as they are free). Putting your Webisode on iTunes is a huge deal. It means you'll be tapping into a worldwide audience of billions of people. Sure, you'll be just a drop of water in a sea of content, but it's the right sea, and if you can just get a little bit of notice, you could get very popular, very quickly. Here's what you need to do:

1. Shoot, edit, and output each Webisode exactly as you would a short film. You are going to end up with several short episodes, probably between five and ten minutes each.

2. Sign up for a Video Publishing service such as Hipcast or Podcast Generator. There are dozens of other services to choose from as well. You are looking for a Web-based service to help you publish your video files to the iTunes store, which is a process that takes a little bit of technical know-how. Hipcast charges $5 a month and is very easy to use; Podcast Generator is free but a little less easy to use. Use a search engine to find "publishing video podcasts to iTunes" and you'll see many other options.

3. Once your videos are published to iTunes you need to drive as much traffic to the iTunes Store as you can, in the hope of attracting attention from the store administrators. If you are getting downloads, and they see that, they just might highlight you on the main page—which will mean even more downloads, more attention, and more buzz.

There are other places to upload your Webisode videos, but iTunes is by far the most desirable. You should simultaneously upload them to all the other Web sites that have been mentioned.

There are dozens of *Webisode contests* running at any given time; some require you to create original work, others allow you to submit work already created. Entering the contests not only gives you a chance to win a prize, but also gives you something of interest to blog or to post, further helping you drive traffic. A quick Google search for "Webisode contests" will reveal dozens of current opportunities: just hunt around a bit and you will find those that are currently being promoted. Because the time period for contests is short-lived, we have not listed any of them here. It's possible that if your Webisode is good enough, and popular enough, someone (a Web site owner, or the Web division of a broadcast/cable television company) might approach you to strike a paying deal; it's been known to happen. If this happens, use the negotiating skills we discussed in Chapter 10 (Broadcast Distribution). The types of things you should be familiar with, as a review, are:

- Term: the length of the contract
- Fee: what you are paid, and how it is determined / structured
- Territories: probably "worldwide," because it's the Internet
- Exclusivity: do they have the only right to the material (be prepared to be asked to remove it from all other sites if they require exclusivity)
- Platforms: although they might be requesting permission to show it on the Internet, do they also care about other platforms? If possible, negotiate to keep these other platforms for yourself. Maybe the success of your Internet Webisode can lead to some DVD sales or, even better, a broadcast television deal.

In the following interview, director Brian Amyot shares his thoughts on the world of Webisodes and offers filmmakers some advice.

CREATING AND DISTRIBUTING WEBISODES
Brian Amyot
Webisode Director

Brian Amyot is a director and one of three members of Ragtag Productions, the group of filmmakers behind the wildly popular Web series *We Need Girlfriends*. *We Need Girlfriends* has millions of views on YouTube and was purchased by CBS television. Currently, Brian is working on a new Web series, *My Future Girlfriend*, which he describes as a romantic comedy in the vein of *Terminator*.

JM: *We Need Girlfriends* has been one of the most popular Webisode series to date. What are your feelings about the future of Webisodes?

BA: It's a really tricky time. I feel like it changes every day. There was a sense that people were tired of what they were seeing on TV and in theaters so they retreated to the Web for original material. As a result, so many Web series have been made and it makes it harder and harder to sift through content, and find what is good. Also, the networks and studios have seen how popular this stuff can get and want to monetize it. I'm not saying that's a bad thing, it's led to shows with high-production value and big stars, that the viewers gravitate to. Unfortunately, a lot of these shows don't reflect new voices, opinions, and techniques, they are just more of the same stuff we see on TV and in theaters that people were trying to retreat from. The Internet can really level the playing field, not everyone can post a video on television, but everyone can on the Internet. Now there just needs to be a way to help people sift through the good and the bad whether it was made for nothing, or had a studio-size budget.

JM: You had a very innovative promotion strategy for *We Need Girlfriends*. Can you describe that process and the results?

BA: We really targeted the users of social-network sites and bloggers. We first created MySpace pages for all the characters in the show before we even put an episode online. We had their personalities play out in their MySpace pages and had them interact with each other. To our surprise, they gained friends, who became invested in these characters as real people. Then, when the first episode was ready, we told everyone "this is really a show," and we already had a couple hundred people as a built-in audience for this show. They just wanted to see what happened with these characters, and they never would have found the show if we didn't get them interested in the personalities of the characters. Another thing that helped us was that we had a gag in the show where the characters of Rod and Henry created "Team Rod" and "Team Henry" T-shirts. We decided we should sell those shirts. People got

really invested in supporting their "team" and we sold a lot of merchandise, all the shirts had the Web site on the back, and word spread all over the world. Shirts were shipping to Australia; apparently, the show was quite popular there.

JM: What general advice do you have for anyone who wants to create and distribute a Web series? Are there any major do's or don'ts?

BA: The best I could give is PLAN. Plan every aspect. Start with the story, plan out an entire season. You don't have to write every script or know every beat, but know where it's going, be able to talk about it with the cast and crew. You might not be able to afford to shoot a whole season on your own, so if you can shoot at least an episode, be able to pitch it to potential interested parties with funding, to tell them where it's going.

As far as production goes, planning again is key. Figure out what you need, what you can afford, and what you have. You can really make something out of nothing, if you plan ahead. Especially if you are a DIY person or working with a low budget, everything can and will go wrong, so if you have a well-thought-out plan, you won't crack under the pressure.

With distribution, no screening, blogger, interviewer is too small. Tell everyone about your show, spread the word like wildfire. If your series is great, but nobody watches, it doesn't matter. Anyone who wants to cover it in a blog or Webcast, or show it in their parents' basement, let them. Good can only come from it if people see it. You never know who might tell their friend to watch it and you never know who their friend might be.

JM: Can you briefly describe your experience with CBS and where it has led?

BA: Working with CBS is a dream come true, I just never had a dream quite like it. It's amazing to get to work with a studio, a network, and veteran producers. Especially on a project like this, that is so personal. Because you will be having an intense discussion about what a character would do or say, and you think to yourself, I just came up with these characters sitting in my apartment in Queens for fun, I can't believe this is my job! On the other hand, it is incredibly difficult work. Everything is done by committee, you have to try to make everyone happy now, not just you and the friends in your apartment. You have to work on someone else's schedule, which is almost always, "hurry up and wait." This particular project has languished in development at CBS for some time. But the experience has gotten me in other rooms pitching new shows to producers, production companies, studios, and networks.

JM: You are currently working on a new Web series, *My Future Girlfriend*. Can you tell me a little about that series?

BA: We are actually just wrapping up post-production on *My Future Girlfriend* and are really excited about it. It actually has nothing to do with *We Need Girlfriends*, but they say write what you know, and we know about guys trying to get girlfriends. This show is a sci-fi romantic comedy. It's kind of like *Terminator 2*, if it were a romantic comedy. Clark, a lovable slacker, is destined to do great things, he meets Lisa, the perfect girl for him. Unfortunately, Lisa has been sent back from the future to seduce him and keep him from meeting the true love of his life, Kelly. So Kelly comes back from the future to try to help Clark win over present-day her. Not too hard to follow right??

It's a series that we made like a mini-movie, where in each episode we try to tell a complete self-contained story, but also have it lead directly into the next, so if you want the entire series all in a row it will feel like a movie, but if you just watch an episode at a time, you can also enjoy it.

And us being movie nerds, we tried to pack the show with as many sci-fi and time-travel references as we could, whether it be a shot, music cue, or line of dialogue. We'll reference *Star Trek*, *Back to the Future*, *Terminator*, *Lost*, *Quantum Leap*, just to name a few.

Spec Commercials and Music Videos

Spec commercials can find the same type of popularity on the Web that a "real" commercial can: audiences like commercials that are either very funny, visually dynamic, original, or dramatically powerful. Most Web audiences don't particularly care if a commercial is spec or real, if it's good, they will watch it and perhaps pass it on to a friend. There are a few "commercial only" Web sites that attract small numbers of Web viewers, such as veryfunnyads.com and funny-commercials.net, but most of these sites show professional ads only and won't accept your spec-commercial submission. There are some "spec-only" Web sites, which will show your spec, and they function a bit like the "opportunities" model short-film Web sites: there is no pay, but there are opportunities for you to network, give and receive peer reviews on work, and so forth. Sites like thespecspot.com will allow you to post your spot, watch other specs, and network with filmmakers. It's a great way to learn more about the process, but not an ideal way to really distribute your spec spot.

The best platform for getting your spec spot seen by the public is YouTube (and now Vimeo, to some degree). When posting your spec commercial to YouTube, the same rules apply in terms of driving traffic: keep the page updated with information about yourself and your project, reply to comments, and use your promotion skills to get the word out. The advantage to distributing a spec commercial is that it's short, so it's much easier for someone to commit to watching it. Use that selling point as you ask people to watch it and pass it on.

In addition to giving away your spec spot and hoping it goes viral, there are also contest opportunities. Many well-known brands have discovered that reaching out to amateur and upcoming filmmakers is a great way to not only reach their audience but also to create original, compelling work for their product. Web sites such as MOFILM.com specialize in connecting clients with filmmakers. On MOFILM.com, you can enter any number of contests that require that you make a spec commercial for a nationally recognized brand. The rewards can be impressive: cash prizes, camera and lighting gear, even opportunities to meet and work with working producers and directors in the commercial production world. Although you might not be able to directly distribute your current spec spot, there is always a chance you might be able to repurpose it to fit into one of the many contests that they run. Past winners have seen their spots screen in Times Square, so it's a legitimate site to consider. See Figure 13-1 for a screenshot of the MOFILMWeb site.

Music Videos are more difficult to distribute than spec commercials, because they are primarily a celebrity-driven medium. Audiences who watch music videos are generally already fans of the artists whom they are watching, which means that to promote your music video requires intricate maneuvering.

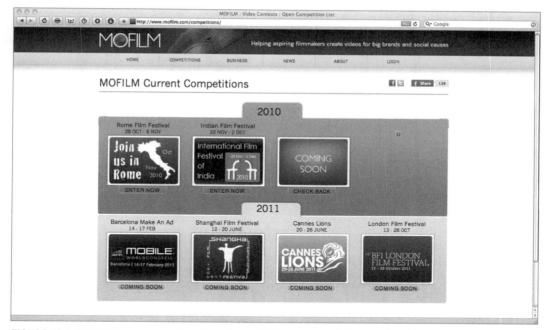

FIGURE 13-1. MOFILM connects aspiring filmmakers with "brand names" clients and social causes that are looking for exposure. Courtesy of MOFILM. Used with permission.

A crucial consideration when distributing your music video—one that many filmmakers consider too late in the process—your music video must be completely original, with an original band or singer and original music. A project that uses an existing song from an already successful artist is not considered a "real" music video by the music-video production industry. Anyone trying to break into the music-video production industry must create music videos with real up-and-coming musicians, bands, or performers. If your video has cool images and great editing but the song is a popular song from the radio, then it's considered a "fan video," and it should not be distributed if you are trying to further your career, because it's considered amateur, and you want to be considered on a professional level.

Assuming you have an original music video with an up-and-coming artist, you can post the video on all the usual Web sites: YouTube, Vimeo, MySpace, and Facebook. There are no Web sites dedicated for music videos: record labels keep tight control over their artists' videos, releasing them only in

specific places (an artist/label, YouTube channel, in the iTunes Store, etc). In fact, YouTube is constantly removing music videos posted by fans as a result of copyright violations. (Remember that we discussed that anyone posting to a Web site must own the rights?) So where does this leave you? You need to be a tireless and conscientious self-promoter. Blog, Vlog, Podcast, email, and update your social-networking sites to advertise.

An excellent idea is to team up with your band or artist and tap into their existing fan base; if fans of your musicians will help you promote, you can reach a far wider audience than if you try to do it all alone. Combine a test screening of the music video with a live performance by the musicians and make it a highly anticipated event. Post the video on the artists' site and ask them to help drive traffic as well.

If you want to try and monetize your video, post to a Web site such as Openfilm.com. Openfilm, as we discussed in the previous chapter, will split ad revenue with you, and will also allow you to request donations and even sell a mobile version of your video.

Spec commercials and original music videos have their place on the Web, but there is actually one other place where these projects really belong: the best way for you to distribute your spec commercial or music video is on a demo reel. This is because the primary audience for this type of work is not the general public; it's producers working in these industries who are looking for talent. If you want to really get the most out of your spec commercial or original music video, continue reading. In Chapter 14 (Distributing Your Demo Reel), you'll learn some valuable techniques to help you get this work to where it really belongs: on the desk of a commercial or music-video producer.

Action-Sports Videos

Options for distributing action-sports videos have increased significantly in the last few years, thanks to continued growth of the action-sports culture and, of course, the Internet. Additionally, while action-sports videos can be as long as a short film, or even longer, they can also be edited into smaller, download-friendly bits without significantly altering the content. For example, a short film can't really be split into ten clips of sixty seconds, but many action-sports videos can be. Making content that is exciting and trendy available at these short lengths dramatically increases their ability to get passed around on the Web. It's no surprise that literally hundreds of action-sports

Web sites exist, many of them full of clips and movies from "amateur" or "independent" filmmakers. Because of the popularity of the genre, however, and the availability of inexpensive equipment to shoot and edit, it's a very saturated market.

Although you can upload your videos to literally hundreds of various action-sports Web sites, it's unlikely that doing so will help your career. Because there are so many Web sites scattered around the Internet, you'll never really get a huge "buzz" on any given video. Even if you post to YouTube, you're unlikely to see enough attention to really turn any heads: YouTube viewers will rally around one particular shot or trick, but rarely around an entire sports video.

Your best bet, in terms of really promoting yourself, is to upload your video to a Web site that has either a contest format or some sort of judging/peer review/scoring setup with a prize or other reward for the best submissions.

You want to be working with a Web site that will give you some return for your investment of time and energy. There are some Web sites that do just this. Shredordie.com, created by the founders of the popular comedy Web site funnyordie.com, is an action-sports Web site that has some genuinely decent benefits to members. The site works along the social networking/career building model that some of the short-film Web sites use. It allows members to communicate with each other, and even gives each member their own page where they can upload videos, write information about themselves, and so forth. Members could potentially use this type of page to do some VODO style fundraising: put a trailer on the front and end of your video asking for people to donate, and add your PayPal information on your page. The site also hosts occasional contests that can result in cash, prizes and/or exposure. The Web site Innersection.tv is a surfing-only site that allows its members to compete to have their video featured on upcoming professional DVDs by leading surf filmmakers. Do some research and seek out these types of Web sites, where you can connect with other action-sports video artists, win a prize, or in some other way advance your career.

Other Types of Projects

As with the previous types of projects, the key to distributing any other "non-film" project is to identify its audience, look at what career paths it might lead to, and do your best to attract some attention toward the work. Some other popular projects being produced by students and indie filmmakers that are getting noticed on the Web are video remixes, mashups, lip dubs, and repurposed videos. All of these works involve creating new work from old, using

found footage and re-appropriating it so that it becomes a completely new piece of art or entertainment. This type of work usually demonstrates editing skills, so for an aspiring editor, accruing views on YouTube for this type of work is valuable. Amateur, user-generated videos are usually not considered methods to launch your filmmaking career, but if yours happens to be that one-in-a-million video that makes the entire world laugh, you just might find some doors opening. If you are truly passionate about a funny home video you made, you can certainly follow some of the steps in this book in order to maximize your exposure. Vlogs, or video blogs, have given anyone with a Webcam and a microphone the chance to be a newscaster, pop-culture commentator, stand-up comedian, or talk-show host. If you have the talent, charm, and drive, you might achieve some notoriety. The convergence of television and the Internet is upon us, and the rules have yet to be written. This means everything is available at this point and anything can happen. If you use the methods we have discussed to organize your plan, promote yourself, research your options, and drive traffic to your site, your Vlog might just end up being the next attention-grabbing craze.

SUMMARY

As with short-film distribution, finding distribution success with alternative content is based on a combination of the quality of the work, the time and energy you devote to promoting it, and a little bit of luck. Because every project is different, your distribution strategy for your project should be created by first considering what your career path might be, then looking for the audience, and finally researching the proper Web sites and choosing those that can be valuable for you. Although broadcast opportunities for alternative content do not yet exist, many other opportunities do. And with the Internet evolving so dynamically, more possibilities for distribution appear every day. Stay connected, and continue researching so that you'll be able to take advantage of any new opportunities that arise.

1. What were the types of alternative-content projects you learned about in this chapter? What career paths did each of them lead to? Name as many as you can. Can you think of any others not mentioned in this chapter?

2. What are the three steps of the alternative-content DIY distribution plan?

3. Why is it important to know your audience?

4. What are the three types of Web sites you learned to look for when distributing alternative content on the Web?

DISCUSSION / ESSAY QUESTIONS

1. Write a short essay about how you would go about distributing a Webisode. Be detailed about your plan and promotional strategy. What types of things would you negotiate for in your contract? What would be the ideal outcome of your distribution plan?

APPLYING WHAT YOU HAVE LEARNED

Research/Lab/Fieldwork Projects

The following lab projects will help you if you are planning on distributing alternative content.

1. Identify the strengths and weaknesses of your project and make sure it is ready for distribution. Get feedback from an instructor or mentor so you are sure you are ready.

2. Following the steps of the DIY plan, create your promotional materials and get the word out using social networks and the Web.

3. Research the relevant Web sites and create a list of the sites that offer you the most return on your investment.

4. If applicable, choose a site that has a "for-pay" model or one that allows you to use a VODO type strategy.

5. Premier your project, drive traffic to the site, and do everything you can to create buzz and interest.

DISTRIBUTING YOUR DEMO REEL

OVERVIEW AND LEARNING OBJECTIVES

In this chapter, you will:

- Learn the purpose of a demo reel
- Discover the various types of demo reels
- Learn how to distribute your demo reel in order to further your career

Why Have a Demo Reel?

To this point, this book has stressed the importance of making and distributing a creative and original short film. You've learned about the many opportunities for distributing short films, and you have seen the value a short film can have for your career. Although a good short film is extremely valuable to a writer/director, other creative crew members, such as cinematographers and editors, will derive more benefit from a solid demo reel. In this chapter, we will look into what, exactly, a demo reel is, what its purpose is, and how it can be distributed.

What, exactly, is a demo reel?

A visual artist uses a demo reel to show potential clients or employers what they have done and what they are capable of.

NOTE

In the film and television industry, the types of people who usually have demo reels are: directors, actors, cinematographers, editors, composers, sound designers, and production designers. A reel consists of a collection of the artist's work—their best work—and is viewed either on a DVD or on a Web site on the Internet.

Clients or employers wanting to hire one of these artists watch demo reels in order to evaluate experience, talent level, and range of work. Although a visual artist will always have a résumé, that alone will not get them a job. After all, a résumé can only report that a job was completed; it cannot really show how the job turned out. A demo reel can. Although every reel is different, they all perform the same function: they visually and audibly demonstrate the experience and creativity of an artist.

The DVD Demo Reel
A DVD demo reel consists of three things: the DVD itself, a reel insert, and a case with cover art.

The DVD Itself
The demo reel can either be a simple "play-only" reel with no navigation interface, or it can be a fully authored DVD with menus and buttons.

The advantage to a fully authored DVD is that you can add additional content to the reel, such as a page with contact information, a bio or résumé page, and additional content not featured in your main reel.

Make sure that the DVD is labeled with your name and contact information, because DVDs can easily get separated from their cases. See Figure 14-1 for an example of a DVD demo reel.

FIGURE 14-1. A demo-reel DVD should include contact information on the disk itself. "Series" refers to the date in which the DVD was made (reels are often updated with new work). Courtesy of Jason Moore. Used with permission.

Reel Insert

A reel insert is a card or piece of paper that is attached to the inside cover opposite the DVD itself. It provides a table of contents and contact information. Here you can include the titles of the projects included on the reel, with additional information such as dates, awards, or additional credits (for instance, on your director's reel you might include your credit(s) as editor or writer on a certain project). See Figure 14-2 for an example of a reel insert.

Case with Cover Art

The black or white "Amaray"-style case is the most common sort of demo reel case. This is the type of case that encloses any store-bought DVD. A demo reel case does not need to have elaborate cover art, but it should be clean and well designed. Simple and minimal is acceptable, even preferred.

Jason Moore

Director

Match.com	"Instinct"
California Pistachios	"Recovery"
McDonald's	"Spare Change"
Tide.com	"Boxers"
Los Angeles Kings	"Girlfan"
Bud Light	"Rover"
USDT	"Ryman"

T: 212-991-8344
E: jasonmo@mac.com
W: www.jasonmoore.com

FIGURE 14-2. Reel inserts are printed on card stock and slipped into plastic tabs on the inside of an Amaray case. Courtesy of Jason Moore. Used with permission.

Let your work be the most creative thing about the reel, not the cover art. Your name should be featured on the front, and below that, your title, such as "Sound Designer," "Cinematographer," or "Editor." Be sure to include your contact information (usually on the back). See Figure 14-3 for an example of a demo-reel case with cover art.

FIGURE 14-3. Cover art of a director's DVD demo reel. Courtesy of Jason Moore. Used with permission.

What goes on a demo reel?

Not only does every type of visual artist have a different reel (director, editor, etc.), there are even different types of director reels and different types of editor reels.

In the next section, we will look at some common types of demo reels. There are many more variations, but for the purposes of this book, we will examine those that are likely to be helpful to the three most common visual artists—whether hobbyists or students at a film school: directors, cinematographers, and editors. We will focus on these three types of reels because these specialty areas attract a majority of students and amateur creative crew members. Although the work on each reel demonstrates a different skill set, they all share similar elements, and are constructed and distributed in a similar way.

Specialized Reels: Director Reel, Cinematographer Reel, Editor Reel

Although it is common for a film student to have worked in a variety of positions during school, the film and television industry is extremely specialized. Most people are either a director *or* an editor *or* a cinematographer; there are exceptions to this rule, but they are rare. The reason for this is that people who produce film and television projects are typically financing a large sum and they want the very best person in each position. The job of a cinematographer, for example, is demanding, and most people are more comfortable hiring someone who concentrates on that one position, rather than someone who does a little bit of everything. Demo reels, therefore, are generally specialized: directors have director reels, editors have editor reels, and so forth.

There are many different types of demo reels, and it is critical to understand which type is appropriate for you. If you use an unsuitable reel when you are trying to land a job, it's unlikely that you'll succeed.

Qualities of a Director's Reel

Work on a director's reel should demonstrate his skill in the following areas:

- Directing actors
- Using the camera to tell a compelling visual story
- Controlling the elements of mise-en-scene to support the story
- Providing a clear and unified vision for the overall film

Qualities of a Cinematographer's Reel

Work on a cinematographer's reel should demonstrate his skill in the following areas:

- Lighting
- Framing and Composition
- Lens selection
- Controlling the color palate
- Camera movement

Qualities of an Editor's Reel

Work on an editor's reel should demonstrate his skill in the following areas:

- Rhythm and Pacing
- Utilization of various editorial techniques such as continuity editing, cross-cutting, jump cutting, and others, in order to support the story
- Sound design and Music editing
- Color Correction

Demo Reels Show Small Pieces of Work

An important thing to understand about a director, cinematographer, or editor reel is that it is a place to show small segments, scenes, or pieces of work; a reel is not supposed to be a collection of entire works (except in special cases, to be discussed later). Generally a reel will consist of short moments (the best moments) from a variety of projects. If, for example, a director has made four or five short films, the demo reel would consist of the best scenes from each film, not four or five complete films. The same is true for an editor or cinematographer.

Demo Reels Are Short and Fast Paced

It's rare for a demo reel to be longer than five minutes. Remember what the purpose of a reel is: a reel is meant to be watched by a prospective employer or a client. If an employer or potential client is watching your demo reel with the intention of hiring someone, they will be watching more than one reel. They will likely have a large stack of reels and will want to be able to evaluate work quickly and efficiently. For this reason, demo reels are short and fast paced. Artists select pieces of their best work and edit them into a montage or series of clips. They keep the pace moving so the viewer will not get bored, and in order to highlight of as much of their ability as possible into a short amount of time. Clients or employers watching reels are immediately discerning as they evaluate the work; some will know in less than thirty seconds that the work is not appropriate for what they are doing. Someone viewing a demo reel will quickly stop the reel and move on to the next one, so it is crucial that the reel not drag on or be boring in any way.

A good demo reel will hook a viewer in with the first scene or clip and will move rapidly, never lingering on one scene or clip very long.

Demo Reels Showcase Only the Best Work

A demo reel is no place for mediocre work. It should represent only what you consider to be the absolute highest quality of your abilities. If you put a mediocre piece of work on your reel, an employer will assume that you think this work is good, and it will likely ruin your chances of getting the job. It is always better to have a short reel with a few strong pieces on it rather than a longer reel with some average work on it. A reel is not meant to show that you *can* do work, or even that you *have* done work; a reel is meant to show that you do *quality* work.

The Evolution of a Demo Reel

As an artist's career begins, grows, and evolves, so does their demo reel. The type of reel and the contents of the reel will change over time as an artist moves into different stages of their career. Here are some of the common stages of a director, editor or cinematographer reel:

Recent graduate/Early stages of career

When you graduate from school or are in the early stages of your career, you will have a wide variety of work to put on your demo reel. You might have a few short films that you wrote, directed, and edited. You may have some spec commercials, or a music video, or both. You might have some television work, some motion graphic or visual effects work. Essentially, you will have a collection of your best work from the classes you took or various projects in which you participated on a nonprofessional basis.

NOTE

Although the industry encourages specialization, when you are taking the initial steps of your career, you are not in a position to require a specialized reel; you have a general reel. This type of reel won't be sufficient to get you a high-end job as a director, cinematographer, or editor, but it will be very helpful as you look for minor, freelance jobs as you work your way into the industry. On this type of reel, it's acceptable to have a wide variety of work, and it's also acceptable for you to have served in more than one crew position.

At the beginning of this type of reel, make a simple title that reads "Your Name" and underneath your name, "General Reel" or "Filmmaking Reel."

Narrative or documentary film reel

When you are trying to find a job in the narrative or documentary film world, you need a reel that showcases only that type of work. For instance, if you are a cinematographer or editor wanting to be hired to work on a short or feature narrative film, you'll need a reel that demonstrates your experience and creativity in only that area. A director, perhaps seeking funding, will also need a reel that shows their best narrative or documentary work. Occasionally, you might include work in commercials or music videos, but it's really best if you have a 'film-only' type of reel for film projects. You will still be using only select scenes or clips from the various films you have worked on, but if you can create a full-feature DVD with menus, you can consider building a menu page with some of your complete films, in the event a viewer likes your reel and wants to see one of your pieces in its entirety.

Specialized industry reel

Once you start to work in the industry, you will want to choose a specialty and create a reel that showcases that particular kind of work. Common areas of specialty in the industry are commercials, music videos, episodic television, reality television, and sports. With the growth of the Internet, it is possible that Webisodes as a specialty might soon evolve. Finally, there is the narrative film or documentary film specialty, which was addressed previously. When you begin to specialize, your reel should contain work in only that particular field.

If you find that you are starting to specialize but are still doing work across a few different fields, you should create multiple reels, one for each specialty, or create multiple sections on your DVD, so that a viewer can click to see a commercial reel, click to see a music-video reel, or whatever might be of most interest to him.

Further specialized reels

In some cases, as you become increasingly specialized, so will your reel. It's common for some people to specialize within a certain field; for instance, a cinematographer who works in commercials and most of his work is car commercials. His demo reel will likely contain all commercials and perhaps will even be nothing but car commercials. Other sub-specialties might be visual effects editors, or water cinematographers, or directors specializing in working with children. As you become an expert in a certain field, your

demo reel should reflect that. Your chances of getting work are directly tied to your demo reel, so if you specialize in a field and your reel is compared to someone who does not specialize in that field, you will have the advantage: you have the experience and skill.

Distributing Your Demo Reel

As you might have guessed, a demo reel cannot be distributed in the same way a short film can.

A demo reel is not made for the public, it is not entertainment. A demo reel is only meant to be distributed to professionals in the film and television industry, and its purpose is to help you find work. There are no festivals or contests or Web sites that showcase demo reels to general audiences. Distributing your demo reel is about getting your reel into the hands of someone who can hire you.

For a director, that means getting your demo reel seen by a producer, a client, an investor, or someone who can help you with your next project or hire you for a job. For a cinematographer, it means your reel being seen by a director who is planning his next project. For an editor, it could mean your reel being viewed by a director, or an owner of a post-production facility. Although a demo reel is not distributed in a traditional manner, there are still some things you should be doing in order to ensure your reel is brought to the attention of the people who should see it. Let's explore your options for distributing your reel to industry professionals.

On request

A common way your reel finds its way into the hands of someone in the industry is on request: someone asks you for it. Perhaps someone has recommended you, or you submitted your resume and are then asked to follow up by sending your reel, or you networked and met someone who subsequently asked to see it. Anytime someone asks to see your reel, you'll obviously be happy to send it along. Be sure to include a brief, professional cover letter thanking them for requesting your reel. Let them know that you would look forward to discussing the job/project further at their convenience. Be sure to triple-check the reel to ensure that it plays. And be sure your contact information is on the reel, the case, and the cover letter.

Submitting your reel

In some cases, you can submit your demo reel directly to an employer. If you read a job posting and the posting indicates that reels are accepted, then by all means, send yours along. If you are seeking employment, there are some instances when you can send your reel, and some when you should not. Let's explore this:

Cinematographers and Editors Seeking Representation

There are agents who represent creative crew members (sometimes referred to as "below-the-line" crew members). These agents will actively try to find you work in the industry, and will take a percentage of your pay should they find you a job. Sending a cover letter and a reel to this type of industry professional is acceptable, but you should do your research first. Understand exactly what type of artist the agent represents, and become familiar with their roster. Be sure your work is on the same level as those represented. Try to determine whether or not the agent has any artists whose style is similar to yours (you prefer they don't, so you might fill a gap in their lineup). Write a brief, professional cover letter requesting that they look at your reel. Don't expect to receive a reply from the agent; it's a competitive industry, and agents receive a steady stream of submissions. Every person on their roster, however, got there because they have a demo reel, so it does happen, even if it takes time.

Directors Seeking Representation

Directors are represented in a number of ways, depending on the sector of the industry in which they work. Feature-film directors and episodic television directors have agents, usually powerful Hollywood agents that also represent well-known actors. You won't be sending your reel to them just yet, but someday you might. Directors who work in commercials and music videos are signed to production companies. A production company will have a roster of directors, and when their director gets a job, the company produces the work. You can, at some point, send your demo reel to the producers at these companies in the hope of signing to work as one of their directors; for this to occur, you need to have work on your reel that is on the same level as the other directors at the company. For most of you, this may come in a few years. When it's time for you to send your reel to these companies, you must do your research and learn as much as you can about the company before you submit a reel to them. Get familiar with their other directors, the jobs they have done, and the types of work the company generally does. For instance, if the company does commercials, don't send them your music-video reel. Look at the company's roster of directors and see if you can find

anyone with a similar style. If you can't, that may be a good thing: you can hope to add something to their lineup. Just be certain your work is generally in line with what they do.

Movie Studios, Networks, and Cable Companies

Directors, editors and cinematographers do not usually send their demo reel to one of these types of companies; the business is simply not organized in this way. If you are a director wishing to make a feature film, you will do so by gaining attention for your short films, by networking and meeting producers, and by eventually showing your reel to someone who requests it. The same idea is true for editors and cinematographers looking for work in this sector of the industry. It is a gradual, step-by-step process.

Sending your reel to a large studio or television network is a waste of time: even the secretary receiving the reel wouldn't know what to do with it: there is simply no process in place for reels to be reviewed at this level. At best, it would be returned to you. More likely, it would be thrown away.

Networking and day-to-day encounters

The single most customary way that your demo reel will be brought to someone's attention is for you to put it in their hands. Always carry your reel with you, everywhere you go, every day. For anyone trying to succeed in the film and television industry, every day offers a new opportunity. You might find yourself sharing an elevator with a producer or director: maybe they will watch your reel. You'll be at a party and meet someone. Perhaps you will be taking a class, attending a workshop, or sipping coffee next to someone at a coffee shop.

Opportunities present themselves in everyday situations and during industry networking or social events. You must always be prepared to seize the moment. Always carry your reel with you, everywhere you go.

When you have the occasion to share information about yourself and what you are working on, mention your demo reel. Ask for feedback. Talk about the process of putting the reel together, and start a conversation. All the same promotional techniques you used for your film apply to promoting your reel.

Distributing your reel on the Internet

In addition to physically giving your demo-reel DVD to people, you will also need to have your work available to be seen on the Internet. Although the quality of your reel will be better on a DVD, it has become standard procedure to view work on the Internet. There are several ways to put your reel on the Web, and having it there has several advantages.

Social Networking and Free Video Sites

It's a good idea to have your reel up on any of the social-networking sites you use, simply because it will make your work available to a large number of your friends and peers. Opportunities can come from anywhere, and it is likely that at least some of your work will be acquired through friends. YouTube and Vimeo are also good places to host your reel, although Vimeo is the destination where more professional people choose to go to view films. Putting your reel up on these sites won't cost you anything, and it will be available for large numbers of people to see; Vimeo in particular is gaining a reputation as a popular place for artists to host their demo reels.

Professional Networking Sites

Another suitable place for your online reel to live is on professional networking sites such as those we discussed for your film: shootingpeople.org, thesmalls.com, and so on. These sites are especially useful for cinematographers and editors, because a majority of the members are filmmakers.

Paid Demo-Reel Hosting Web Sites

There are a number of Web sites that you can pay to host your demo reel, and some have selling points that make them worth consideration. Giantfin.com is a well-designed Web site that offers demo-reel hosting for film and television professionals. For a fee of around $30 per month, you can host your reel on their site on your own page. Your page can be very robust and full featured: you can have your reel (which can be segmented so people can watch individual scenes), pictures (like a press pack), a biography, Web links, and so on. They design everything and you can constantly add work to your reel. It's a slick, professional interface that projects a better appearance than Vimeo or YouTube. Other Web sites that are specifically for the industry can cost much more than that, and for your monthly fee, your work will be made available to large numbers of working professionals. Sites like sourceecreative.com and nicespots.com specialized for high-end commercial and music-video reels and have a price tag to match.

Your Personal Web Site

One of the best places for your online demo reel is a Web site that features you and only you. By purchasing a domain name like *www.yourname.com*, you can build a private Web site to host your reel. Your Web site can be a sort of home base for all of your work. Purchasing a domain name and paying to host your Web site is not as expensive as you might imagine—costs can range from $75-$200 a year, depending on the various options you might choose. Of course this only rents the space; you'll need to either design the site yourself or find someone to do it for you. But with the ever growing demand to have your work available on the Web, this is certainly an option worth exploring. See Figures 14-4 and 14-5 for examples of personal Web sites.

FIGURE 14-4. The Web site of cinematographer Alexandre Naufel. Alex has divided his work into categories such as commercial, narrative, music video and documentary. Courtesy of Alex Naufel. Used with permission.

In addition to putting your demo reel on your site, you can put entire films and projects, pictures, your biography, your résumé, and whatever else you want to share.

Creating and distributing a demo reel is a skill that evolves over time. The more reels you make, watch, and send out, the better you get at determining

FIGURE 14-5. Author Jason Moore's commercial directing Web site. Courtesy of Jason Moore. Used with permission.

what should be included on a demo reel and how to bring it to the attention of people who can help you.

In the following interviews, seasoned professionals Clayton Hemmert, Alexandre Naufel, Dave Barrett, and Tim Fender offer their advice on demo reels.

In the first interview, Clayton Hemmert discusses his thoughts on what should be included on an editor's demo reel.

Clayton Hemmert is a multiple-award winning editor and founding member of Crew Cuts, one of the most respected post-production companies in the industry.

INTERVIEW

AN EDITOR'S DEMO REEL *CLAYTON HEMMERT*
Editor and Founding Member of **Crew Cuts**

JM: *How should an editor who is just starting out construct an editing reel?*

CH: Being able to show a variety of work is very important. Have one reel under 10 minutes running time, as no one wants to sit through an hour's worth of material on their first viewing. If someone is interested in pursuing a deeper understanding of

your work, then supply the full-length pieces. But keep the initial reel on the short side. Put yourself in the viewer's shoes. Remember that this person is often screening many reels, and can't afford to screen longer lengths for everyone. For an editor they want to pursue, they'll follow up with a request for more material. For a 10-minute (or under) reel, cull the most diverse range of your work. This way they can see a spectrum of your work. And have a lineup printed/posted so it's easy to follow or review. Don't make the viewer do the work. And if there are excerpts, make sure these are clearly identified.

JM: *Are there any mistakes an aspiring editor should avoid when putting together a demo reel for the first time?*

CH: People often want to "typecast" talent, whether it's an editor, cinematographer, director, or on-camera talent. Keep the work as diverse as possible, as you want to be able to show your talents on multiple styles. Include dialogue, music, comedy, dramatic, montage, quick-cutting styles, slow-cut styles, graphics, etc. Show as many different types as possible. Then if they want to see more of a particular style, put together another reel that's tailored toward their request. And when first submitting the reel (the diverse one), make sure the viewer understands there's more work available in a particular genre if it's desired.

JM: *Do you feel an aspiring editor should begin to specialize in one area (films, music videos, commercials) or can they market themselves as an editor who can work across those boundaries? Is it conceivable to have several reels, or a reel with several areas of specialty on it?*

CH: It's pretty hard to market yourself across these areas—although not impossible. Variety's the spice of life, and it's no different for an editor. Working across boundaries is the ideal world. If you can create a career where you dip into a few different genres, that's the best thing. But again, some producers/creatives often stereotype an editor by the formats they've worked in. In terms of learning the art/craft of editing, as well as the technical process, commercials offer a great platform, as they're all very short films. And the process of dailies to finished masters happens a lot more often in this very short form than in features or longer docs. However, it's easy to get stuck in that world, and not be able to cross over into long form. There are some editors who have successfully done this, but the overwhelming majority hasn't. If you can establish relationships with directors, there's often a trust that's formed which can transcend these boundaries. And yes, if you have the material, certainly have several reels. It's always good to have one general reel available for that general interest call you might receive. But you have to be prepared for the next call you hope will happen: which is having more work in a particular genre or format.

JM: *When you look at an editor's reel, what types of skills and artistic abilities do you look for?*

CH: Diverse styles, and diverse technology/software platforms. And someone who enjoys the aesthetic of film.

JM: *For an editor who is just getting started and looking for work at a post house, can they send their reel around and have any hope of getting a call back? Or should they intern first and work up? Is it possible to break into the editing world without any personal contacts?*

CH: Use both approaches. It's hard to say if either position will be available, so if you're lucky to be offered either one—grab it. If you have a reel, great. But many times a post house isn't looking for an editor. They're looking for a hard-working, organized, hardware/software diverse person, and most of all, a person who can get along with others. Editing is done in close quarters. And no one wants to deal with an entry-level person who simply isn't a decent person. Just use common sense, which isn't so common. Those unique, cranky artists only last so long before they burn out their relationships. You've got to be able to articulate ideas, styles, and be able to understand the same from others. Communication is key. It is possible to break in to the editing world without any personal contacts. Probably the best people in this field did it "anonymously." Get your foot in the door somewhere. If you have a choice, take the job that has the best opportunity for growth. Otherwise, just get your foot in the door.

JM: *Do you have any other advice for an editor who is just starting out?*

CH: The world has more technological democracy now. You don't need obscure and expensive equipment to practice your craft. Get Final Cut and start editing. Learn graphics. See movies—all kinds of movies. Remember that there are millions of frames shot during any one shoot. They can be juxtaposed in a million different ways. With an infinite variety of sound behind it.

As an editor, you want to have some awareness of what was being pursued on the script, but don't be a slave to that. An editor's talent is often their objectivity, and their ability to judge what was captured on screen, and what wasn't. That cold, unbiased viewpoint is critical to the process. Often a director will hope they achieved a certain performance on the set/location. Sometimes that hope influences judgment. It's your job to be an unforgiving judge of what works, and what doesn't. Understand music and its countless styles, and the many roles that music plays in any film. And seek out unusual films, and short films. There are some great festivals out there that have done some of the selecting for you. YouTube just has too much. Go to some festivals that have picked the best of the best. Then figure out how to get yourself inserted into that process. Write down credit names, write to people, and introduce yourself. And be honest about your own capabilities—don't oversell yourself. You'll lose any chance of trust a person might have in you. Be honest, and be yourself. And be ready to be a hard worker and a self-starter. Ask questions when appropriate.

No one's born with the knowledge, so ask how certain things are done, how certain software works, etc. Pitch in on anything that needs to be done. The key word here is *"anticipate."* Anticipate what might be coming up next in the process and have it ready or prepared. People will then trust you. And trust is the basis of many relationships between directors, clients, and yourself.

Cinematographer Alexandre Naufel will share his thoughts and advice about what a cinematographer's demo reel should be.

Alexandre Naufel is a Brazilian-born award-winning director of photography with experience in all corners of the globe and in all formats. Some of his recent projects are the indie film *A Marine Story*, directed by Ned Farr, starring Dreya Weber and Paris Pickard; the documentary series *History Made for Tomorrow*, about ancient sustainable living techniques still used in India and China today; the acclaimed HBO documentary *Sand and Sorrow*, produced by George Clooney; commercials for Coors/ESPN, V-Tech and Tide; and the award-winning PSA campaign for USDT. A graduate of AFI's cinematography program, he moves easily from genre to genre, enjoying the variety and the possibilities that each production brings. He is a long-time resident of Venice Beach, where he lives with his family, their dog, their tortoises, and their chickens. Alex's work can be seen at www.naufel.com.

INTERVIEW

A CINEMATOGRAPHER'S DEMO REEL
Alexandre Naufel
Cinematographer

JM: *In regard to the short films you have DP'd, do you feel it's mainly the director/producer's responsibility to take care of distribution, or do you get involved?*

AN: With most short films, and even with features, when the shoot is over, everyone goes off to do their own thing. DPs are usually not involved all the way through, which is too bad. It's typical that only the producer or director handles the distribution process, but in a short film, everyone should be a "Producer." I'd like to be more involved. I'd like to have more of a say about what festivals we enter the film into, for instance. On a short film, the budgets are low and often I'm working way below my rate or even for free. So even though the producer or director might be contributing cash, I'm also contributing to the film with my time, and sometimes my gear. So I've started to realize that I should also consider myself a "producer." Now when I discuss projects with directors, I'm setting that relationship up from the beginning: I want to be part of the producing team and have some sort of ownership. Not that

I'm looking to make money or anything like that, but I see my efforts as valuable, and again I'm contributing quite a bit to the film, so I'd like to have a little more input on the back end. For instance, I want the producer/director to agree to submit the film to festivals with technical awards—meaning awards for cinematography—so that I can try and reap some rewards on the festival circuit just like they are. I'm a team player, but as a DP sometimes it feels like you put all this effort into the front end of a project and then are a bit forgotten about. I think it's time that DPs advocate a bit stronger for involvement in the later stages as well.

JM: Is there value for a DP to attend a film festival? Do you? What can a DP gain from this?

AN: Of course there is. If you've done a nice job, you gain the satisfaction of compliments from people, for one thing. Really, the movie isn't over until it screens for an audience, and I always want to be a part of that cycle. It's the end of the cycle where you find out and learn the most: did the things you think would work actually work, for instance. What do people really think? That's where you get valuable feedback. It's also where you meet other directors—film festivals are full of filmmakers—so you meet them, maybe they saw your film, they like your work, and maybe you meet someone who will give you your next job. Another great thing about festivals is that you can watch other films and learn from them. What's interesting is that any festival that your film has been accepted to will generally have other films that are kind of in your same league, meaning budget, scope, level of experience. Whether it's the Tribeca Festival or the Topanga Festival, if you are screening, it's likely that other films at your level are also screening. Which is great because you can see what others are doing on similar budgets and with similar resources. You can see what others are doing and learn from them.

JM: Do you help promote the short films you DP? How and why?

AN: Yeah, sure, in whatever way I can, I'll show it to people, talk it up, try and push the rest of the team. Of course, why wouldn't you? I guess unless you are not happy with the film, or had a falling out with the director, or like, broke up with the director, then you wouldn't really be out there pushing the film. But otherwise, you're all on the same team, so you are talking up the director, talking up the producer, actors, writers.

JM: You've seen plenty of DP demo reels and have put many reels together for yourself. Can you talk a little about what you feel a DP's reel should do, what works best?

AN: Putting reels together is one of the hardest thing a DP can do. Don't do it in a vacuum; get a good friend, or an editor, who can be objective about the material. You need someone with taste who can tell you: this works, this doesn't. Kind of like a director working with an editor on a film—sometimes a shot you love, maybe because you worked so hard to get it—just doesn't work. Other times something you might not like will actually be better than you know. So it's important to get feedback.

A cinematographer's reel needs to show range, and it needs to show personality, so that you can get a feel for that person's unique, individual eye. You want to understand that person a little bit. Not too much personality, but some. A good reel has to have all the classic things: beauty, lighting, night exteriors, an action sequence, a technically challenging shot, but it also must have inspiration. It's one thing to be able to execute great storyboards, but showing that you bring something to the film, you want some extra shots like that, some spontaneous, inspired moments. If you are doing a montage type of reel it should be short, about three minutes, and it should be entertaining and not repetitive. Start with your best foot forward because there is no guarantee that people will watch the entire thing. Never include material you did not shoot. If you were the gaffer, or the assistant camera person, you put that experience on your resume. A reel is meant to show what you can do, a resume can show all the different things you have done. For a DP who is just starting out, they will probably have a general reel with lots of different types of work. But if they have a niche they want to go in to, like commercials, or music videos, it's a good idea to start putting together a more specific type of reel. In fact, it's good to have several reels, and it's even better to make a new reel for every job. Today, everyone can pretty much put their own reel together at home, so if you are up for a job, and can find out what kind of things they are looking for, it's a good idea to customize your reel to specifically show them something close to what they are looking for.

In the next interview, cinematographer Dave Barrett discusses the importance of film festivals and a DP's demo reel.

Dave A. Barrett is an award winning cinematographer and owner of Magic Hour productions, based in Tampa, Florida. Dave is regarded as an artist who has balanced his instinctively creative cinematography with his vast knowledge of the latest high-definition technology and concepts. Dave has won multiple Addy and Telly awards on both the local and regional scale, as well as national Videography awards and Best Cinematography awards won in film festivals throughout the country. Dave has shot all over the world, most recently in Morocco, where he shot the independent feature film *Real Premonition*. Additional film credits include *Pierced*, *Mint Cologne*, and *The Flight Dr.*, a documentary on the life of Ferdie Pacheco. Dave is also a highly sought-after cinematographer for NFL Films, shooting for over ten years, including several Super Bowls. His work can be seen at www. magichour.net.

A CINEMATOGRAPHER'S DEMO REEL

Dave A. Barrett
Cinematographer

JM: *In regard to the short films you have shot, do you feel it's mainly the director/producer's responsibility to take care of distribution, or do you get involved? If so, what kind of involvement have you had?*

DB: I think it is the director/producer's responsibility to take care of distribution but I would help if they asked me to do so. For example, I did help the director of a feature I shot, *Real Promotion*, shop the movie around in Los Angeles. He made appointments for me and I took a trailer around showing it to distribution companies.

JM: *Is there value for a DP to attend a film festival? If you have ever attended a festival that one of your shorts has been in, were you able to promote yourself there?*

DB: I think there is a tremendous amount of value a DP can get from attending a film festival. I love to attend and have attended many festivals including several Sundance and Los Angeles Film Festivals. One of my favorite aspects of a film festival is the question and answer session that happens after a movie plays. Being able to ask the moviemaker (not always a Producer or Director but also crew members, like DPs) a question about the film you have just watched can be very rewarding. Promoting yourself in an "introducing" kind of way to producers and directors and seeing your peers' work are good reasons to attend a film festival, but letting the film community see your work in a film festival can be even more worthwhile. Sometimes there is no better way to market yourself as a DP than having your film viewed at a film festival. One of my favorite jobs came from meeting a director who introduced himself to me after he saw me receive an award for Best Cinematography at a film festival.

JM: *Can you talk a little about what you feel a DP's reel should do, what works best?*

DB: Most often, the reason a DP gets a job from his reel is because the viewer sees something on that reel that is similar to something they want to shoot. If a DP can select work for a reel that is related to something the client wants to shoot, the DP will be way ahead of the game. Make chapters or drop down menus with thumbnail images on DVDs and Web sites so the viewer can pick something that may be similar to what they are looking for.

JM: What are some mistakes you've made or seen others make that you can advise beginner DPs not to do?

DB: There is a running debate on the advantages of having montages on a reel.

Directors who do not like DP montages for a reel feel it's too easy to select a group of images shot at different times for different jobs and make them look good as a montage with a range of looks. What if the DP can't hold a single look throughout the entire project? Some directors would rather see a whole scene from a movie or a complete commercial spot instead of a montage of selected shots. However, there are directors that do like montages on a DP reel. They like to see that a DP has a vide variety of work and experience and they want to see all the work in a short amount of time.

Our final interview is with Tim Fender, who will share his experience of putting together editor's demo reels.

Tim Fender is an award winning editor at Beast Editorial, San Francisco. Tim has worked in post-production for twenty years, and has been an editor at some of the country's top editorial companies, including Bob 'n' Sheila's Edit World, Filmcore, and BEAST. Tim recently won an AICE award (Association of Independent Creative Editors) for his U.S. Cellular spot *Calling All Communities*.

INTERVIEW

AN EDITOR'S DEMO REEL
Tim Fender
Editor

JM: You've made and seen your fair share of editor's demo reels. What advice would you give a young editor putting together a reel?

TF: Keep it short, certainly not more than 5 minutes. Put your best work first because your target may not stick around to watch the whole thing. Unless you're an FX guy, montages seem cheesy. Just show the actual piece so there is some context. If your work is long format, show 30 - 60 second excerpts. Keep it moving. If your reel is online, make sure it streams or downloads as quickly as possible. Executive producers are busy, don't make them wait.

JM: Can a young editor send his/her reel out to editorial houses, or is it more about interning, working your way up?

TF: Sending out a reel shows you're proactive and serious about becoming an editor, but you should be prepared to be an intern, runner, or assistant first. Research editors and directors whose work you admire and seek out those companies. Get in, build trust, and soon work will begin to trickle down to you and you'll be able to start building a professional reel and client-base.

SUMMARY

In this chapter, you learned what a demo reel is, why you need one, how to put one together, and how best to distribute it. Although distributing a demo reel is quite different from distributing a short film, it is an essential part of finding success in the film and television industry. A demo reel might not win awards or be broadcast on television, but it's a great way to get you hired and help you find your next job.

REVIEW QUESTIONS: CHAPTER 14

1. What is the primary purpose of a demo reel?

2. Why are demo reels specialized?

3. What is a typical length of a demo reel?

4. What are some of the ways you can distribute your demo reel?

DISCUSSION / ESSAY QUESTIONS

1. Write a short essay about how you would go about distributing your demo reel. What type of demo reel do you want to make? Who do you want to watch your reel? What projects that you have completed would you put on your reel? Where would you send it, and where on the Internet would you put it?

APPLYING WHAT YOU HAVE LEARNED

Research/Lab/Fieldwork Projects

The following lab projects will help you if you are planning on distributing alternative content.

1. Put your own demo reel together using the best work you have. Decide on the type of reel you want to make. Create a simple cover and insert. Show your reel to film students or friends or your experienced filmmaker mentor and get some feedback.

2. Do some research and make a list of the ways you can distribute your reel. Send it out, or host it online, and get some feedback.

THE END OF ONE CYCLE, THE START OF ANOTHER

OVERVIEW AND LEARNING OBJECTIVES

In this chapter, you will:

- Learn how to wind down the distribution cycle
- Learn how to deal with rejection
- Discover how to leverage your success and gain momentum for your next project

Winding Down

At some point, after you have submitted to as many festivals as you can, sent your film to all the distributors, sales agents, buyers, and Internet sites that you are able to, you will find yourself at the end of your distribution cycle. Hopefully thousands, or at least hundreds, of people have seen your film. Ideally you have enjoyed the process, learned a great deal, and formed new relationships with people who can help you as you move along your career path. Once you have explored every avenue of distribution for your film, regardless of your success or failure, it will be time to wind down, put the project aside, and begin thinking about your next film.

There is no exact time frame for winding down a project, but there are some things to consider that will help you decide whether or not you should keep working.

NOTE

The festival life for any film is one year. If you submit to a festival and are rejected, you are generally not advised to submit the same film to the same festival the next year. Festivals want current films, so most have a stipulation in their submission form that the film must have been completed within that year. The same goes for submitting to distributors, sales agents, buyers, and Internet Web sites: if they reject your film once, they will probably not accept it later.

Although it might be nice to be able to resubmit your film to all these venues, there is also some comfort in knowing when you should stop. After all, you cannot and should not spend the rest of your life trying to distribute one film. You need to achieve a balance between creating work and trying to get it seen. One approach to a timeline for your distribution cycle is to consider how long you spent making the film. You should spend an equal amount of time promoting it. After all, if you spent six months writing, directing, and editing a short film, does it make sense to spend only a few weeks attempting to get it noticed and appreciated? On the other hand, it wouldn't make sense to spend a year or more; if you did, you would really be more of a distributor than a filmmaker.

A good rule of thumb is to spend one month trying to distribute for every month you spent working on the film.

Once you have exhausted as many distribution outlets as you can in that time period, it is probably time to bring the distribution aspect of your project to an end and move on.

Wrapping things up

As you start to wrap up the distribution cycle, there are a few things you should do to properly bring your film project to a close. You want to keep proper records of everything, put your materials together in one place, and make sure that everything associated with your film is filed and available for reference in the future. Make room in a filing cabinet, use a cardboard box with hanging file folders, or create some other sort of organized filing system.

You want everything together, organized, labeled, and easy to locate. This will become your archive—essentially a vault for everything related to your film.

Items that should be carefully stored in this archive are:

- All of your press materials: cover art, production stills, synopses, bio, etc.

- All deliverables: signed releases, memos, and contracts

- Any festival records: brochures, forms, awards, and correspondence

- Any materials from distributors/sales agents or buyers: contracts, deal memos, payment records

- All pre-production materials for the film: script, storyboards, schedules, etc.

- Several copies of the film in various formats

Additionally, you should create some new documents that you will find useful in the future:

- A list of every festival you were accepted to, with dates, the name of the festival programmer, and some notes about your experience there

- List of every distributor, sales agent, buyer, and Internet company you submitted your film to, with the names of your contact person and notes on the result

Finally, you want to organize your contact information of all the people you sent emails to, networked with, or with whom you otherwise interacted during your promotion process. You can create a comprehensive list of names, email addresses, and phone numbers, or group them in your email application on your computer. It doesn't matter how.

You want to be able to quickly and easily reach out to everyone who supported your film. Why? Because once this project is wrapped up, it's time to start thinking about the next one.

Dealing with Rejection

Failure and rejection are fundamental parts of the creative process, and it is likely that by the time you are winding down your project, you will have dealt with a fair amount of both. Perhaps your distribution plan did not go as well as you hoped. Maybe you sent your film out to dozens of festivals only to be ignored by most, or even all of them. Distributors did not return your calls, sales agents sent you rejection letters, and you only got three views on YouTube, all from your mother. Every filmmaker has experienced rejection and failure on many levels. Look at your favorite film director, recording artist, fine artist, actor, or author; they have all experienced just as much failure as success. That's how creativity goes: sometimes you make great work, sometimes you don't, and sometimes even when the work is good, audiences don't respond. It happens, and you should not be so devastated by it that you stop working.

SIDE NOTE

Failure Can Help You Embrace your failures and mistakes as learning experiences. You always learn more from mistakes than success, so chalk it up to experience and keep working. Fear of failure is the number one reason why many artists give up. Think of failure as your friend: it means you are trying. It means you took a risk. It means you learned something. As much as you want to create work for an audience, you also must embrace the process itself and enjoy the act of doing, trying, collaborating, experimenting, and yes, sometimes even failing. If you can make peace with failure (not that you seek it out, of course) you will be able to continue working in this industry for a long time. If you let failure cripple you, you simply won't last. Failure, unfortunately, is not going anywhere soon. The faster you can accept it, learn from it, and pick yourself up to try again, the better off you'll be.

If the project you have been working on during this distribution cycle fizzled and failed, it's time to put it to bed and start brainstorming on the next one.

Leveraging Success and Gaining Momentum: Step 5 of Your Distribution Plan

As you gear up for your next project, you will be entering the final phase of your distribution plan. It's been a few chapters since we've talked about the plan, so let's recap:

1. Promote your film and yourself (done!)

2. Submit to film festivals and hope to win (done!)

3. Attempt traditional broadcast distribution through a distributor (done? In the process?)

4. Secure Internet distribution either with a distributor or DIY style (done? In the process?)

5. Leverage your success, no matter how big or small, into momentum for your next film. (Coming up soon)

Although you might still be taking the final few steps of this plan, I'm going to discuss Step Five now. The basic idea is that you want to use all of your experience, success, and even failures as resources when you begin your next project. Here are some things to consider as you start a new film production-and-distribution cycle.

Self-Evaluation

A useful way to collect and organize all of the knowledge you have gained during this process is to do a formal self-evaluation. Write a summary of what you have learned during this process and be as specific as possible. You want to use this to help you build on your strengths and correct your weaknesses as you begin your next project. Your self-evaluation will be a series of questions that you answer as honestly and as completely as possible. Use the following template to get started, but feel free to add questions of your own as well.

Self-Evaluation: The Film

1. Overall, what are my feelings toward my film? Do I like it, love it, hate it?

2. Overall, how did audiences respond? Did they respond as I expected, or was I surprised?

3. What specifically am I proud of with regard to the film? (Example: proud of the dialogue, proud of the ending, proud of the lighting, proud of the subject matter.)

4. What did audiences seem to enjoy the most?

5. What was a common type of feedback I got from audiences?

6. What part of the filmmaking process (writing, directing, editing, etc.) was the most fun for me?

7. Based on this evaluation, what are a few of my strengths as a filmmaker?

(Now on to the areas of improvement . . .)

8. What part of the film did not turn out the way I wanted (example: unhappy with script, art direction not strong enough, dialogue too false, characters a bit generic, lighting uninspired, etc.)

9. Why do I think I allowed this to happen? (Resist the urge to lay blame on anyone else but yourself: you are evaluating yourself, not "them.")

10. How can I assure that I don't make these mistakes next time?

(Thinking ahead towards the next project . . .)

11. Because I know it's constructive to build on my strengths, what elements of filmmaking that I am good at will I employ again on my next film?

12. Because I want to correct my mistakes, on what elements that need work shall I redouble my efforts for my next project?

13. What new genre, technique, or style am I looking forward to trying?

14. In what way will my next project be more ambitious and more professional than the last?

15. What is my overall goal for the next film?

Self Evaluation: The Distribution Process

1. How successful was my distribution process? Did I achieve my goals?

2. What am I most proud of in terms of distribution? (Example, a great screening, a festival acceptance, a particular distribution deal.)

3. What do I wish I had achieved that I did not?

4. Where did I excel as a promoter/distributor? What part of the process did I seem to have a knack for?

5. What part of the process did I not do as well? Why?

6. How can I improve for the next time? What specifically do I need to do differently?

7. What are the three most important things I learned about distribution? (Can be positives or negatives)

Do this evaluation thoroughly and sincerely. You want to make sure that all of the hard work you did on this project serves you well in the future. If you write everything down, and store this evaluation with your other records, you will be able to look at it again later, as you strategize for your next project. You'll be surprised at how many small details you might forget about, and this self-critique can help you make some good decisions and avoid some bad ones as you get ready to start all over again.

Make your next film distributable

One of the best things you can do to assure yourself of more success on your next film project is to incorporate everything you have learned about distribution into the writing and directing of your next film. It isn't necessary to list everything here, but for example: as you write, consider all the red flags that might pop up in the distribution process: don't write in a montage set to a U2 song, instead, indicate in the script that it is a song similar to a U2 song (with the understanding that you'll find an up-and-coming rock group to make an original score). Consider all the films you

saw on the festival circuit, and remember what drew response from the audiences. During pre-production, get your social networks up and running and start promoting as early as possible. When you are directing your next film, remember to get contracts signed, make sure to get production stills during the shoot, and make sure to get location and art releases. When you are in post, research film festivals early enough to make some decisions about when and where to make your world premier. Consider your distribution goal for the next film and be sure to keep distribution in mind every step of the way.

Utilize your network of fans, friends, and peers

During the distribution phase of your last film, you connected with a lot of people as you promoted your film. Many of them became friends and fans of you and your work. As you gear up for your next project, consider all of these people assets and resources, not just an audience. Reach out to them for feedback on your script. Don't be afraid to ask for donations of money, time, favors, or services. People who are movie buffs are often thrilled to be a part of making one: it's fun, after all.

Don't wait until your film is finished to get back in touch with everyone: keep your network of friends, fans, and peers involved with your project from the very beginning. You'll find solutions to problems (anyone have a backyard I can use to shoot a scene?), recommendations (anyone know of a good makeup artist?) and support in general. Plus, involving your network in the process ensures even more excitement and participation from them when the film is finished.

Leverage your success

As you start the pre-production process on your next film, you'll be looking for actors, crew, locations, equipment, money, props, wardrobe, and more. Regardless of your budget or experience, you can help yourself by framing your needs for this next film in terms of the success of your last one (whatever that success might have been). You want people to know you have a

good track record, and that you expect this next project to be as successful, if not more, than the last.

When you are trying to round up all the resources that we've mentioned, make sure people know what you did with your last film. For example, you are approaching a camera rental house to ask them to donate a camera package for your weekend shoot. In addition to pitching your current project to the owner or head of the rental department, you want to say something along the lines of "On my last film, we were lucky enough to get into four festivals and secure a great Internet distribution deal at Indiefilm. com. Everyone who participated was thrilled with the success and exposure. We're hopeful that this film will do even better, and we are really hoping you'll be a part of it with us." You want people to know that you are a serious, experienced, professional (or at least semi-pro!) filmmaker who plans to work hard to get the film seen. The fact that you have done this all once before is favorable, so you need to let people know. Anybody considering helping you will find great value in this: nobody wants to help a film if it's just going to sit on the filmmaker's bookshelf.

<div style="text-align:right">_____
NOTE</div>

Gain momentum

The final piece of the plan is about moving you to the next level as a filmmaker or creative crew member as you progress toward your goal of working in the film and television industry. No matter what your next project is, you want do your best to gain momentum. You want your work to get better. You want to improve. You want to move up the ladder of professionalism so that you make yourself more and more valuable to the filmmaking community. One good way to do this is to consciously try to make your next project more ambitious than the last.

Push yourself to do better with your next project, whatever "better" means to you. This doesn't have to mean a longer film, or a film with a heftier budget, but it can, if that is important to you. It means that you must try, with every ounce of energy that you have, to make your next work significantly better than your last.

Now that you have all of the experiences of the production and distribution of your last project, you must not ignore them. Build upon both your successes and your failures, and set your goals just a little bit higher this time. A few more festivals. A prize, or more prizes. A better distribution deal, or perhaps just a good one. More hits on the Internet. More press. Better press! Make a few specific goals that are beyond your last ones and set about achieving them. If you do this with passion, if you try your best, and if you remember that anything is possible in this business, you just might find yourself at the front of the theater, gripping an award, making the speech of your life.

Good luck!

SUMMARY

In this chapter you learned how to wind down the distribution cycle of your film, how to deal with rejection, and how to leverage your success and gain momentum for your next project. Although you may still be in mid-distribution cycle, these important lessons will help you soon. Be sure you organize all the important files and elements of your film so that you can access them later. Don't let rejection get you down: we've all experienced it, and rejection is a natural part of the creative process. Learn from it, and do not fear it. Leverage your success by doing a self-evaluation and by using all the techniques you have learned in this book to make your next film distributable from the beginning. Stay in touch with all the networks of fans, friends, and peers you have developed, so that they are there for you on your next project. Finally, help yourself gain momentum on your next film by setting the measure of success for yourself just a little bit higher than it was on this film.

REVIEW QUESTIONS: CHAPTER 15

1. About how much time should you spend attempting to distribute your film?

2. As you wrap up your film, you will create an archive of important documents and items. Name as many of those documents and items as you can.

DISCUSSION / ESSAY QUESTIONS

1. Write a short essay about dealing with rejection. What do you think is the best way to handle rejection? What are some positive ways to look at failure and rejection? If you have faced any failures or rejection, what have you learned from them?

Research/Lab/Fieldwork Projects

The following lab projects will help you if you are planning on distributing alternative content.

1. Using the example from the chapter, create a Self-Evaluation form and fill it out. Share some of your answers with your mentor or your friends or some film school students. What parts of the self-evaluation do you find most helpful?

2. Create, or begin to create the archive for your film project. Collect the materials discussed in the chapter and organize them. Share your archive with your friends who are experienced filmmakers. What part(s) of the archive are most valuable for you as you consider your next project?

APPENDIX

I. **Short Film Distributors Domestic and Foreign**

II. **Short Film Buyers Domestic and Foreign**

III. **Educational Film Distributors and Buyers**

These are partial listings of domestic and foreign short film distributors. Do your research before approaching anyone on this list! These listings also appear on the companion DVD. Courtesy of Jason Moore. Used with permission.

I. Short Film Distributors - Domestic and Foreign

Canada
Ouat Media
www.ouatmedia.com
2844 Dundas Street West
Toronto, ON, M6P 1Y7 CANADA
Tel: +1 416 979 7380

England
Dazzle
hwww.dazzlefilms.co.uk
Unit P102, Penn Street Studio, 23 - 28 Penn Street
Hoxton, London, N1 5DL, UK
T: +44 (0)20 7739 7716

United States
Cinetic Media
www.cineticmedia.com
555 West 25th St. (4th floor)
New York, NY 10001, USA

Indiepix
http://blog.indiepixfilms.com/
31 East 32nd Street #1201
New York, NY 10016, USA

Omni/Filmgrinder
www.omnifilmdistribution.com
Linda Cavatto
1107 Fair Oaks Avenue #816
South Pasadena, CA 91030

Shorts International
www.shortsinternational.com/
Acquisitions:
Linda Olszewski
P.O. Box 2514, Toluca Lake, CA 91610, USA
E: linda@shortsinternational.com

Strand Releasing
www.strandreleasing.com
6140 W Washington Blvd
Culver City CA 90232
T +1 310 836 7500

II. Short-Film Buyers – Domestic and Foreign

Argentina
Caloi En Su Tinta
Av. Paseo Colon 1011 - 8° B C1063ACK
Buenos Aires Argentina
Tel.: +54 114.362.0904
info@caloiensutinta.com.ar www.caloiensutinta.com.ar
Maria Veronica Ramirez - CEO
caloiensutinta@gmail.com

Australia
Special Broadcasting Service - SBS
14 Herbert St. NSW 2064
Artarmon - Sydney Australia

Tel.: +61 2.9430.3602
www.sbs.com.au
Lien Aguilar - Short Film Acquisitions
lien.aguilar@sbs.com.au
Broadcasts in 65 languages. Short film acqustions: seeks films for the program "Eat Carpet," maximum running time: 20'. All genres. Films must be in English or subtitled. Period of license: 3 years. Territories: Australia. Fee per minute: AUD$120.

Belgium
Be Tv
656 Chaussée de Louvain
1030 Bruxelles Belgium
Tel.: +32 2.730.02.11
www.betv.be
Dominique Brune - Program Director
dominique.brune@betv.be

Canada
Movieola Short Film Channel
M6P 1Y7 Toronto Canada
Tel.: +1 416.492.1595
For short film acquisitions: Running time between 30' and 40', all genres (fiction films, animated films and documentaries), films must be in English or subtitled, 2- to 4-year contract , non-exclusive broadcast for Canada, via cable and satellite, fee per minute: between 20 and 35 Euros.
info@movieola.ca www.movieola.ca
Jennifer Chen - Head of acquisitions, Programming Director
Jennifer.Chen@tvchannelzero.com

Spafax CANADA
1179 King St West, Suite 101 M6K 3C5 Toronto, ON Canada
Tel.: +1 4163502425
www.spafax.com
Shane Smith - Producer
ssmith@spafax.com

Finland

YLE 1 - YLE

PO Box 98 - Radiokatu 5 00240 Helsinki Finland

Tel. : +358 9.14.801

www.yle.fi

Sari Volanen - Acquisitions, Head of Co-Productions

sari.volanen@yle.fi

Tel.: +358 9.14.80.27.83

Concerning short film acquisitions - Running time: up to 60 minutes. All genres. Films must be in English or subtitled, preferably on DVD. Contract: 2 years exclusive. Broadcast territories: Finland.

Fee per minute: not specified. Present at Clermont-Ferrand.

France

Arte France

8, rue Marceau 92785 Issy-les-Moulineaux Cedex 9 France

Tel.: +33 1.55.00.77.77

www.arte-tv.com

Hélène Vayssières - Head of Short Film Programming, Acquisitions

h-vayssieres@artefrance.fr

Arte GEIE - Strasbourg

4, quai Chanoine Winterer

67080 Strasbourg France Tel. : +33 3.88.14.22.22

www.arteradio.com

Barbara Häbe - Short Film Acquisitions

barbara.habe@arte.tv

For short film acquisitions: Maximum running time 30' for terrestrial broadcast, 60' for cable and satellite broadcast. Films of all genres, Exclusive 2-year contract. Broadcast territories: France (terrestrial, cable and satellite), Germany (cable and satellite), Switzerland and Belgium (cable). Price per minute depends on length. Present at Clermont-Ferrand and at international film festivals.

Canal+ France

1, place du Spectacle 92130 Issy-les-Moulineaux France

Tel. : +33 1.71.35.35.35 For short film acquisitions:

Lorraine Sullivan - Film Acquisitions

lorraine.sullivan@canal-plus.com

Maximum running time: 30' - but 15' and less preferred

License Period: 1 year - exclusive - unlimited broadcastings

Broadcasting Territories: France - French speaking Swiss - Dom Tom Broadcasting ways: Satellite - Cable - Terrestrial - Internet - VOD Price per minute: between 250 and 800€ Presence at festivals and markets: Clermont-Ferrand - Brest - Annecy (animation) - Cannes Purchasing per year: more than 200 Pre-Purchasing: 30 French Films Short Films are broadcasted on 2 Programs : "Mensomadaire" and "Mickrocine" There are 10 hours of Short Films each week on Canal +.

Chalet Pointu
10, rue des Goncourt 75011 Paris France
Tel. : +33 1.48.05.12.50
www.chaletfilms.com
Guillaume Calop - CEO
guillaume@chaletpointu.com
 Activity: DVD edition - Broadcastings : Internet, major outlets, festivals
To broadcast Short Films: Maximum Running Time: 59' Types: every type
Length of Contract: between 3 and 5 years, non exclusive - contracts established with producers or directly with directors

Cinecourts-Cinecinema
c/o Le Retour en Avant - 34, rue de Picpus 75012 Paris France
Tel.: +33 1.43.42.57.40
www.cinecinema.fr
Patrice Carré - Director of Short Film Acquisitions, Chief Editor
cinecourts@club-internet.fr
"Ciné Courts" : Program broadcasted on the channel CinéCinéma Club, and reserved for Short Films.
Presented by Patrice Carré. Runtime: 26'
Short Films purchasing: Maximum Running Time: 25' Types: All Versions: Every Language
License Period: 2 months, in exclusivity - 10 months non exclusive
Broadcasting Territories: France –
Price Per Minute:Less than 10' : 800 €, Between 10' and 15' : 1150 €, Between 15' and 20' : 1350 €
More than 20' : 1650 €

Cuisine TV
15, rue Barbette 75003 Paris France
Tel.: +33 1.55.37.68.68.
www.cuisine.tv
Isabelle Grillot - Programming and Acquisitions Director

isabelle.grillot@canal-plus.com
For short film acquisitions: Maximum running time: 15′, all genres provided the theme is linked to the field of cooking and that food is not a subject of derision or simply a pretext. Films in French version only, 6- to 12-month contract, for territories covered by Canal Satellite: France, French overseas departments and territories, Monaco, Andorra, Africa, Switzerland and French-speaking Belgium.

Equidia (Pôle TV Multimedia)
ZAC Kléber, 165 boulevard de Valmy -Bât. D - Porte
402 92700 Colombes, France
Tel.: +33 1.46.52.8931.
www.equidia.fr
Natacha Clouzet - Acquisitions
natacha.clouzet@equidia.fr
To buy short films: Maximal Running Time: no restriction
Types: horses or equines (pon, donkey, zebra), even if they play a minor role
Versions: French version or original version with French subtitles,
or original version (Subtitles made by Equidia)
Length of contract: 1 year, non exclusive - 3 years when subtitles are made by Equidia and for pre-buying

France 2
7, esplanade Henri de France 75015 Paris France
Tel. : +33 1.56.22.42.42
www.france2.fr www.francetvod.fr/
Christophe Taudière - Short Film Acquisitions
christophe.taudiere@francetv.fr
"Histoires Courtes": Weekly Short Films' program
For short film acquisitions: Maximum running time: 59 minutes
Types: Fiction - Documentary – Animation
Versions: French - Original version wtih subtitles
License Period: 42 months/ 3 broadcasings
Price per Minute: Purchase: 700 € /min until 15′ (more: 500 €) Pre-Purchase: 1000 €/min until

Lowave
14, rue Taylor 75010 Paris France
Tel.: +33 1.45.72.50.10
www.lowave.com
Marc Horchler - Acquisitions

marc@lowave.com
Company specializing in video publishing and experimental short film distribution on DVD.
Sometimes, the company distributes films for its partners.
Maximum Running Time: 30′ Types: Experimental - Video Art
Version: Original Version with French, English, or German subtitles is desired.
License period: 5 years
Commission: 50% shared between the number of films included in the DVD compilation

Mouviz
3, rue de l'Hôtellerie 44482 Carquefou Cedex France
Tel. : +33 2.28.23.24.01
www.mouviz.com
Jérôme Poulain - Manager
jerome.poulain@mouviz.com

Shorts TV - Shorts International
Tour Ariane 5, place de la pyramide
92800 Puteaux France
Tel. : +44 207.613.5400
www.shortsinternational.com
Julien Hossein - Representative
julien@shortsinternational.com

Germany
NBC Universal Global Networks
Theresienstr. 47a
80333 Munich Germany
Tel.: +49 89.381.99.0
www.nbc-universal.de
Bjoern Fickel - Acquisitions
Bjoern.fickel@nbcuni.com

ZDF - Zweites Deutsches Fernsehen
Postfach 4040 55100 Mayence Germany
Tel.: +49 30.20.99.13.31
www.zdf.de
Ingrid Graenz - Director of Short Film Acquisitions
info@zdf.de

Great Britain
Spafax UK
the Pumphouse 13-16 Jacob's Well Mews
W1U3DY Londres Great Britain
Tel.: +44 2079062001
www.spafax.com
Sophie Wesson - Acquisitions
swesson@spafax.com
Activity: Sells programs to airline companies
Maximal Running Time: 30', but flexible
Types: every type, but no politic or religious themes, in order to suit all the
customers – airline issues/crashes
Version: English subtitles obligatory
Length of contract: 6 months
Territories of broadcasting: the World
Broadcasting ways: On airline companies' partners
Price per minute: to negotiate

Special Broadcasting Services - SBS
Morelands, 2nd floor 5-7 Old Street E
C1V 9HL Londres Great Britain
Tel.: +44 20.7336.6160.
www.sbs.com.au
Marie Stroud - Short Film Acquisitions
mstroud@risalto.com
Short film acquisitions: SBS seeks films for the programs "Eat Carpet" and
"Fetching Shorts,"
maximum running time: 20'.
Genres: all genres except documentaries.
Period of license: 2 broadcasts over 3 years.
Fee paid per minute: AUD$120.

Hungary
MTV - Magyar Televizio
1054 Budapest Romanian, Slovak and Croatian. Hungary
Tel.: +36 1.353.32.00
www.mtv.hu
Sonja Varga - Acquisitions
sonja.varga@mtv.hu

Iran

IRIB

www.irib.ir

Italy

NBC - Universal Global Networks Italia

Via Po, 12 00198 Rome Italy

Tel.: +39 06.85.209.441

www.studiouniversal.it

Vincenzo Scuccimarra - Acquisitions

orsola.clausi@nbcuni.com

RTI

Via Lumiere, 420093 Cologno Monzese (Milano)Italy

Tel. : +39 02.25.14.77.111

www.gruppomediaset.it

Imma Petrosino - Director of Short Film

Acquisitions

imma.petrosino@mediaset.it

For short film acquisitions: ideal running time between 3′ and 5′, maximum 15′.

Genres: fiction (black & white films not accepted), animations, family films and comedies highly valued.

Films must be in English or subtitled.

Sky Italia

Case Postale 13057 20130 Milan Italy

www.sky.it

Japan

Japan Entertainment Network (Cartoon Network)

Cartoon Network Japan 5F, 6-4-1

Ginza/Chuo-ku

104-0061 Tokyo Japan

Tel.: +81 3.55.37.17.63

www.cartoon.co.jp

TV Man Union Inc.

Cosmos Aoyama 5-53-67 Jingumae -Shibuya-ku 150-0001 Tokyo Japan

Tel. : +81 3.64.18.87.00.

Rumi Ono - Short Film Acquisitions
To buy short films: Maximal Running Time: 25' Types: every type, except experimental
Versions: English subtitles obligatory
Length of contract: between 2 and 5 years (depends on the film)
Price per minute: 100-150€, but it depends on the film

Zazie Films
Dai-Ni Atmosphere Aoyama 7F, 2-10-8 Meguro, Meguro-ku 153-0063 Tokyo Japan
Tel.: +81 3.3494.7494
www.zaziefilms.com
Yuji Sugeno - Acquisitions

Morocco
Soread 2M
120, avenue des Champs Elysées 75008 Paris France
Tel.: +33 53.53.46.00
Nordine Arras - CEO

Netherlands
Netherlands Kunstkanaal/Arts Channel
P.O. box 53066 1007 RB Amsterdam Netherlands
Tel.: +31 20.6271496
www.kunstkanaal.nl
publiciteit@felix.meritis.nl

NPO
PO Box 26444
1202 JJ Hilversum Netherlands Tel. : +31 35.67.78.039
www.vpro.nl
Caro Van Der Heide - Short Film Acquisitions
caro.van.der.heide@omroep.nl

Poland
Canal+ Polska
CANAL + Cyfrowy Sp. z o. o.,Al. gen. W. Sikorskiego 902-758 VarsoviePoland
Tel.: +48 223282796
www.cplus.com.pl
Urszula Skassa - Short Film Acquisitions
urszula.skassa@cplus.com.pl

Portugal

RTP2 - RTP

Av. Marechal Gomes da Costa,
37 1849-030 Lisbon Portugal
Tel: +351 21.794.70.00
www.rtp.pt
Fatima Nunes Cavaco - Acquisitions
fatima.cavaco@rtp.pt
For short films broadcast on the program "Onda Curta": maximum running time 40' (broadcast of 60' films possible). All genres.
Versions accepted: films broadcast in original version, with subtitling undertaken by RTP.
Period of license: 3 broadcasts over 2 years.
Fee per minute: variable, up to €65.

Spain

Canal 9 - TVV

46100 Burjassot (Valence) a
Tel.: +34 96.318.30.00
www.rtvv.es
Vicente Suberviola Lloria - Programming and Acquisitions Director
suber@rtvv.es
Running Time: between 5' and 15'
Types: Comedy and animation - more rarely: Drama, fantastic, musical comedy, documentary
Version: English or English subtitles + List of Dialogs
License Period: 1 year
Price per Minute: 150 € Acquire more or less

Chello - Multicanal

c/ Saturno, 1 28224 Pozuelo de Alarcón, Madrid Spain Tel. : +34 91.714.1080
www.canalhollywood.tv
Irene De La Cruz - Director of Short Film Acquisitions
icruz@chellomulticanal.com
The most important thematic channels.
Independent producer of Spain and Portugal. It produces nine thematic channels: Canal Hollywood (cinéma), Canal de Historia (documentaires), Canal Cocina, Odisea (documentaires), Sol Mùsica (musique), The Biography Channel (documentaries), Canal Panda (programmes pour enfants), Canal Decasa, et Extreme Sports Channel (sports).
It attracts more than 13 millions of viewers.
Running time between 2' and 20'

Types: all types except experimental, documentaries, erotic black & white and gore films
Versions: English version preferred - original version accepted
Length of contract: 1 year - exclusive
Price per minute: $30 US

Kiwi Media
Gran de Gracia 15, 2-1 08012 Barcelone Spain Tel.: +34 933682383
owww.kiwi-media.net
David Albareda - Programming Director
david@kiwi-media.net

TV FOX ESPANA
C/ Orense 34, 2º. Edificio Iberia Mart 2
28020 Madrid Spain Tel.: +34 917022690
isabel.vazquez@fox.com
Isabel Vázquez - Program Director
isabel.vazquez@fox.com

Sweden
Canal+ Television AB (Ex-Filmnet)
Tegeluddsvägen 7 11584 Stockholm Sweden
Tel. : +46 84.59.28.00
www.canalplus.se
Line Mykland - Programming and Acquisitions Director
line.mykland@canalplus.se

Sveriges Television AB - SVT
Oxenstiernsgatan, 26 105 10 Stockholm Sweden
Tel. : +46 8.784.0000
www.svt.se
Hans Elefalk - Film Acquisitions
hans.elefalk@svt.se
For short film acquisitions: maximum running time: variable according to genre.
All genres accepted.
English language or subtitles preferred.
Length of license: variable according to genre.
Fee paid per minute, negotiable.

Switzerland

SRG SSR
SRG SSR idée suisse Direction générale Belpstrasse 48
3000 Berne 14 Switzerland Tel. : +41 44.305.63.62
www.srg-ssr.ch
Veronika Grob - Program Director
veronika.grob@sf.tv

Swiss Films
Neugasse 6 - Postfach 8031 Zurich Switzerland
Tel. : +41 43.211.40.50
www.swissfilms.ch
 Francine Brücher - International Sales
info@efp-online.com
Simon Koenig - Head of Short Films

TSR - Télévision Suisse Romande
20 Quai Ernest Ansermet, Case Postale
1211 Genève 8 Switzerland
Tel.: +41 22.708.2020
www.tsr.ch
Sandrine Waller - Short Film Acquisitions
sandrine.waller@tsr.ch

Taiwan

PTS Taiwan
No 50 Lane 75, Kang-King Road,
Sec 3 114 Taipei, Taiwan
Tel.: +886 226338037
Victoria Liu - Acquisitions
prg2101@mail.pts.org.tw

United States

Atom Films
225 Bush Street - Suite 1200
San Francisco, CA 94104
Tel.: 415.503.2400
www.atomfilms.com

Eurocinema (USA)
4045 Sheridan Ave -#390 33140 Miami
Tel.: 704.814.6965
www.eurocinema.com
Steve Matela - Vice-President
stevem@eurocinema.com
TV Channel. For short film acquisitions: Films of all genres and running times, films must be in English or subtitled, 5-year contract renewable for 4 years

Kqed
2601 Mariposa St.
San Francisco, CA 94110
Tel. : 415.553.2218
www.kqed.org
Scott Dwyer - Programming Director
sdwyer@kqed.org
For short film acquisitions: Running time between 2' and 26'. Genres: fiction. Films must be in English or subtitled in English. License period: 3 years non-exclusive for California. Fee per minute: US$100.

Spiritual Cinema Circle
369 Montezuma #234
Santa Fe, New Mexico 87501
Tel. : 505-989-9897
www.SpiritualCinemaCircle.com
Anna Darrah - Head of acquisitions
anna.darrah@gaiam.com

Swamp - SouthWest Alternate Media Project
Houston, TX
Tel. : 713.522.8592
www.swamp.org
Mary Lampe - CEO
mmlampe@swamp.org

Vista Higher Learning
31, St James Avenue
Boston, MA 02116
Tel.: 617.426.4910
www.vistahigherlearning.com
Raphael Rios - Short Film Acquisitions
rrios@vistahigherlearning.com

III. Educational Film Distributors and Buyers

Energized Films
www.energizedfilms.com

Fanlight Productions
www.fanlight.com
32 Court Street
Brooklyn, NY 11201
(718) 488-8900

Green Planet Films
www.greenplanetfilms.org
21 Columbus Avenue, Suite 205
San Francisco, CA 94111
(415) 377-5471

New Day Films
www.newday.com
Karen Kox
190 Route 17M, P.O. Box 1084
Harriman, NY 10926

INDEX

A

action-sports videos
 career path, 270
 definition, 23
 DIY distribution, 280–282
adding value, 113
AdSense, YouTube program, 251
advance, definition, 217
agreement, 213–216
Alexandre Naufel, interview with, 304–306
alternative content
 career paths
 action-sports videos, 270
 episodic television, 268–269
 music videos, 269–270
 spec commercials, 269–270
 Webisodes, 268–269
 DIY distribution
 distribute your work on Web, 272
 know your audience, 272
 promote your project and yourself, 271–272
 short-film distribution, 22–23
amateur videos, 25
Amazon's CreateSpace, 253–254
American Seoul, 116
American Society of Composers, Authors, and Publishers (ASCAP), 68
art materials release deliverable, 68
 strategies for, 86
aspiring creative crew member, 80
 goals for, 169–170
 strategies, 136–137

aspiring feature director, 29, 80
 goals for, 166–167
 strategies, 135–136
Atom, 257–258

B

Babelgum, 254–255
behind-the-scene clips, 104
BetaCam, 78
Bittorrent, 262
blank cue sheet template, 70
Blip.com, 262
blogging, 119–121
blogs, definition, 47
blooper reel, definition, 104
Blu-Ray, 78
Brian Amyot, interview with, 275–277
broadcast distribution
 approaching broadcast buyers directly
 contract, 221
 finding, 220–221
 getting paid, 221
 approaching distributors and sales agent
 cover letter, 208
 DVD, 209–210
 follow up, 210
 press pack, 208–209
 deal negotiation
 contract, 212
 exclusivity, platforms, and territories, 218
 fees, 217
 first contact, 211–212

Internet deals, 218–219
negotiating, 212, 217
term, 219–220
distribution plan, 180–181
finding distributors and sales agent
film festivals and markets, 205–206
international distribution
companies, 207
Internet research, 204–205
networking, 206–207
general strategies
deal negotiation, 202–203
explore contacting buyers
directly, 203
film submission, 202
territories and platforms, 203
broadcast distribution platform
broadcast, 184
educational, 185
home entertainment, 184–185
Internet, 185–186
mobile, 186
theatrical, 186–187
business card, 104–105
buzz, definition, 5

C

cable television, film distribution, 13–14
cinematographer's reel, 293
classic distribution model, 43–44
benefits, 48
challenges, 48
vs. DIY model, 45–47
Clayton Hemmert, interview
with, 301–304
Coca-Cola Company®, 81
contract
approaching broadcast buyers, 221
negotiating a deal, 212
creating your story, 105–106
crew list, 76
cue sheet, definition, 68
Current.tv, 262

D

Dave A. Barrett, interview with, 307–308
deliverables

the film itself, 58
dialog list, 79
formats, 77–78
music and track effects, 79
list of, 58–59
promotional materials, 57
crew list, 76
director biography, 74
director's statement, 74–76
DVD artwork, 71–72
film synopsis, 76
one sheet (Poster), 71–72
production stills, 72–74
script, 76
rights and releases, 57
art materials release, 68
locations release, 65–66
music cue sheet, 68
music releases, 64–65
producer/director release, 62
screenplay release, 64
talent releases, 62
demo reel
definition
case with cover art, 289–290
DVD, 288
reel insert, 289
distribution
Internet, 299–301
Networking, 298
On request, 296
Submitting your reel, 297–298
evolution
further specialized reels, 295–296
narrative or documentary
film reel, 295
recent graduate/early stages of
career, 294
specialized industry reel, 295
purpose
short and fast paced, 293
showcase only the best work, 294
showing small pieces of work, 293
specialized reels, 292–293
dialog list, 79
DigiBeta, 78
digital filmmakers, 17

director
 biography, 74, 102
 business card, 104–105
 statement, 102–103
director's reel, 293
director's statement, 74–76
distribution
 benefits, 2
 buzz, 5
 distribution model, 5
 film festival circuit, 3
 film market, 4
 licensing film rights, 4
 panel discussion, 4
 definition of, 2
 film distribution
 cable television and home
 entertainment, 13–14
 early, 8–10
 film festivals and short films, 14–15
 Internet, 15–16
 television and independent
 film, 10–13
 filmmaker
 novice, 2
 opportunities, 16–17
 goal, 42, 52
 plan, 42, 51–52
 step-by-step process, 6–7
 types of short films and videos
 alternative content, 22–23
 amateur videos, 25
 short films, 22
 user-generated videos, 24–25
distribution company, 183
distribution cycle
 dealing with rejection, 314–315
 gain momentum, 319–320
 leverage your success, 318–319
 make your next film distributable,
 317–318
 networking, 318
 self-evaluation, 315–317
 winding down, 312–314
distribution language
 distribution company, 183
 distribution platform, 184–187

exclusivity, 187–189
fee, 190–191
film buyer, 184
nonexclusive, 189–190
release window, 191–192
sales agent, 183
term, 190
territories, 187
distribution models
 classic distribution model, 43–44
 definition, 5, 42–43
 Do It Yourself (DIY), 44–45
distribution plan
 broadcast distribution, 180–181
 film festivals
 attendees, 133
 happening things, 133–134
 organizers, 132–133
 screening films, 133
 gain momentum, 319–320
 leverage your success, 318–319
 securing Internet distribution,
 232–233, 248
 self-promotion
 believe in yourself, believe in
 your film, and enjoy the
 process, 95–96
 benefits of, 92–93
 if the film is not perfect?, 93
 standing out from the crowd, 95
 understanding your
 audience, 93–94
distributor. *See* distribution company
DIY (Do It Yourself) distribution
 alternative content
 distribute your work on Web, 272
 know your audience, 272
 promote your project and
 yourself, 271–272
 benefits, 48
 challenges, 48–49
 definition of, 248–249
 exclusivity and territories, 262–263
 vs. help from a distributor, 235
 Internet release window, 240–241
 types of techniques, 249
 Voluntary Donation (VODO), 258–259

Web Sites geared toward filmmakers
 Atom, 257–258
 Raindance.tv, 257
 ShootingPeople, 257
 The Smalls, 257
 Triggerstreet, 257
Web sites with "for-pay" model
 Amazon's CreateSpace, 253–254
 Babelgum, 254–255
 IndieFlix, 252–253
 YouTube, 249–252
Web sites with "no-pay" model, 259–260
 Bittorrent, 262
 Facebook, 260–261
 Hulu, 262
 MySpace, 260–261
 Netflix, 262
 Vimeo, 260
documentary film reel, 295
DVD
 artwork, 98–99
 format, 77
 fulfillment, 252–253

E

early film distribution, 8–10
E-Commerce, definition, 45
editor's reel, 294
educational distribution platform
 broadcast distribution, 185
 non-broadcast distribution, 237–238
educational film distributors and
 buyers, 337
elevator pitch, 271
elevator pitch, definition, 115
email, 117–118
email newsletter, definition, 117
episodic television, 268–269
exclusivity, 49–50, 187–189
executive producer, definition, 12
experimental films, definition, 22

F

Facebook, 123–124, 260–261
festival guide, definition, 134
festival rights, definition, 84

film buyer, definition, 184
film distribution
 cable television and home
 entertainment, 13–14
 early, 8–10
 film festivals and short films, 14–15
 Internet, 15–16
 television and independent
 film, 10–13
filmed entertainment, 27
Film Festival Circuit, 3
film-festival invitation, goals for,
 167–168
film festivals
 communication
 ask questions, 159–160
 format requirements, 158–159
 volunteer yourself, 159
 distribution plan
 attendees, 133
 happening things, 133–134
 organizers, 132–133
 screening films, 133
 film distribution, 14–15
 goal setting
 aspiring creative crew members,
 169–170
 aspiring feature directors, 166–167
 first-time filmmakers, 170–171
 intermediate-level filmmakers,
 168–169
 Internet, withoutabox.com Web site
 building online press kit, 144–147
 finishing the project form, 144
 project creation, 139–144
 register, 139
 researching festivals, 147–148
 submission status, 151
 submitting to festivals, 148–150,
 152–154
 screening
 add value and give more than you
 receive, 160–161
 flyers/postcards/swag, 161–162
 interviews and press opportunities,
 164–165
 refining your story, 162–164

strategies
 aspiring creative crew-member,
 136–137
 aspiring feature-director, 135–136
 first-time filmmaker, 137
 intermediate-level filmmaker, 136
Web sites, 138
film-itself deliverables
 dialog list, 79
 formats, 77–78
 music and track effects, 79
filmmaker
 aspiring creative crew member, 80
 aspiring feature director, 80
 digital, 17
 first-time, 28, 30–31, 82
 independent, 14
 intermediate-level, 28, 30, 80–82
 novice, 2
 opportunities for, 16–17
 personal Web site, 120
 Websites
 Atom, 257–258
 Raindance.tv, 257
 ShootingPeople, 257
 The Smalls, 257
 Triggerstreet, 257
film market, definition, 4, 205
film synopsis, 76, 102–103
first-time filmmaker, 28, 30–31, 82
 goals for, 170–171
 strategies, 137
further specialized reels, 295–296

G

Genre, definition, 95
Grace Rowe, interview with, 174–176
greeking out, definition, 86

H

HD CAM, 78
homage, definition, 36
home entertainment
 broadcast distribution, 184–185
 non-broadcast distribution, 235–237
home-entertainment buyers, 78
Hulu, 262

HungryFlix®, 239, 256
Hybrid distribution model, 50–51
 steps of, 56

I

independent film company, definition, 13
independent filmmakers, 14
IndieFlix, 252–253
intermediate-level filmmaker,
 28, 30, 80–82
 goals for, 168–169
 strategies, 136
International Film Festival Circuit,
 definition, 3
Internet
 demo reel distribution
 paid demo-reel hosting
 Web sites, 299
 personal Web site, 300–301
 professional networking sites, 299
 social networking and free video
 sites, 299
 distribution platform
 broadcast distribution, 185–186
 non-broadcast distribution, 232–235
 exclusivity and territories, 262–263
 film distribution, 15–16
 film festivals, withoutabox.com
 Web site
 building online press kit, 144–147
 finishing the project form, 144
 project creation, 139–144
 register, 139
 researching festivals, 147–148
 submission status, 151
 submitting to festivals, 148–150,
 152–154
 promoting yourself
 blogging, 119–121
 email, 117–118
 podcasting, 121–123
 social networking sites, 123–124
 Website, 118–119
Internet blogs, definition, 24
Internet meme, definition, 47
Internet Movie Data Base (IMDB)
 Web site, 146–147

interview
>Alexandre Naufel, 304–306
>Brian Amyot, 275–277
>Clayton Hemmert, 301–304
>Dave A. Barrett, 307–308
>Grace Rowe, 174–176
>Philip B. Swift, 152–154
>Salim Baba, 192–196
>Sylvian Chivot, 222–223
>Tim Fender, 308–309
>Tony Armer, 171–173

L

licensing, definition, 181
licensing film rights, definition, 4
lip dub, definition, 270
locations release deliverable, 65–66
>strategies for, 85

M

machinima, definition, 24
mashup, definition, 25,270
materials release form, 69
MDistribute®, 239, 256
mobile broadcasters, 78
mobile distribution platform
>broadcast distribution, 186
>non-broadcast distribution, 238–239
music cue sheet, 68
music release form, 66
music releases deliverable, 64–65
>strategies for, 83–84
music videos
>career path, 269–270
>DIY distribution, 277–280
MySpace, 123–124, 260–261

N

narrative film reel, 295
Netflix, 262
niched subject material,
>definition, 13
non-broadcast distribution
>educational, 237–238
>home entertainment, 235–237
>Internet, 232–235

>mobile, 238–239
>other non-broadcast platforms, 240
nonexclusive deals, 189–190
novice filmmaker, 2

O

one sheet (poster), 98–99
one sheet, definition, 57
Openfilm, 256
opportunities, filmmaker, 16–17

P

panel discussion, definition, 4
performance release form,
>definition, 83
performer release agreement, 63
personal web site, 300–301
Philip B. Swift, interview with, 152–154
podcast, definition, 122
portfolio piece, definition, 26
postcards, 98–99
pre-Internet promotion model, 96
premier, definition, 44
press pack, definition, 92
producer/director release deliverable, 62
>strategies for, 82
production stills, 72–74, 99, 101
professional networking sites, 299
promotional material deliverables
>crew list, 76
>director biography, 74
>director's statement, 74–76
>DVD artwork, 71–72
>film synopsis, 76
>one sheet (Poster), 71–72
>production stills, 72–74
>script, 76
promotional poster, 57
promotions
>Internet
>>blogging, 119–121
>>email, 117–118
>>podcasting, 121–123
>>social networking sites, 123–124
>>Website, 118–119

real-world
elevator pitch, 115–116
golden rules, 112–114, 127
test screening, 114–115
timing, 125–126

R

Raindance.tv, 257
real-world promotion
elevator pitch, 115–116
golden rules
add value, 112–113
give more than you receive, 113–114
test screening, 114–115
reel insert, 289
release window, definition, 191
remix, definition, 25, 270
Revver, 256
rights & releases deliverables, 60–61
art materials release, 68
locations release, 65–66
music cue sheet, 68
music releases, 64–65
producer/director release, 62
screenplay release, 64
talent releases, 62

S

sales agent, 183
Salim Baba, interview with, 192–196
screening films, at festivals
add value and give more than you
receive, 160–161
flyers/postcards/swag, 161–162
interviews and press opportunities,
164–165
refining your story, 162–164
screenplay release deliverable, 64
strategies for, 83
self-evaluation, 315
distribution process, 317
the film, 316–317
self-promotion
believe in yourself, believe in your film,
and enjoy the process, 95–96
benefits of, 92–93

if the film is not perfect?, 93
standing out from the crowd, 95
understanding your audience, 93–94
selling, definition, 181
selling films
deliverables, 182
festival success, 182–183
promoting on the Web, 181–182
selling *vs.* licensing, 181
The Sherman Anti-Trust Act, definition, 10
ShootingPeople, 257
short film buyers, 324–337
short-film distribution
participation
aspiring cinematographer, editor, set
designer, sound designer, 29
aspiring feature director, 29
first-time filmmaker, 30–31
intermediate level filmmaker, 30
qualities
film length, 32–33
production value, 34
subject matter/what your film is
about?, 35–37
short film distributors, 323–324
short-film festivals, world wide, 135
short films
chance for success, 25–26
types of
alternative content, 22–23
experimental films, 22
short video interviews, 104
Sling.com, 262
The Smalls, 257
social networking, 271
definition, 46
Websites, 123–124
spec commercials
career path, 269–270
definition, 23
DIY distribution, 277–280
specialized demo reels
cinematographer's reel, 293
director's reel, 293
editor's reel, 294

specialized industry reel, 295
standard location release, 67
the studio system, 9
step-by-step distribution
 process, 6–7
Stuff We All Get (SWAG),
 definition, 162
The Sundance Film Festival, 14
Sylvian Chivot, interview
 with, 222–223

T

talent release form. *See* performance
 release form
talent releases deliverable, 62
 strategies for, 82–83
teaser, 103
television
 broadcasters, 78
 commercials, 23
 episodic, 268–269
 film distribution, 10–13
television network, definition, 11
telling the story, 106
term, definition, 190
territories, 187
test screening, 114–115, 271
theatrical distribution
 platform, 186–187
Tim Fender, interview with, 308–309
Tony Armer, interview with, 171–173
top-rated festivals, definition, 44
traditional *vs.* DIY promotion
 models, 96–98
trailer, 102
Triggerstreet, 257
Twitter, 123–124

U

user-generated videos, 16, 24–25

V

video on demand (VOD), 236
Vimeo, 260
vlogs, definition, 24
Voluntary Donation (VODO), 258–259

W

Web broadcasters, 78
Webisodes
 career path, 268–269
 definition, 23
 DIY distribution, 273–274
Weblog, 47
Websites, 118–119
 filmmakers
 Atom, 257–258
 Raindance.tv, 257
 ShootingPeople, 257
 The Smalls, 257
 Triggerstreet, 257
 for-pay model
 Amazon's CreateSpace, 253–254
 Babelgum, 254–255
 IndieFlix, 252–253
 YouTube, 249–252
 no-pay model, 259–260
 Bittorrent, 262
 Facebook, 260–261
 Hulu, 262
 MySpace, 260–261
 Netflix, 262
 Vimeo, 260
withoutabox.com Web site, 138–154
world-class film markets, 206

Y

YouTube, 249
 channels, 250
 partner program, 250–251
 AdSense, 251
 YouTube rentals (Beta), 251–252